·Alfred Stieglitz·
and the American Avant-Garde

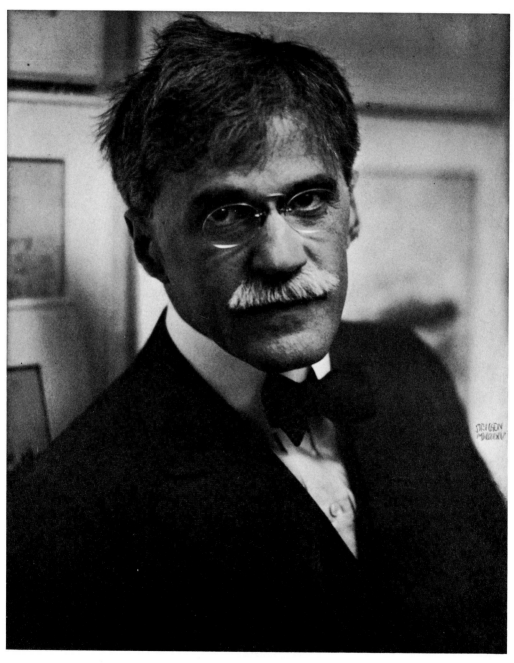

Eduard Steichen. *Alfred Stieglitz at 291*. 1915. Photograph. The Metropolitan Museum of Art: The Alfred Stieglitz Collection, 1933.

·Alfred Stieglitz·
and the American Avant-Garde

William Innes Homer

Boston
New York Graphic Society

First Edition

Library of Congress Cataloging in Publication Data

Homer, William Innes.
 Stieglitz and the American avant-garde.

 Bibliography: p.
 1. Stieglitz, Alfred, 1864–1946—Art patronage.
2. Art, American. 3. Art, Modern—20th century—United
States. 4. Photography, Artistic. 5. Artists—United
States—Biography. I. Title.
N5220.S858H65 1977 709'.73 76–50068
ISBN 0-8212-0676-1

Designed by Janis Capone

New York Graphic Society books are published by Little,
Brown and Company
Published simultaneously in Canada by Little, Brown and
Company (Canada) Limited
Printed in the United States of America

To the memory of my grandfather, William Thornton Innes, and to my son, Stacy Innes Homer

· PREFACE ·

Friends have often asked me why I wanted to write a book on Alfred Stieglitz and his circle. My answer was simply that I have long admired Stieglitz and the ideals for which he stood. I first learned of him when, at the age of fifteen, I read Thomas Craven's biased but fascinating book *Modern Art* (1934). Although Craven did not like the impresario, I found him an engaging personality and was curious to know more about him. In my teens, I often visited the Philadelphia Museum of Art, where I studied the work of John Marin, Marsden Hartley, and Georgia O'Keeffe, prominent artists of his circle. In 1945 Nancy Newhall's *Paul Strand*, a Museum of Modern Art exhibition catalogue published in that year, was given to me by my high school art teacher and it became one of my most treasured possessions.

At first, I was attracted to the artists of the Stieglitz group because I hoped my own studio work would benefit from their example. The watercolors I produced as an undergraduate at Princeton were much influenced by Marin, just as the photographs I took were affected by my admiration for Strand's images. Then, when I become an art history major, I began to look at the work of the Stieglitz circle from an historical as well as creative prospective.

By the time I entered graduate school at Harvard, my studio work declined in favor of the history of art, particularly of nineteenth- and twentieth-century European painting, and my interest in Stieglitz subsided. When I started teaching, however, I lectured on the Stieglitz group as part of the general history of American art, and I began to explore the subject in greater depth when I gave graduate seminars on avant-garde art in the United States. My preparation for these courses convinced me that much research remained

to be done, particularly in the years from 1905 to 1917, when Stieglitz was operating his gallery at 291 Fifth Avenue as a center for progressive art and artists.

In my research for this book, I first reviewed the existing publications on Stieglitz and his associates. Then I turned to all available primary sources — letters, diaries, scrapbooks, and so on — in order to check information that had appeared in previous books and articles. This primary material, much of it unpublished and, in some cases, unavailable to other scholars, enabled me to arrive at new insights about the Stieglitz circle.

I also interviewed several individuals who had been connected with Stieglitz and who could speak with authority about the man and his ideas. Georgia O'Keeffe, his widow and one of the most talented artists of his group, received me at her home in Abiquiu, New Mexico, and graciously answered innumerable questions about herself and her late husband. I am indebted to her for allowing me to publish excerpts from letters in the Stieglitz Archive at Yale. Stieglitz's friend and colleague Dorothy Norman granted me many interviews, patiently answered my queries, and, I am happy to say, also became a friend. I am grateful to her for permitting me to publish materials from the collections that she gave to the Alfred Stieglitz Center at the Philadelphia Museum of Art. The photographer Paul Strand, also a friend of Stieglitz, gave me much of his time, generously making himself available for interviews even in periods of imperfect health. I am particularly indebted to Mr. Strand because he read and approved the portion of the manuscript concerning his early life and work.

Six other individuals, besides O'Keeffe and Strand, granted me interviews in which I drew on their intimate knowledge of Stieglitz before the close of 291 in 1917. Flora Stieglitz Straus, his niece, graciously provided recollections of his life and told me much about his family background. Mrs. William Howard Schubart, a niece of Emmeline Stieglitz, his first wife, shared her rich memories of Stieglitz and his associates at 291. Ben Benn, a painter, and his wife Velida, a poet and playwright, likewise offered valuable glimpses not only of the activities of the 291 circle, with which they were associated, but also of the broader life of the New York avant-garde during World War I.

My special discovery, unknown to other scholars, was Mrs. George K. Boursault, formerly Marie Jourdan Rapp, Stieglitz's secretary at 291 from 1912 through 1917. A student of vocal music, she had started to work for the photographer when she was eighteen and soon became one of his protégées and a sympathetic member of his group. She was closely involved with the

daily life of the gallery and at this writing is the last known living participant whose knowledge extends back to the period before the Armory Show. Her phenomenal memory made the people and events of 291 come alive.

Still another link with the past is Gertrude Traubel, daughter of Horace Traubel, who was Walt Whitman's biographer, editor of the liberal journal *The Conservator*, and a close friend of Stieglitz. She often accompanied her father on trips from Philadelphia to New York and in this way came into contact with 291 and other advanced artistic and intellectual circles. A gifted musician, she was receptive to what she saw and heard and, therefore, was able to recapture the creative ambience of that exciting period.

During the course of my interviews with Miss Traubel I came to realize that I may have been predisposed to write about Stieglitz and his circle. Her father was a lifelong friend of my grandfather William Thornton Innes, a Philadelphian who shared his devotion to Whitman's ideas. These, in turn, were of central importance to several members of the Stieglitz circle — Marin, Hartley, and Walkowitz — as well to Stieglitz himself. My grandfather, moreover, was the publisher of Traubel's *The Conservator*, a periodical Stieglitz held in high esteem, and of *Cosmic Consciousness* (1901) by Richard Maurice Bucke, Whitman's champion, a book that had influenced Hartley.

There are ties in the photographic realm as well; around the turn of the century, Grandfather Innes was a talented amateur photographer in the pictorial tradition that Stieglitz had fostered since the mid-nineties. Significantly, a group of his photographs was accepted by the first Philadelphia Photographic Salon of 1898, and Stieglitz served on the jury for that historic exhibition. Innes's images, closely resembling Steichen's early photographs, were very much a part of my childhood environment, for they were hung prominently in my grandfather's home. Through repeated exposure to these pictures, I came to admire and accept photography as an art.

This book has been enriched by a unique contribution from the late Nancy Newhall, a distinguished historian and critic of photography. Through her husband, Beaumont Newhall, I learned that she had started a biography of Alfred Stieglitz in 1941 and that the first chapter, "Stieglitz and His Family," had been completed. Because Stieglitz was alive at the time of writing, he was able to review and correct it. When I read the manuscript, annotated by Stieglitz, I thought it would be appropriate to publish it as part of this book. Beaumont Newhall endorsed this plan and gave me permission to use the manuscript. I am grateful for his sympathetic cooperation.

I am indebted to the John Simon Guggenheim Foundation for awarding

me a fellowship for my research during the 1972–1973 academic year and to the University of Delaware for granting me a sabbatical leave for that period. I continued to work on this book through the summer of 1975, with additional assistance from an American Philosophical Society grant-in-aid and several faculty research grants from the university.

A special feature of this book is the section on New York Dada and the Arensberg circle. Written in large part by Louise Hassett Lincoln, with additions by me, it first appeared in slightly different form in *Avant-Garde Painting and Sculpture in America, 1910–25*, an exhibition catalogue issued in 1975 by the Delaware Art Museum and the University of Delaware. Because this essay includes new insights about the Arensberg group and its relation to Stieglitz, it seemed appropriate to publish it here. I am indebted to Ms. Lincoln for allowing her material to be used in this way and to the Delaware Art Museum for granting permission for its use in this book. The Museum has also authorized me to publish here, in revised form, my catalogue essays on "Progressives vs. the Academy at the Turn of the Century," "The Armory Show and Its Aftermath," and "Mabel Dodge and Her Salon." The section on Paul Strand in this book was first presented, in longer form, as a paper at the International Museum of Photography, Rochester, New York, on February 20, 1975, and was published in *Image*, June 1976.

Many other people have helped me in this project. The members of the staff of the Beinecke Rare Book and Manuscript Library, Yale University, were exceptionally cooperative during my many visits to the Stieglitz Archive. Dr. Donald Gallup deserves special mention for his wise counsel in all matters pertaining to the archive. My use of the Archives of American Art, an indispensable resource, was facilitated by Garnett McCoy, who gave me many valuable research leads. Grace Mayer, of the Museum of Modern Art, was unfailingly helpful in making the riches of the Steichen archive available to me. The staffs of the Philadelphia Museum of Art's Alfred Stieglitz Center and the Metropolitan Museum of Art's Department of Prints and Photographs were most cooperative.

I also gratefully acknowledge the help of Ansel Adams, William C. Agee, Thomas Hart Benton, Norma Berger, Doreen Bolger, Richard Boyle, Fannie T. Brenner, Doris Bry, Richard C. Bull, Peter Bunnell, William A. Camfield, Alphaeus Cole, Imogen Cunningham, Jean d'Albis, Bernard Danenberg, Rodrigo de Zayas, Paul Dove, William Dove, Scott C. Elliott, Sidney Geist, Lloyd Goodrich, Frederick Haviland, Nicole Maritch Haviland, Frank Hemingway, Lotte Jacobi, Martha Jenks, Paul Juley, Leo Katz, George Knox,

Elizabeth Lorentz, Harry Lunn, Jr., Stanton Macdonald-Wright, Wade Mack, Malitte Matta, Elizabeth Rhoades Reynolds, John H. Rhoades, Martica Sawin, Robert Schoelkopf, Suzanne Mullett Smith, Hazel Strand, Karl Struss, Roberta K. Tarbell, Joan Washburn, Joy Weber, Maynard P. White, Jr., Caroline Wistar, Lee Witkin, Beatrice Wood, Mrs. Albert Yoder, Virginia Zabriskie, and Carl Zigrosser.

My graduate students deserve special mention for stimulating my thinking about Stieglitz and his circle. At the University of Delaware in 1972 and 1974 I held seminars on this subject during which I presented many of the ideas in this book and, in turn, benefited from my students' reactions. Moreover, several students — Percy North, Eva Rünk, Priscilla Siegel, and Judith Zilczer — wrote under my direction graduate theses on members of the 291 circle. Although I supplied research leads and advice, they arrived at their own conclusions, and I have profited from my discussions with each of them.

I would like to thank Judy Gould and Melinda Parsons for making valuable editorial suggestions and Margaret Pyle Hassert of the University of Delaware and Robin Bledsoe of the New York Graphic Society for preliminary editing of the manuscript. Caryl Horty's careful review of the text improved its content and consistency. Thanks also go to Betsy Fahlman, who helped me with the notes and bibliography, and to Susan Reinhardt and Norma Zeller, who typed drafts of the manuscript and handled much of my research correspondence. A large part of the photographic work for the illustrations was done by Debbie Reinholz; I am grateful to her for her skill.

Finally, to my wife goes an extra measure of gratitude for her sympathy and patience during my four years of research and writing.

William Innes Homer

University of Delaware
April 1976

·CONTENTS·

·Alfred Stieglitz·
and the American Avant-Garde

·INTRODUCTION·

This book treats the revolution in the arts sponsored and encouraged by Alfred Stieglitz in the early years of our century. At his gallery at 291 Fifth Avenue, New York, progressive artists and critics met to discuss the urgent need for change in the culture of their time; the paintings and critical writings that grew out of these discussions belong to the first avant-garde in American art. Stieglitz, of course, did not create singlehandedly the revolutionary talents who congregated at 291, but he provided the inspiration and the environment that welded them together in a common cause. From 1908 to 1913, the year of the Armory Show, Stieglitz and his colleagues were virtually alone in the production and encouragement of avant-garde artistic currents in America. Their heroic efforts before 1913 would be reason enough for a book on the subject. But Stieglitz and his circle continued to work actively for the advancement of modernism until the gallery closed in 1917; thus this volume focuses on the lifespan of 291 from 1905 to 1917.

Three main motifs are intertwined in the following pages. The first is Alfred Stieglitz, the central character. His artistic personality and deeds, in turn, strongly affected the second theme — the intangible spirit of 291. That mysterious essence, together with the force of Stieglitz's own character, profoundly influenced the creative development of the artists of his circle. Therefore the third theme of this book is the art of the American avant-garde that flourished under his dedicated sponsorship.

Thus far, no one has considered the exact relationship of these artists to Stieglitz, to each other, and to the state of American art in the early years of

the twentieth century. Their activities should, I believe, be treated as an integrated whole, for none of the members would have developed as he or she did without drawing on the collective body of visual and theoretical knowledge generated at 291. A complete picture will emerge only when the artists' lives and their works are reviewed side by side with their economic problems and their relation to the public. It is also important to consider the effect of avant-garde exhibition schemes in promoting American acceptance of modern art and to recognize the influence of advanced European art and artists on the aesthetic education of the American audience.

I was drawn to this subject by the exceptional talent and originality of the artists of the Stieglitz circle, men and women who are only beginning to receive the attention they deserve. By recasting the visual language of European modernism in an American mold, they created unusually progressive styles, which not only placed them in the vanguard of the New York art world, but also fostered the disintegration of artistic provincialism in the United States. By analyzing in depth this rich and unique episode in American culture, I hope to provide a more thorough understanding of avant-garde American art and its relation to Europe in the early twentieth century.

To the reader who is not familiar with Stieglitz's achievements a few words of introduction may be helpful. He was a man of many talents—photographer, editor, gallery proprietor, raconteur, philosopher, and patron of the arts—a vital figure in directing the course of American art and culture from the turn of the century through the end of World War I. He was, above all, a superb photographer who quickly grasped the full artistic potential of his medium. Through the brilliant example of his own work and his determined efforts on behalf of his colleagues, he fought for the recognition of photography as a valid mode of artistic expression. He realized that the techniques and aesthetics that set photography apart from the fine arts were not its shortcomings, as so many critics believed, but that properly employed, the photographic aesthetic could produce a work of art able to stand on its own beside contemporary painting and sculpture. Beginning in 1902, Stieglitz promoted his ideals through an organization he called the Photo-Secession, a select group of men and women, sympathetic to his ideas, who became a powerful force for change in American photography.

Through *Camera Work*, the journal he started in 1903, Stieglitz promoted not only the photography he valued but also the latest developments in art and criticism, and for many years it was the most advanced American periodical devoted to the arts. Then, in 1905, he opened the Little Galleries of the Photo-Secession at 291 Fifth Avenue to help advance the cause of photog-

raphy, but in 1907 he also began to show paintings and drawings in comparison to photographs. Nonphotographic art soon took precedence, and as early as 1908, 291 had become the leading showplace for avant-garde European and American art.

As an integral part of 291, Stieglitz was a vocal spokesman for the arts and their role in American society. Although he had no elaborately structured aesthetic theories, he believed in all progressive causes and was vehemently antiacademic and antidescriptive in his view of the fine arts. He encouraged experimentation, emphasizing the free and vivid expression of the individual's personal point of view. But he also liked to support certain kinds of advanced painting and sculpture simply because they irritated people and forced them to reassess their views about art.

Stieglitz's associates could not have accomplished their goals without his faithful support. Why did he help them? Certainly not for commercial gain, because he lost money on the gallery and exhausted his personal funds to support the artists of his circle. Surely not for personal fame, as he did not try to reach a large audience through his gallery and did not publicize himself in the art world. His commitment, in fact, was intensely personal: he was a born missionary whose search for excellence in the arts had become an obsession, a lofty ideal to which he devoted all of the enormous strength of his ego.

This book is about Stieglitz's struggle to attain that ideal, both for himself and for his artist friends during the years when 291 flourished.

·CHAPTER ONE·

Alfred Stieglitz • The Formative Years

Stieglitz and His Family
by Nancy Newhall

Alfred Stieglitz was born in Hoboken, New Jersey, on New Year's Day, 1864. His father and mother, Edward and Hedwig Stieglitz, were Jewish. His father was born near Hannover-Münden in Germany and his mother in Offenbach near Frankfurt. His parents were not cramped by American notions of respectability. In addition to the deep Jewish sense of the family, with its cycles of birth and love and death as the center of existence, they had a Continental gusto for living.

Behind Hedwig lay the rich tradition of a rabbinical family. Warm, witty, and charitable, she was devoted to her family and friends, and anyone who came to her with a pathetic story could be sure of her instant generosity. Brought to America when she was eight, she was only nineteen when her first child, Alfred, was born. Within the short space of seven and a half years the house on Garden Street became tumultuous with children, six in all — Alfred, Flora, the twins Leopold and Julius,[1] Agnes, and Selma.

Edward Stieglitz, an erect and dashing man of medium height, had many magnificent qualities; but he was also vain and could be so tempestuously unreasonable that his household always stood a little in awe of him. He took enormous delight in horses and billiards, music and painting. He was an amateur painter himself and not without talent. (Alfred Stieglitz's photograph of him, palette in hand, is reproduced as Figure 1.) Business and businessmen were not his chief interests, but to support his growing family and the free, full life that was necessary to him, he applied himself to business ably and honestly, determined to lay by a modest but sufficient fortune. He had come to America around 1850 as a maker of mathematical instruments,

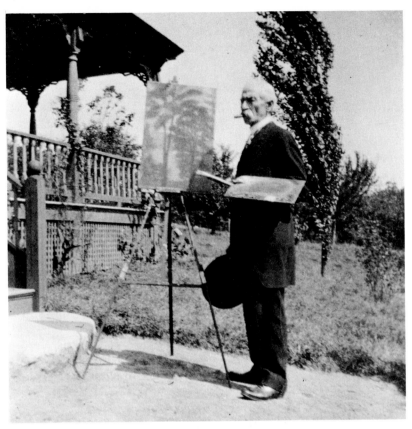

1. Alfred Stieglitz. *Portrait of Edward Stieglitz.* Photograph. Philadelphia
 Museum of Art: From the Collection of Dorothy Norman.

and for a while manufactured these delicate and precise tools. When the Civil
War broke out, he enlisted in the New York militia and became a first
lieutenant, but in 1862 he left the service, having found a substitute, in order
to marry Hedwig Werner and establish himself as a woolen merchant. So
upright and solid was his reputation that the most conservative bank in New
York City lent him money on his personal word alone. A. T. Stewart and
Marshall Field, the foremost department stores in New York and Chicago,
respectively, were among his customers. He came to know influential men
and prospered.

In 1871 he moved his family across the river to Manhattan and into the
house he had built for them at 14 East Sixtieth Street. This was a brown-
stone, modern and luxurious in its time. The chandeliers flared with gas, the
fireplaces were aided by steam heat, and ice water ran from the taps. Here,
on Sunday afternoons after the family dinner in the ground floor dining
room, Edward and his friends, mostly artists and professional men, with
perhaps a sprinkling of merchants, retired upstairs into one of the spacious
and lofty parlors.[2] The shutters were closed early against the lingering day-
light, the gas was lighted, and Edward informed the company that time —
American time, already beginning to be insistent — no longer existed. They
were free to enjoy themselves and were not to mention business. Choice

7

cigar smoke scented the air, and choice wines were brought up from the cellar by Edward's dark-eyed eldest son.

Alfred was seven when his parents brought him to the city. It was already apparent that there was something puzzling about him. It was, perhaps, mildly odd that a child of two should have clung passionately to so flat and unresponsive an object as a photograph, even one of a beautiful boy cousin. And it was curious later that he was so peculiarly sensitive to the weather, noting all its fluctuations — morning, noon, and night — in the diary he was starting, the diary he was to keep with scrupulous honesty and fidelity for many years. The weather, he insisted, explained why he did or did not do things on certain days. But why at school should he absolutely refuse to learn to draw? The Charlier Institute, which he entered in 1871, was an excellent French school, and he was already beginning to prattle fluently in that language, as well as in the German and English spoken at home.

He was an observant small boy, extraordinarily sensitive to the feelings of others. The doings of his elders left profound impressions on his mind. His attitude toward his father was one of silent, critical, and rebellious admiration. Knowing himself in many ways unmistakably Edward's son, he was driven by the spectacle of Edward's vanity and impatience to annihilate every vestige of these faults he found within himself. And he was puzzled and hurt that his father should lavish money on a sumptuous dress for his mother and at the same time keep her strictly and unhappily to an allowance because of her charitable excesses. The baseless temperamental explosions when Hedwig timidly and desperately produced her accounts at the wrong moment caused the boy to dislike and distrust money. What was money that it distorted values and could bruise and twist such generous people as his parents?

This imaginative sensitivity did not prevent him from being active and ingenious. He invented his own games, complete with rules, and saw that the rules were kept. When he sensed that the interest of the other children lagged, he changed the game or suggested a new one. He taught himself billiards in the game room at the top of the house and soon learned to defeat his astonished father. At nine he placed successfully in a public contest in Boston, but it appeared that he did not care much for competition. Perhaps it was too easy. Perhaps he did not like the atmosphere it engendered. In any case, he preferred to practice long hours alone, perfecting difficult shots.

In the summers Edward Stieglitz took his family to a hotel at Lake George in the Adirondacks, and it was in the village there that Alfred met his first

photographer. The boy had invented a horse-race game and went with his playmates to the booth of the local photographer to have him make a tintype of it. He arranged the toys carefully. The man took the photograph and disappeared behind a dark curtain. Alfred, fascinated, left his playmates and followed him. For the first time, he watched the strange and magical process of development. He kept coming back, haunting the primitive darkroom and asking questions. One day he found the photographer putting carmine on the cheeks of the tintyped faces. He was shocked. The man explained that it made them look more natural; Alfred insisted stubbornly that it did not. At nine he was convinced that the crude daubs of unnatural color spoiled the dark clarity of the images.

If his physical strength was suspect, it had to be tested. Record-breaking contests were the sporting enthusiasm of the day, and Alfred, in emulation, undertook to run a twenty-five-mile race against himself. For three and a half hours he sprinted round and round in the cellar, perspiring from the heat of the huge furnace, while his brothers and other boys looked on, holding stopwatches, sponges, and pails.

The rituals and routines of ordinary polite society beat in vain against the Stieglitz unconventionality. Within the strong shelter of home that Edward and Hedwig provided, the children were free to become individuals, and they did. No one tried to mold their personalities into fashionable patterns. It was a genuinely social way of life, as ancient as the patriarchs of Biblical days, under the shadow of whose strength whole tribes and even nations had flourished. To Alfred it was as natural as it was appealing. Unconsciously, a very old ideal blended with a very young one: the immemorial patriarch extended his protective hand to shield the glowing American dream of individual liberty in a free and active society where all creeds and all races were equal.

Growing up in that house full of children and hospitality, Alfred lived constantly with people and seemed to have no more need of privacy and isolation than could be obtained, in moments of crisis, by a long walk or a row on the lake. He was at once humble about his personal qualities and yet so challengingly positive, even aggressive, about his sudden judgments. Whence came those strange impulses that guided him, and why could neither difficulty nor the passage of years deflect him from a course chosen apparently on the spur of the moment? Why, when he enjoyed people so thoroughly and showed promise of being a brilliant conversationalist, was he so lonely? He could be very gently and endlessly patient one instant and devastatingly forthright the next. His sense of responsibility and honor was

so deep as to be troubling. When closely pursued for an explanation, he eluded his questioners. Sometimes his answers, though couched in the simplest terms, were as incomprehensible as a parable. Sometimes he took refuge in wit, which further bewildered his listeners. All his life he was to be surrounded by people asking "Why?" in accents ranging from amazement to fury and despair. Attempts to solve the mystery invariably ended in helpless confusion. Alfred remained Alfred, unpredictable, sometimes infuriating, yet curiously lovable.

In 1877 the boys were sent to public school, not only to save the tuition charged by private school, but also to give them the necessary democratic knocking-about. Alfred found the school work too easy, and whatever interest he may have had in scholarly pursuits vanished forever. He got by on a minimum amount of studying and devoted his time to sports, horses, and music. The boy excelled in baseball, track, and billiards, and he was a devoted fan of horseracing. His father owned a thoroughbred riding horse and was the only Jewish member of the New York Jockey Club. To Alfred there was something profoundly satisfying in the elemental vitality and the lightning responses of the beautiful racehorses. The walls of his bedroom were covered with sporting prints, most of them by Currier and Ives. Music he adored, but his performance at the piano was undistinguished. To painting and the painters who frequented the house he was indifferent, perhaps because none of them possessed that arresting, living quality that he was later to cherish.[3] Stretched out on the floor of the back parlor, with his head propped on his hands, he fed his passionate belief in the American dream from the pages of Revolutionary history. As he pored over his father's beautiful edition of Goethe's *Faust*, something set him unmistakably tingling, something to do with the passionate search of Faust and with the woman who appeared each time in a more universal form.[4]

His sense of life, that ancient Jewish heritage, became more and more concentrated in Woman. Certain women seemed to him immeasurably greater and more real than men. Their quick instincts rose, he felt, from the deepest sources of reality. Were not women in the truest sense the real creators of life, whose immense and humble destiny it was to bear children? He was always in love, and he was not ashamed of it; but it never occurred to him that any of the women he adored with such humility could possibly find him worthy of love in return. His mother remarked, when he was about seventeen, that she supposed he would be marrying soon. He instantly responded that he would never marry; he was too unworthy of any woman he would want to marry. He felt that he would never make money, and,

more than that, he was convinced that the magnificent qualities of the patriarch were not within him. Women and children, he felt, were like plants, and a man should be like a gardener. He should see that they had the light and soil they needed, freedom from pests and plagues, and water during the drought — above all, that they had space enough to develop to the last leaf and blossom that was in them. None of this was ever defined, deliberate, or codified. It rose in him as naturally as a spring rises bubbling into light from the dark recesses of the earth.

In 1879 Alfred entered the College of the City of New York.[5] His tendencies did not point decisively to any recognized profession. His father cherished no particular ambitions for his children. It was enough that they were decent citizens. Still, a man should be trained for something, and Edward discussed with Professor Werner, a relative of Hedwig who taught at the college, what Alfred might be suited for. Werner foresaw that engineering and chemistry were to change the world; why not make Alfred an engineer? To those men in those times, such a profession naturally implied a course of training at one of the great German polytechnic institutes.

In 1881 Edward retired from business, leaving the woolen trade to his younger partners. He had all the money he wanted; the income from four hundred thousand dollars, invested at the high rates of the period, would enable him to live as he chose and to support his wife and children. He was only forty-nine; he wanted to travel and paint, to bask in the atmosphere of the Continent. All the children would benefit from a European education, and Alfred would get the best engineering training in the world.

[The remainder of this chapter is by W. I. H.]

Berlin and New York:
Early Experiences in Art and Photography

Edward Stieglitz took the family to Germany in 1881 so that his children could enjoy the advantages of a Continental education. Alfred first enrolled at the Karlsruhe Realgymnasium and in 1882 entered the Technische Hochschule in Berlin as a student of mechanical engineering. (Figure 2 shows Stieglitz in Karlsruhe, aged about seventeen.) However, after studying this subject for a time, he was diverted from it by a course in photochemistry under Dr. Hermann Wilhelm Vogel, a noted expert in the field. Inspired by Vogel, Stieglitz started to take pictures in 1883, fell in love with photography, and produced countless prints in Berlin and elsewhere on the Con-

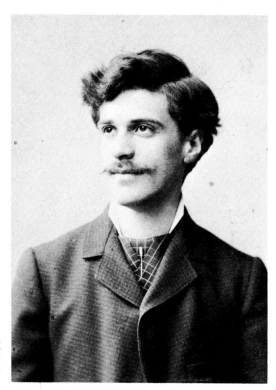

2. *Alfred Stieglitz.* c. 1881. Photograph by Th. Schuhmann & Sohn. International Museum of Photography at George Eastman House, Rochester, N.Y.

tinent during his frequent travels. He mastered his technique so thoroughly in 1887 that he won first prize in an exhibition sponsored by the London magazine *The Amateur Photographer* and judged by Dr. Peter Henry Emerson. This marked the first official recognition of his skill as a photographer; eventually he would win more than 150 awards.

While Stieglitz was a student in Germany, he spent much of his time reading, visiting art galleries, and attending plays, concerts, and operas. He seems to have had an insatiable appetite for the arts, following his natural impulses rather than pursuing "culture" because someone else thought it was good for him. His tastes were catholic, though he inclined toward the romantic and the epic. In 1884, replying to a questionnaire, he stated that his favorite authors were Shakespeare, Byron, and Bulwer-Lytton; his favorite composers, Beethoven, Mozart, Schumann, and Wagner; and his favorite artists, Rubens, Van Dyck, and Michelangelo. The dramatists who appealed to him, besides Shakespeare, were Calderón, Goethe, Lessing, Schiller, and, among the moderns, Ibsen and Echegaray. Wagner's *Tristan* and Bizet's *Carmen* were his favorite operas, and he attended them many times over. In literature, he was first drawn to such romantic naturalists as Lermontov, Pushkin, Gogol, Turgenev, and Tolstoy, as well as to Scheffel's historical romance *Ekkehard*. Then he discovered the more detached naturalism of Daudet and Zola. He admired Daudet's *Sapho* and the Tartarin series, and he liked Zola's *Madeleine Férat, La Faute de L'Abbé Mouret, Une Page d'amour, L'Oeuvre,* and others of the Rougon-Macquart series. This turn toward objective naturalism in literature, however, was not echoed in his

taste for painting. His favorite artist was Rubens, whose portrayals of women — especially Hélène de Fourment — stirred him throughout his life. He also appreciated Tintoretto, but in museums he passed by many other Old Masters because he thought they looked like "old leather." [6]

Stieglitz seems never to have wanted to become a painter, and in 1883 he decisively adopted photography as the artistic medium in which he would make his mark: "I saw that what others [photographers] were doing was to make hard cold copies of hard cold subjects in hard cold light. I did not see why a photograph should not be a work of art, and I studied to learn to make it one." [7] From 1885 to 1887 he worked intensively at his photography, learning everything he could from Dr. Vogel, from courses in chemistry at the University of Berlin, and from his own experiences with the medium. Then, using technical mastery as his springboard, he began to treat the photograph as an art form. He did so spontaneously, with a fresh eye and no formal training in art: "I went to photography really a free soul — and loved it at first sight with a great passion. . . . There was no short cut — no foolproof photographing — no "art world" in photography. I started with the real A.B.C. — at the rudiments — and evolved my own methods and my own ideas virtually from the word go — even to the method of learning the A.B.C." [8]

Working with a new medium designed to produce veristic optical records of the natural world, Stieglitz instinctively used his direct experience of nature rather than past styles as the basis for his art. Part of his study of the camera, however, involved making photographic copies of works of art and reproductions. His prints after the works of Fedor Encke, Wilhelm Hasemann, Friedrich von Kaulbach, Pierre Cot, and Tito Conti, among others, indicate that he was drawn to works in the sentimental-academic mode. [9]

Stieglitz had some personal contacts with contemporary artists in Germany, but little is known about who they were or what he learned from them. He is said to have traveled with a painter early in his German period, and in 1908 he told a reporter that in Berlin he had lived with a sculptor who taught him to be open-minded about the work of the Old Masters. [10] In Germany, there was no tradition of pictorial photography upon which Stieglitz felt he could draw, and, instead, he derived his knowledge of it from photographic English journals, especially *The Amateur Photographer*. [11]

Stieglitz's first photographs are little more than descriptive records of familiar persons and places. As his style matured in the late eighties, his photographs echoed the sentimental storytelling genre paintings and picturesque cityscapes that were popular in academic exhibitions throughout

Europe. His exceptional talent, however, enabled him to produce photographs that surpassed most contemporary paintings in the sentimental idiom. Stieglitz's early images reveal his consummate skill as a designer, and they function as significant works of art despite their anecdotal flavor.

In his less sentimental moments, Stieglitz was able to achieve more generalized pictorial effects, albeit within the sharply detailed, descriptive mode which the photographic process invites. *Sun Rays — Paula — Berlin* (1889, Figure 3) reveals him as a literal realist, exploiting the effects of sunlight upon the subject and recording an infinite number of details. At the same time, he created a broad, dignified impression through bold massing of light and shade, not unlike that of the genre paintings of Adolf von Menzel.[12] In this straightforward presentation of a scene from daily life, he produced a visual counterpart to the works of the literary naturalists.

Artists and critics praised Stieglitz's photographs, calling them as "artistic" as paintings. When, for example, his *Watching for the Boats* was reproduced in *The Photographic Times*, January 1896, many correspondents asked

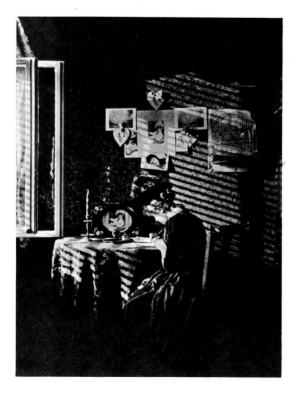

3. Alfred Stieglitz. *Sun Rays — Paula — Berlin*. 1889. Photograph. Private Collection.

whether it was a reproduction of a painting.[13] Yet when Stieglitz heard that the German painter Franz von Lenbach had admired the artistry of some photographs he had exhibited in Munich, he denied having any knowledge of the laws of composition.

Apparently the young photographer felt that he had little to learn from the official art world and generally held contemporary German painting in low esteem. Reminiscing about his early years, he said: "I sent my work to England and received recognition there [from photographic circles] at once. Artists in Germany, in Berlin and Munich, saw prints of mine and offered to give me paintings and etchings in exchange for prints. I didn't want etchings or paintings. I gave the prints away." [14]

If Stieglitz had had his way, he would have stayed in Berlin indefinitely. He loved the people and the culture of the city, but nine years abroad, his father felt, was enough. Alfred would have to come home, be practical, and earn a living. So, in 1890 Stieglitz returned to the country of his birth and tried to satisfy his father by settling down to a conventional existence. With financial assistance from Edward Stieglitz, he entered the photoengraving business, which, with two partners, he operated for five years without any great interest.

It was through one of his partners, Joseph Obermeyer, that Stieglitz met Emmeline Obermeyer, Joseph's sister. Although he did not consider himself ready for marriage, he succumbed to family pressures and wed the adoring Miss Obermeyer, nine years younger than himself, in 1893. She gave birth to their only child, Katherine, in 1898.

Emmeline was a fearful, conventional woman, uninterested in his photographic work, and he must have chafed at the restrictions marriage imposed upon him. He was further disillusioned by the dishonest tactics and lack of respect for fine craftsmanship he found in the New York business world. Lacking customers at the beginning of his photoengraving venture, he spent much of his time taking pictures and experimenting with photographic techniques.

He became a frequent exhibitor in the most prominent photographic salons, and by the end of the nineties he commanded respect and attention in Europe as well as in America. He had identified himself with the progressive members of the photographic fraternity who believed in the artistic expressiveness of the medium. Of the two camps within pictorial photography — the fuzzy Romantic-Impressionist school, which obviously imitated painting, and the sharp-focus "straight" approach — Stieglitz favored the latter. He despised manipulation, faked effects, and excessive retouching, firmly believ-

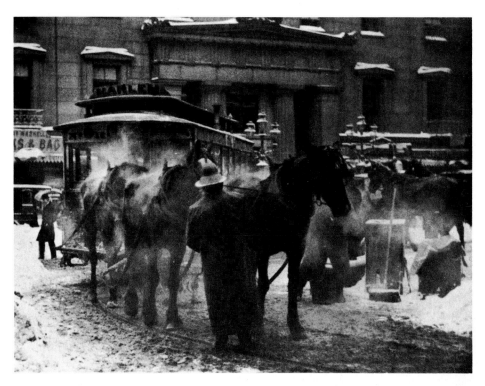

4. Alfred Stieglitz. *The Terminal*. 1892. Photogravure. Collection of John Biggs.

ing in the unique qualities of the photographic medium. "The arts," he stated, "equally have distinct departments, and unless photography has its own possibilities of expression, separate from those of the other arts, it is merely a process, not an art. . . ."[15]

Stieglitz put his beliefs into practice in most of his photographs of the early nineties, particularly in the scenes of New York, a city he recorded with clear, objective vision. *The Terminal* (1892, Figure 4), one of his most famous early works, portrays an actual event — a driver watering a pair of steaming horses at a streetcar terminal. Yet, in spite of the obvious realism, Stieglitz said: "There seemed to be something closely related to my deepest feeling in what I saw, and I decided to photograph what was within me."[16] About this and other city scenes he confessed that he was trying "to record a feeling of life."[17] He told an interviewer, "Nothing charms me so much as walking among the lower classes, studying them carefully and making mental notes. They are interesting from every point of view. I dislike the superficial and artificial, and I find less of it among the lower classes. That is the reason they are more sympathetic to me as subjects."[18]

In this point of view, Stieglitz anticipated the aesthetic credo of the "New York Realists" of the early 1900s — Henri, Sloan, Glackens, Shinn, and Luks, the group of painters later called the "Ash-Can School." They wanted to make stirring works of art from their urban experiences — Sloan's *The Wake of the Ferry* (*No. 2*) (1907, Figure 5) is a prime example — ignoring academic rules of composition and eschewing "artistic" effects. Yet they suc-

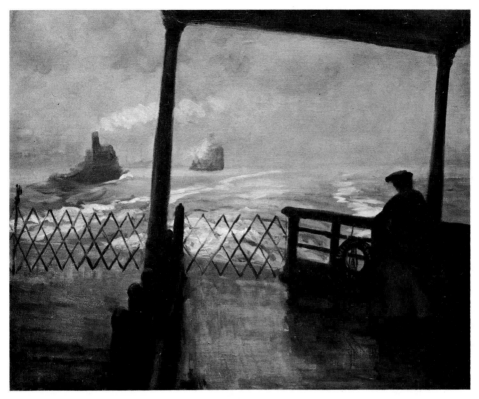

5. John Sloan. *The Wake of the Ferry (No. 2)*. 1907. Oil on canvas. The Phillips Collection, Washington, D.C.

ceeded in creating visually appealing designs that captured the excitement they felt when confronting their subjects. Like these painters, Stieglitz depicted everyday urban scenes and responded sympathetically to the human drama, framing his message, as they did, in compelling pictorial terms.

As Neil Leonard has observed, there is a close tie between Stieglitz's approach and Emile Zola's attitude toward his characters. In the nineties, too, Stieglitz's naturalism must have been reinforced by his enthusiastic reading of the reportorial novels of Jack London.[19]

On a summer trip to Europe in 1894, Stieglitz trained his camera on picturesque genre subjects, producing some of his best-known prints of the decade. *Scurrying Home* (Figure 6) shares the quiet dignity of *The Terminal*, yet the monumental peasant figures are more serene, more timeless than those of the earlier print. Unlike *The Terminal*, this photograph recalls the sentimental naturalism of Jean François Millet and the contemporary Dutch masters Israëls and Blommers. It is not that Stieglitz imitated specific canvases by these artists — that idea would have been repugnant to him — rather, he embodied in his prints some of the breadth, simplicity, and feeling of the "noble peasant" that pervades these painters' work.

Although Stieglitz's photographs sometimes resemble paintings, with the camera he often caught an effect of momentary spontaneity that would have been difficult, if not impossible, for a painter to achieve. It is this quality

17

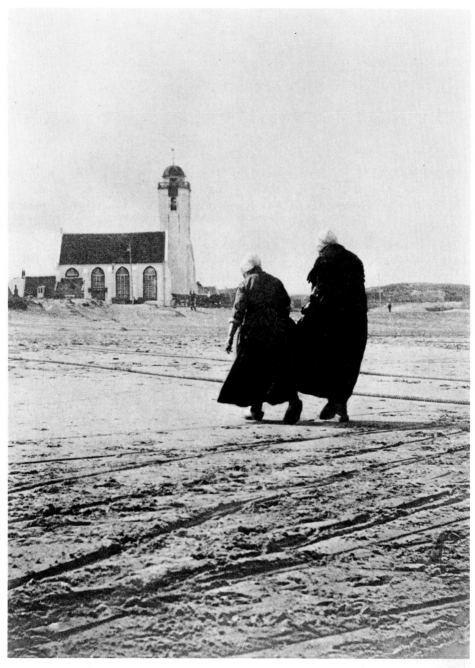

6. Alfred Stieglitz. *Scurrying Home*. 1894. Photogravure. Philadelphia Museum of Art.

that permeates his best photographs and led the contemporary critic Charles H. Caffin to place him among the Impressionists.[20] Stieglitz, Caffin observed, worked "chiefly in the open air, with rapid exposure, leaving his models to pose themselves. . . . He is to be counted among the Impressionists; fully conceiving his picture before he attempts to take it, seeking for effects of vivid actuality." [21]

Stieglitz was both more and less than an Impressionist in his photographs of the nineties. He was keenly interested in portraying fugitive effects of light and weather, which he captured instantaneously by waiting for the proper moment and then rapidly exposing his negative. To record the image of a moving cab in a snowstorm, as in *Winter, Fifth Avenue* (1892–1893),[22] or the wet city streets at night under artificial light, as in *Reflections — Night (New York)* (1896?),[23] required not only the desire to capture momentary impressions but also considerable technical knowledge and patience. In the Impressionist vein, too, is *A Wet Day on the Boulevard (Paris)* (1894, Figure 7), representing with great immediacy, yet precise formal control, pedestrians crossing a boulevard in Paris. In some obvious ways, however, Stieglitz parted company with the Impressionists. He did not work in color, and he eschewed

7. Alfred Stieglitz. *A Wet Day on the Boulevard (Paris)*. 1894. Photograph. Courtesy of The Art Institute of Chicago.

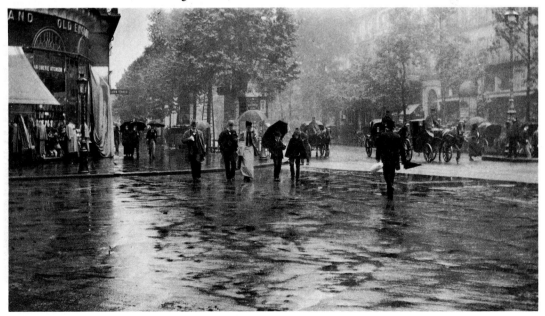

the soft-focus effects favored by Monet, Renoir, and Pissarro. Although he professed great admiration for Renoir, his closest affinities were to Degas and the later work of Manet.

Stieglitz's photographs in this period usually followed the principles of "straight" photography. The exceptions are a series of platinum prints such as *A Study in Two Colors* (1898).[24] Using a process he had developed with a fellow photographer, Joseph T. Keiley, he brushed glycerine onto the print to control the development of the image. This enabled him to alter the values recorded by the camera, "to introduce his own conception of the values, tonal qualities, feeling and artistic effect of the theme under treatment."[25] This use of a manipulative technique that blurred the boundaries separating photography and painting was only a momentary detour; in the future he would faithfully respect the intrinsic limitations of the photographic medium.

Typical of Stieglitz at his best is *The Hand of Man* (1902, Figure 8), in which he tried to capture the aggressive masculine mood of America. He found dignity and strength in this view of a locomotive steaming head-on down the tracks. Using somber tonalities to dramatize a common, industrial subject, he created a composition that is of lasting value, ranking with some of the best paintings of the period. *The Hand of Man* belongs to the naturalistic tradition — not the descriptive naturalism of Thomas Eakins but rather the subjective naturalism of the "New York Realists," who celebrated the distinctive mood and character of the city. Considering this photograph, it is hard to determine whether Stieglitz influenced the painters or vice versa; suffice it to say that they were working simultaneously in similar directions.

In *The Flat-Iron Building* (1902–1903, Figure 9) there are strong suggestions of mood and feeling undoubtedly stimulated by his knowledge of Maeterlinck and Whistler. "I stood spellbound as I saw that building in that storm," he wrote. "I had watched the structure in the course of its erection, but somehow it had never occurred to me to photograph it in the stages of its evolution. But that particular snowy day, with the streets of Madison Square all covered with snow, fresh snow, I suddenly saw the Flat-Iron building as I had never seen it before. It looked, from where I stood, as if it were moving toward me like the bow of a monster ocean steamer, a picture of the new America which was still in the making."[26]

The composition is based on two major vertical thrusts, that of the building and the tree in the foreground, countered by the horizontals of the benches and treetops in the middle distance. Stieglitz worked with blocks of tone in relation to each other, in the Whistlerian manner, thinking in terms

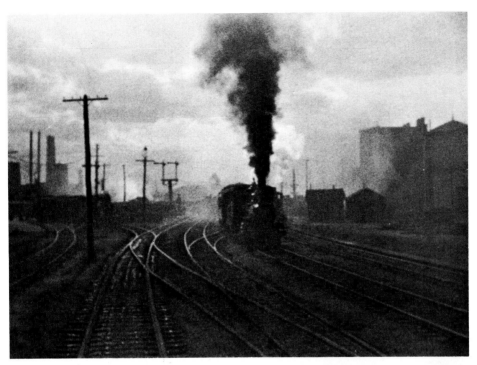

8. Alfred Stieglitz. *The Hand of Man.* 1902.
Photogravure. Private Collection.

9. Alfred Stieglitz. *The Flat-Iron Building.*
1902–1903. Photogravure. Lunn Gallery/
Graphics International Ltd., Washington,
D.C.

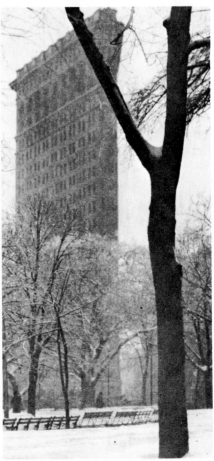

of the total design rather than individual objects against a neutral background. The final result is a thoughtfully balanced composition in which the details of nature are minimized to stress a suggestive mood.

On the basis of works like *The Hand of Man* and *The Flat-Iron Building*, Stieglitz established himself as the foremost pictorial photographer in America. His technical ingenuity and artistry were recognized not only in his native land but in the major European countries as well. He could have become more famous by continuing to take and exhibit photographs of high aesthetic merit, but this course of action did not present enough of a challenge. A born propagandist, he also wanted to reform the art of photography and to spread his ideas to a wide audience. To this end, he used a group to which he had attached himself, the Society of Amateur Photographers, as his base of operations, producing exhibition catalogues for them and, from 1893 to 1896, editing their journal, *American Amateur Photographer*. When, after financial difficulties, this society merged with the New York Camera Club in 1896 to create the Camera Club of New York, an organization of real substance, Stieglitz's battle for photographic reform began in earnest.

Pictorial Photography
and the Origins of the Photo-Secession

Stieglitz's crusade for pictorial photography stands as the American counterpart of an international movement that grew up in the 1890s. Early in that decade, groups were formed in England, France, Germany, and Austria whose members believed the medium was an art in its own right, not imitating painting but following the aesthetic principles that could be learned from painting. The first group to exert wide influence was The Linked Ring, organized in London in 1892 in opposition to the conservative policies of the Royal Photographic Society. The Ring was a loose federation of progressive English and foreign photographers, including J. Craig Annan and Frederick H. Evans, who advanced the cause by presenting in 1893 the first in a series of annual salons in which no medals were awarded. The structure of this society was informal; there was no president or council, and membership was determined solely on the basis of artistic merit. (Stieglitz was elected in 1894.) Their example was followed by the Photo-Club de Paris, which formed a salon in 1894 under the guidance of the leading French pictorialists Robert Demachy, Charles Puyo, René Le Bègue, and Maurice Bucquet. In

Germany, the aesthetic value of the medium was recognized by the Kunsthalle in Hamburg, which presented a series of annual shows of photography beginning in 1893. Later in the decade, the artistic viewpoint in photography found supporters in Austria, Italy, and Belgium as well.

After a slow start, American photographers came to play a vital role in the international pictorial movement, beginning in the mid-nineties, thanks largely to Stieglitz's leadership. In 1901 Caffin wrote: "Both in his pictures and in his writings, as well as by his personal influence, he has, little by little, in the face of a dead inertia of indifference and of the more active opposition of misconception and ridicule, upheld the hands of artistic photographers and won recognition for the art." [27] Stieglitz and others working along the same lines, such as Gertrude Käsebier, F. Holland Day, Clarence White, Eduard Steichen, and Frank Eugene, believed that photography was a valid means of artistic expression, ranking with painting and sculpture but having its closest parallels in the graphic media of etching and lithography. (Examples of Käsebier's, White's, and Steichen's work are reproduced as Figures 10, 11, and 16.) Apologists for artistic photography admitted that their work could not help being determined by the mechanism of the camera, but they hastened to point out that the photographer could exercise a great deal of control over the final result. There were many avenues for modifying the negative or manipulating the print. "The modern photographer," Stieglitz argued, "has it in his power to direct and mold as he wills virtually every stage of the making of his picture. He can supply, correct, or eliminate; he can even introduce color or such combinations of color by means of successive printings — similar to those resorted to in lithography — as to produce almost any effect that his taste, skill, and knowledge may dictate." [28] The degree of alteration of the print varied widely among the pictorialists. Stieglitz himself advocated "straight" photography, with little or no retouching or manipulation of the final image, although he tolerated his colleagues who went to great extremes in tampering with the optical image to produce painterly effects. Pictorialists like Steichen purposely moved the camera or threw the lens out of focus to create a fuzzy impression; others, like Eugene, did not hesitate to draw on and otherwise manipulate their prints.

Caffin readily admitted that the photographers were influenced by painting but asserted that they were not trying to emulate specific works by specific masters. Rather, they hoped to adapt to their own medium "the general principles applicable to all forms of pictorial representation." [29] The models the photographers chose from the art of the past were determined by their aesthetic goals. Among the Old Masters, Rembrandt and Velázquez

10. Gertrude Käsebier. *Blessed Art Thou among Women.* 1897. Photogravure. Helios, Inc., New York.

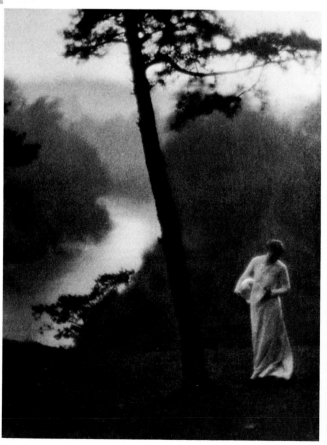

11. Clarence White. *Morning.* 1905. Photogravure. Private Collection.

12. Alfred Stieglitz. *Self-Portrait.*
Photograph. Private Collection.

were highly favored. The Pre-Raphaelites, Whistler, and the painters of the Munich Secession were popular among the more progressive pictorialists, whereas the soft-focus branch, specializing in suggestive moods and impressions, preferred the misty, subdued tonalities of Corot, Carrière, and Inness. With few exceptions, the photographers' subject matter was contemporary rather than historical, and symbolism and allegory gave way to straightforward explorations of pictorial form and suggestive mood. The sentimentality and anecdotal content of popular academic art (paralleled also in traditional photography) were all but dead.

As the most prominent member of the Camera Club of New York, Stieglitz (Figure 12) used that organization as a platform for his crusade for high standards in pictorial photography. Many of the more conservative members were out of sympathy with his views, but the attention he brought to the club placated them until open rebellion broke out in 1902. From 1896 to that year, Stieglitz labored tirelessly for the cause within the framework of the club, helping to arrange monthly exhibitions of work by photographers he believed in, assembling loan shows that were sent to national and foreign expositions, publishing portfolios of "American Pictorial Photography," and, most important, managing and editing *Camera Notes*, the club's quarterly journal (Figure 13).

Established by Stieglitz shortly after the merger of the Society of Amateur Photographers and the New York Camera Club in 1896, *Camera Notes* became the leading American forum for, and instigator of, pictorial photography. He explained in the first issue, in July 1897, that it would deal with the achievements of prominent pictorialists abroad as well as at home. Besides commissioning photographers to write about the technical and aesthetic

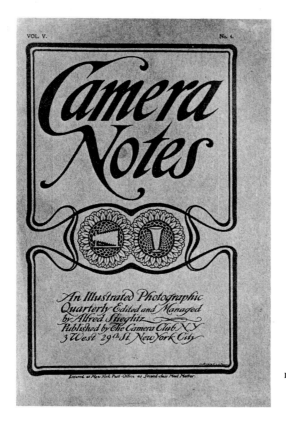

13. *Camera Notes, Front Cover* (vol. V, no. 4, April 1902). Private Collection.

problems of their medium, he enlisted the services of such critics as Sadakichi Hartmann and Caffin to elucidate the relationship between photography and art. In the pages of *Camera Notes*, there was much talk of how painting — from the Renaissance to the Munich Secession — could exert a beneficial effect on photography. Paintings were often illustrated in the magazine, but the best and largest reproductions were reserved for photographs by prominent American and European pictorialists. Stieglitz selected only the best examples of their work and spared no effort in obtaining the finest possible photogravure reproductions of them for *Camera Notes*. As a result, the magazine became a vital medium for spreading the immediate visual message of artistic photography to a wide audience. Besides this, Stieglitz published news articles and reviews of European expositions where art organizations and galleries had begun to open their doors, much more than their American counterparts, to the work of the camera. As editor, Stieglitz often chided his countrymen for their inertia and urged the formation of an American salon of such importance that it would be recognized in Europe.

Stieglitz's aggressive efforts often brought him into conflict with the more conservative members of the Camera Club of New York, who criticized him for waging a personal battle for an advanced cause that seemed far removed from the interests of the club's rank and file. While he could argue that *Camera Notes* had paid its own way and brought international attention to the club, it was obvious that he represented only one sector of the club's membership — the progressive group, of which he was the leader. One faction attacked him in a special meeting, in October 1900, for bringing in two

editorial associates from the outside, Joseph Keiley and Dallett Fuguet, photographers who sympathized with Stieglitz's views but who had not belonged to the club until he invited them to join and to assist him in editing the magazine. Stieglitz survived this attack and continued to produce *Camera Notes* as he pleased until the issue of July 1902, when he and his editorial associates announced that they were withdrawing from the publication. The installation of a new board of club officers who were unsympathetic to the "policy so long maintained by *Camera Notes*" had abruptly forced the issue.[30]

Stieglitz's influence in photographic exhibitions was first felt on a national scale in 1898, when the Pennsylvania Academy of the Fine Arts and the Photographic Society of Philadelphia jointly sponsored a large photographic salon at the Academy. It was a doubly significant event because it was America's first international salon and because it was held in a gallery identified exclusively with the fine arts. Stieglitz was appointed to the jury, and a large number of his American allies, including Käsebier, Day, and White, participated in the show in which "distinct evidence of individual artistic feeling and execution" [31] was a criterion for acceptance. (This was followed, in the United States, by the Chicago Photographic Salon, established in 1900 under the joint auspices of the Art Institute and the Chicago Society of Amateur Photographers, a salon Stieglitz thought surpassed the Philadelphia event in quality.) He also fought for the admission of photography into American art exhibitions, following the examples set by the Munich Secession (1898), the Glasgow International Arts and Industrial Exposition (1901), and the Vienna Secession (1902).

Stieglitz obtained broader support for artistic photography when, in 1902, he assembled a group called "The Photo-Secession" and became its self-appointed leader. The Photo-Secession came into being rather casually, though its creation, in retrospect, seems to have been inevitable. Stieglitz had been invited by Charles de Kay to organize an exhibition of pictorial photographs for the National Arts Club, New York, for March 1902. He gladly seized this opportunity to define his artistic-photographic beliefs in tangible form, and on a large scale, in a show of American work that was sure to attract wide public attention. He asked only those whose photographs were distinguished by artistic and technical excellence, including many whom he had previously invited to appear in the pages of *Camera Notes*, the exhibition rooms of the Camera Club of New York, and in various international expositions abroad: Käsebier, Steichen, Day, White, Eugene, Keiley, Fuguet, Eva Watson-Schütze, and others whose names are now obscure or forgotten.

Although some of these same photographers had been invited to exhibit to-
gether by Day in an important show that anticipated Stieglitz's, the "New
School of American Photography" presented in London in 1900 and Paris
in 1901, they had never been formally identified and drawn together in a
consolidated group. Day, a Boston photographer and publisher who had
traveled to London to promote pictorial photography, was the only person
who came close to rivaling Stieglitz as the leader of the American movement.
A person of discriminating tastes, he paid close attention to the aesthetics of
framing, matting, and hanging photographs, and the New School of
American Photography catalogue reflected the fine typographical traditions
of William Morris. Although Stieglitz had featured Day's articles and photo-
graphs in *Camera Notes*, he refused to give his support to Day's show,
ostensibly because the prints he exhibited were "seconds" that were "not up
to exhibition finish."[32] Later, Alvin Langdon Coburn remarked: "They
were, I think, a little jealous of each other."[33]

Although the date of the founding of the Photo-Secession is given as
February 17, 1902,[34] at the time of the National Arts Club Show there was
no formal organization or official charter. The group existed, for the moment,
as a projection of the values Stieglitz believed in, as evidenced by the high
individuality and artistic merit of the photographs he chose to exhibit.
Stieglitz gave it shape by calling the show "American Pictorial Photography
Arranged by the ' Photo-Secession,' " using this label because he did not
wish to have his own name or that of the Camera Club of New York
attached to the event. Some of the participants were surprised to find them-
selves associated with a new, as yet undefined group. Stieglitz recalled Ger-
trude Käsebier's confusion at the opening:

> She said to me, "What's this Photo-Secession? Am I a photo-secessionist?"
> My answer was, "Do you feel you are?"
> "I do."
> "Well that's all there is to it," I said.[35]

Stieglitz felt that the idea of the Photo-Secession had evolved naturally
within the profession: "Those of a similar mind and ideals found themselves
unconsciously drawn closer and closer together. Such tendencies work
cumulatively, and it followed as the most logical conclusion from such
premises that when the time was ripe these kindred spirits would act as a
unit. This having occurred, the next step, the formation of the Photo-Seces-
sion, was but giving a local habitation — a name to what already existed."[36]
For Stieglitz to fight honestly for his beliefs required the act of secession,

separation from the "fetters of conventionalism, tradition and provincialism" which dominated most American photography.[37] Like the Munich and Vienna Secessions in the fine arts, he and his fellow exhibitors stood for the new, the experimental, and the living, "seceding," he said, "from the accepted idea of what constitutes a photograph."[38] One of the strongholds of accepted ideas was the Camera Club of New York, and Stieglitz's secession, in very specific terms, freed him from the obligation to placate its more traditional factions. The formation of the Photo-Secession gave him a medium through which he could openly promote his own ideas, with the help of his allies, without compromising his aesthetic tenets.

· CHAPTER TWO ·

Stieglitz, Steichen, and the Photo-Secession

Eduard Steichen, Early Life and Work

Stieglitz's most valuable ally in implementing the Photo-Secession's program and, later, in bringing shows of modern art to his gallery was the young photographer Eduard Steichen.[1] (His self-portrait is reproduced as Figure 14.) Born in Luxembourg on March 27, 1879, Steichen emigrated to Hancock, Michigan, with his parents when he was two years old. He remained there until he was nine, when he was sent to the Pio Nono College preparatory school near Milwaukee. The rest of the family moved to Milwaukee in 1889, while the young Steichen studied in the public schools of that city until he was fifteen.

An inventive boy, interested in all kinds of mechanical and electrical devices, he also displayed early a marked talent for drawing. After leaving school he apprenticed himself to the American Fine Art Company in Milwaukee, where he worked for four years (1894–1898), eventually rising to the position of designer. Under the auspices of this firm, Steichen created posters and advertisements, but in his spare time he pursued his ambition of becoming a painter. In 1896 he and several friends organized the Milwaukee Art Students' League, a group that gave members an opportunity to draw from the model and to benefit from the criticism offered by two local artists, Richard Lorenz and Robert Schade.

Although Steichen was anxious to learn everything he could about painting, he also explored photography with equal enthusiasm. He had purchased his first camera when he was sixteen and used it to take pictures of his family and friends. He soon discovered, however, that the medium could provide visual documentation of landscapes and farm scenes for the posters he was

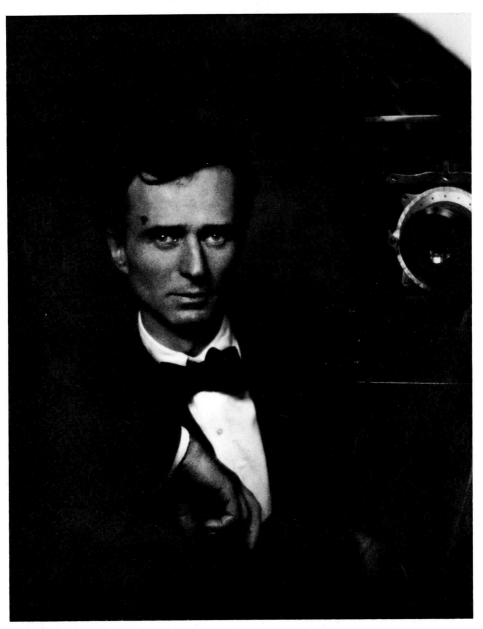

14. Eduard Steichen. *Self-Portrait*. Photograph. Private Collection, New York.

15. Eduard Steichen. *The Pool—Evening*. 1899. Photogravure. Art History Collection, University of Delaware.

designing for the American Fine Art Company. After a time, he also began to probe the artistic possibilities of photography. His change of direction was motivated by his discovery of *Camera Notes,* and "far from being a solitary worker, groping in a new field, he found himself at one bound in a field already worked and planted with artistic intentions similar to his own. Though as yet not knowing them, and still to them a stranger, he became a fellow-worker in the new movement." [2] Shifting from a descriptive to an evocative, hazy approach to the photographic image, Steichen trained his camera on woody landscapes at dusk or in moonlight, trying to capture the romantic and mysterious mood of his subjects. *The Pool—Evening* (1899, Figure 15) is typical of his efforts at this time. He had been attempting to create effects similar to these in his painting, and at this early point in his studies he perceived close analogies between that medium and photography. He stated: "Although painting offered unlimited opportunities to deviate from the purely naturalistic, I found that I brought to painting some of the discipline of the literal that was inherent in photography. The moonlight subjects appealed to me on a romantic basis, but I made realistic notes of the actual night colors on the spot, describing the colors I saw in terms of the mixture of pigments to be used in the painting." [3]

At this time, Steichen, isolated in Milwaukee, had been able to obtain very little instruction in the technique of photography. He absorbed what he

could from the few photographic magazines in the Milwaukee Public Library, admiring particularly the work of Clarence White; then he turned to the shelves of art books. "These," he recalled, "were really exciting to me." [4] Of the painters, he was fascinated by the Pre-Raphaelite George Frederick Watts, Franz von Lenbach of the Munich School, Claude Monet, and above all James Whistler, whose work was exerting a strong influence on progressive painting and photography. Steichen saw photographs of Auguste Rodin's sculpture, which he greatly admired, and he eagerly read plays and essays by George Bernard Shaw and Maurice Maeterlinck. He vowed that, one day, he would visit these three celebrities.

Steichen's first recognition as a photographer came when two of his prints were shown at the Second Philadelphia Salon in 1899; Clarence White, a member of the hanging committee close to Stieglitz, wrote Steichen a letter congratulating him on his entries. Encouraged by the warm reception of his work in Philadelphia, Steichen redoubled his efforts, and in 1900 he exhibited several of his landscape prints at the first Chicago Photographic Salon.

Following the close of the Chicago show, shortly after his twenty-first birthday, Steichen decided to quit his job as a commercial artist and make his pilgrimage to Paris to study art and to meet Rodin. He stopped in New York and, on the advice of White, he called on Stieglitz at the Camera Club. Stieglitz gave him over an hour of his time and later recalled that he was amazed "at the variety and vigor of artistic intention" [5] of Steichen's portfolio of photographs, paintings and drawings. He bought three of the photographs, offering the princely sum of five dollars apiece. As his young visitor was leaving, Stieglitz asked: "Now that you are going to Paris to study art, do you feel that, when you have mastered drawing and painting, you will abandon the camera?"

"Never," Steichen replied. "I shall use the camera as long as I live; for it can say things that cannot be said in any other medium." [6]

When Steichen arrived in Paris in May 1900, his first act was to rush to the Rodin exhibition at the World's Fair. A few days later, he made the first of his many visits to the Louvre to study the Old Masters and then went to the Luxembourg Museum to see the art of the Impressionists. He enrolled briefly at the Académie Julian, but after several weeks he left, disgusted by academic methods of drawing. His real affinities were with artists — and writers — who dealt sympathetically with human experience, often in Romantic and Symbolist terms. Those he admired he asked to pose for their photographic portraits. The list is a revealing document of his tastes in the years 1900–1902: George Frederick Watts, Alphonse Mucha, Franz von

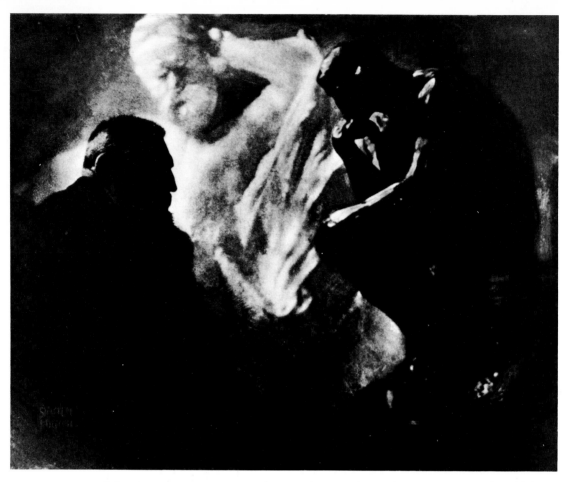

16. Eduard Steichen. *Rodin — Le Penseur*. 1902. Photogravure. Private Collection.

Lenbach, Israel Zangwill, Franz von Stuck, Albert Besnard, Maurice Maeterlinck, Albert Bartholomé, and Rodin. (He wanted to photograph Whistler and Fernand Khnopff but was unable to do so).

Rodin was Steichen's greatest hero. He was introduced to the celebrated sculptor by the Norwegian painter Fritz Thaulow in the fall of 1901. Rodin immediately expressed a liking for Steichen and his work and invited him to visit his studio as often as he pleased. After months of studying the sculptor at work, the American took a series of penetrating photographs in 1902, the most famous of which is *Rodin — Le Penseur* (Figure 16). The photograph, printed from two negatives, is the masterpiece of Steichen's first Parisian period and reveals the full force of his pictorial imagination. He has reduced the subject to a few simple silhouettes, dramatically contrasting the sculptor and *Le Penseur* in the foreground against the luminous, massive marble of the *Victor Hugo* rising behind them. In this work, Steichen explored the potential of the photographic medium in two ways. He used his artistic skill to select powerful visual images for the negatives, and by using the gum bichromate process of printing he was able to manipulate the tones of the print to create the effect he desired.

In 1901, Steichen wrote Stieglitz: "We have set our mind to what a photo-

graph should be and defined its limitations. Who shall today be able to mark the fotograph's [sic] limitations? They have not yet *been sighted*." [7] For Steichen, making aesthetically significant negatives and controlling the printing with the gum process constituted one of the fine arts, and he tried to prove his point to the public in several ways. He submitted his work to photographic exhibitions that stressed the artistic value of the medium, such as Day's "New School of American Photography" and Stieglitz's National Arts Club Show of "American Pictorial Photography." In his first one-man show in Paris (1902), consisting of paintings and photographs, Steichen called his manipulated prints in the latter medium *peinture à la lumière*. His boldest move was to submit a group of ten photographs together with some of his paintings and drawings to the official Salon of 1902. [8] The jury accepted several of his entries in the traditional media and *all* of the photographs. This was the first time in the history of the Salon that photographs had been admitted; but the hanging committee refused to display them on the grounds that photography was not a recognized form of artistic expression. The news of their acceptance and the controversy over their omission generated international publicity for Steichen and the cause of pictorial photography. Although the photographs were never hung, Steichen had at least opened the door — if only for a moment — of a conservative art organization.

Steichen fought his battles without depending on Stieglitz, who, however, reinforced and supported his views. The two corresponded actively in 1901 and 1902, and in Paris Steichen assiduously followed American developments by reading *Camera Notes*. Although Stieglitz disliked excessive manipulation and "arty" effects in photography, he saw Steichen as an energetic, talented young artist who embodied in his photographs the doctrine he had been promoting since the mid-1890s. Steichen was only in his early twenties, but he was a formidable ally whose genius as a photographer had been recognized by many noted artists and critics in Europe and America. He, in turn, looked up to Stieglitz and was delighted to join him in the fight for excellence in pictorial photography.

Exhausted after two strenuous years in Paris, he returned to Milwaukee to rest during the summer of 1902. Then, in the fall, he went to New York and reestablished ties with Stieglitz. The older man introduced him to his associates at the Camera Club, and at Stieglitz's home Steichen saw for the first time original photographs, rather than reproductions, by his mentor. Deciding to remain in New York rather than return to Paris immediately, Steichen established himself as a portrait photographer in a studio on the top floor of 291 Fifth Avenue. In becoming a commercial photographer, Steichen did

not intend to give up his painting or to lose touch with European art movements. He stated: "I believe that art is cosmopolitan, and that one should touch it at all points. I hate specialism. That is the ruin of art. . . . I am no specialist, I believe in working in every branch of art." [9]

The Photo-Secession and the Creation of Camera Work

Steichen forged closer ties with Stieglitz when he and several other photographers who had exhibited at the National Arts Club in March 1902 urged him to give more definite shape to the Photo-Secession. In due course, a society with seventeen fellows and thirty associates was created; founders, who were also members of the "council," included many of Stieglitz's allies, among them Käsebier, White, Steichen, Eugene, Keiley, and Fuguet. (Day was invited to become a member but sent a polite refusal, making no reference to the tensions between Stieglitz and himself.) Stieglitz, refusing the title of president, was named director. The object of the group was "to advance photography as applied to pictorial expression; to draw together those Americans practicing or otherwise interested in the art, and to hold from time to time, at varying places, exhibitions not necessarily limited to the productions of the Photo-Secession or to American work." [10] Like the English Linked Ring, it was a small, exclusive body, and only those few Americans who were considered worthy of the honor, such as Alvin Langdon Coburn, were elected. A photographer's high professional reputation alone would not guarantee his election to the Photo-Secession; it was necessary for him to be in full sympathy with the principles and spirit of the group.

Stieglitz held meetings of the Photo-Secession in public restaurants for almost three years. During this time the group (that is, chiefly Stieglitz and Steichen) performed two major activities. First, they circulated collections of American pictorial photographs, mainly by members, to prominent American and foreign exhibitions. Thanks to Stieglitz's reputation and the distinguished roster of members he had recruited, the Photo-Secession was quickly recognized at home and abroad as the principal representative of enlightened pictorialism in photography. And through these shows Stieglitz won international recognition for the best photographic efforts of his countrymen.

17. *Camera Work, Front and Back Covers* (No. 4, 1903, designed by Eduard Steichen). Ex Libris, New York.

More lasting in importance, however, was Stieglitz's creation of a new periodical, *Camera Work*. First issued in January 1903, it was a sumptuous quarterly that preserved and carried on many of the best features of *Camera Notes*.[11] With three associate editors formerly with him on *Camera Notes* — Keiley, Fuguet, and John Francis Strauss — Stieglitz issued a joint statement of the aims of *Camera Work:* "It is proposed to issue quarterly an illustrated publication which will appeal to the ever-increasing ranks of those who have faith in photography as a medium of individual expression, and, in addition, to make converts of many at present ignorant of its possibilities."[12] As editor and publisher, Stieglitz wanted the magazine to play a missionary role, as *Camera Notes* had done, advancing the cause of pictorialism within the photographic brotherhood, but it was now possible for him to do so without allegiance to any group other than the Photo-Secession.

In several other ways Stieglitz perpetuated in the early issues of *Camera Work* the ideals and policies of *Camera Notes:* he was more concerned with broad principles of photography than with technical recipes; he carried articles on the relation of the fine arts to photography, often by Hartmann and Caffin; and he published superb reproductions (usually in photogravure) of American and European photographs, which were produced with great care, often under his personal direction. The journal's typography, however, was far more tasteful than that of its predecessor. Steichen applied his artistic skill in designing the front and back covers of the magazine (Figure 17) and probably collaborated with Stieglitz in arranging the handsome layout of the

text and advertising pages. Thoughtfully conceived and printed as a work of art, in the tradition of William Morris, *Camera Work* was the most luxurious and expensive photographic journal of its day.

During the years 1903–1907 the coverage of *Camera Work* was almost exclusively photographic. But in 1908 its pages were opened to articles on the contemporary fine arts and criticism for their own sake, and art received increasing attention, at the expense of photography, until the magazine's last years. Later issues carried articles about avant-garde European and American painting and sculpture, as well as literary essays and poetry, and from 1908 until 1915 it was the most advanced American periodical devoted to the arts. *Camera Work* was discontinued in 1917, after fifty numbers.

The Little Galleries of the Photo-Secession

Although the Photo-Secession had sponsored *Camera Work* and circulated photographic loan shows between 1902 and 1905, it remained an informal group lacking definition and public visibility. Stieglitz and Steichen were prompted to remedy this state of affairs after a competing organization, the Salon Club, mounted a vast international exhibition of four hundred photographs at the Clausen Galleries in December 1904. Dedicated to a popular version of pictorialism, the show was billed (erroneously) as "The First American Salon at New York." It was organized by Curtis Bell, a photographer who believed that "it was time to save photography from Stieglitz and what Stieglitz represented," [13] referring to his rival's unwillingness to sacrifice high artistic standards to attract a wide a audience. Stieglitz, understandably, dissociated himself from Bell and the exhibition — "this noisy project for popularizing the 'art' side of photography, under the auspices of the so-called professional art patrons and the professional artists." [14] None of the Secessionists participated. Clearly, however, Stieglitz's pride was wounded, and he undoubtedly saw the Photo-Secession's modest campaign for photographic excellence threatened by the success of Bell's commercial efforts. Stieglitz's counterstroke was to plan a rival exhibition for the spring of 1906, under the auspices of the Photo-Secession, "consisting of the very best that has been accomplished in pictorial photography, from the time of [David Octavius] Hill up to date, in the various countries." [15] But the show never materialized because adequate gallery space in New York could not be obtained. At this point Steichen suggested that the studio he had recently vacated, plus two

rooms behind it, on the top floor of 291 Fifth Avenue, be converted into galleries. Thus, a series of exhibitions could be held by the Photo-Secession throughout the year, and "in that way New York would at least have a chance to understand what we have been talking about, as well as what we have already done." [16] After some hesitation, Stieglitz agreed to operate the gallery and to provide financial support, while Steichen volunteered to redecorate the rooms.

The older man had harbored doubts because he did not think there were enough top-flight photographs being produced around the world to fill the galleries continuously. Steichen, however, proposed that works in other media be shown as well. From the beginning, therefore, they agreed to show pictorial photographs, American and foreign — Austrian, German, French, and British — "as well as modern art not necessarily photographic." [17] The decision to include art was a logical one because Stieglitz and Steichen both believed in eradicating the distinctions among all the visual media and in hanging works of art and photography together, or in sequence, in the same gallery. Because art galleries had generally rejected photography, Steichen thought it made sense for the Photo-Secession gallery to "try the opposite tack and bring the artists into our sphere." [18] Stieglitz, more concerned at that time with the education of photographers than with painters, wanted to show the fine arts "so that photography could be measured in juxtaposition to other media of expression." [19] Their position laid the foundation for the gallery's emergence as the leading showplace for avant-garde art in the United States — though this was far from their original intention.

The inaugural show at the "Little Galleries of the Photo-Secession" opened on November 25, 1905 (Figure 18). Featuring prints by members of the group, it was a great success, even though Stieglitz and his associates had avoided noisy publicity, assuming that "those who love and understand and have the art-nose will find their way." [20] Announcements of the exhibition were few, and the gallery's sign on the ground floor of 291 Fifth Avenue was "small and almost unnoticeable." [21] Visitors, who arrived via a rickety elevator, found that Steichen's artistic decoration of the rooms was clearly inspired by the interior designs of the Vienna Secession.

One of the larger rooms is kept in dull olive tones, the burlap wall-covering being a warm olive gray; the woodwork and moldings similar in general color, but considerably darker. The hangings are of an olive-sepia sateen, and the ceiling and canopy are of a very deep creamy gray. The small room is designed especially to show prints on very light mounts or in white frames. The

walls of this room are covered with a bleached natural burlap; the woodwork and moldings are pure white; the hangings, a dull ecru. The third room is decorated in gray-blue, dull salmon, and olive-gray. In all the rooms the lampshades match the wall-coverings.[22]

The catalogues of this and future shows (Figure 19) reflected the highest standards of typographical design. Printed on gray or buff handmade paper with deckle edges, they often carried the decorative symbol of the Photo-Secession, a golden disc.

For more than a year the galleries were dedicated exclusively to the work of American and European pictorial photographers, featuring such masters as Käsebier, White, Steichen, Robert Demachy, J. Craig Annan, Frederick Evans, and Heinrich Kuehn, in one intimate show after another. Plans for the display of art were delegated to Steichen, who had grown tired of portrait photography, closed his studio, and embarked for France in September 1906. Intending to paint and photograph on a noncommercial basis, he remained there, making only occasional trips to the United States, until 1914. From his vantage point in Paris, and later at nearby Voulangis, he would be able to inform Stieglitz of the latest developments in French art. At the same time, he planned to search for talented young American painters working in new directions.

Stieglitz and Steichen had agreed that the first nonphotographic art to be shown at the gallery would be drawings by Rodin. Shortly after Steichen returned to Paris, he told Rodin of the gallery and of their desire to exhibit Rodin's work. Responding warmly, Rodin agreed to cooperate. Stieglitz, in the meantime, was making other plans. Always responsive to new ideas and willing to act on impulse, he unexpectedly offered a one-woman exhibition to Pamela Colman Smith (1878–?), an American-born painter and illustrator then residing in London, who had brought a portfolio of her drawings to show him.[23] Disturbed when he heard Stieglitz's plans to present her work, Steichen cabled from Paris: "Do you want Rodin drawings?" omitting the word "still" to save money. Steichen believed that Stieglitz had "jumped the gun"[24] in giving Miss Smith a show, perhaps to demonstrate his independence or simply because he became impatient waiting for the proposed Rodin collection.

At this moment, Stieglitz had become weary of the jealousies and the arrogance that had developed among his Secessionist colleagues, who he felt depended too much on him to advance their private interests. They did not realize, however, that his "battle was for an idea bigger than any indi-

18. *The Little Galleries of the Photo-Secession* (opening exhibition, November 1905–January 1906) (Photo: *Camera Work*, no. 14, April 1906).

19. *Photo-Secession Catalogue* (for Marsden Hartley Exhibition, May 1909). Private Collection.

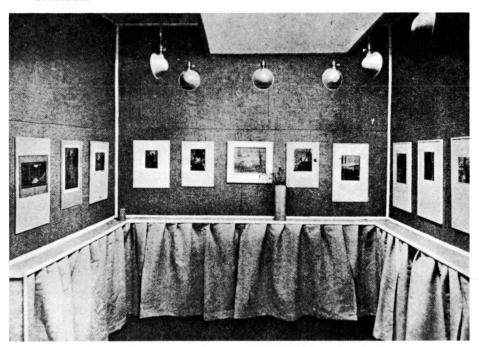

vidual." [25] The nature of that battle was spelled out on the editor's page of *Camera Work* in a statement aimed at the photographers who were disturbed by the presence of drawings in the gallery:

The Secession Idea is neither the servant nor the product of a medium. It is a spirit. Let us say it is the Spirit of the Lamp; the old and discolored, the too frequently despised, the too often disregarded lamp of honesty; honesty of aim, honesty of self-expression, honesty of revolt against the autocracy of convention. The Photo-Secession is not the keeper of the Lamp, but lights it when it may; and when these pictures of Miss Smith's, conceived in this spirit and no other, came to us, we but tended the Lamp in tendering them hospitality.[26]

Miss Smith was a free spirit whose mystical, symbolic art revealed influences from Aubrey Beardsley, Walter Crane, Gordon Craig, and the Pre-Raphaelites and paralleled the efforts of Munch and Ensor on the Continent (Figure 20, *The Wave* [1903]). A remarkable artist, almost forgotten, but

20. Pamela Colman Smith. *The Wave.* 1903. Watercolor. Collection of Whitney Museum of American Art, New York. Gift of Mrs. Sidney N. Heller.

recently rediscovered, Pamela Smith spent her early years in England, Jamaica, and the United States.[27] After studying at Pratt Institute in Brooklyn from 1893 to 1897 — she was in Arthur Wesley Dow's classes — she spent two years painting, illustrating, and working with the miniature stage in New York. Then she settled in London in 1899 and soon became a friend of William Butler Yeats and a group of talented writers, actors, and artists, many of whom were involved in the Irish Renaissance — Ellen Terry, Arthur Symons, AE (George Russell), Gordon Craig, and Jack Yeats. W. B. Yeats's father, who admired Miss Smith's illustrations, observed: "She has the simplicity and naiveté of an old dry as dust savant — a savant with a *child's heart*."[28] In London in the years 1903–1904 she published and edited a handsomely printed magazine, *The Green Sheaf*, which featured contributions by Yeats, J. M. Synge, John Masefield, Lady Gregory, and others, along with her own drawings.

Her sense of wonder and romance, her departure from the real world into the realm of imagination, suited Stieglitz's personal tastes, if not Steichen's, at that moment. Many of her paintings and drawings were from visions inspired by music, and at the opening of her show, which ran from January 5 to 24, 1907, she recited West Indian nursery tales and chanted ballads by Yeats. Stieglitz must have been delighted when James Huneker's review in the New York *Sun* "brought the Whitneys and Havemeyers, Vanderbilts and all classes of people into these tiny rooms of ours."[29] As a result of high attendance by interested patrons, her work sold well.[30] Although Stieglitz usually denied having any commercial interests, there was undoubtedly an element of financial and social prestige attached to the success of Miss Smith's show. One reason that he had agreed to set up the Photo-Secession gallery was to help his colleagues win the interest of wealthy, socially prominent patrons, an interest that his competitor Curtis Bell had already tapped. Stieglitz later recalled: "The names of Morgan and Gould and Vanderbilt seemed to symbolize much money. Of the men about me, many were poor. And if I, holding aloof should be making a mistake, it would be fatal possibly to their future."[31]

Pamela Colman Smith had not been a pioneering artist of the avant-garde, but she produced highly original, individual work in an idiom that seemed fairly progressive in New York at the time. However, when one considers the array of modern art that Steichen sent beginning in 1907 — including works by Rodin, Cézanne, Matisse, Picasso, and Brancusi — her efforts do seem rather conservative. Still, she was the first nonphotographic artist to be

43

shown at the Little Galleries of the Photo-Secession, and her favorable reception in her first and subsequent exhibitions in 1908 and 1909 probably encouraged Stieglitz to continue scheduling shows of paintings and drawings.

·CHAPTER THREE·

291 and the Arts
before the Armory Show

The Role and Operation of 291

Following the introduction of the art of Pamela Colman Smith in 1907, the doors of the Little Galleries of the Photo-Secession opened wider to admit exhibitions of paintings, drawings, graphics, and sculpture by advanced European and American artists. From 1908, the number of photographic shows gradually declined as Stieglitz gave increasing attention to the fine arts, and 291, by 1913, had become a center for avant-garde art unequaled anywhere else in the world.

Stieglitz seems to have had a grand plan for the gallery, and as important as art exhibitions were to him, they represented only part of his scheme. He also wanted to establish at 291 a community of artists and critics whose interaction would generate new discoveries and new statements in the arts. Stieglitz, of course, was the self-appointed director of this collective enterprise, a benevolent leader who tried to fashion a favorable aesthetic, intellectual, and material environment in which his artist friends could flourish.

In the early years, 291 came to be more than just a gallery or a meeting place for artists. Its essence was indefinable, but the spirit of 291 unquestionably had the power to shape the lives of those who gathered there. Behind it all, of course, was Stieglitz, but 291 was not a reflection of its proprietor alone, influential though he may have been. He attracted to the gallery a community of kindred souls who generated a rare kind of creative electricity. Discussions of art and aesthetic theories were mingled with broader issues such as the economics of art, patronage, the role of the artist in society, and the development of an American language of expression.

The setting for these debates was a suite of three rooms in the attic of an

old brownstone house at 291 Fifth Avenue, between Thirtieth and Thirty-first streets. Stieglitz paid the rent for three years, but in 1908 the landlord demanded a four-year lease and doubled the rent. Unable to shoulder this financial burden, Stieglitz reluctantly closed the galleries in April. Because he believed in the work of the Photo-Secession, Paul Haviland, a connoisseur, came to the rescue. He offered to pay for a three-year lease on quarters across the hall, in the adjoining building, but Stieglitz would not accept full support from Haviland and turned to several other people for help, contributing some of his own money to round out the guarantee fund.

The two new rooms, one fifteen feet square and the other little more than a hallway, were redecorated to resemble the previous establishment, and the number 291 was retained even though the street address was actually 293. (A floor plan, drawn from memory by Marie Rapp Boursault, is reproduced as Figure 21.) With the opening of the new gallery on December 1, 1908, the name 291 came into general use. Marsden Hartley, who was introduced to the gallery in 1909, recalled that the only public announcement of 291 was a small showcase on the street level "with a photograph in it and the name 'Photo-Secession' and a gold disk between the words."[1] A tiny elevator carried visitors — no more than three or four at a time — to the main gallery on the top floor.

Extremely conscientious about the physical appearance of the gallery, Stieglitz paid close attention to the coloring of the walls and woodwork, the lighting, and the arrangement of the furnishings. Hartley recalled: "A shelf followed round the walls of the room, and below were curtains of dark green burlap, behind which many mysteries were hidden, things having to do with the progress of photography in those days."[2] A white screen, suspended from the ceiling, converted the harsh illumination from the skylight into "a quiet light . . . full of a soothing, mystic feeling."[3] In the center of the room was a square platform, also covered with burlap, and on top of it stood a large brass bowl filled with autumn foliage, which became a trademark for 291. There was no heat. During the winters Stieglitz and his friends would warm themselves around an iron stove in the small room behind the main gallery, the picturesque headquarters of a decorator, Stephen B. Lawrence, who allowed them to gather there.

The gallery also served as headquarters for *Camera Work*. Although Stieglitz consulted with his associate editors Keiley, Fuguet, Strauss, and J. B. Kerfoot, he was in charge of assembling each issue and personally approved the production of the plates and the printing. After 291 began to show an interest in the work of modern artists as well as of Secessionist photographers,

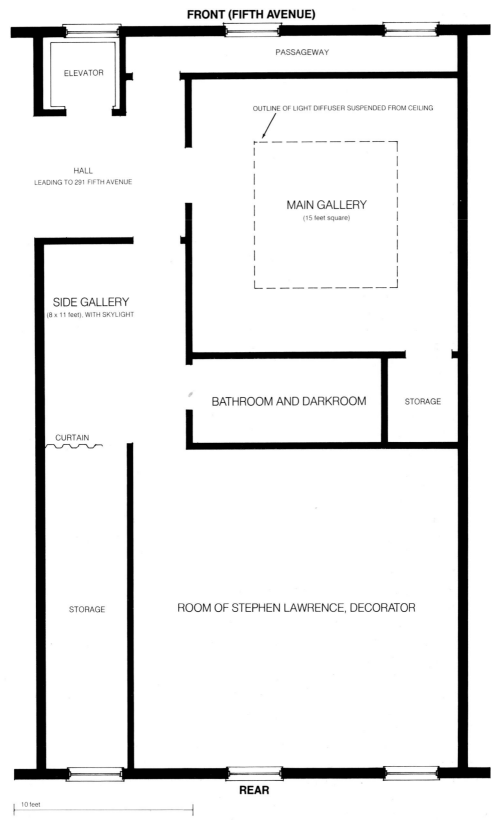

FRONT (FIFTH AVENUE)

PASSAGEWAY

ELEVATOR

OUTLINE OF LIGHT DIFFUSER SUSPENDED FROM CEILING

HALL
LEADING TO 291 FIFTH AVENUE

MAIN GALLERY
(15 feet square)

SIDE GALLERY
(8 x 11 feet), WITH SKYLIGHT

BATHROOM AND DARKROOM

STORAGE

CURTAIN

STORAGE

ROOM OF STEPHEN LAWRENCE, DECORATOR

REAR

10 feet

21. *Stieglitz's Galleries at 293 Fifth Avenue* (called "291"). From a drawing by Marie Rapp Boursault.

in 1908, *Camera Work* followed suit. The magazine actively reflected the aesthetic climate and the exhibitions held at 291, carrying explanatory articles by contributors such as Hartmann, Caffin, Haviland (later an associate editor), Marius de Zayas, Benjamin de Casseres, and J. Nilsen Laurvik. In addition, Stieglitz often reprinted newspaper reviews of the shows he had sponsored.

On the floor of 291, Stieglitz's intense personal magnetism engulfed everyone who came in contact with him. (Figure 22 shows Stieglitz at the gallery.) In his encounters with friends and strangers alike, he stripped away the masks of convention, trying to uncover the individual's deeper self. Stieglitz often changed his approach in response to the person with whom he was talking. Marie Rapp, his secretary, recalled: "It all depended on the person. If they were young people, he would respond and try to help. If they were older people who were staid and academicians, and so on, he could really tear into them with a vengeance. You have to realize that it was always two people that made the complete picture; it wasn't just one person." [4]

Vitality of thought and even argumentation intrigued Stieglitz because he felt that something worthwhile might be revealed through the act of dispute. He enjoyed serving as a midwife for ideas in one-to-one relationships, probing, questioning, and challenging, using the Socratic method to draw out the thoughts of those who came to the gallery. He emphasized the art of seeing and tried to make visitors form their own judgments, without preconceptions. He became annoyed with aggressive people who approached him with an attitude of "you show me, you tell me." Marie Rapp recalled:

If someone of this type said to Stieglitz: "What do you see in that painting? What does that mean to you?" he'd often ask: "Do you like oysters?" And they'd say, "Yes" or "No." Then he would reply: "Well, now, you tell me why you like oysters and what they taste like. You tell me, and do you think I'll be able to enjoy an oyster through your telling me what you get out of an oyster?" He'd often use this as an answer to people who came with this type of challenge. [5]

Stieglitz sometimes used parables in his discussions, speaking of his own experiences and letting his listeners apply his insights to the problems of their own lives. Much of the spirituality that others saw in Stieglitz stemmed from this candid exposure of his inner mind. His example, in turn, helped the artists reveal themselves in their work.

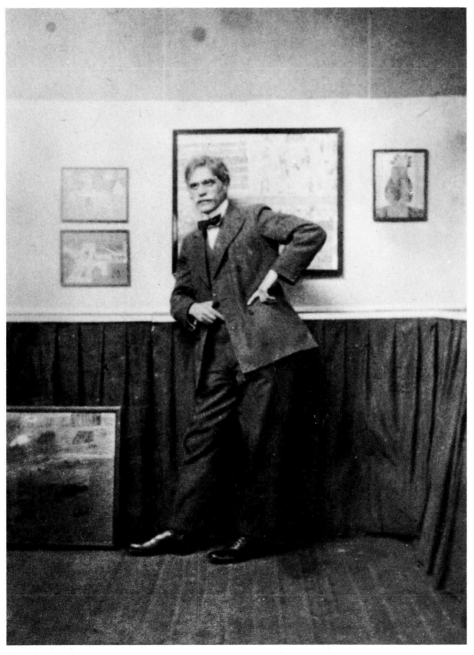

22. *Alfred Stieglitz at 291.* Photograph. Philadelphia Museum of Art: From the Collection of Dorothy Norman.

Stieglitz gave so much to the gallery and to *Camera Work* that there was little left for his photography. He did take occasional photographs — primarily of his close friends — but at this time his energies were devoted mainly to the art of others rather than his own. Although he obviously believed in his mission, his complete dedication, to the exclusion of other pursuits, suggests that he may also have been escaping an unhappy home life. His wife, Emmeline, an anxious, discontented woman without artistic interests, made it clear that she had little sympathy for his work. Accordingly, Stieglitz spent little time at their apartment at 1111 Madison Avenue, preferring the intellectual stimulation that his friends provided at 291.

The gallery and *Camera Work* could not have functioned without assistance from Stieglitz's dedicated colleagues. At the beginning, it was Steichen, more than anyone else, who helped give material form to the idea of the Photo-Secession. After he settled in France in 1906, he continued to play an important role in assembling exhibitions of European art for 291 between 1908 and 1913 and also served as a talent scout for promising Americans working abroad. At the outset, he was more knowledgeable than his older colleague about vanguard art in France, and Stieglitz thus relied heavily on his opinions. It took Stieglitz several years to assimilate the new pictorial innovations in European art, but his innate aesthetic judgment consistently enabled him to identify and support artists of merit.

Other individuals besides Stieglitz and Steichen helped make 291 a success: Paul Haviland, Marius de Zayas, and Agnes Ernst Meyer.

Haviland (Figure 23) was born in Paris in 1880, the son of Charles Haviland and Madeline Burty. His father was head of the Haviland china manufacturing firm in Limoges, and his mother was the daughter of Philippe Burty, art critic, collector, essayist, and Delacroix's friend and executor. The family was related to that of Hamilton Easter Field of Brooklyn, pioneering critic, collector, and patron of advanced American artists. A frequent visitor at 291, Field was founder of Ardsley Studios in Brooklyn and *The Arts* magazine.

Growing up in a cultured family, Paul displayed an early interest in the theatre. He received a bachelor's degree from the University of Paris in 1898 and an A.B. from Harvard in 1901. His father insisted that Paul join the family business, making him the New York representative for Haviland and Co. (There is no record of his being a lawyer, as has often been stated.) But in New York Paul Haviland gave only cursory attention to business. Like his celebrated grandfather, he was a dedicated collector, and his interest in the fine arts brought him to 291 in 1908 to see the exhibition of Rodin draw-

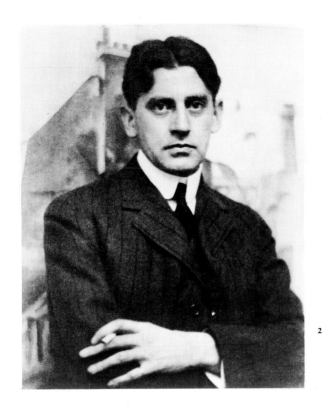

23. Alfred Stieglitz. *Paul Havi-land*. Photograph. Phila-delphia Museum of Art: From the Collection of Dorothy Norman.

ings. Upon purchasing several examples, he made Stieglitz's acquaintance and soon became an ardent supporter of the photographer's cause. From 1908 through 1915, he spent his free time away from the china business assisting Stieglitz in every way he could. A cultivated, well-to-do amateur with many contacts in the Parisian art world, Haviland was an ideal ally.

One of his first gestures of support, as we have seen, was the offer of a lease to keep the gallery going after April 1908. In November of the same year, he investigated for Stieglitz the legal technicalities of importing and selling works of European art. Inspired by Stieglitz, he began to take photo-graphs in the Secessionist idiom, producing examples worthy of being re-produced in *Camera Work* in 1909, 1912, and 1914. Moreover, he began to write articles and reviews for that periodical in January 1909 and remained an active contributor through 1914. Beginning in July 1910, his name ap-peared on the masthead as one of the associate editors, and he became Stieglitz's chief assistant in producing the journal, often writing the section called "Photo-Secession Notes." Presented in a sensitive, urbane style, these brief explanations of the shows at 291 served as invaluable summaries of Stieglitz's aims.

Always a gentleman, Haviland handled Stieglitz with utmost tact and consideration, and he was one of the few people the photographer trusted completely. Jerome Mellquist called Haviland "a friend to all" who served as

"the balance wheel" at 291.[6] He worked well with Stieglitz's other associates, especially De Zayas, with whom he collaborated in writing a small book, *A Study of the Modern Evolution of Plastic Expression* (1913), published by Stieglitz. These two men, along with Steichen, were the chief links between 291 and the Parisian avant-garde, and it was through Paul and his brother Frank Burty Haviland, a painter, that the Stieglitz group gained the confidence of Picasso and his circle.

After working actively for the cause for seven years, Haviland was called back to Limoges by his father in July 1915, and his association with Stieglitz came to an end. Although he remained on the masthead of *Camera Work* until the last issue (June 1917), he contributed nothing further to the periodical or the activities at 291. He wrote to the photographer occasionally after leaving, and he remained a devoted admirer for the rest of his life. Haviland later told his daughter that "he thought he was participating in a movement that was going to change the world. He would have placed the entire Haviland enterprise at Stieglitz's service if he had been able to." [7]

In 1917, Haviland married Suzanne Lalique, and after the war he reorganized the manufacturing processes at his father-in-law's crystal works in Alsace. Later in life he withdrew from business, bought a seventeenth-century priory at Yzeures-sur-Creuse, and became a gentleman farmer specializing in grape culture. He died in 1950.

Haviland's friend Marius de Zayas (Figure 24) was born in 1880 in Veracruz, Mexico, to parents of Spanish origin. His father, Rafael de Zayas Enríquez, an historian and poet, owned two Veracruz newspapers and had been poet laureate of Mexico. The family was forced out of that country by the dictatorship of Porfirio Díaz and in 1907 established itself in New York.

It is said that De Zayas studied art in Europe, learning much from the works of Velázquez, Rembrandt, Goya, and Gavarni, but that his greatest enthusiasm was for the museums of Mexico that specialized in Aztec art.[8] In his native country he worked as a caricaturist for the Mexico City newspaper *El Diario*, and when his family moved to New York, he found a similar position on the *Evening World* depicting personalities in society, theatre, dance, and the visual arts. His biting wit and economy of line brought him instant acclaim, and within his first year in New York he had become a minor celebrity.

Besides his commercial work De Zayas produced caricatures for his own pleasure. He had no desire to exhibit or sell these drawings, but one day in 1907 Stieglitz, acting on the advice of the critic J. Nilsen Laurvik, visited De Zayas in his studio and persuaded him to display his work at 291. His

interest in the Mexican was spurred by his longtime fascination with carica-
ture and satire. He presented De Zayas's first one-man show, consisting of
caricatures of personalities from New York's world of art and society, in
January 1909. The critic Benjamin de Casseres wrote in *Camera Work* that
"these caricatures were among the most remarkable ever seen in New
York," [9] but the public apparently did not share his high opinion. The pene-
trating honesty of De Zayas's imagery may have alienated the New York
public, for the show aroused little enthusiasm. De Casseres pointed out that
the Mexican, like his contemporaries Sem, Capiello, and Fornaro, took the
art of caricature seriously: "The caricaturist has his message. But here in New
York it so happens that this message carries at its core the one great sin,
which is a violation of the Anglo-Saxon injunction: Thou shalt not commit
irony!" [10]

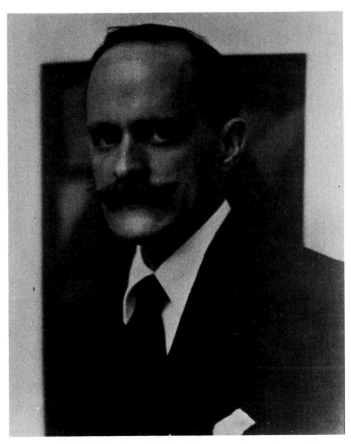

24. Alfred Stieglitz. *Marius de Zayas*. Photograph. Private
Collection.

De Zayas's iconoclasm, irony, and sophistication undoubtedly made him attractive to Stieglitz. Like Haviland, the caricaturist recognized the importance of Stieglitz's revolution in the arts, joined forces with him, and soon became one of his most loyal associates. De Zayas continued to work as a caricaturist throughout the existence of 291, having shows there in 1910 and 1913, but he was more important to Stieglitz as a co-worker, critic, aesthetician, and link between 291 and the Parisian avant-garde. In the group that congregated at 291, William Camfield has observed, De Zayas "must be considered the most influential figure there excepting Stieglitz himself." [11]

At first De Zayas was skeptical about modernism. But an extended stay in Paris, beginning in October 1910, made him realize that the knowledge of modern art he had gained from 291 had been limited and that the artistic revolution was far more violent than he had imagined. He was stunned by the Salon d'Automne, but he soon became a convert, thanks to his close contacts with Steichen and John Marin, knowledgeable members of the 291 circle living in Paris, and with Frank Burty Haviland, Paul's brother, who was well acquainted with Picasso. De Zayas met and interviewed that artist during the winter of 1910–1911, and the two became close friends. His sessions with Picasso and other European artists who would exhibit at 291 helped to educate him, and he came to believe that publishing articles in American journals would help people understand how to look at and judge the new art.

Besides trying to enlighten the American public, De Zayas provided guidance for Stieglitz, sending him a copy of a German book on Cézanne — probably Julius Meier-Graefe's 1910 monograph [12] — and his own essays on Picasso. In April 1911, he wrote Stieglitz about the influence of African Negro sculpture on advanced art in Paris and with great perception urged the photographer to stage a show of African sculpture at 291, which he did in 1914.[13] De Zayas was to pursue his interest in African art throughout the teens, and in 1916 he published *African Negro Art: Its Influence on Modern Art*, one of the earliest serious studies of the subject from an aesthetic standpoint.

More than any other American writer before the Armory Show, De Zayas tried to fathom the complex aesthetic problems of modern art. His essays, printed mainly in *Camera Work*, reflected the state of thinking among the Cubist painters, filtered through his own highly personal, intellectualized views on the evolution of artistic form. These ideas were given their fullest expression in the book he wrote with Paul Haviland, *A Study of the Modern*

Evolution of Plastic Expression, one of the first serious attempts to deal with the central problems of modern art.

After working with several colleagues to establish the periodical *291* and The Modern Gallery (see Chapter 6), De Zayas organized exhibitions for several galleries from 1921 to 1927, but thereafter he withdrew from the New York art world. Spending much of his later life abroad, he devoted himself to his family and to painting, writing, musicology, and filmmaking. He died in Stamford, Connecticut, in 1961.

Closely allied to Stieglitz, Haviland, and De Zayas in the early years of 291 was Agnes Ernst (1887–1970) (Figure 25), a New Yorker who attended Barnard College (B.A. 1907) and then became the first woman reporter with the New York *Morning Sun.* One of her first assignments, in 1908, was to interview the controversial Alfred Stieglitz at his tiny gallery in the attic of 291 Fifth Avenue. The session lasted six hours and became the cornerstone of a close friendship between the two. A dynamic, self-sufficient woman of outstanding beauty, she was attracted by his freedom of spirit and outspoken rebellion against artistic conventions. She became a frequent visitor to the gallery and confessed: "I felt at 291 that my sails were filled by the free air I craved." [14] Inspired by Stieglitz's passionate devotion to the arts, she embarked in August 1908 on an artistic pilgrimage to Europe. She forced herself to attend classes at the Sorbonne and the Collège de France, but she was much more at home looking at pictures in the Louvre and the Luxembourg Museum.

Miss Ernst moved rapidly into the higher echelons of the progressive art world in Paris, visiting the Salon d'Automne of 1908 and interviewing the leader of the Fauves, Henri Matisse, for the New York *Morning Sun.* She also called on Gertrude and Leo Stein and developed a close friendship with Eduard Steichen, whom she had met during her visits to 291. Through her future husband, Eugene Meyer, Jr., a New York banker and broker, she met Rodin, who became very fond of her, invited her to visit his studio whenever she pleased, and took her to museums, where he explained the fine points of sculpture. Leo Stein's perceptive discourses at 27 rue de Fleurus also contributed to Miss Ernst's aesthetic education. She recalled: "When we looked at his collection together, he spoke little, but his occasional words and the intensity of his feeling revealed the modern paintings one saw with him in their highest significance." [15] Gertrude, on the other hand, she regarded as a humbug who lived on others' ideas. [16]

Stieglitz sent the lastest issues of *Camera Work* to Miss Ernst while she

55

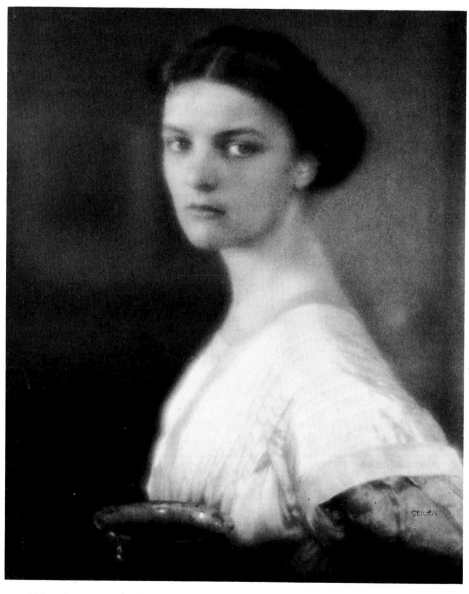

25. Eduard Steichen. *Mrs. Eugene Meyer* (Agnes Ernst). Photograph. The Metropolitan Museum of Art: The Alfred Stieglitz Collection, 1949.

was abroad, and she was delighted to discover that the journal was up to date with contemporary developments in Europe.[17] She was proud to be able to provoke her friends in advanced artistic circles by waving each new issue of *Camera Work* in their faces.[18] At the same time, she realized that except for Stieglitz's colleagues and a few others, the majority of painters in the United States were ignorant of the new forces in European art.

While still in Paris, Miss Ernst vowed that when she returned she would try to help the artists of the Stieglitz group by giving them moral support.[19] Settling in New York after a year and a half abroad, she was drawn to the inner circle of 291 and established intimate ties not only with the proprietor but also with De Zayas and Haviland. After marrying in 1910, she and Eugene Meyer gave not only moral but also financial support to deserving artists like Marin, Weber, Hartley, and Walkowitz through subsidies and the purchase of their works. In this way, the Meyers became the first active, sympathetic patrons of the 291 group at a time when collectors of modern art in America were extremely rare.

Exhibitions of Modern European Art at 291, 1908-1913

When Stieglitz and Steichen established the Photo-Secession gallery, they had agreed to show examples of the fine arts as well as photography, believing that there should be no barriers separating the different media. In 1907, nonphotographic art was introduced tentatively at 291 as a foil for the photographs displayed there and to stir the photographic community out of its complacency. Stieglitz soon discovered, however, that more creative excitement was to be found in the fine arts than in photography. All but the few prominent photographers of his circle, he felt, were narrow-minded, uninterested in the challenge of advanced aesthetic ideas, and given to bickering among themselves. As a result, he committed more and more of his energy to showing avant-garde paintings, drawings, and sculpture, first under the guise of comparison and contrast to photography, and then for their revolutionary message alone.

By January 1909 Paul Haviland could assert that the goal of promoting photography as one of the fine arts "had been attained," and therefore it was appropriate for the gallery to display "new and interesting work in the other arts," as long as it revealed "personal expression." [20] The first exhibition of nonphotographic art, we recall, was devoted to Pamela Colman

Smith in January 1907, unexpectedly replacing the inaugural show of Rodin drawings that Steichen had planned. The Rodin exhibition did not materialize until January 1908, when a collection of drawings Steichen had persuaded the artist to lend was hung. Although Rodin was in no sense an extreme modernist, he was an adventurous and unacademic spirit, and he made daring distortions in his sculpture for expressive purposes. His informal drawings, executed in pencil and watercolor, of models moving about his studio or resting (*Kneeling Girl – Drawing No. 6*, Figure 26) were even more radical in their fluidity of gesture and freedom from detail. Rodin was respected as a sculptor in artistic circles in America, but this, for many New Yorkers, was their first exposure to his controversial drawings. Although the academicians and a few of the critics had doubts about the artistic merits of the drawings, many reviewers praised them.

The spontaneous linearism and shorthand notation of the Rodin drawings were an appropriate prelude to the controversial Matisse exhibition which followed in April 1908. This was the introduction of Matisse to America and his first one-man show outside of France. The drawings, lithographs, etchings, watercolors, and one oil were selected, like the Rodins, by Steichen in Paris and delivered by him in person to the New York gallery. He had met Matisse through Mrs. Michael Stein, the wife of Gertrude Stein's brother, and had obtained the cooperation of the artist in choosing the works to be shown. Steichen, in keeping with Stieglitz's principles, tried to demonstrate the evolution of the artist's style rather than simply present a random assortment of his works. The examples, mainly nudes, ranged from realistic etchings of 1903 to free, vividly colored renditions of the figure dating from 1907, such as *Nude* (Figure 27). This show did not present the artist's most radical efforts, nor did it include any major examples of his painting,[21] but it still created a stir in the New York art world. An unsigned article in *Camera Work*, undoubtedly reflecting Stieglitz's ideas, justified the show: "Here was the work of a new man, with new ideas — a very anarchist, it seemed, in art. The exhibition led to many heated controversies: it proved stimulating. The New York 'Art-World' was sorely in need of an irritant and Matisse certainly proved a timely one." [22] We may question how well Stieglitz really understood Matisse at this time, but he surely recognized the radical and revolutionary quality of his art.

Very few of the New York critics were willing to defend Matisse's art in 1908; in fact, most of them simply scoffed at it. Charles H. Caffin made the only serious effort to understand the artist, pointing out that he was working not from optical data but from a "mental impression." Caffin, who had re-

26. Auguste Rodin. *Kneeling Girl — Drawing No. 6*. Pencil and watercolor. Courtesy of The Art Institute of Chicago: Alfred Stieglitz Collection.

27. Henri Matisse. *Nude*. c. 1907. Watercolor. The Metropolitan Museum of Art: The Alfred Stieglitz Collection, 1949.

28. Henri Matisse. *Joie de vivre*. 1905–1906. Oil on canvas. The Barnes Foundation, Merion Station, Pennsylvania. Copyright 1977 by The Barnes Foundation.

cently talked with Matisse, echoed the artist's statements in observing that he tried to "interpret the feeling which the sight of an object stirs in him." [23] Using nature as his point of departure, the critic observed, Matisse moved toward more and more rigorous simplification of form, the motive for which was his quest for pictorial unity. In this context, the bold, "primitive" expressiveness of Matisse's art was seen as an advantage, not a drawback. Like so many critics of this period, however, Caffin included a disclaimer, suggesting that the artist had cut himself off too abruptly from the established traditions of Western art and, as a youthful trailblazer, still had much to learn.

The first exhibition of an artist of the Post-Impressionist group was devoted to Toulouse-Lautrec. Stieglitz, a great admirer and collector of his work, exhibited thirty of his own Toulouse-Lautrec lithographs in December 1909 and January 1910, in a show that presented that artist's work in the United States for the first time. Stieglitz used the exhibition to convey a lesson as well as an aesthetic message: these examples of so-called "commercial" art indicated that a skilled designer could make worthy artistic statements through lithography without prostituting his talent, and Stieglitz urged young Americans working in this medium not to succumb to crass commercialism.[24]

A second Matisse exhibition, consisting of his drawings and reproductions of his paintings, was held at 291 in February and March 1910. The drawings revealed Matisse's discipline as a draftsman, but the great revolutionary element in his art — its color — was unfortunately absent. The show was im-

29. Henri Matisse. *The Blue Nude.* 1907. Oil on canvas. The Baltimore Museum of Art: The Cone Collection.

portant not so much for its drawings but for the reproductions, in black and white, which constituted the first representative sampling of Matisse's work in America. Included were *Joie de vivre* (1905–1906, Figure 28), *Self-Portrait* (1906, Statens Museum for Kunst, Copenhagen), *The Blue Nude* (1907, Figure 29), *Portrait of Madame Matisse* (1905, Statens Museum for Kunst, Copenhagen), and probably *Harmony in Blue* (1908) and *Harmony in Red* (the first canvas, repainted 1909; Hermitage Museum, Leningrad). It must be remembered that in 1910 Matisse was still a revolutionary figure in France and his art was virtually unknown in the United States.

Stieglitz was fond of three of the major Post-Impressionists, Cézanne, Gauguin, and Van Gogh. He presented an exhibition of Cézanne's watercolors at 291 in March 1911, and he planned an exhibition of Gauguin and Van Gogh for 1912. He believed that Van Gogh's paintings were almost as important as Cézanne's, but the exhibition, for reasons unknown, did not take place.

Stieglitz introduced the work of Cézanne to the American public. Three of the artist's lithographs were included in a loan collection, together with prints by Manet, Renoir, and Toulouse-Lautrec, which was shown at 291 in November and December 1910. This was followed, in March 1911, by an important exhibition of Cézanne's watercolors, mainly landscapes of the 1880s and 1890s executed in a simplified shorthand style, often bordering on abstraction. The watercolors were Cézanne's most radical and controversial paintings, little understood at that time and difficult for some viewers to

61

comprehend even today. Stieglitz and Steichen had admired a group of them at the Bernheim-Jeune Gallery in Paris during the summer of 1907, and Steichen later agreed to select and ship a representative collection to show at 291. (Cézanne's *Fountain* [*Le Parc*] [c. 1888–1894, Figure 30] is the only work that can be securely identified as having been in the show.) Stieglitz shared Steichen's enthusiasm for the twenty choice examples that came from Paris, but the critics of the New York newspapers were mystified by what seemed fragmentary and incomplete paintings.

Cézanne's show was followed by one of watercolors and drawings by Pablo Picasso, eighty-three examples in all. Stieglitz gave him an exhibition in March and April 1911, acting upon a suggestion by De Zayas. Although Stieglitz advertised this as Picasso's first one-man show anywhere, the artist had actually had several previous exhibitions in France. It was, however, his first one-man exhibition in the United States. Picasso at this point was well into his Analytical Cubist style, which had baffled all but the most sophisticated observers in Paris. But advanced critics and collectors generally agreed that he had surpassed Matisse as the leading innovator of his time. Intended to delineate the evolution of the artist's style, the selections at 291 were made by Picasso along with Steichen, De Zayas, and Frank Burty Haviland. Examples ranged from a drawing of a harlequin of about 1905 to a group of early Cubist works of 1909 (see, for example, *Head* [c. 1909, Figure 31]), which constituted the majority of the show. The most advanced and most controversial example was the Analytical Cubist charcoal drawing *Nude* of 1910 (Fig. 32), which Stieglitz purchased for his own collection.

Although most American critics did not understand these works, De Zayas made a serious effort to explain Picasso in the pages of *Camera Work*. Writing on the basis of interviews with the artist, he observed that Picasso "receives a direct impression from external nature, he analyzes, develops, and translates it, and afterwards executes it in his own particular style, with the intention that the picture should be the pictorial equivalent of the emotion produced by nature." [25] De Zayas went on to discuss Picasso's division of the object into planes and his attempt to produce an artistic impression based on the synthesis of various sensations received from nature. He also pointed out that Picasso had a new and different conception of perspective and that he treated form in and of itself, not in relation to other objects. De Zayas understood that Picasso was trying to return to the fundamentals of structure in painting, which the artist believed had been lost by the end of the nineteenth century.

30. Paul Cézanne. *Fountain (Le Parc)*. c. 1888–1894. Watercolor. Collection of John W. Warrington, Cincinnati, O.

31. Pablo Picasso. *Head*. c. 1909. Brush, ink, and watercolor. Courtesy of The Art
Institute of Chicago: Alfred Stieglitz Collection.

32. Pablo Picasso. *Nude*. 1910. Charcoal. The Metropolitan Museum of Art: The
Alfred Stieglitz Collection, 1949.

Despite Stieglitz's and De Zayas's valiant efforts, only two works were purchased — the *Nude* by Stieglitz and an early drawing by the artist-collector Hamilton Easter Field. Stieglitz tried to sell the entire group of works, valued at $2,000, to the Metropolitan Museum, but the offer was refused by the curator, Bryson Burroughs, who saw nothing in Picasso and claimed that Americans would never take the artist seriously.[26]

The last of Stieglitz's ground-breaking pre–Armory Show exhibitions — sculpture and drawings by Matisse in March and April 1912 — was significant because it was the first show of his sculpture held anywhere. The artist, in collaboration with Steichen, chose six bronzes, five plaster casts, and a terracotta to represent his sculptural evolution. The show included some of his finest three-dimensional works, such as *The Serf* (1900–1903, Baltimore Museum of Arts) and states I, II, and III, in plaster, of his portrait *Jeannette*, ranging in date from 1910 through 1911 (the location of the plasters is unknown). They must have provided a strong aesthetic stimulus to those few American sculptors attuned to Matisse's pioneering innovations, although it is hard to measure the effect of the exhibition on the general public. We know that more than four thousand people attended, but only one sculpture, the small *Female Torso* (Metropolitan Museum of Art) was sold, and it was purchased by Stieglitz.

These exhibitions of modern European art held from 1908 to 1913 constitute one of the most important series of events in the cultural history of the United States. Although Stieglitz was usually quite conscious of his own historical role, he could not have appreciated fully the influence they would exert on American art and taste. The exhibitions helped shape the styles of the major painters around Stieglitz in the 1908–1913 period — Marin, Dove, Weber, Hartley, and Walkowitz — as well as many of the lesser figures who visited 291, providing an example for those unable to view these sources in Europe. Explanatory articles in *Camera Work* and Stieglitz's challenging discourses presented on the floor of the gallery reinforced the message of the shows. However, in spite of Stieglitz's great efforts to enlighten collectors, most of the wealthy, cultured patrons who might have been won over to modernism were unprepared to take the leap before 1913. Only after the Armory Show did modern art become acceptable to this group, and even then there were still many dissenters.

Stieglitz proudly announced high attendance figures in *Camera Work*, but we have no way of measuring the real impact on the general public of the exhibitions at 291. The essential fact is that he made challenging and innovative works of art accessible to all, including some who looked in

merely because they were curious and others who came because it was the fashionable thing to do. But throughout his audience was scattered a small number who truly appreciated Stieglitz's efforts, and a few of these joined forces with him to advance his cause.

The Evolution of Stieglitz's Taste

Despite Stieglitz's central role in creating the artistic climate of 291, he never held fixed theories. His explanations of art were largely intuitive, based on feeling and, of course, a sensitive eye. He relied so much on his natural instinct for quality in photography and painting that he paid little attention at first to established aesthetic doctrines. In due time, however, his thinking was stimulated by knowledgeable individuals like Steichen, Caffin, and Hartmann and later, in the 1908–1913 period, also by Max Weber and Marius de Zayas. Stieglitz could absorb rapidly new ideas from his friends; besides having a quick mind and superb visual taste, he was a revolutionary spirit. He wrote his sister in 1909: "I hate tradition for tradition's sake; — I hate the half-alive; I hate anything that isn't real. I never knew I had the ability to hate in me but I find that as I grow older a hatred not against individuals but against customs, traditions, superstitions, etc., is growing fast and strong. . . ."[27] When Stieglitz found the way to combine his passionate spirit of rebellion with specific knowledge of the artistic revolutions of his time, he gained the power to change the course of American art and taste.

How did he obtain this knowledge and how did he use it? At the beginning of his career as a gallery owner, Stieglitz confessed to knowing little about art. But the photographs he had made in Germany and then in America tell us that he had learned much from German and Austrian sentimental-realistic genre painters and the artists of the Barbizon school, and in the nineties he must have looked carefully at the art of the Impressionists. Moreover, he was exposed to advanced aesthetic theories around the turn of the century through his contacts with Steichen, Caffin, and Hartmann. Although we do not know how much he learned from the latter two critics, he had invited them to contribute articles to *Camera Notes*, and after starting *Camera Work* he continued to rely on their articles to convey advanced ideas in the fine arts to the photographic community. Stieglitz, we must assume, was sympathetic to their two-pronged attack on descriptive realism and academic art and their support of abstraction and subjective self-expression.

We have seen that Steichen's ideas and contact with intellectual circles in Europe helped to shape Stieglitz's thinking and the aesthetic climate of 291. Steichen had been in close touch with Maurice Maeterlinck and persuaded him to contribute an essay for the second issue of *Camera Work* (April 1903). Steichen and Stieglitz often discussed Maeterlinck's work and, as Steichen later recalled, "We were both moved by him." [28] Undoubtedly of great significance to Stieglitz's thought was Maeterlinck's conception of the soul as a hidden essence, the real core of man's being. Maeterlinck had recognized the validity of the unconscious mind and believed that the true basis of existence was to be found in the depths of the human spirit. His Symbolist writings excelled in suggesting mystery and mood.

Hartmann, an enthusiastic follower of Maeterlinck, pointed out: "Mystery seems to consist largely of a concealment of actualities, of depriving the words to a certain extent of their literary significance or of investing them with pictorial and musical qualities." [29] Through Hartmann's contributions to *Camera Work*, together with those of Maeterlinck, the Belgian author's writings enjoyed wide currency within the Stieglitz circle. In *Camera Work* (July 1904) Hartmann advocated effects of mystery in painting, urging artists to achieve vagueness by softening their contours and using monochromatic tonal compositions. He saw Maeterlinck as the exemplary model for this kind of imagery, though he also liked the suggestions of mystery and the unknown found in works by the painters Arnold Böcklin and Gustave Moreau. (It is worth noting that Böcklin and Franz von Stuck, an artist of similar tendency, had appealed to Stieglitz around the turn of the century, probably under the influence of Hartmann.)

"Accuracy is the bane of art," Hartmann stated in *Camera Work*.[30] This remark might easily have been made by Caffin, who likewise departed from the idea of description as the chief end of art. Caffin believed in an art of formal arrangement, following the principles of Whistler and Japanese art, which he came to admire under the influence of Arthur Wesley Dow's teachings. (Dow's ideas will be discussed in the section on Georgia O'Keeffe.) Caffin was able to enjoy abstract pictorial relationships without indulging in the kind of mysticism that attracted Hartmann, and thus he more accurately predicted the subsequent course of modernist painting. In a three-part article published in *Camera Work* in 1905 and 1906, he enunciated his artistic credo. The Japanese, he thought, provided the most instructive models for Western art because they combined spiritual values with significant artistic form. Caffin observed that Whistler had learned much from the Japanese, for a time trying to eliminate recognizable form in his paintings and depending as

much as possible upon color and tone alone.[31] Caffin devalued the particular in art and sought, instead, the expression of universal spiritual values:

If painting is to maintain a hold upon the intelligence and imagination, as music does, and possibly poetry, and to grow [sic] forward in touch with the growing needs of humanity, it must find some fundamental motive other than the *appearances* of the world. . . . If it is to keep itself in living competition with the superior impressiveness of modern music . . . it must take on something of quality which is the essence of music — the *abstract*. It is here that it may learn of the Oriental ideal, as exemplified in Japanese art.[32]

Although Caffin believed in the expressiveness of the work of art, he was fundamentally antiexpressionist, feeling that the artist's mission was to communicate universal ideas, a universal spirit, rather than his own personal emotions and sentiments.

Our examination of Stieglitz's early photographs has shown us one side of his aesthetic development, but his tastes in painting followed quite another track at this time. It is as though he had two sets of standards of what was "artistic," one for photography, another for painting. On the walls of his home, there were large reproductions of Franz von Stuck's *Sin* (1893) and Böcklin's *Island of the Dead* (1880, Figure 33), together with Franz von

33. Arnold Böcklin. *Island of the Dead*. 1880. Oil on wood. The Metropolitan Museum of Art: Reisinger Fund, 1926.

Lenbach's portrait of Eleonora Duse holding the artist's child [33] and a photograph of a painting of a nude torso (presently unidentified) by Rubens.[34] We know that Stieglitz's early fondness for Rubens continued for the rest of his life, but he soon outgrew his liking for the nineteenth-century Germanic painters whose romantic imagery had prepared him to admire the mystical, intuitive art of Pamela Colman Smith. Just as Rodin succeeded Miss Smith in the roster of exhibitions at 291, so Stieglitz abandoned his taste for romantic symbolism in painting in favor of the newer antiacademic developments in French art. He could not have taken this step so readily without the counsel of Steichen.

Through his letters proposing shows for 291 and his periodic meetings with Stieglitz in New York and Paris, Steichen was largely responsible for informing his friend about the latest artistic developments in the French capital. During the summer of 1907 Stieglitz accompanied Steichen to the Bernheim-Jeune Galleries to see watercolors by Cézanne and paintings by Matisse. We have no idea of what Stieglitz thought of the Fauve's work at that time, but he later wrote about his experiences when he saw the Cézannes; visiting the gallery during a thunderstorm, he recalled that it was difficult to perceive anything at all. When he was told the price for a watercolor was 1,000 francs, he answered, in amazement, "You mean a dozen. . . . Why there's nothing there but empty paper with a few splashes of color here and there." [35]

If Stieglitz found it hard to appreciate the abstraction of Cézanne's watercolors, he was not unaware of abstract values in pictorial composition at this time, as we can see from his remarks about his photograph *The Steerage* (1907, Figure 34). When he saw this scene on his trip to Europe in June 1907, he was attracted by its abstract shapes. He recalled observing: "A round straw hat, the funnel leaning left, the stairway leaning right, the white draw-bridge with its railings made of circular chains — white suspenders crossing the back of a man in the steerage below, round shapes of iron machinery, a mast cutting into the sky, making a triangular shape. I stood spellbound for a while, looking and looking. Could I photograph what I felt, looking and looking and still looking? I saw shapes related to each other. I saw a picture of shapes and underlying that the feeling I had about life." [36]

Stieglitz had been traveling in first class and had become disgusted with the *nouveau-riche* atmosphere. Searching for relief, he walked down to the steerage and found the scene that he captured a few minutes later in this photograph. He was drawn to the subject because it was sincere and real, in contrast to the artificiality of the wealthy class he had traveled with on

34. Alfred Stieglitz. *The Steerage*. 1907. Photogravure (from *291*, nos. 7–8, September–October 1915). Private Collection.

his transatlantic voyage. In his personal life at this time he had shunned the artificial and pretentious, seeking signs of basic honesty and truth in people. He was not trying to make a penetrating commentary about the social classes found in the steerage but, rather, expressing his personal view that the honesty and unpretentiousness of these people represented the side of his own character that he wished to reinforce.

Leaving Steichen in Paris, Stieglitz returned to New York to arrange the 1907–1908 season of exhibitions, which was to include several shows of paintings, drawings, and graphics, for whose content Steichen would be responsible. Steichen had written Stieglitz enthusiastically about Rodin and his work and, we recall, selected the drawings for his January 1908 show at 291. The director of the Photo-Secession may have known little of Rodin's drawings before the exhibition, but when they went on display he defended them, as Georgia O'Keeffe recalled, with "fantastic violence." [37] Early in the same year, Steichen warmly endorsed Matisse's drawings in a note whose tone suggests that he was instructing Stieglitz: "Drawings by Henri Matisse the most modern of the moderns — his drawings are the same to him and his painting as Rodin's are to his sculpture. . . . I don't know if you will remember any of his paintings at Bernheim's. Well, they are to the figure what the Cézannes are to the landscape. Simply great. Some are more finished than Rodin's, more of a study of form than movement — *abstract* to the limit." [38] Although Stieglitz's initial reaction to the Matisses he saw in Paris was unrecorded, he claimed that, after some exposure, he was able to understand most of them. Just as important for him was the shock value they would have for the New York audience. Correspondence between Steichen and Stieglitz in the years 1907–1909 makes it clear that the two had agreed to show both "understandable" work and examples that would serve as a "red rag" to challenge viewers and shake them out of their complacency.

During the summer of 1909, Steichen took Stieglitz to meet Matisse and to see the superb collection of his paintings in the apartment of Michael and Sarah Stein. The next day they went to 27 rue de Fleurus, the home of Leo and Gertrude Stein (Figure 35) to see their collection of modern paintings and sculptures. Finding much that was completely new to him, Stieglitz was bewildered by the experience. Leo gave a long discourse on art, condemning Whistler and Matisse as second-class painters and Rodin as possibly third-class. Although Stieglitz had known of Picasso at least as early as 1908, when Steichen wrote about him as a potential exhibitor, in his recollections of his first meeting with Leo Stein, Stieglitz did not mention his name. But he must have heard Leo praise that artist as the leading innovator in French

35. *Interior of the Apartment of Leo and Gertrude Stein, 27 rue de Fleurus, Paris.* Early 1906. Photograph. The Baltimore Museum of Art: The Cone Archives.

painting, and he surely saw Picasso's work at the Steins'. Convinced by the logic of Leo's arguments, Stieglitz offered to publish in *Camera Work* anything he might write on art.[39] Here was a thinker who, even more than Steichen, seemed to be at the forefront of the avant-garde and was willing to chastise artists whom Stieglitz had just learned to appreciate. Stieglitz's revolutionary temperament was stimulated by this experience, and from this point onward he sought to absorb and disseminate the most advanced aesthetic principles of his time.

Stieglitz was also fortunate in being able to learn a great deal from the American painter Max Weber, who had spent much of the period 1905–1908 in Paris in close touch with vanguard painters and sculptors. From the fall of 1909 through early 1911 he allied himself with Stieglitz, who admitted that Weber, "being very intelligent, became helpful in a way in clarifying my own ideas." [40] Weber had carefully studied the sources of modern art in the museums, and at this time there was no one else in America who was as well informed about French art and aesthetics. Weber was committed, above all, to Cézanne, whose art he admired passionately. (He claimed that he was the first to bring reproductions of Cézanne's work to this country.) [41] He also understood the art of Picasso and Matisse. At this time, he believed in artistic expression through substantial plastic forms reaching out into and filling space, supporting his views with examples from Egyptian, Assyrian, Greek, and African Negro art, in addition to the paintings of Giotto and El Greco. [42] Weber had brought from Paris a knowledge of primitive and African art, which he had derived from his visits to the Trocadero Museum; and upon his return to New York he studied Mayan, Aztec, and American Indian art at the Museum of Natural History.

Thanks in part to Weber's tutelage, Stieglitz was prepared to give his full support to the works of Cézanne and Picasso that Steichen sent to 291 for exhibition in March and April of 1911. Now he found the Cézanne watercolors not "empty paper" but "as beautiful a lot of pictures as I had ever seen — as a matter of fact, something I had never seen before." [43] He affirmed his faith in Picasso by purchasing the most advanced example, the highly abstract Analytical Cubist *Nude* (Figure 32). He may have been attracted to the drawing because it was the controversial "storm center" of the show, but he seems also to have enjoyed the work aesthetically. A reporter observed: "Mr. Stieglitz declares in all sincerity that when he has had a tiring day in his gallery or elsewhere he goes home at night, stands before this drawing in black and white, which hangs over his fireplace, and gains from it a genuine stimulus." [44] Steichen, it is worth noting, parted company with Stieglitz at this point, admiring Picasso but confessing that he could not follow his excursions into abstraction. [45]

During the late spring and summer of 1911, Stieglitz immersed himself more thoroughly than ever before in the world of avant-garde art. He talked with Secessionist painters in Munich in May and June, but unfortunately, we do not know the names of those he saw. Later in the summer, he spent three stimulating weeks in Paris. In the company of De Zayas or Steichen, he visited the Louvre, the official Salon, the Salon des Indépendants,

the Salon d'Automne, and the Pellerin Collection (rich in Cézannes); went to the Vollard and Bernheim-Jeune Galleries; saw and admired Brancusi's sculpture; and, most important, talked with Rodin, Matisse, and Picasso. (He refrained from going to 27 rue de Fleurus again because he did not want to dilute the impact of his first impression of Leo Stein and the apartment.) He emerged believing that Cézanne, Van Gogh, and Renoir were the three leading modern painters. Matisse, he thought, was producing beautiful work, but somehow it failed to captivate him; by comparison, Picasso appeared to be the more significant artist.[46] Shortly after he returned to New York late in November, Stieglitz implored the Metropolitan Museum to assemble a comprehensive loan exhibition of the best pictures by Cézanne, Van Gogh, Matisse, and Picasso.[47] Steeped in conservatism, the museum took no action.

So Stieglitz arranged to present modern European painting himself, in the pages of *Camera Work.* He devoted a special issue of the magazine in August 1912 to modern art, including Gertrude Stein's controversial essays on Matisse and Picasso — the first appearance of her prose in a nonscientific periodical. In the same issue there were full-page illustrations of five paintings and two sculptures by Matisse and five paintings and a sculpture by Picasso. Previously Stieglitz had published in *Camera Work* a few examples by these artists shown at 291, but this issue was his first concerted effort to expose the reading public to a group of important modern works. (Examples included Matisse's paintings *The Blue Nude* [Figure 29] and *Joie de vivre* [Figure 28] and Picasso's *Daniel Henry Kahnweiler* [1910. Figure 36] and his bronze *Head of a Woman* [1909–1910, Art Institute of Chicago].)

In July 1912, Stieglitz printed in *Camera Work* a brief excerpt, in translation, from Kandinsky's book *On the Spiritual in Art,* a crucially important defense of abstract art that was first issued in German in January of that year. We do not know how Stieglitz obtained this text, but we must assume that he was acquainted with the whole book, not just the excerpt, and that this volume helped him understand the goals of abstract art. In October 1912, he proclaimed the virtues of abstraction in a note to Heinrich Kuehn, an Austrian photographer, stating that just as the world was at the threshold of a new social era, so the true medium of the new art would be abstraction.[48] Stieglitz's appetite for nonobjective art was undoubtedly whetted, too, by the enthusiastic letters on the subject that Marsden Hartley wrote from Paris and Berlin in 1912 and early 1913.

This was Stieglitz's finest hour. He had now become the leading spokesman for avant-garde art in the United States, more advanced in his tastes than most European patrons of modern art.

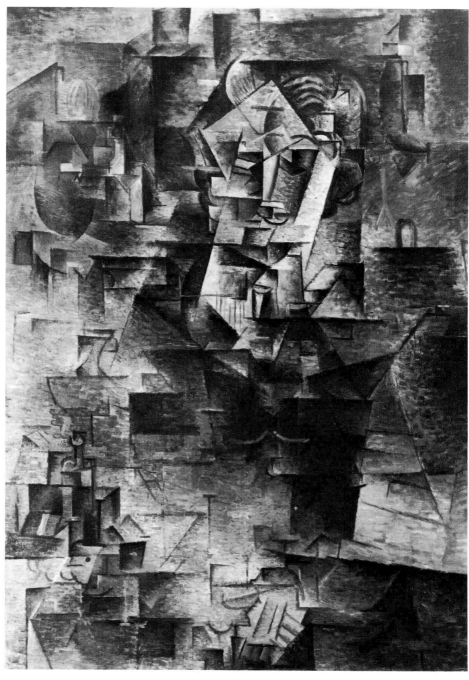

36. Pablo Picasso. *Daniel Henry Kahnweiler*. 1910. Oil on canvas. Courtesy of The Art Institute of Chicago: Gift of Mrs. Gilbert W. Chapman.

Stieglitz and the Spirit of 291

Stieglitz's personal aesthetic in the years between 1908 and the Armory Show is hard to define, for he never described his credo in so many words, and at times he admitted that his ideas eluded definition. His letters, published writings, and conversations, however, give us some valuable clues.

In painting, sculpture, and photography, Stieglitz was committed to the ideal of fine craftsmanship, but he championed, with equal vigor, the forthright expression of subjective feelings. "My conscience," he wrote, "has always told me that I must do the best possible or nothing." [49] His favorite words of praise for the arts (and, by extension, for their creators) were honesty, sincerity, vitality, intensity of feeling, and freshness of vision.

Stieglitz believed that art revealed the creator's personal integrity and commitment to his chosen task. The work of art, in turn, could influence and elevate the spectator because it reflected the best of the artist's inner being. "Art, for me," he said, "is nothing more than an expression of life. That expression must come from within and not from without." [50] Human values moved Stieglitz as much as aesthetic concerns. He believed in integrity, purity, and honesty in every artist; in the nobility and sacredness of making works of art, whether fine or applied; and in the destruction of outworn ideas in favor of the vital and experimental in all fields of activity. Stieglitz dedicated his work at 291 to the promotion of these intensely felt values, and he could not help transforming his personal beliefs into a public crusade that affected a sizable audience. He admitted that it was "a fight for my own life as well as a fight for the lives of all true workers, particularly American." [51]

A born reformer, Stieglitz was driven by strong inner convictions. Throughout his life he rejected dishonesty, carelessness, and insincerity, and he spoke out forcefully against all kinds of injustice. He told Waldo Frank in later years: "I have always been a revolutionist if I have ever been anything at all." [52] In the late 1890s, he began to criticize the indifference to aesthetic values and craftsmanship which prevailed in the United States, and he protested, as well, the American social and economic system that sustained this indifference. "My whole life in this country," he wrote a friend, "has really been devoted to fighting the terrible poison which has been undermining the American nation. As an American I resented the hypocrisy, the short-sightedness, the lack of construction, the actual stupidity in control everywhere. . . ." [53] Acutely aware of these shortcomings, he took positive steps to educate his countrymen to a desire for a living art expressive of contem-

porary America, executed in accordance with the highest standards of crafts-manship. He pursued his goal first among the photographers of the Photo-Secession group and then at 291.

While Stieglitz encouraged the artists and writers around him to develop according to their own special talents, he also placed high value on the collective group spirit, on "the development of an idea." [54] As he explained in a letter to Steichen: "It is only in the process of building that the individuals see themselves sacrificed for the whole. They can impossibly see the whole until it is finished. But I do and can see it — that is my advantage." [55] Because Stieglitz had few allies who shared his vision and strength of personality, he came to rely primarily upon himself as an instrument of reform in the arts. "No help," he wrote. "No one can help. It's all too personal — like a work of art." [56] During the most active years of 291, Stieglitz stood before the world as a self-motivated exemplar of the highest moral, spiritual, and artistic standards.

Stieglitz's aim was to gather a group of kindred spirits at 291 who, under his benevolent patronage, would exchange ideas and make significant new contributions in the arts. A philosophical anarchist, he tried to create a climate conducive to free discourse and discovery. The gallery was open to all comers — artists, writers, critics, photographers, students, collectors, and curiosity seekers — but the intellectual focus of 291 was found in the discussions among those who sympathized with Stieglitz's aims. Between 1908 and 1913 the active members of his coterie included Marin, Weber, Dove, Hartley, Walkowitz, De Zayas, Katharine Rhoades, and Marion Beckett, artists; Haviland and Agnes Meyer, amateurs; Caffin, J. Nilsen Laurvik, Sadakichi Hartmann, and Benjamin de Casseres, critics; and John B. Kerfoot and Joseph T. Keiley, photographers and editors. In the galleries or over lunch at the Holland House, where Stieglitz presided — and paid the bills — the inner circle would "talk about anything and everything, art, poetry, politics, life in general." [57] Although in later years Stieglitz was excessively talkative, in this period he did not try to dominate or control the discussions.

Stieglitz liked to think that he had no theories, no systems, that there were no laws or absolutes in the arts; yet his letters and remarks by his associates indicate that 291 stood for something definite and that there were several basic principles underlying the activities there.

Eugene Meyer's free-verse tribute to Stieglitz's enterprise summarizes the essence of 291:

An oasis of real freedom —
A sturdy Islet of enduring independence in the besetting seas of
 Commercialism and Convention —
A rest — when wearied
A stimulant — when dulled
A Relief —
A Negation of Preconceptions
A Forum for Wisdom and for Folly
A Safety valve for repressed ideas —
An Eye Opener
A Test —
A Solvent
A Victim and an Avenger.[58]

The establishment at 291 was, as Charles E. S. Rasay observed, "a little 'agora' where men may listen, and may speak freely. . . . No one shall stop him nor hinder him there; he shall speak boldly, and as truly as his own condition will permit." [59] Conversation was spontaneous and animated, revealing deeper recesses of the human spirit. Charles H. Caffin observed that this freedom of expression was contagious: "Through this contact with other free spirits, whether the latter were present in person or represented in their works, one's own freedom in liberality." [60] In the last analysis, the central gift of 291 was *opportunity*, as Paul Haviland astutely observed. The gallery provided the opportunity for each visitor to give or to take what he pleased, as his conscience might dictate. The judgments about what was or was not of value were left up to the individual. " '291' . . . makes no propaganda. It teaches nothing, for the professorial attitude is contrary to its spirit." [61]

The enterprise was conducted, as Stieglitz often said, as a laboratory where new artistic expressions could be examined and evaluated by the company at hand. There were but two cardinal principles at 291. The work had to be a frank expression of the feelings of the unique individual who produced it, without following conventional rules or imitating anyone else's style. And the artist was expected to add something new to what had gone before. Stieglitz said: "I am interested in development, in growth." [62]

Although he presented exhibitions at 291, he always insisted that it was a noncommercial enterprise, that he was not a dealer and not in business. As Marie Rapp (Figure 37) recalled: " '291' was not a gallery for selling things; it was to show the world what was being done by Americans. Stieglitz was dedicated to the idea of giving deserving artists a chance to be seen, and it

37. Alfred Stieglitz. *Marie Rapp*. 1916. Photograph. Private Collection.

gave him the greatest joy when he sold something, an absolute joy in getting people interested." [63]

Even so, Stieglitz did not operate like a conventional dealer, often making it difficult for people to buy things. Marie Rapp said: "What Stieglitz resented more than anything else was to have someone who had money come in and offer to buy a painting as if it were a shop or as if the work were some commodity. If he thought they wanted to buy just because they had money, he might double the price of the painting. If someone else came in and was just crazy about something, and had nothing else in mind, he would let them have it for half-price!" [64] His aim was to help the artists of his circle gain recognition and to sell enough of their work so that they could paint without having to worry about money. He did not charge a standard commission for marketing the paintings of his colleagues, and when their works did not sell, he managed to support the artists from his own funds or those he solicited from wealthy patrons of the arts.

From 1908 to 1913, Stieglitz actively promoted his artists with fanatical zeal, sacrificing the practice of his own photography for the greater understanding of art that this experience would give him. Toward the end of this period, however, his failure to convert large numbers made him abandon much of his hope for America's appreciation of art. Nevertheless, whatever his shortcomings might have been, no other individual or institution, here or abroad, had approached the display of modern art with more conviction and with such a definite educational purpose.

·CHAPTER FOUR·

The Rise of the American Avant-Garde·Artists of the Stieglitz Circle before 1913, I (Marin, Dove)

The Background for the American Avant-Garde

The preceding chapters have set the stage for the emergence of the advanced American artists associated with 291. The time has come to treat the lives and works of these artists as they relate to Stieglitz's ideals and to the growth of avant-garde art and culture in the United States. Before taking up this subject, however, it would be well to view other progressive currents that parallel the efforts of Stieglitz and his friends. Within these contemporary movements we will find forces that gave support to Stieglitz as well as those that sought alternate solutions or even opposed him and his ideas.

To understand the various avant-garde movements in early twentieth-century American art, it is necessary first to recognize the power of the academic point of view and the elaborate establishment that supported it. Today it is hard to realize how strong the academic tradition was at that time because the battle against the Academy has long since been won. During the years leading up to the Armory Show of 1913, however, the majority of painters and sculptors in America were academic. Before that event, the progressives were few in number, and their efforts were little recognized. The Armory Show, for which Stieglitz had laid the groundwork, was the first major breakthrough for modernism in the United States, but it did not bring the immediate acceptance of avant-garde art and the sudden destruction of the Academy. To the contrary, between 1913 and 1917, the power of the Academy declined only gradually.

What was the academic tradition that Stieglitz and the other progressives encountered in the opening years of the century? It is difficult to define be-

cause many different styles were recognized and accepted as academic. The term "academic" is, therefore, best applied to a point of view rather than to a particular style. It refers to an approach that stresses the value of inherited tradition, instead of the forthright expression of nature or of the inner emotional world of the artist. In the United States, the academic viewpoint was espoused by the National Academy of Design, founded in 1825, an organization that sponsored annual exhibitions and operated a school to preserve the conservative traditions represented by these shows.

Essential academic tenets were the study of the human figure as the chief basis for the fine arts, a belief in the primacy of drawing over color, a rationalized procedure in arriving at the composition of the work of art, and reliance on worthy models from the past, including the study of casts of ancient statuary to educate the eye of the artist. Although, in principle, art inspired by the classical tradition was most desirable, the Academy also accepted art based on the seventeenth-century styles of Hals and Velázquez, on the Barbizon school, and on contemporary French academic painting, all of which emphasized drawing over expressive color. Around the turn of the century much of the academic art produced in the United States was saccharine, sentimental, uninspired, and often thoroughly dull.

Progressive artists in America rebelled not only against academic painting but also against the machinery that maintained the power of the Academy. The annual exhibitions gave very little encouragement to unorthodox or independent artists, and these financially successful shows dominated the New York art market, determining the trends followed by most of the commercial galleries. The Academy in this way enjoyed almost exclusive control over the exhibition and sale of art, a monopoly that progressive artists in the first decade of the twentieth century tried to break.

At this time, there were several individuals who challenged this authority, but only Robert Henri had any real success before 1910. He fought against blind obedience to established artistic standards and championed a liberal attitude that gave greater freedom to the artist's creative instincts. Above all, he was a crusader for a native American art, an art based on first-hand experience of the contemporary world in which he lived. A group of Henri's friends from Philadelphia who moved to New York, as he himself did, shared his ideas and followed his lead in creating a style of straightforward painting of the everyday world. They devoted themselves to the life of the common people in the city and depicted such scenes as tenements, slums, and bars, all of which the Academy considered improper subjects.

At first, Henri tried to reform the Academy from within, but he soon

realized that compromise was impossible. Consequently, he struck out as an independent artist, setting himself against the established, official forms of art. In doing so, he attracted a group of dedicated friends and disciples, and together they won a respected place for an art created freely from direct experience, not according to traditional rules and formulas. (John Sloan's *The Wake of the Ferry* [*No. 2*] [1907, Figure 5] is a typical example.) Yet their styles — as distinct from their unorthodox subject matter — were *retardataire*, deriving as they did from Manet, Whistler, Eakins, and early Impressionism, as well as from Goya, Rembrandt, Hals, and Velázquez.

But their ideas about the teaching and exhibition of art were truly progressive and helped to foster the emergence of the avant-garde in America. Greatly influenced by Whitman and Emerson, Henri felt that the artist's individuality was sacred and that he should make a bold, forthright statement of his personal view of the world, uninfluenced by fads or fashion. He also believed that the artist should pay little attention to the outward form or style of his work. What mattered was the content, the immediate expression of intensely personal ideas. As Henri said about his idol, Walt Whitman: "[He] can utter truths so burning that the edge of the sonnet, roundelay, or epic is destroyed." [1]

Whitman also insisted that the artist be of his own time and place. Ordinary life, even the smallest details of existence, could reveal some worthwhile truth. He regarded the common man as a challenging subject for treatment by the artist. In asking the artist to reflect contemporary life, Whitman was consciously and proudly American, not in any flag-waving sense but in the belief that he and other artists should celebrate the character of their own nation rather than follow outmoded values and styles from Europe. Henri, in turn, conveyed this self-consciously national spirit, combined with a strongly individual, anti-institutional viewpoint, to his friends and followers in what came to be called the Ash-Can school.

Henri and his colleagues made a strong impression on American art in the opening years of the twentieth century since they successfully advocated exhibitions that liberated them from the jurisdiction of the Academy. Among the most important was the celebrated exhibition of "The Eight," held in 1908 at the Macbeth Galleries in New York. The show was organized chiefly by Henri and Sloan, and in addition to their friends George Luks, William Glackens, and Everett Shinn, three other painters — the romantic visionary Arthur B. Davies, the Impressionist Ernest Lawson, and decorative Neo-Impressionist Maurice Prendergast — were asked to participate because their work was original and progressive and because they, too, were opposed to

the Academy. Although the members of "The Eight," as the newspapers called the group, shared similar attitudes about art, they were never a "school," for they worked in a variety of styles. While some critics attacked "The Eight" for their coarse, vulgar subjects and lack of technical finesse, many others admired their work.

This exhibition proved for the first time that a strongly antiacademic group of artists could attract wide public notice and substantial income — not just as curiosities, but as serious, significant painters. And the show's success gave younger artists the courage to carry on the struggle against the Academy by organizing larger and more radical exhibitions of art, both American and European.

This spirit paved the way for the large Exhibition of Independent Artists of 1910, a little-known forerunner of the Armory Show. The organizers, Henri and Sloan, assisted by Davies and Walt Kuhn, displayed nearly 500 works by American artists who could not gain entry to the Academy shows because their styles were too controversial or because they refused to submit to the Academy's juries. The exhibition had neither a jury nor prizes; the organizers simply rented a warehouse on West Thirty-fifth Street and invited entries by artists they believed in. About half the participants were, or had been, Henri's students, and the rest represented various antiacademic and modern tendencies. Surprisingly, none of the artists linked with Stieglitz was asked to exhibit. The backers of the show probably regarded them, rather narrow-mindedly, as alien representatives of a radical, experimental faction too much involved with European avant-garde ideas.

The Exhibition of Independent Artists did not win large-scale acceptance for progressive American art, nor were there more than a few sales. This must have disappointed Henri, although he was satisfied to have fought for the principle of artistic independence. In many respects, the exhibition represented the culmination of his efforts. After 1910, he lost some of his momentum, and his leadership of the progressives was challenged by others more tolerant of European modernism, which was becoming known in America largely through Stieglitz's efforts. One of those who took the lead was his friend Arthur B. Davies.

Davies is one of the most interesting, original, and underestimated figures in the history of early twentieth-century American art. He belonged to the lyrical-poetic tradition of American painting exemplified by La Farge, Vedder, and Ryder, and in his studies, he had absorbed influences from Giorgione, Botticelli, Piero di Cosimo, Blake, Ingres, Degas, and Puvis de Chavannes. But in the years just before 1913 Davies also managed to gain a

great deal of knowledge about the more advanced tendencies in European painting. This was no easy task since he apparently had to gather most of his information in this country. One of his chief sources was Stieglitz's gallery at 291 Fifth Avenue, which he visited frequently, and he also haunted shops where foreign books and magazines were sold.

Because his unconventional style of painting was not acceptable to the Academy, Davies allied himself with progressive groups in New York, working quietly to advance the cause of independent artists. In the late 1890s, he and Henri became friends and for more than a decade worked together for the antiacademic interests. Davies tended to remain behind the scenes, leaving Henri to deal with day-to-day problems and to make public pronouncements. In addition he became an adviser to wealthy women, like Lizzie P. Bliss, who were interested in modern art, particularly modern American art, and he unobtrusively gave support and encouragement to younger avant-garde painters.

Advanced American Artists
in Paris in the Early 1900s

In the late nineteenth century, almost every American artist seeking full professional training made a point of studying abroad, usually in Paris, Munich, or London. This same pattern persisted for many young Americans during the first decade of the twentieth century, but the possibilities available to them opened up considerably. In Paris, they could take the academic path to what then seemed to be certain success, or they could respond to the challenge of newer avant-garde styles being developed by Matisse, Picasso, and their colleagues. Some of the Americans made their journey to Paris expecting to take the academic route but were converted to modernism along the way; only a few started with the hope that they could ally themselves immediately with advanced French art.

Our concern is with that handful of Americans who became modernists, not with their many countrymen who lived in Paris but ignored the avant-garde. Among the progressives there were some who were destined to have little or no contact with Stieglitz and his circle: Samuel Halpert (arrived in 1902), Maurice Sterne (1904), John Covert, Morton Livingston Schamberg, John Storrs, and Marguerite Thompson (Zorach) (1908), Andrew Dasburg (1909), and William Zorach (1910). Almost all of the artists who were to

become closely associated with Stieglitz arrived in Paris in the first decade of the century: Marin and Weber (1905), Walkowitz (1907), Dove (1908), and Demuth, who joined the Stieglitz group after the decline of 291, visited Paris in 1904 and 1907. Several artists who were briefly involved with Stieglitz also made their way to Paris: Maurer, in 1897; Macdonald-Wright and Carles in 1907 (the latter had visited Europe in 1905). The Synchromists Patrick Henry Bruce (1903) and Morgan Russell (1906), though never members of the Stieglitz circle, were close to many expatriates who were. The person who brought together many of the avant-garde American artists, particularly the future associates of Stieglitz, was Eduard Steichen, who between 1906 and 1914 spent much of his time in Paris and at nearby Voulangis.

Although most of the American artists converged on Paris without knowing each other, they had an opportunity to meet at several centers favored by Americans — the Café du Dôme in Montparnasse, the apartment of Gertrude and Leo Stein, and the Paris studio of Eduard Steichen. At the Dôme heated discussions of the latest trends in art by English, German, and American artists must have been a challenging stimulant to the newcomers. Excitement about new discoveries in painting, sculpture, and literature electrified the atmosphere at the Steins' apartment, which was open to an international mélange of personalities in the arts. Max Weber recalled:

Leo and Gertrude Stein graciously received art students, students of philosophy and languages at the Sorbonne: writers, young poets, musicians and scientists who came to study the paintings by Cézanne and those of other rising artists. For hours they stood around a large table in the center of the spacious and well lighted room, examining portfolios full of drawings by Matisse, Picasso and others, and folios well stocked with superb Japanese prints. . . .[2]

One can hardly overestimate the value of this experience for the young American artist. No other center in Paris, with the possible exception of Michael and Sarah Stein's, could offer him such a concentrated exposure to the latest trends in the world of art. Had Gertrude and Leo Stein not been Americans, hospitable to their compatriots, the course of modern American art would have been far different.

Eduard Steichen did not equal the Steins in intellectual complexity, nor was he in the forefront of the avant-garde in his own painting and thinking. But he was receptive to individual and experimental forms of art and, as we

86

have seen, he was eager to reform the medium of photography. His assignment to seek out new talent for 291 led him to form an alliance of progressive American artists living in France. On February 25, 1908, he called a meeting in his studio to establish a Secessionist organization, the New Society of American Artists in Paris. The advisory board of the Society consisted of Steichen, Maurer, Weber, D. Putnam Brinley, Donald Shaw MacLaughlan, and the charter members included Marin, Carles, Bruce, Jo Davidson, Richard Duffy, J. Kunz, E. Sparks, Maximilien Fischer, and Albert Worcester. (Some of these artists are now forgotten, but the group included several who were to become well known after their return to the United States.) The Society was created as a protest against the firmly entrenched Society of American Artists in Paris, which the founders of the new group felt was a stronghold of conservative art-political power, devoted to nothing more up-to-date than Impressionism. The New Society made ambitious plans to obtain recognition at the international exhibition soon to open in Vienna, to hold an exhibition of their own in the spring of 1908, and to solicit additional members who were sympathetic to their cause. None of these plans materialized, but Steichen drew heavily upon this group for the exhibitions he helped to arrange for 291.

The most important of these shows, entitled "Younger American Painters," held in March 1910, was devoted to the paintings of nine artists, more or less advanced — Brinley, Carles, Dove, Laurence Fellows, Hartley, Marin, Maurer, Steichen, and Weber. All except Hartley had been friends of Steichen, and all were then working in France except Dove, Weber, and Marin, who had recently been there. The participants did not represent a consolidated group or movement, but the common denominator was their "departure from realistic representation, the aim toward color composition, the vitality of their work, and the cheerful key in which their canvases are painted." [3] Brinley and Fellows were relatively conservative, Brinley being judged as "not a radical except in his quest for color and light" [4] and Fellows working in a decorative mode influenced by Egyptian painting.

This first exhibition in the United States of American artists strongly influenced by European modernism was in many respects an outgrowth of Steichen's New Society of American Artists, for six of the exhibitors had been members of that organization. Although little more was ever heard of the Society, Steichen had performed a valuable service in bringing together a group of American artists who were working in distinctly individual directions and making them aware of their common bonds.

John Marin:
Life and Work, to 1913

It was Steichen who introduced Stieglitz to John Marin (Figure 38). The event took place in Paris in 1909 and marked the beginning of a close and lasting friendship between the two men. About their association, Stieglitz recalled, "We have never had a word of difference, we have never questioned one another, and each has remained free, true to himself, true to the other." [5] Marin's brilliant talent and his personal integrity immediately evoked a favorable response in Stieglitz. He believed so strongly in the artist that he guaranteed him an income until his paintings began to sell and offered him one-man exhibitions almost every year. Marin, in turn, trusted Stieglitz completely and was delighted to let him attend to the financial and business aspects of his life.

John Marin was born on December 23, 1870, in Rutherford, New Jersey. [6] His mother died when he was only nine days old, and his father, an accountant, left the boy to be raised by his maternal grandparents and two maiden aunts in Weehawken. Stemming from middle-class English and French stock, perhaps with a touch of Spanish blood, Marin was brought up in an atmosphere of Yankee rectitude and propriety. An admirer of Cooper's *Leatherstocking Tales,* he was fond of outdoor activity — especially fishing — an interest that he pursued throughout his life. When he was seven or eight, he began to make pencil sketches out-of-doors at the peach farm which his grandfather had acquired near Milford, Delaware. He was given no lessons in art, but his grandparents had decorated their home with reproductions of fashionable academic paintings by Meissonier, Bouguereau, Rosa Bonheur, and Leutze. As a boy, Marin was taken to the Metropolitan Museum, and about his trips, he recalled, "I looked at the meticulous paintings there by artists such as Gérôme — paintings very much like the others I had seen before. I thought, of course, they must be wonderful." [7]

When he was ten, he was sent to public school in Union Hill, New Jersey. He continued his education, without showing any particular ambition, until the age of sixteen at Hoboken Academy, Stevens Preparatory, and Stevens Institute of Technology, Hoboken. After earning indifferent grades during four months of study at the Institute, he was advised to withdraw in December 1886. [8] Thereafter, his family expected him to earn a living in a manner acceptable to their middle-class standards. To satisfy them, he took a job as a clerk in a wholesale notion house in New York, and then, after leaving that position, he worked for almost four years as a draftsman and

38. Alfred Stieglitz. *John Marin.* c. 1914. Photograph. Helios, Inc., New York.

apprentice in various architects' offices. In 1893 he set up his own architectural office in Union Hill, but his practice was apparently limited to the design of a few houses in that community. Marin seems to have had little enthusiasm for the routine of a respectable job; his real interest throughout this period was painting.

In the summer of 1888 he produced his first paintings, watercolors in the Impressionist idiom, at White Lake, Sullivan County, New York. Although he had received no formal training in art, he learned something of watercolor technique from reproductions of works by English masters; he could not recall which ones he had studied, perhaps Turner, David Cox, and Peter de Wint. Even while Marin was employed in architects' offices in the early nineties he found time to paint on Sundays, working from nature with a subdued palette reminiscent of the Barbizon school and the American tonalists. After he abandoned his architectural practice, Marin drifted about the country for several years, sketching and painting landscapes in watercolor.

When Marin was twenty-eight, his aunts finally acknowledged his lack of worldly ambition and allowed him to study art at the Pennsylvania Academy of the Fine Arts in Philadelphia. There he enrolled in the classes of William Merritt Chase, the Munich-trained academician and master of virtuoso brush-

work, and Thomas P. Anshutz, a former associate of Thomas Eakins and one of the most open-minded and stimulating teachers of his generation. It is hard to determine what Marin gained from their classes; he claims that he worked from a professional model only once in his two years at the Academy (he did draw from student models, posed informally) and that he spent much of his time sketching on the Philadelphia wharves. It is likely that his natural penchant for freedom of thought was reinforced by Anshutz's teachings, which emphasized the cultivation of the student's individual instincts and abilities. It is not surprising that he associated with the more liberal and progressive of the two student camps — those who followed Whistler rather than Sargent. Among Marin's friends was Arthur B. Carles, one of the most talented students at the school, who later joined the ranks of the modernists in Paris.

After leaving the Academy in 1901, Marin spent a year without any occupation besides his own painting. Then, to please his aunts, he entered Frank Vincent DuMond's classes in composition and life painting at the Art Students League, New York, in 1902–1903. "I must say," he wrote later, "I derived very little from that period." [9] Following this experience, there were two more "blank" years during which he continued to paint and draw.[10] Of course, these were not blank from the artistic standpoint; it was during this time that Marin learned the fundamentals of painting and drawing from nature, as well as the rudiments of the craft of etching.[11]

In 1905, when Marin was thirty-five years old, his aunts reluctantly agreed to allow him to go to Paris to study art. His half brother, Charles Bittinger, also an artist, had persuaded the family to send him abroad. Although this idea was against the senior Marin's better judgment — he expected his son to work for a living — he provided the funds for the trip.

On September 27, 1905, John Marin arrived in Paris.[12] His half brother, who had been living there, introduced him to the company of artists that frequented the Café du Dôme, and, learning of his interest in etching, gave him his press and tools. Marin attended the Académie Julian for two months and then gave it up, preferring to find subjects for the medium that interested him most — etching — in the actual world around him.

Marin began to produce etchings during his first year in the city. At the beginning his style must have been determined, in large part, by his desire to earn money by selling his prints — an effort probably to please his father, to prove that he could be practical and earn a living. From 1905 to 1910 he produced a series of plates — 103 in all — depicting historic landmarks and

cityscapes, picturesque views designed for the flourishing American market for etchings of European subjects. *Notre Dame* (1908, Figure 39) is typical of his best work in this genre.

39. John Marin. *Notre Dame*. 1908. Etching. Philadelphia Museum of Art: The J. Wolfe Golden and Celeste Golden Collection of Marin Etchings.

At the beginning of his stay in Paris, Marin had associated with conservative painters, Bittinger and his billiards partner, George Oberteuffer. But by 1908, he had joined the ranks of the more advanced Americans, thanks to the efforts of his friend Carles, who was in Paris on a traveling fellowship. Carles had become well acquainted with Steichen, to whose attention he brought Marin and his work. Marin, in turn, joined the New Society of American Artists, and through it he came in contact with other American modernists — Maurer, Weber, and Patrick Henry Bruce — all of whom were interested in Matisse and had visited Gertrude and Leo Stein's apartment. Marin, however, later claimed that he did not pay homage to the Steins. "I was never one to push myself forward," he said.[13]

There has been much controversy about whether Marin studied examples of modern art in Paris. He liked to play down the notion that he had consciously borrowed ideas or styles from other artists, claiming: "I didn't look at paintings much in Paris. I guess I took a couple of trips to the Louvre. But mainly I played billiards, walked about, took trips to the country. I didn't know anything about the Impressionists at the time — although I must have seen some of their work in windows when I'd go walking, without knowing it."[14] Stieglitz, striving to promote the image of the American artist as a spontaneous, creative spirit, drawing his imagery from nature and within himself, later supported Marin's denial of outside influences. Yet there is much evidence to suggest that Marin was well acquainted with French Impressionism, Post-Impressionism, and Fauvism.[15] It is also hard to believe that Marin would have been immune to the avant-garde paintings and ideas of his fellow Americans influenced by Matisse (and also Cézanne), who came together in the New Society of American Artists. Besides this circumstantial evidence, Marin's Parisian paintings clearly reveal influences from the advanced styles that were easily available to him.

Between 1905 and 1910, Marin regarded himself primarily as an etcher. But during this period he also produced several oils and a large group of watercolors, works that he must have created for his own pleasure, not for sale. By 1909 his production of watercolors increased significantly, and he began to think of himself as a painter rather than as a commercial etcher; he was now willing to depart from fashionable graphic conventions, a shift that he knew would damage his sales.

Marin's earliest French paintings date from 1907. In subject matter and composition they recall his etchings of the same year, for they also represent picturesque medieval ecclesiastical and domestic architecture. *Mills and Bridge, Meaux* (1907, Figure 40), typical of this period, is conceived as a

40. John Marin. *Mills and Bridge, Meaux.* 1907. Watercolor. Estate of John Marin, courtesy of Marlborough Gallery, Inc., New York.

subtle essay in subdued tones, dominated by pale, silvery grays and blues, echoing Whistler's palette of the 1880s. At first the artist carried over into his watercolors some of the dry, tight manner of his etchings, but he rapidly responded to the innate fluidity of the medium, and in the following year he was creating delicate veils of color — blues, tans, and grays — applied to the paper in loose, diaphanous washes, accented here and there by forceful touches of pigment, in the Whistlerian manner.

From 1908 through 1910, Marin almost always used watercolor in a suggestive rather than descriptive manner, working with broad patches, blocks, and washes of tone. It is as if he needed an antidote to the precise line and literal detail required for his etchings. The accuracy of his draftsmanship actually seems to have deteriorated in these paintings, for many of them are rather weak in drawing, some almost amateurish in execution. This curious lapse may be explained by his new interest in color, which gradually became

more vivid in his watercolors; his loose, informal technique allowed him to explore the sensuous qualities of the medium without inhibition.

It is not easy to categorize the style of Marin's watercolors of 1908–1910 because he explored many different techniques and avenues of expression. We find remnants of his earlier techniques as an architectural painter: extremely fluid, suggestive efforts, Whistlerian in spirit yet transcending the art of that master in their forceful expression of nature's moods, and works emphasizing decorative patterns extracted from nature, recalling the manner of the Nabi painters Bonnard and Vuillard in design and coloration. But his main direction in this period was toward a personal, vitalized form of later Impressionism, an idiom that he developed to record his personal empathy with phenomena of nature. In Paris, he became increasingly responsive to his moods and to states of weather; the suggestive atmosphere induced by the time of day, usually evening; and, perhaps most significant for his later work, the potential for movement in the landscape. Clearly, by 1909 — if not a year or two earlier — he had discovered Impressionist painting, as witnessed by his depiction of informal segments of daily life and his use of small separate strokes of bright color, particularly in representing water, in works such as *Fishing* (1909, Addison Gallery of American Art, Andover, Massachusetts) [16] and *The Seine, Paris* (1909, Marlborough Gallery, Inc., New York).[17] But Marin was never to imitate the detached, optical objectivity and spectral palette of Impressionist painting of the 1870s and early eighties. He was drawn to the more "romantic" kind of Impressionism, as embodied in Monet's work of the 1890s, when that artist was closely involved with nature's moods. Yet there is in Marin's work of this period a vitality of execution and freedom of color that goes beyond the limits of Impressionism.

River Effect, Paris (1909, Figure 41), one of Marin's most successful early watercolors, effectively summarizes his relationship to sources in French painting. It is a quiet moment in the evening just after the sun has set, leaving the sky streaked with pink and orange, tones also reflected across the blue-green surface of the water. The soft, fluid washes in the sky suggest subdued light and atmosphere, but the water below sparkles with bold separate strokes of pigment. These touches record a multitude of hues, some quite appropriate to a sunset scene and others, like the strong pinkish violet below the boat, exaggerated in intensity. In many ways, the painting belongs to the Impressionist tradition, but the vigor of the brushstroke in the foreground and the intensity of colors clearly transcend the Impressionist idiom. If we believe that Marin was sensitive to the art that he saw around him in Paris, we may

41. John Marin. *River Effect, Paris.* 1909. Watercolor. Philadelphia Museum of Art: A. E. Gallatin Collection.

look to the Neo-Impressionist watercolors of Paul Signac and also to Fauvist riverscapes as possible sources of inspiration.[18]

These influences are more obvious in *Movement, Seine, Paris* of the same year (Figure 42). Marin began with a river view, not unlike his *River Effect, Paris,* using delicate hues of yellow, purple, and blue to suggest the quiet luminous tones of the twilight hour. But over this framework he imposed broad flecks and dots of vivid color that bring the painting to life. Explaining these spots of color, Marin said, "I had to put them there. They were not there, but to express my feeling they had to be there." [19] The strokes dance across the surface of the paper, creating a kind of visual excitement surpassing that of any Impressionist canvas. The application of color suggests the small points and dabs typical of the Neo-Impressionist technique, while the bold,

42. John Marin. *Movement, Seine, Paris.* 1909. Watercolor. The Metropolitan Museum of Art: The Alfred Stieglitz Collection, 1949.

energetic drawing of the bridge recalls the vigorous execution of the Fauve painters in the years 1905–1908. The title of the work, as well as its execution, also testifies to Marin's growing interest in the dynamics of nature.

Through Eduard Steichen, Marin's Parisian paintings came to the attention of Stieglitz, who, without ever having met Marin, displayed twenty-four of his watercolors, together with fifteen oil sketches by Maurer, at the gallery in March and April 1909. When Stieglitz visited Paris in June of that year, Steichen took him to Marin's studio, where he met the artist for the first time. Impressed by the etchings he had done for his own pleasure, not to sell, Stieglitz challenged the artist to obey his creative instincts rather than produce salable prints. Whether Marin heeded Stieglitz's advice or simply followed his

own inclinations we do not know, but by 1909 he was well on his way toward a fresh, experimental style of painting and drawing. As his friend Carles said: "His things are beautiful — very personal — distinguished and technical marvels." [20]

Captivated by Marin's work, Stieglitz offered him a one-man show. The artist returned to New York late in 1909 to make arrangements for the exhibition of watercolors, pastels, and etchings, which hung at 291 in February 1910. During his several months' stay in New York, he became a regular visitor at 291 and the Holland House luncheons. In the company of Stieglitz, Haviland, De Zayas, Weber, Caffin, and others, Marin listened to constructive criticism addressed to him in the hope that it would challenge him to develop along more abstract and personally expressive lines. [21]

During Marin's visit to New York, which lasted through the spring of 1910, he painted watercolors of downtown New York and the Brooklyn Bridge, at first using the techniques and methods he had developed in Paris. His visual attitude toward the tall buildings of New York tended to be conventional and gave few hints of the dynamic, fresh angles of approach he would later use. He almost always adopted a standard perspective system that allowed space to progress logically from the foreground down the long, narrow expanse of a street dividing two banks of buildings. His skyscrapers, while loosely drawn, remained stable on their vertical and horizontal axes. Only in the Brooklyn Bridge series of 1910 did he bring forceful diagonals into play to accentuate the dramatic impressiveness of the scene. In these paintings, the influence of Signac's watercolors is once again apparent.

Marin's experience in New York did not produce any great innovations in his style. However, when he returned to Europe in 1910 to spend the summer painting in the Austrian Tyrol, he achieved a breakthrough that affected his subsequent development as a watercolor painter. Stirred by the towering mountains and floating mists, Marin produced paintings like *Tyrol Series, No. 12* (1910, Figure 43) that have a robustness and vitality unprecedented in his previous work. As Caffin observed: "It was not views he was studying, but sensations. He sought to render his impressions of the vastness and the power which are embodied in these great elemental facts of nature." [22] He was capable now of treating the landscape with great breadth, filling the entire surface of the paper and giving full attention to every element of the composition. This new breadth was due, in large part, to his use of very loose, flowing washes, with which he covered most, if not all, of the sheet. At this time he simplified his drawing, as well; in some of the watercolors, trees are treated

43. John Marin. *Tyrol Series, No. 12.* 1910. Watercolor. Courtesy Marlborough Gallery, Inc., New York.

as basic pictographs of straight and diagonal lines, predicting his later graphic conventions. He now began to use color confidently, too, working with a simple but forceful palette of orange, yellow-green, and blue-violet.

The explosive execution and lucid hues of these watercolors link him with the Expressionist tradition in European painting — including Fauvism — that is, before Cubism affected the course of that style. Marin, as we have suggested, probably had experienced Fauve painting, but it is unlikely that he would have known German Expressionism. Yet like the Germans he allowed the unbridled forces of nature to kindle a turbulent emotional response within himself, and he learned to commit his feelings to paper without restraint. About his feelings toward the Tyrolean landscape, he wrote the critic E. A. Taylor: "I looked down into the ravines, I looked up the bellying sides, beheld forests, rocks, rifts, shrub and moss, reached the heights and soared above into the clouds. There were times when great patches were cut off by curtains of rolling clouds. Not all in one day, a succession of days, a succession of moments. Take, choose, make what you please! how you felt and what was revealed." [23] Having once cast aside his inhibitions in response to the stirring landscapes of the Tyrol, he would now be able to react just as freely and vigorously to other less imposing subjects — the calmer terrain of the American countryside and seashore, as well as the soaring skyscrapers and bustling activity in the streets of New York.

Marin returned to the United States early in 1911, in time to see the first American exhibitions of Cézanne (March 1911) and Picasso (March and April 1911) at 291. He renewed his close ties with Stieglitz and his colleagues, and during the summer of 1911, while his mentor was in Europe, he used the gallery as his headquarters. After Marin married Marie Jane Hughes in December 1912, he did not spend as much time in the gallery as did Haviland, De Zayas, and Walkowitz, but he still remained a loyal member of the group. However, his skepticism about abstruse theories and art-critical jargon undoubtedly kept him away from the more philosophical discussions that took place at 291. True to his belief in Marin and his work, Stieglitz gave him shows in February 1911 and January and February 1913.

Thanks to Stieglitz's guarantee of an income that he could live on, Marin was free to devote all of his time to painting as he pleased. (The artist's father had suggested to Stieglitz that Marin support himself by producing salable work in the mornings and paint pictures to suit himself in the rest of his time; Stieglitz, in reply, said this would be artistic prostitution.) Marin was immediately attracted to the frantic activity of New York, and this became

one of his chief sources of inspiration; but during the summer months he was glad to escape from the metropolis to immerse himself in nature.

From the time of his return to the United States in 1911, Marin addressed himself entirely to American subjects, and in the second decade of the century he became one of the country's leading modernists. He worked almost exclusively in watercolor, producing paintings of exceptional originality. No other vehicle would have facilitated the spontaneous recording of the artist's impulsive response to nature, and, as we shall see, Marin capitalized on the loose informality and speed of execution that the medium invites.

By 1911 Marin had been influenced successively by Whistler, the Impressionists, the Nabis, Signac, and, in all probability, the Fauves. There is no evidence, however, to indicate that he had been affected by the emergence of Cubism in Paris, although he may have known Cézanne's work there.[24] Marin, as indicated earlier, did not like to say that he had been "influenced" by other artists, particularly European modernists, yet he admitted he could have seen their works in Paris. His verbal position on this matter is confirmed by his paintings: he did not make a conscious effort to imitate or to quote from avant-garde European painting, as Weber often did. Marin seems to have had a powerful drive for self-reliance, one of his great strengths as an artist.

One of the finest city scenes done in the year of his return is *From the Window of 291 Looking Down Fifth Avenue* (1911, Figure 44). His technique echoes his Parisian-Tyrolean manner, and, while the work may have been painted after he saw the 1911 Cézanne exhibition at 291, it does not register marked influence from that master. Marin is still working in a broad, lyrical vein, suggesting the mood and atmosphere of lower Fifth Avenue through fluid, interpenetrating washes and subtle, impressionistic patches of color. Like Matisse in his views of Paris of 1902, for example, *Notre Dame in the Late Afternoon* (1902, Albright-Knox Art Gallery, Buffalo),[25] Marin has adjusted, enriched, and intensified nature's hues to evoke the ambience of a particular section of the city. As J. Nilsen Laurvik observed about this watercolor: "This blur of beautiful color that gradually resolves itself into the semblance of a street with buildings, when viewed at the proper distance, would never vie in architectural accuracy with the souvenirs of New York made by the globe-trotting snapshot-artists who aim to please and hit the bull's-eye of popular approval almost at every shot."[26] Although Marin has built upon an armature of correct perspective, he has eradicated the hard outlines of reality so that the viewer is stirred primarily by the suggestive color.

100 A significant change took place in Marin's summer work after he saw the

44. John Marin. *From the Window of 291 Looking down Fifth Avenue.* 1911. Watercolor. The Metropolitan Museum of Art: The Alfred Stieglitz Collection, 1949.

45. John Marin. *Landscape (Rolling Land — Delaware River Country)*. 1911. Water-color and pencil. Philadelphia Museum of Art: The Samuel S. White, 3rd, and Vera White Collection.

exhibition of Cézanne watercolors. It is hard to pinpoint Cézanne's influence in his city scenes of 1911, but several landscapes he produced later in that year, such as *Landscape (Rolling Land — Delaware River Country)* (1911, Figure 45),[27] clearly reflect the French artist's later mode of handling water-color. Like Cézanne, Marin used soft, delicate washes, relying on yellows and oranges, pale greens, blues, and blue-grays, and he drew the trees and hills with a light, deft touch, leaving large areas of white paper exposed or barely covered. Although his painting shares the airy lightness and sparkle of Cézanne's late watercolors and he seems to have admired Cézanne's over-lapping, transparent washes of pale color and his creation of visual tensions, Marin characteristically applied the paint with exuberance, in contrast to Cézanne's thoughtful, deliberate execution. He did not adopt the abstract, geometric aspect of Cézanne's work, the part that had served as the corner-stone of French Cubism.

Strong Cubist (and, as we shall see, possibly also Futurist) influences first appear in Marin's city scenes of 1912. The impact of this style, undoubtedly stemming from the 291 Picasso show, is obvious in *Movement, Fifth Avenue* (1912, Figure 46), in which the essential forms of the building are delineated by broadly brushed rectilinear contours. Marin's painterly shorthand, devel-

46. John Marin. *Movement, Fifth Avenue.* 1912. Watercolor. Courtesy of The Art Institute of Chicago: Alfred Stieglitz Collection.

47. Robert Delaunay. *Eiffel Tower*. Oil on canvas. 1910–1911. Destroyed.

oping since 1910, has now come under the influence of the straight-line geometry of Cubism, although much of his free exuberance still remains in the foreground brushwork. His sketchy wash technique and his use of light, transparent color — clearly affected by Cézanne — is distinctively his own and has little to do with Cubism.

Other aspects of the painting, too, suggest that something beside Picasso's and Braque's Cubism affected Marin. The technique of fragmenting city buildings and tilting their axes in conflicting directions was developed a year or so earlier by the French painter Robert Delaunay, particularly in his Eiffel Tower series (see especially *Eiffel Tower* [1910–1911, Figure 47]).[28]

Like Marin, he had been attracted to the latest architectural products of the machine age, in this case the most technologically advanced steel structure in late nineteenth-century Paris. Delaunay had undergone influences from Cubism before his better-known Orphist phase, and he applied Cubist techniques to represent tall buildings in the most dynamic terms, as a play of forces pushing and pulling against each other. Marin is the only early twentieth-century artist, besides Delaunay, who fully exploited these conventions, and it is hard to believe that, with his close ties with 291, he could have invented them by himself.

Marin produced several other advanced city paintings in 1912 — *Thirty-fifth Street and Fifth Avenue at Noon* (Vassar College Art Gallery),[29] *Saint Paul's, Lower Manhattan* (Delaware Art Museum, Wilmington),[30] and a group of adventurous studies of the Woolworth Building,[31] whose tumbling skyscrapers and swaying towers again echo the dynamic pictorial architecture of Robert Delaunay. Marin wrote a brief but revealing statement about his recent New York paintings in his 291 exhibition in January and February 1913, in which he expresses himself in a Futurist vein rather than as a Cubist or a follower of Delaunay:

Shall we consider the life of a great city as confined simply to the people and animals on its streets and in its buildings? Are the buildings themselves dead? . . . If these buildings move me they too must have life. Thus the whole city is alive; buildings, people, all are alive; and the more they move me the more I feel them to be alive.

I see great forces at work; great movements; the large buildings and the small buildings; the warring of the great and the small; influences of one mass on another greater or smaller mass. Feelings are aroused which give me the desire to express the reaction of these "pull forces," those influences which play with one another; great masses pulling smaller masses, each subject in some degree to the other's power.

In life all things come under the magnetic influence of other things; the bigger assert themselves strongly, the smaller not so much, but still they assert themselves, and though hidden they strive to be seen and in so doing change their bent and direction.

While these powers are at work pushing, pulling, sideways, downwards, upwards, I can hear the sound of their strife and there is great music being played.

And so I try to express graphically what a great city is doing. Within the

frames there must be a balance, a controlling of these warring, pushing, pulling forces.[32]

The similarity between this statement and the manifestos of the Italian Futurists is, as Sheldon Reich has shown, striking.[33] The poet Filippo Marinetti had proclaimed in the first manifesto of Futurism, published on February 20, 1909, that, in literature, the Futurists wish to "extol aggressive movement, feverish insomnia, the double quick steps, the somersault, the box on the ear, the fisticuff."[34] This early celebration of dynamic vitality was brought into focus for the visual arts in "Futurist Painting: Technical Manifesto," signed by five of the Futurist painters and published on April 11, 1910. But much more influential for Marin and for the English-speaking world at large was "The Exhibitors to the Public," a Futurist statement published first in French in February 1912 for a show at the Bernheim-Jeune Gallery, Paris, and later in English to accompany the exhibition when it moved to the Sackville Gallery, London, opening on March 1. The following passages must have affected Marin's thinking:

We have declared in our manifesto that what must be rendered is the *dynamic sensation*, that is to say, the particular rhythm of each object, its inclination, its movement, or, to put it more exactly, its interior force. . . .

Furthermore, every object influences its neighbor, not by reflections of light (the foundation of *impressionistic primitivism*), but by a real competition of lines and by real conflicts of planes, following the emotional law which governs the picture (the foundation of *futurist primitivism*). . . .

It is these *force-lines* that we must draw in order to lead back the work of art to true painting. We interpret nature by rendering these objects upon the canvas as the beginnings or the prolongations of the rhythms impressed upon our sensibility by these very objects. . . .

As you see, there is with us not merely variety, but chaos and clashing of rhythms, totally opposed to one another, which we nevertheless assemble into a new harmony.[35]

There can be little doubt that Marin was aware of these Futurist ideas, which he could have learned from the catalogue just quoted, from the French, English, or American journals that covered the show, or from listening to conversations on the subject at 291. However, whether Futurist *paintings* actually influenced his watercolors is an open question. Reich has observed that there are "stylistic analogies" between some of Marin's New York

48. Umberto Boccioni. *Street Noises Invade the House*. 1911. Oil on canvas. Städtische Galerie, Hannover.

paintings of 1912 and contemporary Futurist work without arguing that the Futurists affected his style directly.[36] Although there are a few Futurist paintings, like Boccioni's *Street Noises Invade the House* (1911, Figure 48),[37] that might have served as prototypes for Marin's toppling skyscrapers and bustling street activity, the great majority of Futurist city scenes were conceived in a different style and spirit. While Marin shared the Futurists' interest in the dynamic movement of the metropolis, he did not borrow the abstract language of Cubism to the degree that they did.

Marin absorbed ideas from creative sources around him, digested them, made them his own — and in the process gave them a special American flavor. The tone of his writing recalls Walt Whitman's portrait of New York in his poem "Mannahatta," from *Leaves of Grass*, which Marin undoubtedly knew.[38] We can sense in Whitman a spirit of optimism and enthusiasm, like Marin's, in celebrating the exciting spectacle of New York. Moreover, Marin's paintings have a jubilant expansiveness comparable to Whitman's poetry; and in the work of both artists the form is asymmetrical and ragged,

for the urgency of their message transcended the need for sophistication and technical polish.

Arthur Dove:
Life and Work, to 1913

Arthur Dove (Figure 49) was born in Canandaigua, New York, on August 2, 1880. He was raised in Geneva, where his parents, middle-class Calvinist Presbyterians, led conventional lives as respected members of the town's business community. Although they arranged for him to have a few lessons in flower painting, Dove's father, a prosperous brick manufacturer and contractor, did not foster his early interest in art. He had hoped that Arthur would eventually take over his business or become a lawyer, following the family's pattern of industry and respectability. Later, in fact, the elder Dove strongly opposed his son's plans to become a painter.

From the age of five, however, Arthur Dove's artistic pursuits were encouraged by Newton Weatherly, a versatile truck farmer who was also an amateur painter, composer, and student of philosophy and natural history. Weatherly showed great interest in the young Dove's development, talked with the boy at length about art and philosophy, and taught him to paint in oil. Looking back, Dove felt that Weatherly's counsel had been decisive in shaping his career as an artist, providing, among other things, "the wisdom to turn toward nature and live with her." [39]

After completing private school and high school in Geneva, Dove attended Hobart College for two years (1899–1901) and then transferred to Cornell University, where, following his father's wishes, he began to prepare himself for a career in the law. In his junior year, he studied law, politics, and economics, but in the second semester, he enrolled in "Industrial Art" and "Clay Modeling." During his senior year he took additional law courses, but more than half of his curriculum was devoted to the practice and history of art. [40] Under his art teacher, Charles Wellington Furlong, a magazine illustrator and writer, he produced watercolors and a few oils and drew from the university's extensive collection of plaster casts of antique statuary. Furlong may have encouraged Dove to become an illustrator, but there is little specific evidence of his teacher's influence on the young artist.

Having earned a bachelor's degree from Cornell in 1902, Dove moved to

49. Alfred Stieglitz. *Arthur Dove.* Photograph. Collection of William C. Dove.

New York and entered the field of magazine illustrating. His natural talent as a draftsman rapidly brought him acclaim as a free-lance artist, and he contributed illustrations and comic pictures to *Harper's, Scribner's, Collier's, Life, Saturday Evening Post,* and other popular magazines of the period. Arthur Hoeber of the New York *Globe* called him "one of the leading illustrators, with a charming notion of the humorous, a rational view of humanity, and an altogether delightful draughtsman who . . . depicted the follies of present day men and women." [41] Although Dove made his living as an illustrator, he did a few paintings in his leisure moments and spent much of his free time in the company of painters. He knew William Glackens and John Sloan; the latter frequently invited Dove to his home. There the young illustrator met Sloan's friends, who were developing a vital art, free from academic conventions, based on the everyday world. At Sloan's, Dove met Robert Henri, the guiding force of "The Eight," and it is possible that Henri, Sloan, and their associates encouraged Dove's artistic independence and urged him to favor painting over illustration.

Dove earned a substantial income as an illustrator, which pleased his father, but the artist found that he had little time to pursue his own painting. This, together with his growing dissatisfaction with commercial art, prompted him to try his hand at painting full time abroad for at least a year. So in the middle

50. Arthur Dove. *The Lobster*. 1908. Oil on canvas. Collection of Mr. and Mrs. Hubbard Cobb, East Haddam, Conn.

of 1908 he and his wife, the former Florence Dorsey, whom he had married in 1904, sailed for France.[42]

In Paris, the couple associated with the sculptor Jo Davidson and with Alfred Maurer and Arthur Carles, Americans who had begun to experiment with the Fauvist style of painting. Maurer, who had known Dove in New York, had attended Gertrude Stein's salons and must have told his friend of his excitement about the Matisse paintings he had seen there. There is no record of Dove visiting the Stein apartment, but he undoubtedly viewed works by Matisse and the other Fauves at the Salon d'Automne, in which Dove exhibited in 1908 and 1909.[43]

Paris did not hold Dove for long. He soon discovered that he preferred to paint landscapes in the open country around Cagnes, in the south of France, where the aged Renoir was living. It was here that Dove created in the Impressionist vein a group of landscapes the high coloration of which also hints at influences from the Fauve palette. *The Lobster* (1908, Figure 50), a canvas he exhibited at the Salon d'Automne in 1909, reflects the impact of the intense colors and decorative patterning of the Fauve painters, particularly Matisse, though Cézanne's influence can also be felt in the ordered structure of the composition.

In France, Dove had learned to admire Impressionism, Cézanne, and the Fauves, but the style he practiced at this time can hardly be considered radi-

cal. He departed for America in midsummer, 1909, to live and work in his native country for the rest of his life.

Shortly after his return, Dove called on Stieglitz — probably at Maurer's suggestion — and showed him his work. Stieglitz was sympathetic and invited Dove to exhibit *The Lobster* and several other pictures in the Younger American Painters show. This was no small honor, since it placed Dove in the company of several other promising American artists of the 291 circle — Marin, Hartley, Weber, Maurer, and Carles.

Dove had now decided to make painting his real career, and from this time on Stieglitz became a faithful champion of the artist and his work. Dove, however, had little time to socialize with the habitués of 291. With the birth of his son William in 1910, he moved to Westport, Connecticut, where he supported his family as a chicken farmer and lobsterman. Because Dove's father had stubbornly refused to underwrite his efforts in painting, the artist had to labor every day from four in the morning until midnight to clear the meager sum of $100 a month. Little time was left for art.

Dove worked primarily in oil and pastel, taking his themes chiefly from his rural surroundings, which he regarded as his "first research laboratory." [44] In the years 1910–1912, he produced an amazing array of abstract works, some of which are so advanced for their time that it is difficult to account for their existence. These pictures are remarkably close in form and spirit to European Fauvism, Cubism, and abstraction, a situation all the more unusual because Dove was working thousands of miles from the main centers of artistic innovation. True, he undoubtedly had seen the art of Matisse and Picasso at 291, and he had probably read in *Camera Work* about modern art abroad. These European influences seem to have catalyzed his inventive genius, and from 1910 to 1912 he was able to create a group of works of breathtaking originality. The oils and pastels of this period are not only appealing in their own right; they are landmarks in the history of American art.

Of extraordinary interest is the group of six small oils known as *Abstractions No. 1 to 6* (Figure 51). In previous writings on Dove, they have been dated 1910, but there is no substantial evidence to corroborate this.[45] These abstractions are significant, to be sure, but it is doubtful that they were produced in 1910, the year before Dove saw the 291 Picasso show. A more likely date is 1911, immediately preceding the artist's Ten Commandments series of 1911–1912.

Some critics have suggested that Dove created *Abstractions No. 1 to 6* without a knowledge of European modernism and that, working in isolation,

5

4

1

2

3

6

51. Arthur Dove. *Abstractions No. 1 to 6.* 1911? Oil on board. Nos. 1, 2, 4, 5, Collection of George J. Perutz, Dallas, Tex.; No. 3, Private Collection; No. 6, Private Collection, Boston, Mass.

he paralleled the steps being taken toward abstract art by Matisse, the Cubists, and Kandinsky in the years 1910 and 1911. It is hard to believe, however, that Dove's abstractions were executed without some information — albeit imperfect — about avant-garde tendencies abroad. The milieu at 291 offered him considerable knowledge about European innovations, and the stylistic language of the six panels is too sophisticated to have been created in a cultural vacuum. What, then, were the influences that may have helped to shape these exceptional works?

The six paintings, all based on landscape motifs, present nature in its energetic, vital aspects. In each case, the picture surface is activated by dynamic curved lines and shapes; there is no place for tranquility or repose, and the excited vitality of several of these panels closely parallels the Fauvist treatment of nature. Like Matisse, Dove has used shape and color to create visual relationships and harmonies, without any great commitment to objective reality.

The style of *No. 1* and *No. 4* echoes the shift in advanced French painting around 1907 — particularly in Braque's work — from intense Fauvist coloration and expressionist drawing to the more regulated structure of Cubism. This is not to imply that Dove necessarily knew Braque's paintings, but it is safe to say that he was following a similar course under Picasso's influence, moving toward a more abstract, geometric treatment of form. In the same way, he abandoned Fauvist hues in several works of the series and adopted instead the subdued palette of Analytical Cubism, with its emphasis on tans, grays, and blacks. There is every possibility that Dove gained a knowledge of Picasso's work from his exhibition at 291 in March and April 1911.

The parallels between Dove's and Kandinsky's paintings of this time also invite comment. Both artists were progressing toward an art of abstraction in 1910–1911, and both were intensifying the harmony and relationship of color, abandoning almost all references to the physical world. In Dove's most extreme abstraction of the series, *No. 2*, the artist, like Kandinsky in *Autumn I* (1911, Figure 52), departed almost entirely from nature's forms. It is unlikely, however, that Dove saw any examples by Kandinsky that could have served as visual sources for this or the other five abstractions; his ideas were introduced to the Stieglitz group only in the summer of 1912. Undoubtedly, the two artists were both working independently toward abstraction, under the impulse of Fauvism.

From this group of paintings, Dove went on to execute an equally remarkable series of works in pastel, known as "The Ten Commandments," dating in all likelihood from 1911–1912.[46] These present a wider range of

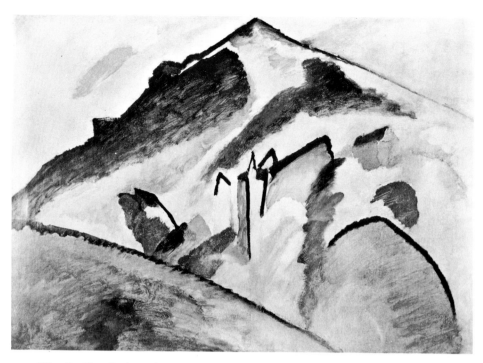

52. Wassily Kandinsky. *Autumn I*. 1911. Oil on canvas. Collection of Mrs. Lora F. Marx, Chicago, Ill.

subjects than do *Abstractions No. 1 to 6*. Landscape constitutes a major aspect of the series, but Dove also addressed himself to animals, urban architecture, and boats. When he executed these pastels, he had clearly come under the influence of advanced European art and theory, as presented to him at 291. Max Weber, a member of the circle, seems also to have been a particularly fruitful source of modernist ideas. Weber recalled that he had influenced Dove during his visit to the artist in Connecticut in 1911: "I walked with him in the country, and we both complained it was still too cold, but I had my little pad in my hand and I drew a church steeple, for instance, or the curve of a hillside. I said, 'It isn't what you see there; you must always symbolize things.' He became the great, what we call abstractionist." [47] Several of Weber's highly abstract works based on natural forms, such as *Forest Scene* (1911, Figure 65) and *Trees in the Park* (1911, Forum Gallery, Inc.),[48] may also have stimulated Dove's achievement in The Ten Commandments. Whatever the degree of Weber's influence may have been, Dove's distance from the centers of avant-garde activity abroad forced him to draw heavily upon his innate capacity for pictorial invention, with exceptional results.

The most obviously Cubist work of the group is *Nature Symbolized No. 1 (Roofs)* (Figure 53), a little-known pastel in which Dove depicted a series of rooftops by means of highly geometric curves, straight lines, and angles. As in Braque's early Analytical Cubist paintings of 1909, such as *La Roche-Guyon: The Chateau* (Private Collection, Roubaix),[49] the space is compressed toward the foreground, and limited modeling defines variations of depth within each plane rather than creating the illusion of three-dimensional mass. Like Braque, Dove used certain forms to refer to physical reality – in this case, architectural elements and rooftops – while other elements cannot be

positively identified but simply serve as building blocks in a rhythmic pictorial construction.

More abstract, yet still indebted to Cubism, is Dove's *Team of Horses* (*Horses in Snow*) (Figure 54). The theme has been abstracted into large, elementary curvilinear shapes whose decorative flatness recalls Gauguin's Synthetist style. But the forms are treated in a simplified Cubist manner, with geometric repetitions in the sawtooth patterns of the horses' stylized manes progressively diminishing in size. Although Dove's style clearly owes a debt to Analytical Cubism, this type of subject was not favored by Braque and Picasso; rather, it recalls the Italian Futurists' fascination with dynamic energy and power. Indeed, one of the most important early Futurist paintings, Boccioni's *The City Rises* (1910–1911, Museum of Modern Art),[50] represented a similar theme of horses tugging and straining to pull a heavy load. We are

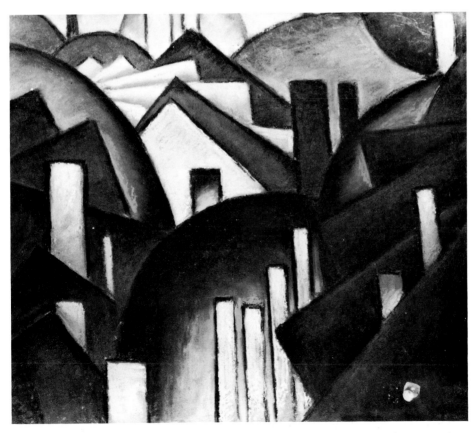

53. Arthur Dove. *Nature Symbolized No. 1 (Roofs).* 1911–1912. Pastel. Present location unknown.

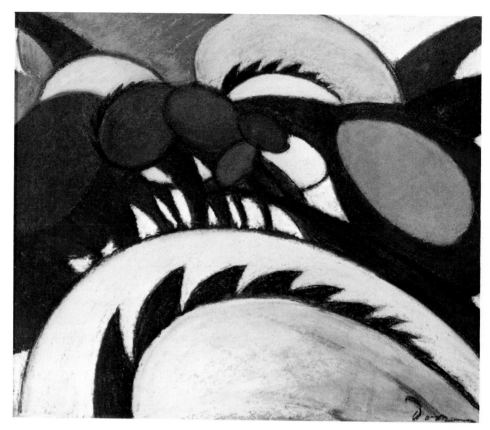

54. Arthur Dove. *Team of Horses (Horses in Snow)*. 1911–1912. Pastel. Private Collection.

not sure whether or not Dove knew Futurist works of art at this time but, as we shall see, critics associated these pastels with Futurism when they were shown in Chicago in 1912.

Vegetal rather than animal themes attracted Dove in *Based on Leaf Forms and Spaces* (Figure 55). Here he departed from the rigid geometric aspect of *Nature Symbolized No. 1*, presenting, instead, voluptuous organic plant shapes, which cannot be identified specifically but which share the basic visual rhythms of leaves and plants in general. The pictorial elements are compressed within a very shallow space, one overlapping the other without significantly suggesting depth. Dove's treatment of form in space and his method of modulating and hatching the individual elements recalls the language of Analytical Cubism, but unlike the Cubists, he worked with relatively few elementary forms which are complete in themselves and do not fuse with each other or with the surrounding space. Also far from Analytical Cubism is Dove's fondness for organic curvilinear units, treated in the spirit of Kandinsky, which twist and turn as if possessed by an inner vital force. Arthur Jerome Eddy, the collector who bought *Based on Leaf Forms and Spaces*, asked Dove for an explanation, and the artist replied: "It is a choice of three colors, red, yellow, and green, and three forms selected from the trees and the spaces between them that to me were expressive of the move-

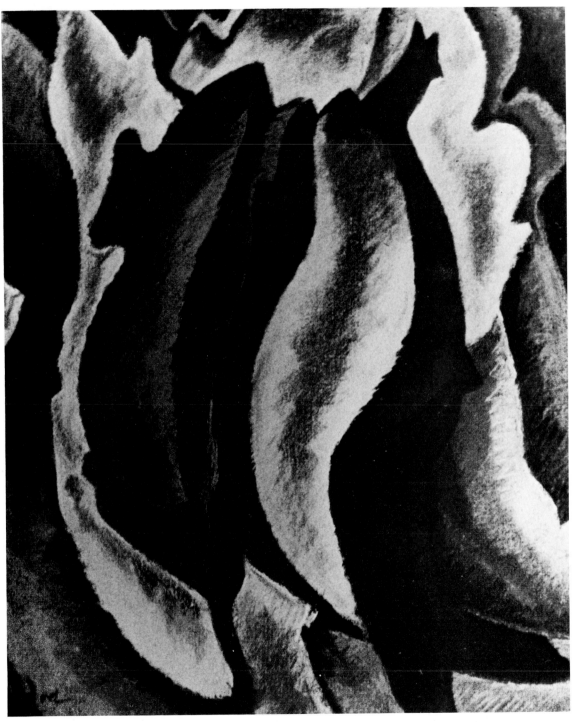

55. Arthur Dove. *Based on Leaf Forms and Spaces*. 1911–1912. Pastel. Present loca-
tion unknown.

ment of the thing which I felt." [51] Dove was reluctant to say more because he expected the viewer to respond to the visual properties of the pastel.

Nature Symbolized No. 2 (*Wind on Hillside*) (Figure 56) illustrates Dove's skill in creating pictorial equivalents for the experience of a specific event, in this case, the sensation of turbulent wind. Working with subdued tones of greenish tan, brown, and light blue, he created abstract commalike forms, curvilinear rhythms, and stylized pointed shapes. The somber coloration, in turn, is undoubtedly meant to signify the cold and desolation that accompanies the gusts of wind. This process of abstraction derives in large part from Synthetist and Nabi theories of equivalence, here reaching a purely nonobjective level in the hands of an American artist of great inventiveness.

Fortunately, Dove provided a lucid explanation of how he created this pastel:

The wind was blowing. I chose three forms from the planes on the sides of the trees and three colors, and black and white. From these was made a rhythmic painting which expressed the spirit of the whole thing. The colors were chosen to express the substances of those objects and the sky. There was the earth color, the green of the trees, and the cyan blue of the sky. These colors were made into pastels carefully weighed out and graded with black and white into an instrument to be used in making that certain painting.[52]

This translation of a specific natural event into purely abstract terms has no antecedents in French Cubism or Orphism as practiced up to that time. However, there is a precedent for this technique in certain works by the Futurists, such as Boccioni's pencil study for *States of Mind: The Farewells* (1911, Figure 57), in which the artist converted his impression of moving crowds into virtually nonobjective curvilinear rhythms. Whether Dove knew this drawing or arrived at his solution independently may never be known.

By far the most abstract work of The Ten Commandments is the remarkable *Movement No. 1* (Figure 58), in which Dove did not try to represent anything except movement itself. There are suggestions of organic life in the curves and straight lines radiating from a focal point in the lower center of the picture, but the forms cannot be identified. Dove's subject is pictorial motion, evoked by spinning and undulating forms. There are parallels here to the art of the Orphists, who also used form and color detached from visible reality to represent movement, but it is unlikely that Dove had any knowledge of the Orphists' work at this time. Indeed, Orphism had only come into existence early in 1912, at about the same time that Dove's Ten Command-

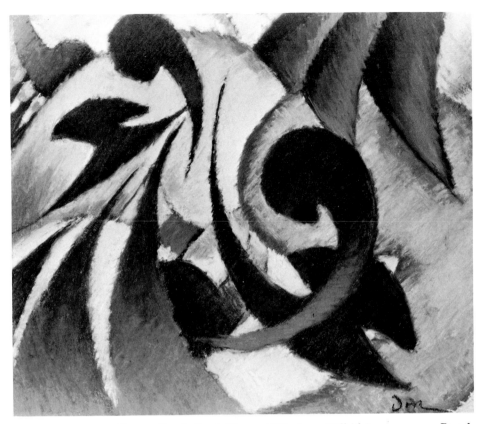

56. Arthur Dove. *Nature Symbolized No. 2* (*Wind on Hillside*). 1911–1912. Pastel. Courtesy of The Art Institute of Chicago: Alfred Stieglitz Collection.

57. Umberto Boccioni. *States of Mind: The Farewells.* 1911. Charcoal. Collection, The Museum of Modern Art, New York: Gift of Vico Baer.

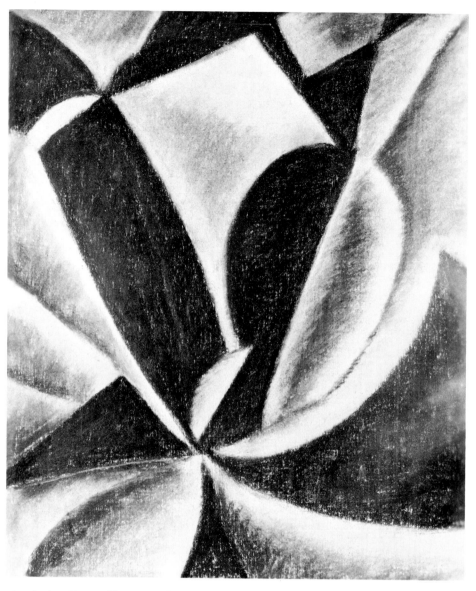

58. Arthur Dove. *Movement No. 1.* 1911–1912. Pastel. The Columbus Gallery of Fine
Arts, Columbus, O.: Ferdinand Howald Collection.

ments were exhibited at 291. Clearly he has used elements of the Cubist
vocabulary, such as limited shading and geometric forms, but *Movement No.
1* is unlike any Cubist painting by Picasso or Braque of the years 1910–1912.
Had Dove been closer to Cubism in Paris, he might have been a more deriva-
tive artist; but, because he was thrown back upon his own resources, with a
limited knowledge of the Cubist vocabulary, he was forced to produce in an
extremely inventive mode.

The Ten Commandments were hung in Dove's first one-man show, which
was held at 291 in February and March 1912. It attracted some attention in
the New York press, but the critics, on the whole, failed to understand the
works, considering them merely examples of decorative pattern-making.

Much more excitement was generated by a second show of The Ten Commandments at the W. Scott Thurber Galleries in Chicago, beginning on March 14, 1912.[53] Here the pastels challenged, mystified, and amused the critics. Dove appeared in person to explain them, but while he drew a great deal of attention to himself, he did not convince many people to admire his unorthodox way of painting. However, the Chicago collector Arthur Jerome Eddy, an early advocate of avant-garde American painting, bought *Based on Leaf Forms and Spaces* and two years later reproduced it in color in his pioneering study of modern art, *Cubists and Post-Impressionism* (1914).

Dove's Theories of Art, 1910-1912

We are fortunate in having Dove's own statements to help explain his *Abstractions No. 1 to 6* and The Ten Commandments. He wrote of the principles underlying his early work, with particular reference to *Based on Leaf Forms and Spaces* (Figure 55), in an important letter to Eddy, which that critic published in his book. Dove first elucidated the few basic principles underlying all good art: "One of these principles which seemed most evident was the choice of the simple motif. This same law held in nature, a few forms and a few colors sufficed for the creation of an object." Once having grasped this concept, Dove gave up his "disorderly methods" — a reference to his Impressionist style — and stopped expressing his ideas "by stating innumerable little facts." In his new method, he first selected a motif and painted it from nature, "the form still being objective." His next step was "to apply this same principle to form, the actual dependence upon the object (literal to representation) disappearing, and the means of expression becoming purely subjective." After working in this way for a time, Dove began to "think *subjectively*" and to "remember certain sensations *purely through their form and color,* that is by certain shapes, planes, light, or character lines determined by the meeting of such planes." [54] In many of his remarks, Dove's stance is close to that of Matisse in "Notes of a Painter" (1909),[55] a theoretical statement which, in turn, owes much to Symbolist art theory. These ties should come as no surprise, for Matisse's ideas were well known in the Stieglitz circle by 1912.

In Chicago, Dove was quoted as saying that he did not like to title his pictures "because they should tell their own story," [56] an idea deriving, again, from the Fauvist-Symbolist aesthetic. Harriet Monroe of the Chicago *Tribune*

reported that Dove said his work was "based on mathematical laws," and she went on to write: "His pictures are essays in the rhythm and harmony of colors and forms, taking their motifs only remotely from nature – all this after the manner of modern music." We do not know what Dove meant by mathematical laws, but the analogy between music and pictorial abstraction was commonly cited in advanced aesthetic theory of the period. Monroe quoted Dove as saying: "Modern minds . . . are reaching out toward an art of pure color and form dissociated from 'representation.' . . ."[57] In this statement – a remarkably advanced idea for any American artist in 1912 – Dove points directly to nonobjective art. Dove and his colleagues at 291 were also undoubtedly aware of the Italian Futurist movement. His Chicago show was titled (by whom we do not know) "Exposition of the Simultaneousness of the Ambient," a phrase from the Futurist manifesto "The Exhibitors to the Public" (February 1912) that had served as the headline for an article on Futurism in the *Literary Digest*, March 12, 1912, two days before the Dove show opened. In a review of the exhibition in Chicago, Harriet Monroe attempted to shed light on the artist's work, and on modern art in general, by quoting from *Futurist Painting: Technical Manifesto* (April 11, 1910), which had accompanied the Futurist exhibition presented at the Sackville Gallery, London, in March 1912.[58] Although there are obvious parallels between several pastels in Dove's Ten Commandments series and the dynamism of Italian Futurist painting, Monroe reported that "Dove and others of his particular group have little use for the 'futurists.' . . ."[59] It was undoubtedly their doctrinaire aspect which the 291 circle rejected.

In connection with his Ten Commandments series, Dove articulated certain highly personal and original ideas that appear to have no discernible ties to established art theory. Explaining himself to the Chicago critic H. Effa Webster, he refused to have his work called Post-Impressionistic, "another kind of luminism," or "another radical departure in 'expression.' " He stated that he viewed the evolution of principles in art in the same way that he saw them in nature, saying that his artistic vision was tempered by his "acceptance of absolute forms in connection with planes of light." "Light," according to Dove, "imparts rhythms of color as well as forms."[60] It is this "special quality" that he later referred to as a "condition of light," explaining himself in these words:

There was a long period of searching for a something in color which I then called "a condition of light." It applied to all objects in nature, flowers, trees, people, apples, cows. These all have their certain condition of light, which establishes them to the eye, to each other, and to the understanding.

To understand that clearly go to nature, or to the Museum of Natural History and see the butterflies. Each has its own orange, blue, black; white, yellow, brown, green, and black, all carefully chosen to fit the character of the life going on in that individual entity.

After painting objects with those color motives for some time, I began to feel the same idea existing in form. . . . This choice of form motives of course took the paintings away from representation in the ordinary sense.[61]

Like the other members of the Stieglitz circle, Dove struggled to find an original language of expression that was all his own, rather than to imitate what others had done. As a Chicago critic reported: "Mr. Dove does not preach of his art, but talks of it as an avenue for experiment." [62] This position was in exact accord with Stieglitz's principles.

·CHAPTER FIVE·

The Rise of the American Avant-Garde·Artists of the Stieglitz Circle before 1913, II (Weber, Walkowitz, Hartley)

Max Weber and 291

Max Weber (Figure 59) was part of 291 for only a brief period — 1909–1911 — but during this time he left an indelible mark on Stieglitz and his associates, bringing them a detailed knowledge of avant-garde European painting and aesthetics. Stieglitz, in turn, not only helped Weber to survive when the artist was extremely poor but, by showing his work at 291, tried to find an audience that might appreciate and purchase it. The liaison between Stieglitz and Weber, however, was destined to fail; each had a strong, aggressive personality, and neither man would submit to the domination of the other.

Weber was born on April 18, 1881, in Bialystok, Russia, a textile manufacturing center populated mainly by Jews. His grandfather, the artist told Lloyd Goodrich, "was a skillful dyer, much in demand, and used to travel from city to city to mix the dyes." [1] Weber's father, Morris, was a tailor. His parents were deeply religious, and the boy was brought up to respect the Jewish traditions cherished by his family. As a child, he showed a lively interest in drawing.

When Max was ten, his mother, Julia Weber, brought him and his brother to Brooklyn, where his father had settled four years earlier. At first, Weber attended Public School No. 7 there, and after only one year at Boys' High School he managed to pass the entrance examinations for Pratt Institute, Brooklyn. He enrolled in the normal course, a two-year program that qualified him to teach drawing and manual training.

Weber was fortunate in being able to study under Arthur Wesley Dow, who came from Columbia to Pratt to teach one day a week. Weber learned

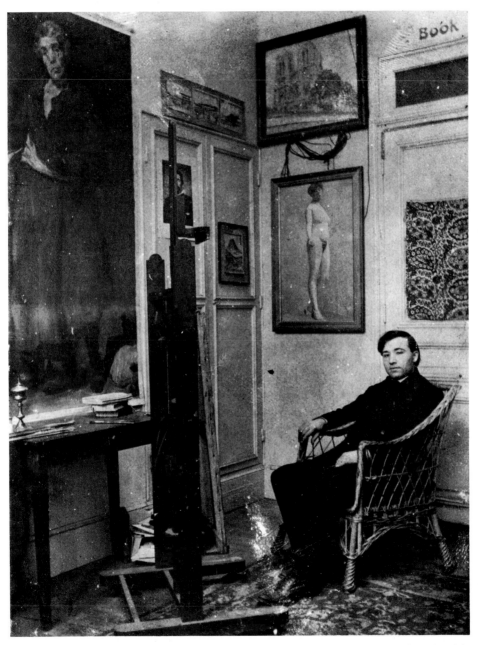

59. *Max Weber in his Studio, Paris.* c. 1907–1908. Photograph. Courtesy of Richard L. Feigen & Co.

much from Dow's lectures on the theory and practice of design and his analysis of Oriental art, and the young painter became one of his most devoted followers, claiming that Dow's principles had affected him throughout his life.[2] Weber graduated from Pratt in 1900 and in the following year spent three evenings a week in charge of the school's offices. This part-time job gave him time to study Dow's teachings in greater detail and to investigate the principles of painting by copying works by the masters — including Velázquez, Corot, and Inness — at the Metropolitan Museum of Art.

To earn his living Weber took a full-time position teaching drawing and manual training in the Lynchburg, Virginia, public schools and on vacation served on the faculty of the Summer School of Methods at the University of Virginia. During this period, 1901–1903, he painted whenever he had free time, firmly believing in the high value of his own talent. "I paint," he wrote to his friend Jake Heyman, "so that my future with God's help is assured, for I see in my work some of the highest qualities, and I compare it justly with masters' work and works of high standing." [3]

From the beginning of his career, Weber was an extremely determined and self-reliant individual who would let nothing deflect him from his chosen path. To Heyman he gave this advice, which undoubtedly reflected his own philosophy: "Communicate with God and the great masters; and do your practical work in the practical world for practical purposes; and then lock yourself up in your silent chamber of Art, and pour out your woes and pangs and sound them with beautiful melodies, harmonies and variations masterly, pure and ideal — such as God enabled you to do. . . . Silence and solitude are great factors in the lives of creators." [4] Weber's firm belief in his own ideals, his willingness to suffer poverty and misunderstanding for the sake of painting as he pleased, made him ideally suited for the Stieglitz circle, which he entered seven years later.

To develop his talent to the fullest, Weber realized that he could not paint in isolation in America, so he worked for the next two years as director of the Department of Art and Manual Training of the State Normal School in Duluth, Minnesota, to earn enough money to study abroad. On September 16, 1905, he embarked for France, where he was to remain — chiefly in Paris — for the next three years.

At first Weber gravitated to the private academies that were fashionable among American art students: the Académie Julian (1905–1906), the Académie Colarossi (1906–1907), and the Académie de la Grande Chaumière (1906–1907). At the first of these schools he met the American art student Abraham Walkowitz, a future member of the Stieglitz circle who was to

remain close to Weber until early 1911. Though Weber succeeded in drawing figures accurately to the delight of his instructors at the Académie Julian, he chafed at academic discipline and left the school after four or five months. Much more stimulating was the example of Paul Cézanne, whose works he saw at the Salon d'Automne of 1906 and again in 1907. Cézanne immediately became a hero to Weber and remained so for the rest of the American artist's life. Of his works, Weber said: "As soon as I saw them they gripped me at once and forever." [5] To Weber Cézanne was admirable not only for his pictorial construction, but also because he opened Weber's eyes to the "archaic approach," [6] which led to "a new austere beauty." [7] Weber quickly appropriated Cézanne's style for his own purposes in several 1907 still lifes and lithographs, changing the master's idiom very little in the process. In the still lifes, there are, in addition, hints of arbitrary Fauve color, stronger hues than Cézanne would have used, but the attempt at structural solidity in modeling and design comes directly from the Aix master.

Weber had discovered Cézanne at the apartment of Gertrude and Leo Stein, a center teeming with creative activity, "a clearing house of ideas," Weber observed, where "many cerebral explosions did take place" [8] and where he was certainly influenced, as well, by the work of Matisse and Picasso. Unfortunately, there is no record of Weber's activities in the Stein household, since Gertrude apparently did not remember him well enough to include him in her memoirs. [9] Weber, however, did become closely allied with the other branch of the Stein family in Paris, Sarah and Michael, who were friendly with Matisse and had amassed an outstanding collection of his work. Sarah had studied painting privately with the artist in the fall of 1907 and with the cooperation of several of her friends, including Weber, organized a small class in Matisse's studio, beginning in January 1908. Matisse gave instruction one day a week, without fee. It was here that Weber was indoctrinated with Matisse's ideas on drawing, expression, and color — particularly that of Persia and India — artistic concepts that helped to shape his style for the next few years. [10]

Matisse surprised his students by insisting that they study both the human figure and antique casts, and he discouraged them from exaggerated distortions of drawing and color. He spoke of color and color relationships, but much of his teaching, Weber recalled, was focused on the "logical construction of the figure. He [Matisse] would refer to the African Negro sculpture, the great archaic Greek of the fourth and fifth centuries B.C., and unfailingly of Cézanne's architectonic, masonic plasticity, his unique vision, and unexcelled meticulous execution." [11] Matisse, Sarah Stein noted, advised his stu-

60. Max Weber. *The Apollo in Matisse's Studio.* 1908. Oil on canvas. Forum Gallery, Inc., New York.

dents to seek inspiration from nature.[12] However, he also urged them to create a clear mental image of the essential pictorial arrangement of the work at hand, always seeking unity – particularly in color – in the process of painting.[13]

Weber had an exceptional gift of rapidly assimilating the styles of other artists, and by 1908 he had learned to paint like Matisse. Weber's *The Apollo in Matisse's Studio* (1908, Figure 60), a study of an antique cast in Matisse's atelier, shows his close understanding of Fauve modeling – pink and violet highlights and green shadows – of a subject placed in a brilliantly colored, luminous interior. Weber adopted Matisse's loose, spontaneous brushwork, tempered at times by Cézanne-like hatching, but he characteristically exercised firm control over the composition, articulating two- and three-dimensional space as a substantial armature for high-keyed Fauve color.

Weber did not return to the class in the fall of 1908, apparently having absorbed what he needed from Matisse. Weber objected to "politics"[14] in the class and had grown impatient because Matisse placed so much emphasis

on conventional drawing from the model. So he went his own way, diligently trying to solve pictorial problems that he thought were challenging. He had tremendous faith in the correctness of his own views and in his own great ability as an artist. For this independence, he often paid a steep price — loneliness, isolation, and misunderstanding.

Weber, however, thoroughly enjoyed the comradeship of Henri (the Douanier) Rousseau, the customs official turned painter, whose naïve "primitive" style appealed to the avant-garde artists and critics in Paris, including Picasso and Guillaume Apollinaire. An artist of natural, if unsophisticated, talent, without an understanding of Fauvism and Cubism, Rousseau frequently invited Weber to his studio, and the two saw much of each other in 1907 and 1908. Rousseau's open, ingenuous personality, his poetic spirit, appealed to Weber more than his art, although the American liked its "primitive simplicity" and confessed that "seeing Rousseau's pictures is like looking through a new window upon a new world." [15] In Paris, Weber obtained a small collection of his paintings and drawings, which became the basis of the Rousseau memorial exhibition which he arranged for 291 in 1910.

Weber met other French painters, too — Picasso, Delaunay, Metzinger, Marquet, Gleizes, Segonzac, and Denis — along with Apollinaire, but it is hard to determine how much he saw of them. Although he was a member of the New Society of American Artists in Paris, he preferred to work in his solitary, self-directed way, seeking inspiration from the art of the Western world at the Louvre, from the ethnological collections, including African art, at the Trocadéro, and from the Oriental art at the Musée Guimet.[16] To expand his knowledge of the masters of European art, he took a trip to Spain in the summer of 1906; to Italy, where he spent time with Walkowitz, during the spring and summer of 1907; and to Belgium and Holland in the fall of 1908.[17]

Weber worked intently at his painting while he was in Paris, eagerly utilizing every moment of his precious time abroad. His work was well received in the advanced salons; he exhibited at the Salon d'Automne in 1906, 1907, and 1908, and at the Salon des Indépendants in 1907. However, by the end of 1908, his savings of $2,000 were nearly gone, and he was compelled to return to the United States. He departed, after attending a banquet Rousseau held in his honor, on December 19, 1908.

Settling in New York in January 1909, Weber hoped to earn enough money to return to Europe, but he never realized this goal. Unable to secure a teaching position in the New York public schools, he tried to raise money by exhibiting and selling his paintings. In the spring of 1909, on Steichen's

suggestion, he went to 291, showed Stieglitz his portfolio, and asked to have an exhibition. Stieglitz, exhausted from a strenuous season, refused. Failing also to obtain an exhibition at Pratt Institute, Weber finally arranged a show, mostly of his European work, at the Madison Avenue gallery of the picture framer Julius G. Haas, in April and May 1909. Haas had been persuaded to present Weber's work by the artist's friend and roommate Abraham Walkowitz, who had held a show of his own pictures there several weeks before. Although few of Weber's unconventional works were sold, he attracted the attention of several influential painters, including Arthur B. Davies, who bought two pictures, and Walter Pach, both of whom were trying to promote advanced unacademic art in the United States.

In the fall of 1909, Weber again visited 291 and this time found Stieglitz much more cordial. "His work rather fascinated me," the proprietor recalled. "There was strength, a sense of color and something thoroughly alive." [18] Yet he was troubled by Weber's close borrowing from Cézanne, Matisse, Picasso, and African Negro art: "The work lived yet seemed to worry one." [19] Despite his reservations, he promised to give Weber the show he wanted so much, but he did not set a definite date. Stieglitz's commitment seems to have encouraged Weber, who thereafter visited the gallery frequently.

After his return to the United States, Weber continued to champion the art of Cézanne. He later claimed that he had brought the first reproductions of the French artist's work to this country.[20] Weber was also well acquainted with the art of Matisse and Picasso, but by 1910–1911 he had turned against the formlessness of Fauvist colorism and would not say anything kind about Picasso.[21] He was advanced not only in his knowledge of contemporary French art but also in his taste for the primitive and aboriginal sources of modern art, the artistic worth of which had been recognized only a few years before by Matisse and his friends, by Picasso, and by the German expressionists. Weber, moreover, was the first artist in this country to discuss the aesthetic values in pre-Columbian and American Indian art, both in themselves and as sources of inspiration for contemporary American painting.[22]

Although Weber was to leave the Stieglitz circle early in 1911, his stylistic evolution up to that moment is significant because he was unquestionably the most advanced painter in the country at that time, and his art, in turn, contained valuable lessons for the 291 group. His first American paintings, such as *The Bathers* (1909, The Baltimore Museum of Art)[23] show his continuing allegiance to the figure compositions of Cézanne and Matisse. But in *Summer*

61. Max Weber. *Summer.*
1909. Oil on canvas. Col-
lection of Mr. and Mrs.
Solomon K. Gross, New
York (Photo: Courtesy of
Forum Gallery).

(Figure 61), a work of the same year, Weber began to move in a more inde-
pendent direction. His vocabulary still relies heavily on Parisian modernism,
though the elements have been conceived and arranged in a more original
manner than had been usual for Weber. The three nude figures have the
simplified curvilinear contours and gestures typical of Matisse of the years
1905–1907, but they seem more weighty, more massive than anything the
French painter had done around this time. They are compressed within a
shallow space, also reminiscent of Matisse, yet the semblance of overlapping
stage flats — some with jagged patterned contours — suggests the influence
of Henri Rousseau. Weber also experimented with the idea of contradicting
the decorative flatness of the canvas — a device inherited from Gauguin and
Matisse — by creating massive stylized foliage in the trees at the upper left.
Typically, he did not pursue this direction any further; he preferred to ex-
plore a variety of styles, to accept several challenges to his pictorial curiosity
in rapid sequence .
 In the same year, he began constructing massive table-top compositions
like *Still Life with Bananas* (1909, Figure 62), a painting handled in the
spirit of Cézanne but without imitating that artist. Weber showed great

62. Max Weber. *Still Life with Bananas.* 1909. Oil on canvas. Forum Gallery, Inc., New York.

respect for the simple, basic shapes and tangible solidity of the objects, but at the same time he has tilted the table top up at a sharp angle, forcing the viewer to perceive the composition as a two-dimensional, as well as a three-dimensional, entity. Weber's superb sense of color is also revealed here. He worked in the coloristic vein of Picasso's 1908 still lifes, stressing deep greens, tans, and browns, but he gave vitality to the whole by introducing brilliant bands of red and pink in the objects on the table, hues that amplify the striking effect of the yellow bananas.

The geometric simplicity of *Still Life with Bananas* was developed in several paintings of the following year, and at that time, too, Weber turned to the nude human figure as a major vehicle of expression. In works like

63. Max Weber. *Composition with Three Figures.* 1910. Gouache on corrugated board. William Hayes Ackland Memorial Art Center, Chapel Hill, N.C.

Composition with Three Figures (1910, Figure 63) Weber obviously used Picasso's squat, faceted figures of 1908 (such as *Nu dans une forêt*, 1908, Hermitage Museum, Leningrad)[24] as his point of departure. He delighted in twisting and contorting the human forms, using robust figures as in Picasso's *Trois femmes* (1908, Hermitage Museum, Leningrad)[25] that threaten to explode the enclosing borders of the picture. Following Picasso's style of 1907–1908, Weber modeled the forms boldly, yet with delicacy, using thin parallel striations of color,[26] but even more than Picasso he exaggerated the knifelike sharpness of the ridges where planes of the figures meet. Although Weber explored several other variations of this idiom in 1910, he did not advance beyond Picasso's style of 1908 before he left the 291 circle early in 1911.

64. Henri Rousseau. *La Maison, environs de Paris.* c. 1905. Oil on canvas. Museum of Art, Carnegie Institute, Pittsburgh, Pa.: Acquired through the generosity of the Sarah Mellon Scaife family.

In the period before the break, the artist was very close to Stieglitz, his family, and his colleagues. When Weber was without money in 1910, Stieglitz arranged for him to live in a room just behind the gallery, occupied by Stephen Lawrence, the decorator. Stieglitz's wife and daughter Kitty grew fond of Weber, and he was often invited to the Stieglitz apartment for dinner. To repay his debt to his mentor, Weber insisted on giving Kitty painting lessons while the Stieglitz family was spending the summer of 1910 at Deal Beach, New Jersey.

Stieglitz believed that Weber was the only person at that time who understood what he was trying to accomplish in his photographs, and he encouraged Weber to write about the visual arts for *Camera Work*.[27] This sympathy for Stieglitz made Weber a valuable aide to the impresario in arranging the 1910 international exhibition of pictorial photography for the Albright Art Gallery in Buffalo, and his taste and skill contributed much to the hanging of the show.

Weber undoubtedly expanded Stieglitz's understanding of modern art and the general fund of knowledge about the subject among those who came to 291.[28] At this time, no one else in America had learned as much as he had of avant-garde French art and aesthetics. More than any other member of the Stieglitz circle, Weber had been in close personal touch with the

leading pioneers of modernism in Paris and had carefully studied their immediate predecessors and sources in the museums of Europe.

Furthermore, in the year of Henri Rousseau's death, Weber persuaded Stieglitz to stage a memorial exhibition, a small show of paintings and drawings from Weber's own collection, held in November and December 1910. This first one-man exhibition of Rousseau's work held anywhere featured four or five oil paintings (including Figure 64), two ink drawings, and a decorated vase. This Rousseau collection was also borrowed from Weber for display at the Armory Show in 1913.[29]

Despite Weber's substantial contributions to 291, friction gradually developed between him and several other members of the circle, especially De Zayas and Haviland, who objected to his intolerance and threatened to withdraw from 291 if Stieglitz continued to accept Weber's rejection of the art of everyone but Cézanne, Rousseau, and himself.[30] Never one to subordinate his ego to another party or to collective group ideals, Weber was a tactless, outspoken critic. Unfortunately, he reacted most violently to the paintings and photographs of Stieglitz's close associate, Steichen, denouncing his work loudly and without mercy. Stieglitz tried to convince him of Steichen's merit, but Weber remained unimpressed, preferring Clarence White and Alvin Langdon Coburn, Secessionist photographers who had already moved out of Stieglitz's orbit.

In spite of these conflicts, Stieglitz finally kept his promise to give Weber a one-man show at 291, which was held in January 1911. The artist arranged the pictures on the walls to create a unified design, but he placed unreasonably high prices on them, contrary to Stieglitz's wishes. On this point, Stieglitz criticized Weber for asking as much as $1,000 for works painted on cardboard with colors that were not permanent. Heated words were exchanged between the two men, and Weber finally exploded with rage and left the gallery, vowing he would never return. From that point onward, Weber had little to do with Stieglitz and would not associate with the group at 291.

Because of this break with the gallery, he did not personally witness the public reaction to his exhibition of the recent paintings he had produced in New York. It is hard to imagine anything more controversial, for he had blatantly magnified the abrasiveness of the new artistic language he had derived from contemporary French painting. He must have been stunned and dismayed when he read the vitriolic attacks on his work that appeared in many of the New York newspapers. Although a few of the reviews were favorable, the show disturbed some of the critics even more than the Matisse

exhibition the previous year. Weber finally appeared on the last day of the show and learned that only one picture, a pastel, had been sold. Agnes Meyer had bought it.[31]

After this, Weber charted his own course as an independent, solitary artist. He had cut himself off from the only vital center devoted to the advancement of modern art in America before 1913, but through his exceptionally powerful will he managed to keep pace with advanced currents in European art without the aid of Stieglitz and 291. After his exile from the group, he allied himself with Secessionist photographers Coburn and White. Coburn, an expatriate living in London, tried to promote Weber's work in England, and White offered him a position teaching the history of art at his school of photography in New York, which Weber held from 1914 to 1918.[32] Davies and Henri thought highly of Weber's art, but he did not try to involve himself with them or their circles.[33] He refused to pay homage to any individual or organization, stubbornly believing only in his own genius and in his ultimate triumph as America's greatest modernist.

From 1911 to early 1913, Weber continued to search for advanced, radical forms of expression, at the same time trying to give his painting an air of archaic, yet timeless, directness. In 1911 he approached the threshold of pure abstraction in a group of small pictures, such as *Forest Scene* (Figure 65), in which simple, boldly geometricized leaf and tree forms are closely packed into the picture space, almost excluding any sense of depth. These works deserve mention not only for themselves but because they are close in style and approach to what Arthur Dove was doing at the time, and, as indicated earlier, they may have influenced that painter's development toward abstraction.

The Armory Show gave Weber a new set of artistic stimuli, and his painting blossomed under the influence of Duchamp, Matisse, and the Cubists; for several more years he explored the implications of advanced European art. He readily assimilated the lessons of Analytical Cubism (in *Woman and Tents*, 1913, Collection of Helen M. Obstler, New York City,[34] and *Tapestry #2*, 1913, Private Collection, White Plains, New York) [35] and Matisse's style of 1910–1912 (in *Decoration with Cloud*, 1913, Collection of Mr. and Mrs. Albert Abramson, Bethesda, Maryland),[36] following a course in 1913 and 1914 that was still mainly derivative. Surprisingly, in 1915, when he was also reflecting new influences from the Italian Futurists and Picabia, his art matured and solidified into something quite personal in works like *Chinese Restaurant* (Whitney Museum of American Art, New York City).[37] This current of originality continued into 1916 in the handsome *Russian Ballet*

65. Max Weber. *Forest Scene.* 1911. Gouache. Present location unknown.

(Collection of Milton and Edith A. Lowenthal),[38] but by 1917, Weber had become thoroughly enmeshed in Picasso's Synthetic Cubism, and his canvases became strongly derivative once again.

Weber's work was seen in New York galleries intermittently from 1909 to 1915. His show at 291 was followed by a large exhibition at The Murray Hill Galleries in 1912 and by shows at the Ehrich Galleries and the Montross Gallery in 1915. (Weber had refused Davies's invitation to participate in the Armory Show because the committee accepted only two instead of the eight or ten works he believed he was entitled to show; in 1913, however, he exhibited with the Grafton Group, London, under the auspices of Roger Fry.) Weber also had the distinction of being the first avant-garde American painter to be given a museum exhibition. It was held at the Newark Museum in 1913, thanks to the insight and courage of the director, John Cotton Dana.

Until the early 1920s Weber was fundamentally an eclectic artist who mirrored European modernism and revealed how a determined American could adapt its styles for his own purposes. Ultimately, he gave up his attempt to keep pace with European innovations and began to search for a personal language that was truly his own. By the late thirties, he had settled on a style utilizing light, floating figures drawn in quick, sketchy, black lines over a soft pastel background. Applied primarily to genre and Jewish religious subjects, this became Weber's favorite idiom, and he continued to paint in substantially the same manner until his death in 1961.

Abraham Walkowitz:
Life and Work, to 1913

Abraham Walkowitz (Figure 66) was one of the lesser artists of the Stieglitz circle, but he deserves attention because he was a close friend of Stieglitz's from 1911–1912 to 1917 and an active member of the group at 291, who was given four exhibitions at the gallery during that period. Like his friend Max Weber, he was caught up in the excitement of avant-garde experimentation in the early years of the twentieth century, and in later years, he tried to represent himself as one of America's leading pioneers of modernism. Although his claim was exaggerated, he was a fairly advanced artist who tried to keep pace with artistic innovations emanating from Europe. While he gained more from 291 than he gave to it, he was a dedi-

66. *Abraham Walkowitz.* c. 1908. Photograph. Zabriskie Gallery, New York.

cated and often interesting modernist who earned Stieglitz's respect and support.

Walkowitz was born in Tyumen, in western Siberia, the son of a Russian Jewish lay rabbi, Jacob Walkowitz, who had gone to Siberia to give spiritual counsel to the Jewish soldiers of the Czarist army stationed there. The year of his birth is given variously as 1878 or 1880; his mother, Yetta, invented the later date to prevent him from being conscripted into the Russian army. Widowed when Abraham was four, she brought him and her two daughters to New York's Lower East Side in 1889, where she supported the family by operating a newsstand.

Attending public schools in New York, Walkowitz took classes in art at Cooper Union and the Educational Alliance, an East Side community house. Toward the end of the decade, he enrolled at the National Academy of Design and also studied etching with Walter Shirlaw, presumably at the Art Students League, though that school has no record of his attendance there. Although he considered Shirlaw "a very fine teacher," he called his instruc-

tors at the National Academy "destructors." [39] He claimed that he received thorough training in anatomy by studying that subject for two years at the Flower Hospital. [40]

From 1900 to 1906, Walkowitz earned his living by teaching art to children and adults at the Educational Alliance. [41] During this period, he embarked on his career as a painter and etcher, portraying city dwellers and laborers going about their daily activities and painting from nature on the Battery and along the banks of the Hudson River. He moved gradually from a dark, subdued palette and a realistic idiom to the fresher, lighter colors and the techniques of the Impressionists.

By 1906, however, Walkowitz could no longer tolerate the cultural barrenness of New York and, following the example of his boyhood friend, the sculptor Jacob Epstein, he set sail for Europe.

After visiting Epstein in England, Walkowitz traveled briefly to Holland, where he made a study of Rembrandt, "attempting to prove Rembrandt had something of the Jewish Cabalistic sentiment in his work." [42] The rich brown tonalities and free brushwork of the interiors he painted on this trip reveal the influence of the Dutch artist.

Arriving in Paris in the fall of 1906, Walkowitz enrolled at the Académie Julian, where he met Max Weber; the two struck up a friendship, but they soon became disillusioned with academic instruction and left the school. Through Weber, Walkowitz was introduced to the world of modern art — in particular, Rodin, Matisse, Picasso, and Rousseau — and, like Weber, he is said to have frequented the salons of Gertrude Stein. Apparently he also shared Weber's enthusiasm for Cézanne; both American artists admired his works at the Salon d'Automne of 1906. Walkowitz later remarked: "I could not see what people had found so revolutionary in his work. I felt at home with his pictures. To me they were simple and intensely human experiences." [43] From this time until at least 1908 Weber served as Walkowitz's artistic mentor, writing letters of encouragement and counsel to his friend when they were apart. [44]

Probably the most moving experience of Walkowitz's entire life was his meeting with Isadora Duncan in Rodin's studio. Soon afterward, he saw her dance for the first time at a private salon, where he was captivated by her free spirit and her musical grace. "She was a Muse," he later recalled. "She had no laws. She didn't dance according to rules. She created. Her body was music. It was a body electric, like Walt Whitman." [45] Walkowitz was to produce over 5,000 drawings from memory of Isadora in motion (Figure 67), spirited, linear sketches, accented with color, in the tradition of Rodin's

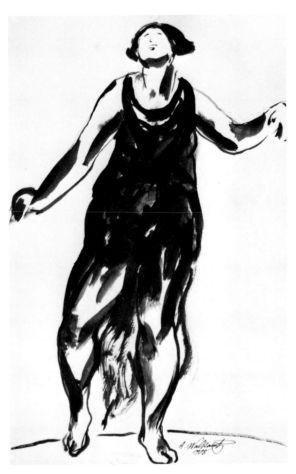

67. Abraham Walkowitz. *Isadora Duncan*. 1908. Watercolor. Zabriskie Gallery, New York.

drawings of the moving model, which helped to establish Walkowitz's reputation as an American artist of some consequence.

Walkowitz furthered his artistic education by taking a trip to Italy in the spring of 1907. Weber joined him there, and they spent some time painting and drawing together at Anticoli Corrado, a small town near Rome. During this period, both artists were working under the influence of Cézanne. Walkowitz also visited Rome, Florence, and Venice, where he looked at the work of Giotto, Cimabue, and the Italian primitives.[46]

Walkowitz had hoped to remain longer than a year in Europe, but his mother's illness compelled him to leave for New York later in the summer of 1907.

Upon his return, Walkowitz found it impossible to live from the sale of his paintings. He earned a meager living by lettering signs and testimonials, but he did so only to support his own creative activities. Taking a studio on Twenty-third Street, he continued painting and drawing in his free time, visiting museums, and benefiting from letters of encouragement and advice Weber sent from Paris. Walkowitz, perhaps under Weber's influence, had no illusions about selling his work. As one interveiwer reported:

He positively scorns the idea of utilizing his art as a means of living. He goes

on dreaming his dreams and painting his pictures, never caring to do things to please anybody, nor ever thinking of it. . . . He would sell his pictures, if people wanted to buy them, after he has turned them out, according to his own inspiration, and according to his own artistic dictates; but he would not paint to order — that is to say, he would not sell his art.[47]

From 1907 to 1911–1912, when Walkowitz met Stieglitz, he did not belong to any group of artists. He steered an independent course, relying on his own inner resources, following the example of Walt Whitman, whose *Leaves of Grass* he considered his Bible. Nevertheless, he did establish close ties with Weber, who returned to New York at the beginning of 1909 without money to pay for lodgings. At this time Walkowitz invited Weber to live with him. During his three-month stay, Weber must have told Walkowitz of the latest developments in French painting, but it is difficult to determine how much influence Weber exerted on his friend's work at this time.

While he was abroad in the year 1906–1907 Walkowitz, like Weber, had studied the latest French art, and these ideas continued to germinate in his creative imagination, affecting the course of his painting for the next few years.[48] Although there is no record of his visiting the exhibitions at 291 before 1911 or 1912, it is hard to believe that he would not have known about them. In any case, Walkowitz managed to remain in the vanguard of American painting in the years before the Armory Show, reflecting in his work the ideas of the Post-Impressionists — particularly Cézanne — Matisse, and the Fauves. This was Walkowitz's best period, a time when European styles were fresh in his mind and he was able to draw upon them, with youthful vigor, in his own way. Walkowitz was most true to himself before the Armory Show, when he was working in a figurative idiom in which he could give free rein to his fine, inventive sense of color. After 1913 his abstract work is much more obviously dependent upon innovations in European and American art, even though he made a determined effort to create an original style of his own.

Upon his return, Walkowitz was drawn to the spectacle of humanity in and around New York City — men, women, and children going about their daily activities or spending leisure moments in the woods, on the beaches, or on the riverbanks. He sometimes portrayed pastoral holiday outings in the spirit of Renoir or Glackens, sometimes in the more severe mode of Seurat and Prendergast. Yet his style, influenced at this time by Matisse, was more advanced than any of these artists. In *Central Park* (c. 1908–1909, Figure 68) Walkowitz presented a group of picnickers, mostly women, informally grouped in a forest glade. The intense greens and yellow-greens of the foliage

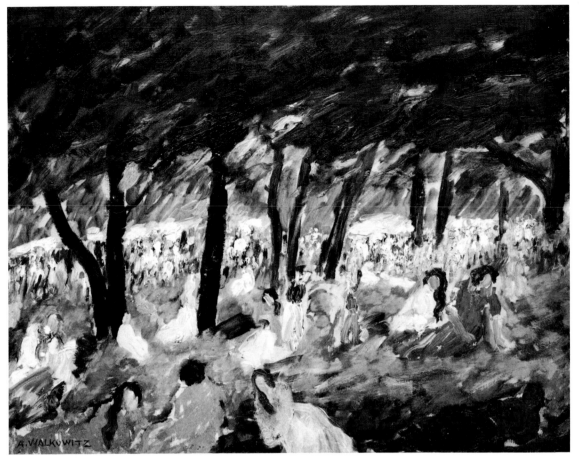

68. Abraham Walkowitz. *Central Park*. c. 1908–1909. Oil on canvas. Mrs. David T. Workman, New York.

and the random organization of the design suggest that he may have been influenced by Renoir (or possibly Glackens), but the agitated, spontaneous brushwork and strong vermilion, orange, and light purple in the women's dresses betray the impact of the Matisse of *Joie de vivre* (Figure 28).

Loose composition was typical of much of Walkowitz's work of this period. But as if to counteract this effect of randomness, he occasionally produced highly structured designs with figures placed at studied intervals, such as *Rest Day* (c. 1908, Figure 69), which appear to owe a debt to the work of Seurat, Puvis de Chavannes, and possibly also Prendergast. This type of painting was repeated with variations many times before and also after the Armory Show. His formula was to portray groups of people enjoying a quiet holiday on a tree-lined riverbank, and like Prendergast, he made his characters relate to each other within small groups. Gestures of warm affection link men and women, parents and children. In some of these paintings, there is an idyllic, timeless quality, recalling Matisse's pastoral scenes, yet Walkowitz's subjects are actual people clad in contemporary dress rather than nudes with allegorical overtones.

Contemporary with these works is a group of genre paintings in which

143

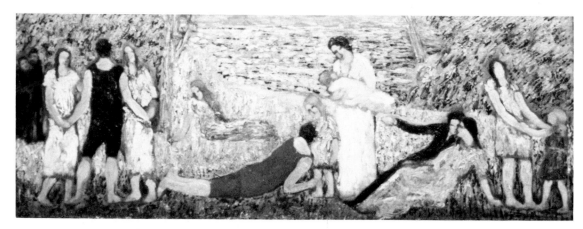

69. Abraham Walkowitz. *Rest Day*. c. 1908. Oil on canvas. Collection of Dr. and Mrs. B. Hurwitz, Lawrenceville, N.J.

Walkowitz revealed his remarkable gifts as a colorist. Again influenced by Matisse in paintings such as *Promenade* (c. 1908, Figure 70), Walkowitz used a quieter palette than that of the French master, one that allowed him to combine the bright blues, violets, and oranges of the Fauves with the earth colors favored by the Ash-Can school.[49] Walkowitz, as far as one can tell, worked according to no theories; he simply followed his natural instinct for evocative color applied, particularly in his beach scenes, in fresh, unusual combinations. If color was his strength, however, compositional inventiveness and anatomical integrity in drawing were often lacking. He began to utilize at this time, probably self-consciously, a naïve doll-like manner of representing the human figure, echoing but not closely imitating Matisse's figure style of 1907–1908. It may be that he was stimulated, too, by Prendergast's treatment of the human figure, likewise consciously stylized to produce a decorative effect. But more pertinent is his fondness for the art of children; he allowed their naïve directness and simplicity of expression to affect his painting in works like *Women in the Park* (c. 1908–1910, Zabriskie Gallery, New York City) and *Beach Scene* (c. 1908–1910, Zabriskie Gallery). In his own life and thought, Walkowitz cultivated a childlike openness and spontaneity of feeling, and he was the first American who consistently drew inspiration from children's art, being one of the first artists anywhere, besides Matisse and Klee, to have done so.[50]

Walkowitz tried to find a gallery in New York, but he was refused by those he visited; his art was so advanced, he recalled later, that the dealers were afraid they would lose their clients if they showed it.[51] However, he

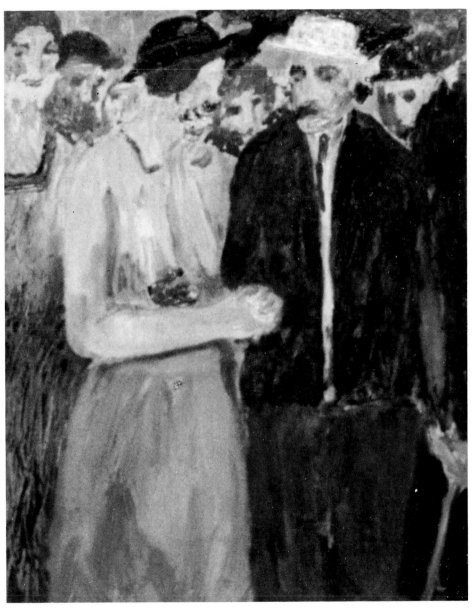

70. Abraham Walkowitz. *Promenade*. c. 1908. Oil on canvas. Private Collection, Lawrenceville, N.J.

71. Georgia S. Engelhard. *Untitled*. Watercolor. Private Collection.

finally convinced his friend Julius Haas to hold a one-man exhibition of his drawings and paintings in the small gallery at the back of his frame shop. According to Walkowitz's recollections, the show was held in January 1908; he later called it "the first modern exhibition held here of modern art." [52] Although many visitors reportedly came, he made no sales.

Through Marsden Hartley, Walkowitz met Alfred Stieglitz in 1911 or 1912. Walkowitz moved into the Stieglitz circle after Weber's expulsion from 291 and became closely associated with the proprietor until the close of the gallery in 1917. During this period, he spent much of his time in Stieglitz's company, advising the photographer on matters of art, helping to hang shows at 291, and serving as one of his faithful disciples. It was Walkowitz who encouraged Stieglitz to present the first exhibition of children's art, *as art*, held in the United States, and one of the first displays of its kind anywhere in the world. Hung at 291 in April and May 1912, the show of young artists aged two to eleven reflected Walkowitz's enthusiasm for the naïve spontaneity of children's work that he had discovered in East Side settlement houses. This exhibition of children's art was followed by three others, including a show of watercolors and drawings by ten-year-old Georgia S. Engelhard, Stieglitz's niece. (One of her watercolors is reproduced as Figure 71.)

Marsden Hartley:
Life and Work, to 1913

Born on January 4, 1877, Edmund Marsden Hartley (he dropped Edmund about 1908) (Figure 72) was the youngest of nine children of Thomas and Eliza Jane (Horbury) Hartley, English emigrants who had settled in Lewiston, Maine, the boy's birthplace. His mother died when he was eight, and his father remarried. Growing up and attending public school in this remote town, Hartley had few opportunities to learn about the arts. A sensitive, thoughtful boy, he spent much of his childhood wandering alone through the countryside. He later recalled that in his parents' home there were some steel engravings by Landseer, and from his father, a billposter for a local music hall, he learned something of the theater. In this small-town environment, he was able to find some intellectual and spiritual nourishment by reading Thoreau and becoming an active member of the Episcopal Church. Hartley, proudly conscious of his Yorkshire heritage, felt a close kinship

72. *Marsden Hartley.* c. 1906.
Photograph. Collection of
Gertrude Traubel.

with Richard Rolle, the fourteenth-century Yorkshire hermit-mystic, and was fascinated by the "mad brilliance" of the Brontës.[53]

At the age of fifteen, Hartley left school and went to work in the office of a shoe factory in Auburn, Maine. Boarding with one of his sisters, he remained at the job for about a year and then joined his father, his stepmother, and three sisters, who had moved to Cleveland. There his artistic training began in earnest. Although he had to earn his living for several years by working in the office of a marble quarry, he arranged to take art lessons one day a week from John Lemon, a little-known American follower of the Barbizon school. Subsequently, in the year 1898–1899, he enrolled at the Cleveland School of Art, where he studied under Nina Waldeck and Cullen Yates. Waldeck introduced Hartley to Emerson's essays, and he recalled later that she was a formative influence in his development as an artist. The role of Yates is harder to evaluate; a "half hearted Impressionist," [54] he had studied under Laurens and Constant in Paris and taught outdoor classes at the Cleveland School of Art. It was probably from Yates that Hartley learned the techniques of plein-air painting.

In 1899 Hartley's artistic promise was recognized by a local woman of wealth, Miss Anne Walworth, who provided a five-year stipend for him to study and paint in New York and Maine. Arriving in the city in the fall of 1899, he studied under Kenyon Cox at the Art Students League. At the same time, he enrolled at the Chase School (officially known as the New York School of Art), where he attended the classes of F. Luis Mora and Frank Vincent DuMond and received criticisms once a week from William Merritt Chase. Disturbed by the "superficiality" of the Chase School, Hartley withdrew at the end of his first year and in the fall of 1900 entered the National Academy of Design, where he found the atmosphere more orderly and "pure." [55]

As a devout Episcopalian, seeking spiritual as well as artistic enlightenment, Hartley was much concerned with the moral aspect of his classes. Like Weber, he responded to the inner voice of the Divine: "I always feel that the good and pure thoughts a man may utter are not wholly his, but they come from God and are given to man's soul of God, and that it is the goodness and purity of man manifesting itself to us." [56] Fortified, too, by his belief in Emerson's and Thoreau's philosophies, he praised the healing, beneficial effect of nature upon his being.[57] Nature, he thought, was a great teacher; more art was to be found in the flowers and insects than in the classes he had taken in New York. Art schools could provide valuable in-

formation about technique, but Hartley insisted that technical accomplishment alone, as understood at the Chase School, was decidedly not art.[58] Like Robert Henri, he believed that art and life were intimately related: "One learns to look for art in everything and one aspires or should aspire to *be art in everything.*"[59] And like Henri, he sounded a note of Emersonian self-reliance, vowing "to be as we would seem to be and to bear out the truth to the very end in everything we do and to live as it was intended for us to live regardless of the thoughts and sayings of others."[60]

During the summers following his two seasons of study in New York, Hartley succumbed to his passion for nature and returned to paint in his native state of Maine. There he spent much of his time alone in the countryside, yet desperately yearning for someone to share his experiences. Despite his isolation, he made several contacts with teachers who furthered his growth as an artist. Through Alice Farrar, a Lewiston painter, he learned of the unconventional teachings of Charles Fox and Curtis Perry, wealthy artists who had set up a school in Portland and a summer art colony, based on Socialist principles, at North Bridgton. Joining the colony in the summer of 1901, Hartley found that Fox and Perry had based their teachings on the close visual and botanical study of nature, an approach that suited him perfectly at that time. In addition to this focus upon nature, Fox and Perry tried to develop character, as well as an aesthetic sense, believing in art for the sake of humanity. Their aim, Hartley was pleased to report, "is to live the higher life and to apply it to their art."[61] Hartley's own high sense of morality, reinforced by the influence of these teachers, led him to view art as a spiritual calling, closely linked with his religious experience of life, though in moments of frustration he thought of giving up painting to become a minister.[62]

In 1901 Hartley embarked on a career as an independent painter. At the outset, he had no prospects of selling his work, and, when his five-year grant from Miss Walworth expired, he was forced to support himself by working as an extra in New York theaters. Sympathetic to his plight, the art dealer N. E. Montross offered him a small weekly stipend for two years. For the remainder of the decade he spent his winters in New York or Boston and his summers in Maine, but little is known of his activities during this period.

We know that from 1901 to 1910 Hartley applied himself diligently to the art of painting and at the same time began to write poetry, a pursuit he followed for all of his life. By 1904 he had become deeply immersed in the writings of Walt Whitman, whom he described as "that great and beautiful

man." [63] Among literary figures, Maeterlinck, Robert Louis Stevenson, and William Vaughn Moody also claimed Hartley's attention; of writers on art, he was drawn to Pater, Ruskin, and Whistler. [64]

Hartley was torn by the dual desire to mix with the crowds of the city and to seek solitude in rural nature. During the summers in Maine, he often regretted his lonely isolation and yearned for the pulse of city life. Yet each summer he insisted on retreating to the country, where he tried to capture the dynamic spirit of the weather and the dramatic seasonal changes in the landscape of his native state. Because so few of his works before 1908 have survived, it is difficult to assess his early stylistic development. We know that as early as 1900 he had demonstrated a lively interest in color in preference to drawing and modeling; he said, "I see color in nature so brilliant and it is impossible for me to 'bring it up' to the right key." [65]

Early in his career, he admired Inness, Wyant, Homer Martin, Winslow Homer, John Twachtman, and Chinese and Japanese art, though his "first direct influence," [66] about 1907 or 1908, came from the art of Giovanni Segantini, the Italian Divisionist. Isolated in Maine but curious about his work, Hartley asked a fellow student from the National Academy, Emil Zoler — later Stieglitz's assistant — to send him reproductions of Segantini's paintings. [67] Zoler apparently obliged, for Hartley later confessed that Segantini "showed me how to begin painting my own Maine mountains." [68] From Segantini, Hartley learned to use fragments of intense color, more like Neo-Impressionism than Impressionism, which he applied in the Italian painter's distinctive "stitch" stroke. Overlapping and interweaving his hues in small, vibrant touches, Hartley created, in 1908, a series of powerful landscapes which reveal the brilliant autumn hues and the turbulent snowstorms in the country around Center Lovell and North Lovell, Maine. In some of these paintings Hartley turned his divisionist technique to a highly personal interpretation of the energies of nature, revealing his empathy with the subject through agitated, swirling brushstrokes that recall Van Gogh's expressionism. (There is, however, no record of his knowledge of Van Gogh's work at this time.) Other paintings in the group, like *Carnival of Autumn* (1908, Figure 73), are quieter and more decorative. The repetitive curvilinear patterns in the mountains and the uniform, tapestrylike surface affirm the two-dimensionality of the canvas and reflect, as well, Hartley's debt to Japanese art.

In this group of Maine landscapes, the artist revealed the essential duality of his style. On one hand, he responded forcefully, often passionately, to the vital spirit and mood of nature, and in this, he shows himself as an expressionist, inclined to mysticism, whose views were parallel to Marin's (although he

73. Marsden Hartley. *Carnival of Autumn.* 1908. Oil on canvas. Museum of Fine Arts, Boston: Charles Henry Hayden Fund.

must have been unaware of Marin's work at this time). On the other hand, Hartley had a natural instinct for decorative pattern and uncomplicated two-dimensional effects. Beginning in 1909, when he came under the influence of Albert Pinkham Ryder, these two facets of his style became united in his paintings.

Hartley's artistic vision was profoundly affected when he first saw the work of Ryder, one of the greatest masters of romantic painting in America. In 1909 Montross invited Hartley to his gallery to view one of Ryder's paintings, a seascape, the sight of which induced an aesthetic and spiritual conversion in Hartley. He found in Ryder all of the mystical and romantic qualities which his own experience of his native New England had brought forth in himself but which he had never been able to express in paint. "I was a convert," Hartley confessed, "to the field of imagination into which I was born." [69] Believing strongly in Ryder's imaginative vision, Hartley sought him out in his dingy Fifteenth Street studio, where he was inspired by a group of diminutive masterpieces. At that time, Hartley recalled, "Ryder's spirit lived intensely in me." [70] In the winter of 1909, he produced a small group of paintings, including *Maine Landscape* (1909, Figure 74), that were heavily influenced by Ryder. Known as the "dark landscapes" (Hartley's term), these canvases reveal the extremes of his expressionist temperament. The tortured trees and gloomy sky of *Maine Landscape* speak of tragedy and doom, perhaps a revelation of the personal despair of an artist who was close to suicide at that moment. Although his canvases are small in size, their expressive message is monumental in impact.

Before 1909 Hartley and his work received little recognition in New York art circles.[71] In that year, however, he attended social gatherings in Henri's studio, apparently introduced by Maurice Prendergast. Sloan and Shinn were invited to inspect Hartley's Impressionist paintings at Glackens's studio in March of 1909, but they expressed reservations about the work. Sloan thought some of the paintings were "affectations" and was repelled by his mysticism. Thus, Hartley did not find acceptance in the one progressive group, besides the Stieglitz circle, that might have adopted him as a colleague.[72]

Sometime after this confrontation, Hartley's friend Shaemas O'Sheel, the Irish-American poet, spoke to Stieglitz about the artist and his struggles, and the photographer suggested that he bring Hartley to the gallery.[73] In due time, Hartley and O'Sheel appeared at 291 and in the course of the conversation, the latter suggested that Hartley be given a show. Stieglitz, tired at the end of the season, refused at first; the gallery was ready to close, and

74. Marsden Hartley. *Maine Landscape.* 1909. Oil on board. Washburn Gallery, Inc., New York.

he had already turned down Weber's urgent request for an exhibition. But after talking with Hartley, Stieglitz capitulated and offered him his first show in May 1909. In it Hartley presented examples of "an extreme and up-to-date impressionism," [74] landscapes recently painted in Maine under the influence of Segantini. Charles Caffin remarked on their startling coloration, which "produced a strictly physical sensation. It irritated the retina and exhausted it. After leaving the Gallery, Fifth Avenue looked more grey than usual." [75]

Poor and lonely, Hartley was moved by Stieglitz's tangible demonstration of faith in him and his art. At 291 he discovered the spiritual home he had long been seeking, and in Stieglitz he found a mentor who genuinely cared about his work and who was willing to nurture his creative development. From 1909 until the end of World War I, Hartley was one of Stieglitz's most faithful protégés. Although he spent much of his time in Europe in the years 1912–1915, he wrote Stieglitz long, revealing letters in which he poured out his feelings about himself and the art and artists he had encountered there. In his replies, Stieglitz, in turn, continued to offer Hartley encouragement and advice.

The years 1909–1912 were crucial for Hartley's artistic development. He was in close touch with Stieglitz and the 291 group, and at the gallery and the luncheon meetings at Holland House he became deeply embroiled in discussions of art and aesthetics.[76] Moreover, he learned much from the exhibitions at 291, which he studied intently and which altered the course of his development. Most valuable for his evolution as a painter were the Matisse exhibition in 1910[77] and the 1911 Picasso show, where he studied the pictures daily for hours.[78] Although Stieglitz later claimed that Hartley benefited from the important show of Cézanne's watercolors held at 291 in March 1911,[79] the artist's letters make it clear that he knew Cézanne's paintings only in reproduction before seeing nine of that painter's works in the Havemeyer Collection, to which he was taken by Davies late in 1911 or early in 1912.[80] In a letter to Stieglitz of August 20, 1911, Hartley stated that he had seen black and white reproductions of Cézanne's work in a book by Julius Meier-Graefe[81] and asked Stieglitz to send him a photograph of a typical Cézanne still life which he could study in Maine.

Picasso's paintings exerted much influence on his works of 1911. In its interwoven, contorted angular trees and jagged rocks, simplified and compressed within the picture space, Hartley's *Landscape No. 32* (1911, Figure 75) clearly reflects the impact of Picasso's landscape style of 1908. (Compare, for example, Picasso's *Landscape* [1908, Hermann Rupf Collection, Bern][82] and *Paysage avec deux figures* [1908].[83]) Stieglitz, who once owned this work, wrote on the back: "First painting he [Hartley] made after the Picasso Exhibition at 291 in 1911." Most of Picasso's paintings shown at 291 cannot be identified, but there were enough proto-Cubist and early Analytical Cubist examples to bring about a radical change in Hartley's pictorial language. Picasso's style of 1910, represented in the show by his drawing of a *Nude* (1910, Figure 32), among other examples, was echoed in Hartley's *Abstraction* (1911, Figure 76), a personal exercise in Analytical Cubism and probably his first nonrepresentational painting.[84]

Hartley was influenced strongly by Picasso's work only briefly in 1911; Cézanne offered a more profound and lasting challenge. During the summer and fall of 1911, Hartley made a thoroughgoing, disciplined study of still life in the spirit of Cézanne, trying to record objects with a sense of authority and conviction.[85] On some days he would explore form, on others, color, abandoning his quest for mood in favor of the impersonal manipulation of shapes.

Stieglitz invited Hartley to participate in the Younger American Painters exhibition of 1910, a significant honor because Hartley was the only artist in

75. Marsden Hartley. *Landscape No. 32*. 1911. Watercolor. University Gallery, University of Minnesota, on extended loan from Ione and Hudson Walker.

the show who had not been abroad. Moreover, in the following spring, Rockwell Kent, at Davies's suggestion, invited him to exhibit with eleven progressive painters, including Davies, Luks, Marin, Maurer, and Prendergast, in the galleries of the Society of Beaux-Arts Architects. In the wake of this show, Hartley was pleased to announce, in a note to his niece, that he was one of the few artists who were effecting great changes in American art and that his colleagues had praised his work highly.[86] His progress was also acknowledged by Stieglitz, who offered him a second show in February 1912, comprising mainly his recent still lifes. Hartley, Paul Haviland noted in *Camera*

76. Marsden Hartley. *Abstraction*. 1911. Oil on board. University Gallery, University
of Minnesota, Gift of Ione and Hudson Walker.

Work, had been stimulated by the shows at 291 "without aping the style of any of the modern men whose work has been shown" at the gallery.[87]

For more than a year, Hartley had yearned to go abroad, but he had been unable to raise the necessary money before the spring of 1912. Finally, Stieglitz saw to it that his expenses for a year — $15 a week — would be covered by funds provided by Agnes Meyer, through purchases of his work, and by Davies, who had obtained a check for Hartley from Lizzie Bliss. After signing over his power of attorney to Stieglitz, Hartley embarked on the *Savoie* for France.

Hartley in France and Germany, April 1912-May 1913

On April 11, 1912, the young man from Maine arrived in Paris wide-eyed and enthusiastic, eager to immerse himself in the artistic life of the city. Within a few days he searched out the treasures of art he had dreamed about for the past few years. He went first to the Louvre, the Luxembourg, and the Salon des Indépendants; then he visited the Renoir show at Durand-Ruel's and went with Steichen to see the Pellerin Collection, one of the finest private collections of modern paintings in Paris. His only regret was finding so few works of Gauguin and Van Gogh in the city.[88] Cézanne and Renoir aroused his enthusiasm, but he was attracted even more to the art of Matisse, whom he deified at that moment. Although Hartley admired Picasso's and Braque's work on display at Kahnweiler's gallery, it was not until the fall of that year that he acknowledged Picasso as the leading avant-garde painter in Paris. In his letters to Stieglitz, Hartley stated that he had seen the art of Seurat, Signac, Cross, Rousseau, Derain, and the Futurists, although he did not mention any of the latter by name.

Even though Hartley was an unknown American painter — and a rather aloof one — he readily found his way into the higher echelons of the Parisian art world. He sought out Steichen, Maurer, Carles, and Jo Davidson, frequented the popular artists' cafés — the Dôme, the Rotonde, and the Closerie des Lilas — and within two months was attending the gatherings at Delaunay's studio, where he met the artist and inspected his latest works.

Like most of the other members of the Stieglitz circle who had lived in Paris, Hartley gravitated to the lively soirées at Gertrude and Leo Stein's apartment. There he found intimacy and warmth, both in the group and in the person of Gertrude, who liked him and made him feel at home. The sight

of so many outstanding modern paintings on the walls transfixed him — an array of pictures, he recalled, "all burning with life and new ideas — and as strange as the ideas seemed to be — all of them terrifically stimulating — a new kind of words [sic] for an old theme." [89] Gertrude hung several of Hartley's works in her apartment and became one of his loyal supporters.[90] Still, although Hartley admired Stein and enjoyed her salon, he found nothing in France that equaled the stimulating atmosphere and spiritual brotherhood of 291.

Shortly after Hartley arrived in Paris, he began to paint still-life compositions, like *Still Life* (1912, Collection of Mr. and Mrs. Hudson D. Walker),[91] in which he fused the styles of Cézanne and Matisse, thereby continuing the stylistic direction of his painting just before he left New York. But within a few months, his penetrating study of Picasso's and Braque's work left its mark on his style. His *Still Life with Fan* (1912, Figure 77), with its compressed space and simplified angular drawing, illustrates how quickly he was able to assimilate their message. Hints of Cézanne's (and also Weber's) respect for the solidity of the objects remain, but the bold, fragmented contours clearly reveal the influence of Analytical Cubism.

Until this time, Hartley had been an eclectic — albeit with a strong individual temperament — who had experimented with a wide variety of advanced styles. In Paris, he decided quite consciously to paint in a completely personal and original way, at the same time admitting that he would willingly learn from both earlier and contemporary art. A small group of highly simplified still-life compositions, dating from 1912, represents his first efforts in this direction. In several of these — *The Bright Breakfast of Minnie* (1912, The Denver Art Museum) and *Handsome Drinks* (1912, Collection of Mr. and Mrs. Milton Lowenthal, New York City), for example — he adopted some of the conventions of French Cubism of 1912 — commercial lettering, multiple viewpoints, and spare geometric drawing — but he attained a starkly simple effect by treating each object as a crisply demarcated unit, stylized and isolated from other objects on the planar surface of the canvas. His iconic mode of treating pictorial forms, resembling a modernized Rousseau or a severe Matisse, was exaggerated in *One Portrait of One Woman* (1912, Figure 78), a symbolic portrait probably representing Gertrude Stein. Here Hartley introduced fresh, new visual schemes suggested by the art he had studied at the Trocadéro Museum. The painting is one of his first, if not his very first, in which the canvas is divided symmetrically and the forms arranged in a rigid hieratic order, a self-conscious essay in bold, "primitive" pattern. (It is possible that the wide, brightly colored bands and ribbons of

77. Marsden Hartley. *Still Life with Fan.* 1912.
Oil on canvas. Nebraska Art Association:
Thomas C. Woods Fund.

78. Marsden Hartley. *One Portrait of One
Woman.* 1912. Oil on composition board.
University Gallery, University of Minne-
sota, on extended loan from Ione and Hud-
son Walker.

pigment were suggested by Delaunay's Orphist paintings.) Hartley's portrait imitates no other style from past or contemporary art; it is one of his earliest and most successful attempts to devise a personal language all his own.

In Paris, Hartley's first exposure was naturally to French art, but after several months he attached himself to the colony of German artists that congregated at the Closerie des Lilas. Unlike the French, whom he believed to be excessively intellectual, the German group was much more in tune with his mystical, expressionist leanings. For Hartley the door to German art, particularly of the Blaue Reiter group, was opened by a young German sculptor, Arnold Rönnebeck, whom he had met and befriended along with the American painter Charles Demuth (later allied with Stieglitz) at the Restaurant Thomas.[92] As early as July 1912, Hartley learned of Kandinsky and the *Blaue Reiter* almanac, which he commended highly and sent to Stieglitz two months later.[93] Toward the end of the year, Hartley decided to travel to Germany to meet Kandinsky and Marc.

Hartley's curiosity about Kandinsky had been stimulated by reading his book *On the Spiritual in Art* (1912), which became the catalyst that released, even more than Ryder's example, the current of mysticism that ran deep within his psyche. Expecting that Stieglitz would be interested in the book, he promised, in September 1912, to get a copy to him.[94] This resurgence of mysticism within Hartley strongly affected his views on the art of Picasso, who, by the fall of 1912, had become one of his most revered idols. Although Picasso's Analytical Cubist work of 1910–1912 had been admired by French critics for its geometric aspect and its constructive complexity, Hartley saw in it a revelation of the inwardness of things.[95]

Hartley also drew inspiration from the art displayed at the Trocadéro Museum, which he visited frequently in September 1912. He admired the strength and simplicity he found in the collections of comparative sculpture, casts of French Romanesque and Gothic works by artists who had invented a bold, powerful formal vocabulary that could teach him valuable lessons for his own painting.[96] These artists worked according to spiritual necessity, Hartley stated, borrowing the phrase Kandinsky had popularized in *On the Spiritual in Art* to refer to art that expressed the inner spiritual essence of its creator.[97]

Curious about art and culture in Germany, Hartley made a brief excursion to Berlin and Munich in January 1913, with his friend Rönnebeck. He fell in love with Berlin immediately: he found it beautiful, modern, spiritually alive, yet calm and quiet, and he decided that he must soon return to live there. In Munich he met Kandinsky and Marc and saw a show of the latter's work

at the Tannhauser Gallery.[98] The two artists welcomed Hartley as an equal, having learned of his reputation from a German woman who had recently visited 291. Eager to expand the spiritual fellowship of the Blaue Reiter, they discussed their beliefs with him, and he and Kandinsky agreed to exchange photographs of their work. Hartley proudly wrote to Stieglitz and Rockwell Kent, describing the artistic aims of Kandinsky and Marc and explaining how his own goals were parallel to, but distinctly different from, the two Munich artists. Hartley saw himself as the originator of a unique style of painting his inner consciousness, or subconscious, in terms of line, form, and color.[99]

In the fall and winter of 1912–1913, under the influence of the ideas of Kandinsky and the French philosopher Henri Bergson, Hartley progressed even further in his quest for an art of pure, personal invention. Using the vocabulary of Analytical Cubism and Orphism as his points of departure, and inspired by Cézanne's watercolors, he undertook a series of canvases, such as *Musical Theme No. 1 (Bach Preludes)* (1912–1913, Figure 79), in which he tried to paint visual equivalents of musical experiences. The circular and rectilinear forms, fragmented and densely packed within a shallow picture space, represent no recognizable objects. Their cryptic, enigmatic quality is accentuated by the presence of indecipherable pictographs that Hartley, like Paul Klee, invented through free association.[100] The intuitive aspect of these paintings was carried even further in a group of abstractions, some of which Hartley called "spot movements," that he produced in late 1912 and early 1913 and that were more obviously under Kandinsky's influence.

Moved by Kandinsky's conception of art as a forthright, immediate expression of the artist's spiritual state and inspired by reading the mystics Böhme, Ruysbroeck, Eckhart, Tauler, Suso, and Richard Maurice Bucke, Hartley allowed his brush automatically to record images and symbols that flowed from his unconscious mind. One result, in *Abstraction with Flowers* (1913, Figure 80), is a radiant galaxy of round, triangular, and irregular geometric figures, some recalling flowers and snowflakes, treated in abstract terms. As in Kandinsky's nonobjective work of the same time, the two-dimensional shapes in the painting are linked by interweaving linear filaments that meander through the painting. But Hartley did not imitate Kandinsky's style, nor did he subscribe to his intellectual theorizing, relying instead on the subjective inner core of his own personality, a mystical essence that he acknowledged as being distinctly American.[101] He proudly announced to Stieglitz that he had created his own style, which, for lack of a better name, the artist christened subliminal or cosmic Cubism.[102]

Increasingly dissatisfied with the clever intellectualism of the French art

79. Marsden Hartley. *Musical Theme No. 1 (Bach Preludes).* 1912-1913. Oil on canvas. Present location unknown.

80. Marsden Hartley. *Abstraction with Flowers.* 1913. Oil on canvas. University Gallery, University of Minnesota, on extended loan from Ione and Hudson Walker.

world, Hartley left in April for Berlin, via Sinselsdorf and Munich, where he again saw Kandinsky and Marc.[103] At Sinselsdorf, in the Bavarian Alps, he spent a memorable three days toward the end of April with Marc and made arrangements to show his work in Berlin. One day in May, Kandinsky, Gabriele Münter, Marc, and Albert Bloch paid a visit to the Goltz Gallery in Munich, where several paintings by Hartley were on view; there the German artists discussed with him the strong and weak points of his work.[104] Writing to Stieglitz about this historic encounter, Hartley compared his conversation with Kandinsky to Emerson's and Whitman's discussion of *Leaves of Grass* on the Boston Common.[105]

Arriving in Berlin in May, Hartley was determined to spend as much time as he could painting in the city that he knew would nurture his creative spirit and offer him an engaging new range of subjects in the prewar military parades and royal pageants.

Summary:
291 before the Armory Show

From 1908 to 1913, Stieglitz was a pioneer in the best, visionary sense of that word. With Steichen's help, he had presented the first American exhibitions of such leading European artists as Rodin, Cézanne, Matisse, and Picasso, thus making 291 a stronghold of modern art when it was virtually ignored by every other gallery and art organization in the United States. The early dates of these shows are significant because they fall in the period just before the Armory Show of 1913, which exposed large numbers of Americans, including many painters and sculptors, to the artistic revolutions taking place in Europe. Some of the artists, of course, had already been to Europe and had witnessed these new styles at first hand, but when they returned to this country, the exhibitions at 291 helped to sustain their interest and generated fresh points of departure. It is safe to say that American painting and sculpture would not have developed as they did without Stieglitz's efforts.

Besides serving as an early showcase for progressive art, 291 played another significant role: it became a meeting place for young avant-garde artists and critics, a forum where they could find encouragement and opportunities for discussion that were unavailable elsewhere in the United States at that time. Nearly every American artist who had been, or wished to be, exposed to modern European art was attracted to 291. Although they were few in number then, the artists who valued what 291 had to offer — Steichen, Marin, Dove, Hartley, Walkowitz, and Weber (briefly) — became stronger through their association with Stieglitz.

The future of 291, however, was profoundly affected by the Armory Show. This event not only forced Stieglitz to alter his goals and his relation to his public but also, in a much broader sense, changed the course of modern art and criticism in America. Thus the later years of 291, from 1913 to 1917, must be viewed against the background of the Armory Show and its aftermath. In this period, other avant-garde galleries were founded, and several influential proponents of modern art, younger and more vigorous than Stieglitz, became active in the New York art world. The story of these events will be told in the following pages.

· CHAPTER SIX ·

Stieglitz and Modern Art in America

The Armory Show (Figure 81), presented in 1913 by the Association of American Painters and Sculptors, was in several important respects an outgrowth of Stieglitz's displays of modern European and American painting at 291. The ideas of the AAPS were largely in accord with Stieglitz's principles, yet he played no direct role in organizing the show, nor was he even invited to do so. He did not believe in vast surveys of advanced art for the general, uninformed public, which he thought would come to an exhibition because they were seeking a sensation rather than responding sympathetically to the aesthetic merit of the works of art. Several influential members of the AAPS had benefited from conversations with Stieglitz and had visited exhibitions at 291, but no one from his immediate circle was directly involved in this ambitious undertaking. Eventually, many of the 291 artists were asked to exhibit, though they represented only one sector in the broad and varied spectrum of progressive painting which the Armory Show surveyed.

The idea of staging a comprehensive exhibition of advanced unacademic art grew out of discussions held by four artists — Jerome Myers, Elmer Mac-Rae, Walt Kuhn, and Henry Fitch Taylor — members of the Pastellists Society who exhibited their work in December 1911 at the Madison Gallery. The gallery, a noncommercial establishment that offered free exhibitions to little-known progressive American artists, was operated by Mrs. Clara S. Davidge as part of a decorating firm with financial backing, it is said, from Gertrude Vanderbilt Whitney. Each of the four men had been linked, in his own way, to advanced currents in the New York art world, and together

81. *The Armory Show* (interior). 1913. Photograph. Armory Show Papers, Archives of American Art, Smithsonian Institution, Washington, D.C.

they opposed the Academy and believed in the need for an alternate exhibition facility. But they did not hold positions of power in the two dominant antiacademic factions of that time — the Henri group and the Stieglitz circle.

The Armory Show's prime mover was unquestionably Walt Kuhn, an energetic former student of Henri who had worked with him on the 1910 Exhibition of Independent Artists. Driven by youthful revolutionary fervor and intense (though fairly well concealed) personal ambition, he concluded that the National Academy would never give the progressives a chance and that a strong rival society would have to be formed. Inspired by discussions with his friends, Kuhn took the initiative in the struggle against the Academy. He joined his colleagues Myers, MacRae, and Taylor in the first recorded meeting of the Association, December 14, 1911, where they discussed the idea of organizing "a society for the purpose of exhibiting the works of progressive and live painters, both American and foreign — favoring such works usually neglected by current shows and especially interesting and instructive to the public." [1] This platform was heavily influenced by the antiacademic climate of the opening years of the decade. There had been earlier

attempts to counteract the dominance of the National Academy – the show of "The Eight," the Exhibition of Independent Artists of 1910, an independent show organized by Rockwell Kent in 1911, and Henri's MacDowell Club exhibition program begun in 1911 – but none of these efforts had been strong enough to deal a fatal blow to the Academy. Kuhn, however, knew the necessary ingredients for victory: a united front involving cooperation among all liberal, advanced groups of American artists; an enterprise of such size and scope that its power would truly rival the Academy; and wide public support gained through a vigorous publicity campaign. At this point, he and his associates seem to have had no definite views about the kind of art they would exhibit; it was enough to have established a progressive organization that could effectively combat the Academy.

The association took more definite shape a few days after the initial meeting, when additional artists, more or less antiacademic in viewpoint, were invited to assemble at the Madison Gallery. Kuhn had made a special point of enlisting the interest of Arthur B. Davies, a painter he had worked with in the 1910 Independents, and he came to the first official meeting, on December 19, 1911, of the American Painters and Sculptors (soon to be incorporated as the Association of American Painters and Sculptors). Almost half of the group who attended had exhibited at the Madison Gallery.[2] Some of the older men had been associated with the Exhibition of Independent Artists, and in certain ways the AAPS carried on the principles established by the artists who had organized that show. Valuable as it was, the 1910 exhibition had had several serious flaws. The central problem was Henri's personal domination of the show, which, with the assistance of several confederates, he shaped according to his own ideas. Because a number of advanced artists were left out, the Henri group was accused of factionalism. What had been advertised as a liberal, open forum for unacademic art turned out to be restrictive too, though in a different way. Moreover, it was a single event, produced without a permanent organization to continue it; Henri refused to establish a formal society that would present future shows.

The AAPS, however, created a national organization. The group adopted a definite platform "for the purpose of developing a broad interest in American art activities, by holding exhibitions of the best contemporary work that can be secured, representative of American and foreign art."[3] Until this time, the National Academy's shows of conservative art had been challenged only by displays of independent progressive efforts by *American* artists. But to drive home their point, the AAPS decided to invite European entries along with American examples. It is worth noting that among the artists attending

the first meeting, only Davies and D. Putnam Brinley had a close knowledge of advanced European movements. Brinley, an Impressionist who had lived in Paris from 1905 to 1908, had been a close friend of Steichen, had exhibited at the Salon d'Automne, and in 1908 had been invited to join the New Society of American Artists in Paris. A member of the Photo-Secession who had exhibited in the 1910 Younger American Painters show at 291, he was the only member of the AAPS who was formally linked to the Stieglitz circle.

It was really Davies, also in touch with Stieglitz and 291, who exerted the most influence in directing the AAPS to advanced foreign art. More than any other member, he had fought behind the scenes for the recognition of modern European painting and sculpture, and he must have realized how urgently American artists and the general public needed substantial exposure to these revolutionary currents. He was able to realize his goals on a large scale when he was elected president of the AAPS on January 9, 1912, replacing J. Alden Weir, who resigned after a brief tenure.

The constitution, which Davies had helped to write, stated that the object of the association was "to provide an adequate place for, and to hold periodically, national and international exhibitions of the best examples procurable of contemporary art in New York or wherever else the Association may hereafter designate." [4] When Davies became president, however, the type and character of the first exhibition had not been determined. During the spring of 1912, Walt Kuhn, the secretary of the AAPS, debated the question at length with Davies, who must have fired the younger man's enthusiasm for contemporary European art. "All this," Kuhn wrote later, "only helped to provide in me the desire to go and see for myself. So with growing familiarity of the subject, due to my talks with Davies (who was thoroughly informed) the picture gradually shaped itself." [5] The catalyst for their plans was a copy of the catalogue of the Cologne Sonderbund exhibition, a show Davies wanted to emulate. Davies sent the catalogue to Kuhn, expressing the hope that he could get to Germany to see the show before it closed. "In a flash I decided," Kuhn recalled,[6] and he immediately embarked to see the Sonderbund exhibition and to borrow examples of avant-garde painting and sculpture from all over Europe.

It appears that Kuhn gleaned his knowledge of modern art almost entirely from Davies, whose "thorough understanding of all the new manifestations" [7] he admired.[8] As early as 1909, if not earlier, Davies had been "a regular and frequent visitor" [9] to the exhibitions at 291, and he was one of the few clients who purchased works from the gallery before 1913. Although Davies and Stieglitz were traveling on separate paths, they admired and respected one

another, and each must have realized that the other was working diligently for the advancement of modern art in America.[10] Kuhn, in turn, benefited indirectly through Davies from Stieglitz's pioneering displays and informative conversations about modern art. Kuhn's experience, supported by his taste and intelligence, enabled him effectively to choose works of art in Europe for the Armory Show.

It was Kuhn's self-confidence and passionate belief in the cause of the AAPS that helped him to secure important loans from artists, collectors, and dealers in Cologne, The Hague, Munich, and Berlin. After visiting these cities, he arrived in Paris, where he called on Alfred Maurer, Jo Davidson, and Walter Pach. While Maurer and Davidson, both loosely affiliated with Stieglitz, made several introductions that were useful to Kuhn, it was Pach who proved to be his most valuable ally. A former pupil of Henri's who was painting and writing in Paris, Pach was one of the best informed Americans on the subject of modern European art. Endowed with a fine historical sense, he had become well acquainted with the art of the Post-Impressionists, Picasso, and the Fauves, had befriended Leo and Gertrude Stein, and was personally acquainted with many of the leading French painters and sculptors. When Davies came to Paris to help Kuhn early in November, Pach introduced the pair to influential members of the art world, making essential contacts for them among the advanced artists and dealers. Kuhn gratefully gave him credit for "a large measure of our success." [11]

During their stay, Davies and Kuhn also paid a visit to Marsden Hartley, living in Paris, and borrowed two of his still lifes for the show. At this meeting, Davies asked Hartley if he thought Stieglitz would help them, and the artist told them that he was certain that they could count on the photographer's cooperation.[12] Kuhn and Davies then embarked for London to see the Second Post-Impressionist Exhibition at the Grafton Galleries, from which they borrowed several works. Although they did not travel to Italy, the pair secured from the Futurists a promise of loans, which was broken at the last minute.

Meanwhile, a domestic committee of the AAPS was obtaining entries from American artists; this section was to be twice as large as the foreign portion. Members compiled a list of progressive American artists to whom invitations to exhibit were issued. (Responding to the publicity about the show, some younger artists asked to be included, so the domestic committee was also obliged to serve, in effect, as a jury.) Every effort was made to represent all of the important antiacademic currents in America, together with unaffiliated artists of merit. The largest group consisted of Henri's associates and former

students, followed in much smaller numbers by the Madison Gallery circle, which included many of the original founders of the AAPS. The next important bloc was the Stieglitz group; all of the prominent exhibitors at 291 were included except for Dove and Weber.[13] Nearly all of the most advanced American entries came from the Stieglitz group, the outsiders being Morton Schamberg, Joseph Stella, William and Marguerite Zorach, and the Synchromists. The Synchromists were represented by Morgan Russell and Patrick Henry Bruce, but the cofounder of the movement, Stanton Macdonald-Wright, did not participate. The remaining artists – and there were many – were independents who had embraced modernism in varying degrees but were not closely affiliated to the groups just mentioned.

In choosing for the European section of the show, the organizers hoped to educate the American public in the evolution of modern painting from the early nineteenth century to their own time. Beginning with Goya, progress toward contemporary art was illustrated by the contributions of Ingres, Delacroix, Corot, Puvis de Chavannes, Courbet, Degas, Manet, the Impressionists, Cézanne, Seurat and the Neo-Impressionists, Van Gogh, Gauguin, Toulouse-Lautrec, and Redon. The show's survey of "the present situation"[14] stressed the French contributions, though there were examples of contemporary work from England, Ireland, Holland, Germany, Austria, and Switzerland. All of the major figures in French painting were represented – Matisse, Picasso, Braque, Duchamp, Picabia, and Delaunay – along with Fauves who followed Matisse's lead – Camoin, Derain, Dufy, Friesz, Manguin, Marquet, and Vlaminck – and the lesser Cubists Gleizes, La Fresnaye, Léger, and Villon. The show included only one significant pioneer from outside of France, Wassily Kandinsky, whose sole entry, the abstract *Improvisation No. 27* (1912, Figure 82), was purchased by Stieglitz.

What was Stieglitz's relation to the Armory Show? His role as spiritual father of the progressive artists was recognized in the public press by several knowledgeable writers. Before 1913 his shows at 291 had presented many of the leading European modernists whose works were displayed at the Armory – Manet, Renoir, Rodin, Cézanne, Toulouse-Lautrec, Matisse, Picasso, and Rousseau – not to mention the innovative American artists of his own circle. Stieglitz had also given practical help by lending works from his own collection – several Matisse drawings, a drawing and a bronze head by Picasso – and he served as an unofficial public information agent concerning the art and artists represented in the show. Interested critics and journalists realized that he, more than anyone else, could enlighten them on questions about the new art. In January 1913, Stieglitz was pressed into service to write an

82. Wassily Kandinsky. *Improvisation No. 27*. 1912. Oil on canvas. The Metropolitan Museum of Art: The Alfred Stieglitz Collection, 1949.

explanatory article for the *Sunday New York American*, "The First Great Clinic to Revitalize Art" (January 26, 1913), which was meant to prepare the public for the coming event.

To draw attention to the Armory Show, in June 1913 Stieglitz devoted a special issue of *Camera Work* to modern art. In it, he featured a long critical interpretation of the show by Oscar Bluemner, along with related articles by Gertrude Stein, Mabel Dodge, Gabrielle Buffet Picabia, Maurice Aisen, Benjamin de Casseres, Francis Picabia, and John Weichsel. At 291, however, he did not attempt to explain or supplement the show, presenting, instead, a one-man exhibition of his own photographs, his only show at the gallery. By 1913, photography was firmly established as a vehicle of artistic expression, thanks in large measure to Stieglitz's own strenuous efforts. It was logical, therefore, for America's foremost photographer to present his own works as a challenge to himself and to the art world at large. He wrote a friend: "I am putting my work to a diabolical test. I wonder whether it will stand it. If it does not it contains nothing vital." [15]

Stieglitz also contributed to the success of the Armory Show in other less obvious ways. Many of the critics who supported the show — and there were quite a few who did — had been educated by five years of exhibitions and explanations of modern art at 291. In laying this foundation, Stieglitz in-

directly promoted the surprisingly large number of sales that were made from the show — 174 works in all. This unexpected commercial success worked to Stieglitz's advantage, too, for collectors would now purchase more readily from the shows he presented at 291.

Stieglitz knew very well that he and his gallery had provided the essential germ for the Armory Show, and he stated this in letters to his friends at the time of the exhibition. Yet in a rare moment of humility he wrote Davies to tell him how much he appreciated his efforts: "A vital blow has been struck. . . . You have done a great work. My compliments also must be extended to all those who helped you to realize the big task you set yourself." [16] Davies and his colleagues had done what Stieglitz would never have attempted himself. Like Henri, Davies wanted to spread the word about progressive art far and wide, to let it stand or fall on its own merits; Stieglitz aimed his crusade at a select audience that he could personally control within the aesthetic sanctuary of 291.

After the Armory Show:
Stieglitz and the Changing Aesthetic Climate at 291

Although Stieglitz disliked the popularizing aspect of the Armory Show — he once referred to it as a circus — he saw that the show had vindicated him and his crusade for modern art. He quickly recognized that a large part of his battle was over. After 1913 he continued to promote advanced painting and sculpture at 291, but, having been deprived of his unique role and feeling that his supporters were drifting away from him, he gradually lost enthusiasm for his task and assumed a more passive role in the New York art world.

New galleries began to spring up, and several older ones shifted their emphasis to capitalize on the anticipated surge of interest in modern art. Between 1913 and 1917, 291 was rivaled by the Daniel, Carroll, Washington Square (later Coady), Montross, and Bourgeois galleries, along with The Modern Gallery, an offshoot of 291. [17] Various clubs and exhibition societies began to sponsor shows of progressive American art, the most notable of which were the 1914 Exhibition of Contemporary Art at The National Arts Club and the Forum Exhibition of Modern American Painters of 1916 (Stieglitz was one of its organizers). The Society of Independent Artists held its first annual in 1917. [18]

Just as 291 was challenged, so *Camera Work* lost its exclusiveness as the

only avant-garde periodical of the arts in America. Journals like *The Seven Arts* and *The Soil* explored ground that it had opened up. Later issues of *Camera Work* became fewer and thinner, and Stieglitz occasionally left some of the tasks of producing the magazine to others. In the years before 1913, he had pinned his hopes on *Camera Work* as a powerful medium of reform for photography and art, but after the Armory Show, he became depressed by his failure to gain a sizable number of converts to modernism, and he gradually withdrew from the arena, abandoning any strong desire to win over the public.

Despite his discouragement, Stieglitz proceeded with his annual exhibitions, though without the visionary zeal of the pre-1913 years. He mounted shows of European and American art that satisfied him or served the interests of his close associates, without worrying about how many people came to see them. Because he cared little for publicity and would not try to compete with the new galleries, attendance at 291 gradually dropped. But he remained firm in his resolve to attract buyers for the American artists closest to him — Marin, Hartley, Dove, Walkowitz, and O'Keeffe — so that they could live from the sale of their paintings and eventually become self-supporting. For this reason, he gave them exhibitions regularly. At times, however, he seems to have relaxed his firm control over the gallery, for he exhibited secondary talents too, at the suggestion of his colleagues. Such artists as Marion Beckett, Katharine Rhoades, Charles Duncan, René Lafferty, Frank Burty, and Torres Palomar made their debuts at 291 between 1914 and 1916, and one cannot help but feel that Stieglitz opened his doors to some of them as a gesture of friendship, rather than out of strong conviction.

After 1913, 291 changed from a pioneering institution to a more exclusive center for aesthetic investigation. Stieglitz continued to envision 291 as a "laboratory," but it gradually became a kind of private club devoted to an artistic elite. (Stieglitz and his friends are shown on a picnic outing, 1914, in Figure 83.) More and more, he rejected commercialism, especially the kind he found in the New York galleries established in the wake of the Armory Show. The keynote of 291 thus became "purity," an unspoiled dedication to honesty and idealism in all aesthetic endeavors. Stieglitz still regarded his work there as part of the fight for excellence in artistic photography, although from 1913 to 1917 he came to believe that all but a few of its practitioners were unimaginative and unable to receive his message. Discouraged by his failure to reach the photographers, Stieglitz increasingly used 291 as a means of nurturing the creative development of a select group of talented American artists he believed in.

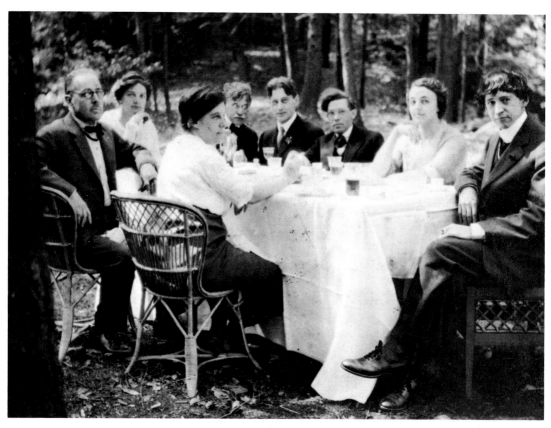

83. *Picnic at Seven Springs Farm, Mount Kisco, New York.* 1914. Photograph. Abraham Walkowitz Papers, Archives of American Art, Smithsonian Institution. Left to right: Eugene Meyer, Jr., Agnes Meyer, Emmeline Stieglitz, Alfred Stieglitz, Paul Haviland, Abraham Walkowitz, Katharine Rhoades, John Marin.

Stieglitz is said never to have told his artist friends how or what to paint. He liked to think that he allowed them infinite freedom to create as they pleased, but in subtle as well as explicit ways he shaped the aesthetic climate at 291.

Stieglitz did not write much about art. But by gathering a group of critics, artists, and patrons whose views were in accord with his own, he created a milieu that was largely an expression of his personal ideas. He exerted his influence directly by talking endlessly to friends and visitors who came to the gallery, using parables and experiences from his own life to illuminate specific issues in the arts. The personalities who met at 291 must have gained

much from Stieglitz's discourses and from long talks around the potbellied stove in the back room of the gallery.

From these discussions and from the exhibitions and the articles in *Camera Work*, a definite 291 aesthetic took shape. There were two cardinal principles: the work of art had to be a frank expression of the feelings of the individual who produced it, without regard for conventional rules or the styles of any other artists; and the creator of the work was expected to add something new to what had gone before. "I am interested in development, in growth," Stieglitz said.[19]

Beside these two broad principles, a set of identifiable aesthetic tenets characterized the 291 milieu after 1913 and conditioned the thinking of the artists who came to the gallery. Essential was the idea that abstraction could best express the artist's inner feelings, a view that owes much to Kandinsky's aesthetic theories. These feelings, however, could be generated by the artist's particular experiences in the real world, as Picabia had demonstrated in his New York paintings of 1913. If the work of art was to have a recognizable subject, the most appropriate would be a theme concerning the city or unspoiled nature, both of which might (but did not necessarily have to) embody a distinctly American character. (These interests echo Stieglitz's own dual concern with New York City and Lake George as subjects for his photographs.)

Much emphasis was placed on the unconscious mind and the discovery of thoughts and feelings from within. Stieglitz and his circle, however, did not believe in the unbridled flow of unconscious imagery as, for instance, in the manner of Gertrude Stein. They felt instead that the expression of subjective feelings should be channeled within a pictorial structure of lasting aesthetic value. (For this reason, the discipline of Cézanne and the Cubists was valued at 291.) The group, moreover, did not advocate every possible kind of emotional expression: there was a strong belief in healthy optimism in the artists' attitudes toward their themes, with little or no reflection of the irony and despair of the European Dadaists. The 291 circle's commitment to Walt Whitman's forthright romantic celebration of America undoubtedly influenced the content of many of their paintings. Yet the formal language the artists used to express themselves could hardly be called nativist because it derived in large part from the most sophisticated works of the European avant-garde.

Although the Stieglitz coterie continued to play an important role in the artistic vanguard in New York after the Armory Show, other circles grew up that challenged its exclusiveness. The groups that gathered around Mabel

Dodge and Walter and Louise Arensberg, the most impressive rivals to the 291 circle, actually included a few members of Stieglitz's entourage, but the direction and character of these newer groups were fundamentally different from 291.[20] By way of comparison, let us consider the scope of their activities.

Mabel Dodge and Her Salon

Mabel Dodge (1879–1962) (Figure 84) became an influential member of the New York avant-garde in the winter of 1912–1913 when she established a salon that was the first to rival 291. Already known to a select circle of advanced writers and artists, Mrs. Dodge gained prominence when she contributed an article on Gertrude Stein to a special issue of *Arts and Decoration* published in connection with the Armory Show. This not only brought the controversial Miss Stein to the attention of the New York public, it also placed Mrs. Dodge in the limelight as a sympathetic interpreter of experimental art forms. From 1912 to 1917, when she left for Taos, New Mexico, her apartment at 23 Fifth Avenue was the site of endless artistic, literary, and political discussions.

She was a wealthy aristocrat from Buffalo who had been widowed early in life. Seeking some new direction, she left this country to live in Europe, a change that seems to have rejuvenated her. There she married Edwin Dodge, a Boston architect who adored her but remained in the background of her cultural pursuits. In the early years of their marriage they lavished their attention on the charming Villa Curonia, just outside Florence. Mrs. Dodge was keenly interested in interior decoration, and she made the villa a showplace. Gregarious and intensely interested in people, she became an internationally popular hostess with the leading figures in the arts from all over Europe, and for ten years there was a steady flow of artists and writers through the villa.

Her artistic horizons were greatly expanded upon meeting Gertrude Stein. The two women were drawn to each other immediately. Mrs. Dodge was delighted to discover at 27 rue de Fleurus the paintings of Cézanne, Matisse, and Picasso, and there she could discuss the work of these artists with Gertrude and her brother Leo. Mrs. Dodge did not have a great intellect, but she saw that a revolution was taking place in the literary and visual arts, and she intuitively sensed the importance of these changes. She seems to have

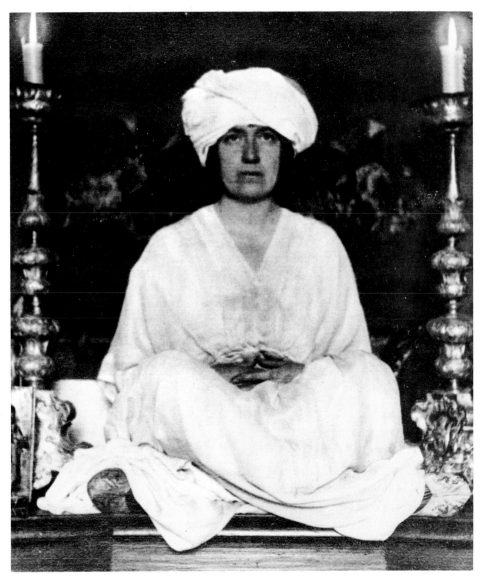

84. *Mabel Dodge Luhan*. Photograph. Collection of American Literature, Beinecke Rare Book and Manuscript Library, Yale University.

been caught up in the creative spirit of the new movements, although she was fundamentally interested in how people affected her and her effect upon them. She admired the Steins for buying works of art for their appeal rather than for status, and through their example, Mrs. Dodge gained the courage to support artists who appealed to her, without worrying about whether critics considered them acceptable.

In the fall of 1912, the Dodges had to leave Italy for the United States so that Mrs. Dodge's son could attend school. Seeking sophistication, they gravitated to New York and there rented an apartment at 23 Fifth Avenue, not far from Washington Square. Shortly after the Dodges arrived in New York, they reestablished contact with the American sculptor Jo Davidson, a

friend they had met in Europe, who had recently been elected to the Association of American Painters and Sculptors.

Through Davidson, Mrs. Dodge became involved in the preparations for the Armory Show. It is hard to determine precisely what her role was, although we know she contributed money toward the show and wrote Gertrude Stein: "I am working like a dog for it. I am *all* for it. . . ." [21] Her article about Gertrude Stein for the Armory Show issue of *Arts and Decoration* was "the first thing that was ever published in America about her [Stein's] writing." [22] But this piece, which was quite complimentary, marked the end of the friendship between the two women; Gertrude, Mrs. Dodge thought, was becoming jealous of the public attention she was receiving. [23]

Mrs. Dodge soon went to see Alfred Stieglitz and became a frequent guest at 291. These visits must have contributed much to her artistic education, although her thinking and her tastes had already been shaped to some extent by Gertrude and Leo Stein. Like Gertrude in Paris, she began to attract creative figures from the world of art and criticism, and she often invited them to take lunch and dinner at her Fifth Avenue apartment, which she had decorated entirely in white. Stieglitz did not become a member of her circle, being serious and unsocial when he was outside his own domain; but Marsden Hartley was close to Mrs. Dodge and spent much time with her and her friends during his visit to New York in late 1913 and early 1914.

By the late spring of 1913, Mrs. Dodge's "evenings" had become famous among the New York intelligentsia. People from all stations of life appeared on the scene — "Socialists, Trade-Unionists, Anarchists, Suffragists, Poets, Relations, Lawyers, Murderers, 'Old Friends,' Psychoanalysts, I.W.W.'s, Single Taxers, Birth Controlists, Newspapermen, Artists, Modern-Artists, Clubwomen, Woman's-place-is-in-the-home Women, Clergymen, and just plain men all met there and, stammering in an unaccustomed freedom a kind of speech called Free, exchanged a variousness in vocabulary called, in euphemistic optimism, Opinions!" [24] Such noted personalities as Carl Van Vechten, Lincoln Steffens, Hutchins Hapgood, and Max Eastman were present at her salons, together with the painters Hartley, Marin, Picabia, Maurice Sterne, and Andrew Dasburg. The intellectual and aesthetic ferment generated at her apartment had no particular direction; people were mainly interested in exchanging their own highly individualistic ideas. Still, Mrs. Dodge played an important role in drawing together many influential figures in the world of the arts and social reform. Never claiming to be an intellectual or artist herself — although she was a talented writer of memoirs — she simply enjoyed serving as a catalyst. As Jo Davidson said: "With

taste and grace, the courage of inexperience and a radiant personality, she had done whatever it had struck her fancy to do and put it and herself over." [25] As time went on, she became more interested in social radicalism and anarchism, becoming a close friend of John Reed, a poet and journalist who was moving toward political radicalism. In the course of these tempestuous years in New York, Mrs. Dodge divorced her husband and invited John Reed to live with her. In 1915 she was attracted to the artist Maurice Sterne, with whom she also lived before their 1917 marriage. In that year, the couple left New York to settle in Taos, which was just becoming popular as a colony for artists and writers. Mabel and Maurice soon found they were incompatible and separated after a brief marriage. Before the break, Mabel found what she had been looking for as a spiritual complement to her own personality — Tony Luhan, a Pueblo Indian, whom she subsequently married.

With her removal to Taos, she permanently severed her ties with the New York scene and contributed nothing further to the activities of the avant-garde in that city.

New York Dada and the Arensberg Circle
by Louise Hassett Lincoln and William Innes Homer

The second group rivaling 291 gathered around Walter Conrad Arensberg (1878–1953) (Figure 85), beginning in 1914. Its interests were on the whole different from those of the Stieglitz circle, although the two groups shared several members. Arensberg was perhaps less knowledgeable than Stieglitz, but he was also less domineering and self-assertive and more interested in listening to the opinions of others. He was an unusual figure to find at the center of an artists' group, and his friends were as exceptional as he was.

After graduating from Harvard in 1900, Arensberg traveled to Europe, spending the better part of a year in Italy, where he became deeply interested in Dante. He returned to his alma mater for a year of graduate study and then moved to New York to work as a reporter for the *Evening Post*. There he began to develop a serious interest in art. In 1907 he went to Boston to marry Mary Louise Stevens, an intelligent, sensitive musician from Lowell, Massachusetts. The Arensbergs lived in Boston for five years, and during this period Walter concentrated on writing poetry. While visiting New York in 1913, he attended the Armory Show on the last day of the exhibi-

85. *Walter Conrad Arensberg.* Photograph. Collection of Beatrice Wood.

tion. Although he did not purchase anything, he was so thunderstruck by what he had seen that he forgot to go home for three days. When he returned to Boston, still moved by the impact of this experience, he was determined to move his household to New York so that he could be close to the people and ideas that fascinated him.

By early 1914 Walter and Louise Arensberg were settled in a comfortable apartment on West Sixty-seventh Street (Figure 86), and at that point they began to collect art and artists. Among the first guests were artists Walter had met at the Armory Show; the first canvas purchased was a small still life by Jacques Villon. Gradually the apartment became a popular gathering place for young artists, whose works the Arensbergs frequently bought. Poets also joined the circle, and by 1915 it was a well-established salon.

In that year European artists escaping the First World War began to congregate in New York, where many discovered the Arensbergs' hospitality. Of these the most important was Marcel Duchamp. Exempted from

conscription by a heart ailment, Duchamp found himself in France without the company of his friends and in an atmosphere hostile to those who were not in military service. Consequently, he decided to sail to America and arrived, it has been said, as a "missionary of insolence." [26]

When Duchamp's ship docked, Walter Pach was waiting to take him directly to the Arensbergs. At their insistence Duchamp remained as a guest until he found a suitable studio, and naturally he attended their soirées. Along with the other French artists in the city at the time, he soon became the center of attention in the New York art world. The Arensberg circle presented the best opportunity, thus far, for American and European artists to meet on an equal footing.

The guests would begin to assemble in the late afternoon and would stay until two or three in the morning. Walter and Louise provided an endless

86. Charles Sheeler. *Arensberg Apartment, New York*. c. 1918. Photograph. Philadelphia Museum of Art.

supply of food, liquor, and attention and were rewarded by the attendance of the leading figures of the avant-garde. Duchamp, Picabia, Albert Gleizes, and Jean Crotti were joined by the composer Edgar Varèse, the critic Henri-Pierre Roché, and the poet Henri-Martin Barzun to form the French contingent. Such young painters as Sheeler,[27] Demuth, Stella, Schamberg, and Man Ray, along with John Covert, who was Walter's cousin, made up the American side. The company was enlarged by Americans in other arts: the poets Alfred Kreymborg, Amy Lowell, Allan Norton, and William Carlos Williams; Max Eastman, editor of the radical journal *The Masses;* Ernest Southard, a neurologist who was a close friend of Walter's; and the dancer Isadora Duncan. There were also other assorted Europeans: Mina Loy, the British poetess and caricaturist; Arthur Cravan, a fantastic adventurer who claimed to be Oscar Wilde's nephew; and the Baroness Elsa von Freytag-Loringhoven, a redoubtable Dadaist who shaved her head, painted it purple, and decorated herself with an assortment of implements. Stieglitz was an "enthusiastic but infrequent" visitor.[28]

The dominant artistic direction of the group was toward Dada, although the movement was not officially named until 1916. In that year Dada was founded at the Café Voltaire, in Zurich, by the Rumanian poet Tristan Tzara, the writers Hugo Ball and Richard Hulsenbeck, and the Alsatian painter and sculptor Hans (Jean) Arp. The key to the Zurich Dadaists' nihilistic spirit was the effect of World War I on their personalities. As Willy Verkauf, a member of the group recalled: "Life in the years 1915–1916 had become nearly intolerable for young artists. Reason appeared to them to have been abandoned by humanity. They thought that anyone who took life seriously must perish." [29] The Dadaists saw all the old ideas of honor, courage, and beauty shattered by the war. To the sensitive artist, the world no longer made any sense. Verkauf observed: "Dada negated all the values until then considered sacred and inviolable, ridiculed fatherland, religion, morality, and honour, and unmasked the values that had been made idols of. . . . Dada was an outbreak of despair on the part of the artist, who felt the ever-deepening rift between himself and the society of a time which crystallised in senseless mass-murder." [30] The Dada artists were thus destructive, nihilistic spirits whose gestures of protest were meant to sweep away the mistakes of the past. In their works they questioned or rejected traditional political, moral, and religious values, as well as the accepted values of the fine arts.

The Dada spirit had arisen simultaneously in Paris and New York several years before 1916 without having a name attached to it. Toward the end of

the war, the American and European groups discovered each other, and Dada became an international movement. However, it lasted only a few years before dying out in the early 1920s.

Duchamp, the leading figure of the New York Dada group, had been painting for several years in Paris before emigrating. As early as 1913, he had created his celebrated *Bicycle Wheel*, generally regarded as a Dada gesture, although he was unconscious of initiating or belonging to a definite movement at the time. It is the first of a series of "ready-mades," the term Duchamp used for manufactured objects which he selected, placed in an artistic context, and signed and/or inscribed. The experimental *Bicycle Wheel* was followed by a series of increasingly sophisticated Dada works, often in the form of "ready-made" objects, many of which he produced in New York. There, in 1915, for example, he hung a snow shovel from the ceiling and gave it the title *In Advance of the Broken Arm*. The process of selecting the object, rather than making it with his own hands, became the creative act for Duchamp. By placing a commonplace manufactured object in a new context, he forced his audience to question the very nature of art. Although some viewers may not feel that *In Advance of the Broken Arm* is art, the work requires us to examine our preconceptions about artistic expression, and on this level the snow shovel is an iconoclastic work, a witty visual challenge to traditional aesthetic tastes.

It was not until 1916 or 1917 that news of Dada activities reached the United States. Works in the Dada spirit, however, were already being produced here, primarily by Duchamp and other European members of the Arensberg circle, including Picabia himself while he was visiting in 1915 and 1916. Recognizing themselves as Dadaists, the members organized Dada exhibitions, magazines, and lectures, the most famous of which was Arthur Cravan's address to society matrons on modern art, at which he arrived drunk and began to take off his clothes. Arensberg somehow kept him out of jail, and Duchamp pronounced it a Dada event and a wonderful evening. And when Duchamp's first exhibition of the famous urinal entitled *Fountain* (1917) was placed behind a partition by the committee of the Society of Independent Artists in 1917, the circle rallied in support of the pseudonymous Richard Mutt in speech and in print. Stieglitz, in turn, photographed the work for reproduction in *The Blind Man* (May 1917) and exhibited it at 291.

These incidents summarize the character of New York Dada as opposed to the European variety. The horror of World War I was much closer to artists in Switzerland and France than to the Americans and expatriates in

New York, and the European response was far stronger. Dadaists abroad reacted with a black, bitter rejection of the cultural expressions of the society that had given rise to that war. If European Dada had a destructive, even self-destructive, character, New York Dada was irreverent and almost playful. In political terms, the difference was similar to that between the committed revolutionary and the adherent of "radical chic." The American version was less violently antiart and less publicly disruptive. A comparison between European Dada magazines and the publications of Arensberg, Duchamp, and their friends shows that the American journals were not as iconoclastic either in content or in format.

New York Dada rose and fell with the Arensberg group. It appeared in its embryonic stages in 1914 and 1915, as the circle came to life, and it declined in the early twenties, when the Arensbergs moved to California. In the intervening years the circle clearly reflected Dada interests and activities. The lectures, art exhibitions, and publications, however, represent only one side of the coin. The other is less public, but equally important: the endless conversations, arguments, chess games, and word games that took place nightly at the Arensbergs were Dada both in their content and in their spirit of frivolous nihilism. The emphasis on discussion, on cerebral puzzles, the stress on the intellectual rather than the aesthetic are all characteristic of American Dada, as was the tranquil avoidance of the political and social issues that preoccupied the European Dadaists.

From the standpoint of Arensberg's legacy it is fortunate that he was not a better Dadaist, imbued with the European antiart spirit. Never really possessing the Dada contempt for works of art, he made it his business to buy the finest pieces of the period. And, when all is said and done, his most lasting contribution was as a collector and not as a Dadaist. His collection, now in the Philadelphia Museum of Art, is less a group of pictures from a particular period than a collection in which each piece caught the attention of an intelligent man of extraordinarily esoteric interests. It follows that Arensberg was less concerned with the aesthetic appeal of these works than with the mental challenge they offered him.

Patronage of "little magazines" is perhaps the literary equivalent of collecting paintings, and Arensberg took an equal interest in both endeavors. Early in 1915 he met the poet Alfred Kreymborg at the home of Allan Norton, a Greenwich Village restaurateur, poet, publisher of the magazine *Rogue*, and frequent guest at the Arensbergs' evenings. The consequence of their all-night discussion was the publication of the poetry magazine *Others*, edited

by Kreymborg and financed by Arensberg. The magazine had a fruitful and relatively long life until it folded in 1919 amid disagreement among the contributors.

Arensberg's next publishing venture, oriented primarily toward art, was connected with the first exhibition of the Society of Independent Artists in 1917. Several members of the circle were instrumental in founding the society,[31] and for the occasion of the exhibition, Arensberg, Duchamp, and Roché produced *The Blind Man*, which lasted two issues, and *Rongwrong*, which appeared only once. Duchamp later asserted that if the magazines were not Dada in name, they were in spirit.

In 1921 the Arensbergs abruptly packed up their huge art collection and moved to Hollywood, California. Perhaps the radical departure came about through their realization that the Dada movement was on the decline; perhaps, as they said, they merely became tired of the eighteen-hour daily commotion in their home.[32] They retained close ties only with Beatrice Wood, an actress and artist who followed them to California in 1927, and with Duchamp, who visited them and acted as their European agent and dealer.

All things considered, Walter Arensberg was most important historically as host of a salon, introducing and emulsifying the various characters present at his parties. Who else could have recognized so clearly Duchamp's greatness at such an early date? And who else could have provided an atmosphere interesting and attractive enough to keep William Carlos Williams coming back to be lectured by the venerable Amy Lowell? He created an ambience which allowed American and French artists and writers to mingle, and he encouraged, especially among the Americans, a free and exuberant use of the imagination, whether it was to rush to the defense of Duchamp's ready-made urinal or to turn Cravan's abortive lecture into a successful Dada event.

It is in contrast to Stieglitz that one can best appreciate Arensberg's attitude toward his friends. Here, Duchamp's criticism of Stieglitz as a "sort of Socrates," [33] moralizing and humorless, must be seen as an unfavorable comparison to his preferred host, the less doctrinaire Arensberg. While the 291 group was essentially an extension of Stieglitz and his thought, the freedom of the Arensberg circle was much more in keeping with the development of Dada.

Picabia and the Stieglitz Circle

One of Duchamp's friends, Francis Picabia, moved back and forth between the Arensberg circle and the 291 group, the only artist who served as a bridge between these two vanguard camps. Arriving in New York with his wife, Gabrielle, in January 1913 to see the Armory Show, Picabia was the first representative of the European avant-garde to make a personal appearance there. An outspoken propagandist for modern art, Picabia was lionized during his first brief visit; newspapers and magazines sent reporters to obtain his statements on modern art, which were meant to enlighten the American public. His views were indeed advanced for his time and played a central role in educating Stieglitz and the 291 circle.

Shortly after his arrival, Picabia called on Stieglitz, and the two soon became close friends. The photographer admired the intelligence and "purity" of Picabia and his wife and described them as "about the cleanest propositions I ever met in my whole career." [34] Coming from Stieglitz, never a flatterer, this was a supreme compliment. He readily brought Picabia and Gabrielle into the 291 circle and gave the artist a one-man exhibition of his recent paintings, which opened two days after the end of the Armory Show.

The photographer, always receptive to new ideas, absorbed Picabia's aesthetic canons and as a result became much more sympathetic to abstract art. In return, 291 offered Picabia stimulation not only from Stieglitz but also from such cosmopolitan spirits as Marius de Zayas and Paul Haviland. The French artist, moreover, was enthralled by the raw energy and excitement of New York, an experience that had a marked effect upon the paintings he did there.

What was the essence of Picabia's contribution to the aesthetic climate at 291? Like many other artistic rebels of his time, he started as an Impressionist and rapidly moved through Neo-Impressionist and Fauvist phases. By late 1909 he had combined Cubist elements with his Fauvist vocabulary, and before the end of the year he had experimented with almost totally abstract forms. In a restless search for an original pictorial language that would express his emotions, he tried various stylistic directions between 1909 and 1911. Although he was aware of Cubist theories, he aggressively pursued another direction — the Symbolist-Synthetist vocabulary, refined and expanded by Matisse's Fauvist coloration, a style Picabia extended even further toward abstraction. He advocated, as William Camfield has observed, "a type of painting not bound by the representation of objects, but free to express the artist's emotional states as freely as a musician might express his emotions

by improvising at the keyboard of a piano." [35] Although the fundamentals of this theory were not novel, his fervent espousal of it placed him in the front ranks of those searching for new aesthetic directions outside Picasso's and Braque's Analytical Cubism.

Picabia found congenial support for his ideas within the so-called Puteaux group in Paris. Such artists as Jacques Villon, Albert Gleizes, Jean Metzinger, and Fernand Léger in different degrees sought to relate their art to broader concerns of society, and they embraced a wide variety of advanced aesthetic doctrines, along with the basic vocabulary of Cubism. Picabia's paintings of 1912 relate to the interests of the Puteaux artists, for he was practicing a personalized form of faceted Cubism, as in *Dances at the Spring* (1912, Figure 87) and *Procession, Seville* (1912, Herbert and Nanette Rothschild Collection, New York),[36] accented by intense, rich color, based on specific events or themes in daily life. Picabia's vital interest in an art inclining toward abstraction, supported by analogies to music, appealed to the critic Guillaume Apollinaire, who became a close friend of the artist during the summer of 1912. These two, together with Duchamp, exchanged ideas on the latest currents in painting, and, as Camfield has pointed out, these discussions probably helped Apollinaire clarify his ideas about *"peinture pure"* and perceive new approaches to painting besides those of the original Cubists.[37]

The paintings in Picabia's exhibition gave the New York audience a glimpse of one of the most innovative styles being practiced at that time. His artistic language in works such as *New York* (1913, Figure 88) is quite personal and did not overtly imitate the work of any other painter, though his use of rectilinear and curvilinear abstract forms in a shallow pictorial field owes something to Picasso's and Braque's emerging Synthetic Cubism.

In the preface he wrote for the exhibition, Picabia asserted that the painter no longer needed to seek the objective representation of nature but should turn, instead, to the abstract expression of the properties of the objects that interested him. The feelings which an artist experiences before an object, he thought, could be expressed through "objective and mechanical representation," and he insisted that the painter objectify his sensations in the work of art. He buttressed his argument by citing examples from music, an art based on the laws of harmony and composition. For the "new objectivity" in painting, there are laws similar to those that govern music, Picabia believed, but the public had not yet discovered and understood these laws as they pertain to the visual arts. In his closing statement, Picabia remarked: "In my paintings the public is not to look for a 'photographic' recollection of a visual impression or a sensation, but to look at them as but an attempt to ex-

87. Francis Picabia. *Dances at the Spring*. 1912. Oil on canvas. Philadelphia Museum
of Art: The Louise and Walter Arensberg Collection.

88. Francis Picabia. *New York*. 1913. Watercolor and gouache on white drawing
board. Courtesy of The Art Institute of Chicago: Alfred Stieglitz Collection.

press the purest part of the abstract reality of form and color in itself." [38]
Picabia's wife, writing under her maiden name Gabrielle Buffet, elucidated
the last point in her article "Modern Art and the Public," published in a
special issue of *Camera Work:* "The most advanced works of this movement
[including Picabia's] seem to us a combination of different volumes of form
and color, one balanced by another, in which it is impossible to find any
vestige of representation either concrete or symbolic. These works do not
form any part of Decorative Art (as has been alleged) for they form a
unity, wholeness, in themselves, and awaken an emotion of the same kind
as that which music evokes." [39] This statement reflects some of the most ad-

vanced artistic thinking of her time, combining elements from Cubist theory and Kandinsky's views about painting, and it applies particularly to Picabia's New York pictures.[40]

After serving for several months in New York as a self-appointed cultural emissary, Picabia returned to Paris in April 1913, where he remained for the next two years, absorbing almost every important development in the avant-garde world of the arts. Particularly attracted to Apollinaire and Duchamp, he continued to move in an increasingly original direction, producing master-pieces such as *Udnie* (1913, Musée Nationale d'Art Moderne, Paris)[41] and *Edtaonisl* (1913, Art Institute of Chicago).[42] Still operating within a Cubist framework but now also influenced by Duchamp, he worked with bands and strips of color of varying width, creating highly original abstractions referring to women and the sexual experience.

In June 1915 Picabia once again appeared in New York, stopping over on his way to purchase sugar in Cuba for the French army. Apparently he did not take his military responsibilities too seriously, for he was able to involve himself in the New York art world for several months before continuing on his mission. Again he allied himself with Stieglitz, and at this time he joined forces with the younger activists in the Stieglitz circle, De Zayas, Haviland, and Agnes Meyer. Working with them, he played a part in establishing The Modern Gallery and became a contributor to the avant-garde periodical *291* which they produced, two enterprises that will be discussed in the following pages.

The De Zayas-Haviland-Meyer Circle:
The Magazine 291 and The Modern Gallery

In the quieter years of *291* following the Armory Show, De Zayas, Haviland, and Mrs. Meyer took the initiative from Stieglitz in generating public interest in modern art. Much younger than their mentor, they had begun to sense that he was losing interest in the cause. Picabia's portrait of Stieglitz as a camera (Figure 89) symbolizes the photographer's declining energies in the struggle for modern art after the Armory Show. The inscription "foi et amour" refers to his salient traits, faith and love, revealed to select friends; and at the top of the picture the lens of the camera reaches for the word "Ideal," printed in Germanic type. William Camfield observed that this is the image of a "broken, exhausted camera which had failed to attain its ideal,"[43]

89. Francis Picabia. *Ici, c'est ici Stieglitz.* 1915. Reproduced in *291*, no. 5–6, July-August 1915. Lunn Gallery/Graphics International Ltd., Washington, D.C.

a point reinforced by the automobile gearshift and brake lever, the brake in the set position for a stopped or parked car and the gearshift in neutral, providing no power.[44]

About this period, Stieglitz recalled, De Zayas, Haviland, and Agnes Meyer felt the war had "put a damper on everything." They had the idea "that 291 should publish a monthly devoted to the most modern art and satire. . . . The proposed periodical," he said, "met with my fullest approval. Maybe such a publication might bring some new life into 291." [45] He agreed to lend the name of 291 to the magazine, published it from the gallery, and with Haviland and Mrs. Meyer became one of three financial backers. The advanced cosmopolitan spirit of *291*, produced in twelve numbers from March 1915 to February 1916, was inspired by the second series of the avant-garde journal *Les Soirées de Paris*, which was under Guillaume Apollinaire's direction from November 1913 until August 1914. It was chiefly De Zayas, in close personal touch with Apollinaire in 1914, who transmitted the ideas of *Les Soirées de Paris* to the Stieglitz circle. Much of the drive behind *291* came from De Zayas and Agnes Meyer, though Stieglitz played a valuable role in editing and printing the magazine. When Picabia arrived in New York in 1915, he joined the group in producing *291*, and he remained an active contributor until early in the following year.

291 continued many of the best traditions of *Camera Work*, but it was far more experimental. Handsomely printed in a 20″ x 12″ format, issues carried reproductions of drawings created expressly for the journal by such artists as Picabia, Marin, Walkowitz, Steichen, De Zayas, and Katharine Rhoades. (The title page of the first number is reproduced as Figure 90.) The visual and literary arts were sometimes intertwined, as in Apollinaire's *idéogrammes*, or poem-pictures, and De Zayas's "psychotypes," an extension of the *idéogramme*, which he executed in collaboration with Agnes Meyer or with Rhoades. There were also reproductions of recent paintings and drawings by Picasso, Braque, and Picabia, which were meant to inform readers of the latest progress in French art.

The literary material in *291* was mainly critical and satirical, though satire did not play as large a role as Stieglitz had originally hoped it would. Contributions included essays, poems, and reviews by writers from both sides of the Atlantic such as Max Jacob, Georges Ribemont-Dessaignes, Stieglitz, De Zayas, Mrs. Meyer, Haviland, and Rhoades, together with music by Alberto Savinio. After Picabia allied himself with *291*, it took on a more pronounced French flavor, with considerable emphasis on the role of the machine in contemporary aesthetics.

291

No. 1 10 cts. March 1915

291 throws
back its forelock.

M. de Zayas

90. Marius de Zayas. *291 Throws Back Its Forelock* (caricature of Alfred Stieglitz).
Published in *291*, no. 1, March 1915. Lunn Gallery/Graphics International Ltd.,
Washington, D.C.

In design and content, there was no periodical in America more advanced than *291*. Although Herwarth Walden's journal *Der Sturm* and Apollinaire's *Les Soirées de Paris*, itself influenced by *Der Sturm*, had preceded *291* in giving sympathetic coverage to the latest developments in all media, the American journal was unparalleled anywhere in the world as a total work of art. Thanks to De Zayas's and Picabia's international contacts, *291* was frequently as adventurous as anything emerging from Paris in 1915 and 1916, and copies Picabia sent to his friends in the French capital are known to have influenced artistic thinking there.

It is to Stieglitz's credit that he was open-minded enough to assist his younger associates in producing *291*, but he was not so cooperative in the next venture they proposed. During the late spring and summer of 1915 De Zayas persuaded Mrs. Meyer, Haviland, and Picabia that a commercial branch of the gallery at 291 Fifth Avenue should be established to make modern art of high quality readily accessible to the public. Stieglitz's concept of 291 as a pure, nonprofit experimental laboratory had prevented him from making any strenuous efforts to market the works on display there. De Zayas and his colleagues, however, felt that his unwillingness to promote sales had hurt the cause. In a letter to Mrs. Meyer, De Zayas wrote:

At present it is in the power of Stieglitz to make of New York the world center of the best elements of modern art. But to do it he would have to take a business attitude which for personal reasons and lack of capital he refuses to take. The only thing for us to do, in my opinion, is to become an active and productive group. I consider this the only way in which we can be useful to ourselves and to the general movement of modern art.[46]

De Zayas, always respectful to Stieglitz, negotiated the founding of The Modern Gallery with consummate tact and diplomacy. He made it clear that the gallery would not compete with or replace 291 but would "continue your work with two different methods which complete each other: one purely intellectual at 291 and the other purely commercial at the new gallery."[47] Despite De Zayas's persuasive arguments, Stieglitz was not enthusiastic about the idea, saying he had no money to support the gallery and warning the group about all kinds of pitfalls. But De Zayas, Agnes Meyer, Haviland, and Picabia were determined to make a success of the new enterprise and arranged to finance it between themselves, with substantial help from Eugene Meyer, Jr.

A dynamic spirit of reform pervades a letter from Mrs. Meyer to Stieglitz:

> "291"
>
> announces the opening of the
>
> **MODERN GALLERY**
>
> 500 Fifth Ave., New York
> on October 7th, 1915
>
> FOR THE SALE OF PAINTINGS OF THE
> MOST ADVANCED CHARACTER OF THE
> MODERN ART MOVEMENT ——— NEGRO
> SCULPTURES—PRE-CONQUEST MEXICAN
> ART ——— PHOTOGRAPHY
>
> The gallery will be open from 10 A. M. to 6 P. M. daily, Sundays excepted
>
> The work of "291" will be continued at 291 Fifth Avenue in the same spirit and manner as heretofore
> The MODERN GALLERY is but an additional expression of "291"
>
> **291** TWELVE NUMBERS A YEAR—*Subscription price, regular edition,* ONE DOLLAR, *for Numbers 1-12, excluding the Double Number 7-8.—Special edition limited to one hundred copies on special paper, for Numbers 1-12, including special portfolio and box,* FIFTEEN DOLLARS.—*Regular edition, single copies, Ten Cents—Single copies of Double Number 5-6, Twenty cents; single copies of Double Number 7-8,* TWO DOLLARS.—*Single copies de luxe, prices on application*—ADDRESS REMITTANCES TO PAUL B. HAVILAND, *291 Fifth Avenue, New York, N. Y. Published by "291", 291 Fifth Avenue, New York.*

91. *Announcement of The Modern Gallery.* Inserted in *291.* Ex Libris, New York.

De Zayas was up here the other day and we had a long talk about 291 [referring to the gallery] and its work[,] present, past and future. We had a firm conviction that something must be done to keep us all from getting into a deep gulf of inactivity and aimlessness, to keep 291 from dying an involuntary and nasty death. . . .

Speaking for De Zayas and herself, she underlined the importance of creating a new gallery: "We both . . . felt that the only field left . . . is the scattering of works of modern artists among the American public. . . . It seems to me to be the only future left for us. Let's stop talking and do something." [48]

Thanks to these efforts, The Modern Gallery opened its doors at 500 Fifth Avenue on October 7, 1915. De Zayas had been appointed director, and the announcement (Figure 91) declaring that the gallery would sell "paintings of the most advanced character of the Modern Art Movement — Negro Sculptures — Pre-conquest Mexican Art — Photography" [49] closely reflects

195

his tastes. The following statement by De Zayas gives a comprehensive picture of the organizers' aims in establishing the gallery:

The traditions of "291", which are now well known to the public, will be upheld in every respect by the new gallery.

It is the purpose of the Modern Gallery to serve the public by affording it the opportunity of purchasing, at unmanipulated prices, whatever "291" considers worthy of exhibition.

It is the purpose of the Modern Gallery to serve the producers of these works by bringing them into business touch with the purchasing public on terms of mutual justice and mutual self-respect.

It is the purpose of the Modern Gallery to further, by these means, the development of contemporary art both here and abroad, and to pay its own way by reasonable charges.[50]

During the three seasons of the gallery's existence, certain 291 artists were also exhibited at 500 Fifth Avenue — Cézanne, Toulouse-Lautrec, Picasso, Braque, Picabia, Brancusi, Marin, Dove, Walkowitz, Paul Strand, Frank Burty, and Marion Beckett — but De Zayas placed greater emphasis than at 291 on African Negro sculpture and pre-Columbian art and featured, as well, works by Van Gogh, Derain, Vlaminck, Modigliani, Gris, Diego Rivera, Charles Sheeler, Patrick Henry Bruce, Morton Schamberg, and various lesser-known artists. The Modern Gallery, Jerome Mellquist pointed out, "was the first up-town gallery devoted to Modern Art,"[51] and it was a major source for Walter Arensberg's extensive purchases of contemporary and pre-Columbian works. He, in turn, became a financial backer of the De Zayas Gallery (1919–1921), the successor of The Modern Gallery, and the works he bought from both of these establishments constituted the core of the outstanding collection of modern painting and sculpture he gave to the Philadelphia Museum of Art in 1950.

Exhibitions of European Art at 291, 1913-1917

After the Armory Show, when other vanguard galleries, including The Modern Gallery, were trying their own exhibition schemes, Stieglitz continued to present shows of European art at 291. During the 1913–1917

92. *Exhibition of Sculpture by Brancusi at 291, March-April 1914* (Photo: *Camera Work*, no. 48, October 1916).

period, when he lost some of his drive, the younger members of his circle sympathetic to modernism – De Zayas, Steichen, and Picabia – took the initiative in helping to organize important shows for the gallery. These enriched the New York exhibition scene, and some among them were extremely influential, especially those of Brancusi, Picasso, and Braque, and African Negro sculpture.

We have already mentioned Picabia's 1913 show at 291. The next major exhibition of European art was the sculpture of Constantin Brancusi, held in March and April 1914, his first one-man show in America (Figure 92). The Rumanian had recently won a place as a leading abstract sculptor in Paris, and his pioneering work was extremely advanced for that center, not to mention New York. Stieglitz had admired Brancusi's sculpture when he was in Paris in 1911 and, at Steichen's suggestion, borrowed eight examples to show at 291. Although several pieces of Brancusi's work had been seen in the Armory Show, all were in plaster, whereas Steichen brought over sculptures in their original handsome materials – marble, bronze, and wood. Agnes and Eugene Meyer covered the expenses, and Steichen arranged the works in the galleries.

The exaggerated proportions and bold stylization of Brancusi's work shocked many people in New York, just as Cubist painting had earlier dis-

93. *Exhibition of African Sculpture at 291, November-December 1914* (Photo: *Camera Work*, no. 48, October 1916).

turbed them; somehow distortions of this kind applied to sculpture seemed all the more outrageous. Avant-garde artists, of course, must have found the show stimulating because it presented, for the first time in America, the works of an extraordinarily innovative sculptor of the modern movement. It was one of only two shows that Stieglitz offered to sculptors; the other was given almost two years later to Elie Nadelman, a Polish-born artist, active in Paris, who had settled in the United States after the outbreak of the war. (Earlier there had been several sculptures by Picasso and Matisse shown at 291, along with their paintings and drawings.)[52]

Closely related to the exhibition of Brancusi's sculpture which preceded it, and to the paintings of Picasso and Braque which followed it, was the show of African Negro art held in November 1914, "the first exhibition of its kind," Stieglitz proudly announced, "in any country as a medium of art expression."[53] It consisted of a collection of eighteen examples which De

Zayas had obtained in Paris, displayed, *Camera Work* reported, "in a setting of crude and violent color . . ." (Figure 93). Steichen was responsible for designing geometrical patterns of yellow, orange, and black paper, a prophetically modern arrangement for 1914. The examples were placed on view with the hope that the audience would regard them as works of art, not ethnological specimens, and it is obvious that the organizers of the show knew that works of this kind had influenced such modern masters as Matisse, Picasso, and Brancusi. This was an historic exhibition, though it had been anticipated on a much smaller scale by the showing of several examples of African art at Robert J. Coady's Washington Square Gallery that spring.

Of special significance in the New York art world was the exhibition of painting and drawings by Picasso and Braque held from December 9, 1914, to January 11, 1915, a small but comprehensive collection. Stieglitz had felt that 291 was suffering from inertia and wanted to stimulate interest by staging an important exhibition. De Zayas agreed and went to Paris to assemble the pictures. Originally, the plan had been to present only the work of Picasso, but when De Zayas found that his dealer, Kahnweiler, had made an exclusive arrangement with Coady's gallery for a New York showing, De Zayas obtained a group of paintings by both Picasso and Braque from Francis and Gabrielle Picabia. (The idea of including Braque's work was proposed by Picabia and accepted by De Zayas and Stieglitz.) The value of the exhibition was enhanced by the fact that the works by Braque and Picasso had been executed recently and therefore reflected some of the latest currents in French painting — the art of collage and the beginnings of Synthetic Cubism.

Immediately following the Picasso-Braque show there was an exhibition of three recent paintings by Francis Picabia, all large in scale, in January 1915. This, too, resulted from De Zayas's trip to Paris, during which he was impressed by Picabia's latest work and proposed the exhibition to Stieglitz, who asked De Zayas to bring the pictures back with him. These, like the works by Picasso and Braque, represented Picabia's current style, now entirely non-objective.

The last exhibition of a European artist was held a little over two years later — paintings, drawings, and pastels by the Italian Futurist Gino Severini. The artist had written to Walter Pach expressing the hope that he might have an exhibition in New York, and Pach asked De Zayas, who was then operating The Modern Gallery, if he would present his work. But De Zayas did not want to mix Futurism with the artists he had already planned to exhibit. He, in turn, suggested that Stieglitz might wish to give Severini an

exhibition, and the photographer agreed to do so, even though he had already announced in *Camera Work* that he intended to hold no further displays of modern European art.

The show, held in March 1917, consisted of twenty-five examples, presenting primarily Severini's Futurist style but also several of his recent Cubist works. Futurism had not been represented at the Armory Show and was rarely seen in the New York galleries, so this show was particularly noteworthy. Surprisingly, the sales were good, and several pictures went to John Quinn, the lawyer and noted collector of modern art.[54]

The Closing of 291

In June 1917, after nine years of pioneering exhibitions of modern art, Stieglitz decided to close the doors of 291 permanently. A variety of circumstances made him give up the gallery. The landlord had threatened to tear down the building as early as 1914, so for three years Stieglitz had lived in a state of uncertainty. His finances were shaky, and he was able to keep the gallery going only by borrowing money. If Stieglitz had had the drive, he surely could have overcome these obstacles, but he seems to have lost the will to fight. He was physically and psychologically exhausted after years of struggle, feeling that, in spite of his efforts, Americans had not been won over to his cause. Not only had his associates De Zayas, Haviland, and Agnes Meyer broken away from his authority, establishing The Modern Gallery and the magazine *291*, but Steichen, too, became a dissenter and openly criticized Stieglitz for his lethargy and his unwillingness to open 291 to new ideas and new personalities in the arts. Finally, the war scattered many of his former allies. Steichen volunteered and was sent to France with the American Expeditionary Forces; Haviland was called back to Limoges to help his father run the family's porcelain factory; and Agnes Meyer, already becoming independent of Stieglitz, spent more and more of her time in Washington, where she moved in 1917.

One of the most important cultural forces in America in its time, 291 passed from the scene without fanfare.[55]

·CHAPTER SEVEN·

Life and Work of the Artists of the Stieglitz Circle, 1913-1917

In the years immediately following the Armory Show, modernist experimentation flourished. Avant-garde artists outside the Stieglitz circle came into their own and allied themselves to groups and galleries besides 291. The Arensbergs, for example, nurtured American artists sympathetic to Dada — Morton Schamberg, John Covert, and Man Ray — as well as Joseph Stella and Charles Sheeler. The Synchromist group, led by Stanton Macdonald-Wright and Morgan Russell, practiced an art of color abstraction related to Orphism and found congenial support from Stanton's brother, the critic Willard Huntington Wright, and the collector John Quinn. On the other hand, advanced painters like Stuart Davis, William and Marguerite Zorach, and Thomas Hart Benton (in his Synchromist phase) and sculptors such as John Storrs, Alice Morgan Wright, and Adelheid Roosevelt did not form close attachments to the prevailing artistic circles, preferring to work independently. While all of these artists' styles were different from those practiced by the Stieglitz group, they shared the common goal of promoting the acceptance of new, experimental forms of expression and shaking America out of its provincial slumber.[1]

After 1913 the 291 artists continued to develop and mature. Although they were aware, in varying degrees, of what their American contemporaries were doing, they continued to learn primarily from the shows at 291 and from each other.

Marin: Life and Work, 1913-1917

The bonds between John Marin and Stieglitz, forged in 1909, became even closer in the years 1913–1917. Stieglitz continued to serve as Marin's agent and financial manager, but above all he was a trusted and loyal friend. Marin had married in 1912 — his only child, John III, was born in 1914 — and the family spent their winters in Brooklyn (1913), New York (1914), and northern New Jersey (1915–1917). Away on his summer painting trips, Marin wrote Stieglitz candid, revealing letters about his life and his concerns with his painting.

Because Stieglitz believed so completely in Marin, he offered him shows at 291 every year except 1914 until the gallery closed in 1917. At first, Marin, like the other 291 members, found it difficult to sell his paintings and had to depend on Stieglitz for financial support. Stieglitz's enthusiasm for his work, however, helped him obtain a modest following by the middle of the decade, and his paintings began to sell at reasonably good prices. To give Marin wider exposure, Stieglitz made arrangements with the New York dealer Charles Daniel to carry selected examples of the artist's work. Daniel, a former cafe proprietor, who entered the art business in 1913, was truly excited about Marin's paintings and successfully conveyed his feelings to a small group of collectors, who began to acquire them.[2]

During this period, Marin was so completely involved in painting that little else seemed to matter to him. Although he enjoyed the intellectual company of the regulars at 291, he had little time for their rarefied intellectualism. Always an independent, he presented himself as a natural Yankee American, a self-styled Whitmanesque folk-primitive. Yet in his stance there was a great deal of sophistication and subtle wit, and because he was ideologically attuned to the Stieglitz circle, he was able to learn much from the cosmopolitan language of advanced European art and thought.

Like Dove, Marin was well enough acquainted with European modernism before 1913 to derive much from the experience of the Armory Show. It was a catalyst that helped him to expand his artistic horizons and liberate his technique, yet because Marin had come to the Armory Show with a modernist style already formed, he was not overpowered by what he saw. He learned a great deal from the show and subsequent exhibitions of modern art in New York, but he valued his own inventiveness too much to be an imitator or an eclectic. Marin's style was dictated in large part by his im-

mediate visual and emotional response to his subject; he was not tempted to experiment with other artists' styles solely on the formal level.

During the five years after the Armory Show, Marin was a prolific water-colorist (although he did a few oils), addressing himself mainly to landscape motifs during his summers at Castorland, New York, West Point and Small Point, Maine, and Echo Lake, Pennsylvania. He was always eager to experi-ment, trying new angles of vision, new techniques, and new formal devices inspired directly or indirectly by advanced European and American painting. He almost always painted out-of-doors, and in his vital, immediate response to nature, he resembles Cézanne and Winslow Homer; he shared with these masters an almost religious devotion to nature and a belief in the economy of pictorial means. And like them he was a self-reliant individualist who could readily detach himself from the world of cultivated society. He pro-fessed no concern with the broader social issues of his time.

It is difficult to summarize Marin's creative development in the years 1913–1917 because he followed so many avenues of expression. In his works from the summer of 1913, for example, his color and technique became explosively Fauvist. Only in the following year did the firmer compositional discipline and geometric drawing of Cubism become evident. Without relinquishing bright coloration, he continued to explore abstract Cubist techniques in 1915 and 1916, at times nearly obliterating his subject matter. In the latter year, however, he often moved away from Cubist geometry toward fluid, organic near-abstractions recalling Kandinsky's nonobjective paintings.

In Castorland, in 1913, Marin painted with tremendous gusto. Giving up the Cubist allusions of his architectural scenes of 1912, he approached nature with all of the vigor of a Fauvist painter, splashing brilliant colors onto his sheets with unbridled enthusiasm. His *Castorland* (1913, Figure 94) reveals his newly liberated technique of broad, bold strokes of color, applied quickly or floated, without any particular direction, into liquid washes of pigment. The compositional structure in this and related works is quite loose; it is as if Marin had to discover the potential of vivid color and dynamic brushwork before he could consider disciplining these elements in a more reflective way.

This discipline appeared in his summer's work at West Point, Maine, in 1914. In *Pine Tree* (1914, Figure 95), for example, he retained much of the spontaneous technique and fluid color of the preceding year, but his brush drawing now defined the trees, foliage, and terrain more precisely. The frenetic tempo of the Castorland watercolors was substantially reduced, and

94. John Marin. *Castorland*. 1913. Watercolor. Courtesy of Marlborough Gallery, Inc., New York.

95. John Marin. *Pine Tree*. 1914. Watercolor. Vassar College Art Gallery, Pough-keepsie, N.Y.: Gift of Paul Rosenfeld, 1950.

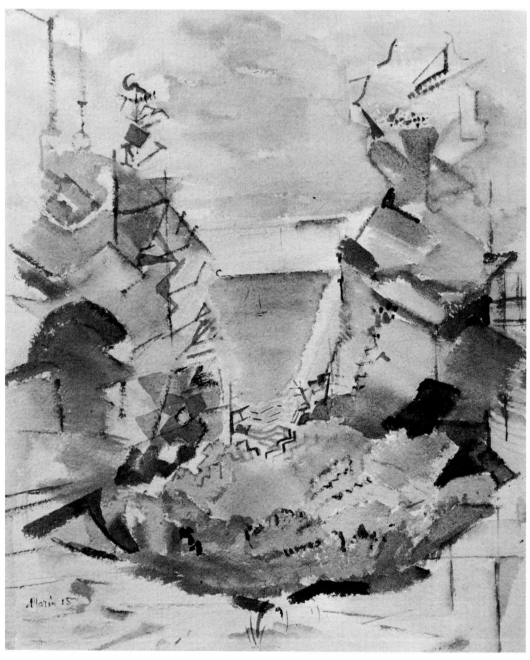

96. John Marin. *Rocks and Sea.* 1915. Watercolor. Present location unknown.

the slower brushwork served to guide and control the movement of the eye through the picture. In the depiction of the tall tree, there are hints of rectilinear Cubist drawing, but bold patches of liquid color, freely applied, still dominate this and most of the other Maine watercolors of 1914.

By the next summer, however, Marin had renewed his interest in Cubism, probably as a result of seeing the Picasso-Braque show at 291 the previous winter. His watercolors from Small Point and West Point reveal a Cubist bias that was stronger than at any time since 1912. In works such as *Rocks and Sea* (1915, Figure 96) he imposed over natural forms a linear framework that controls and articulates the pictorial space. Rather than drawing with a broad brush, he now worked with a Cubist network of thin, often discontinuous lines that define the edges of planes or hover over the colored elements. Borrowed from Cubism, too, was his heavy reliance on straight lines and sharp angles, and in 1915 he began to use repetition of geometric elements to create patterns. The dryness of execution and reduction of color in this phase of his work did not really suit Marin's temperament, but the summer of 1915 at least allowed him to control his impulsive expression of the past two years. As he wrote Stieglitz at this time: "A great man is a combination of deliberation & impulse." [3] Actually, this statement would apply better to his work of 1916 at Echo Lake, where he relaxed the confining geometric framework and once again allowed his impulsive side to come out.[4]

In 1917, the year 291 closed, Marin again found a new direction for his painting. Although he sometimes continued to work as in the preceding few years, more or less under the influence of Cubism, he now also used pronounced curvilinear compositions for a number of watercolors, including the powerful *Study of the Sea* (1917, Figure 97). Echoing Kandinsky's abstract designs, Marin created a series of swirling baroque rhythms in his work, but he did so without losing touch with his subject matter. For Marin's *Study of the Sea*, there are other possible channels of inspiration within the abstract tradition, both European and American, but whatever his sources, this stands as one of his finest watercolors.

Marin's ability to apply advanced European techniques to the personal expression of American themes and values appealed immensely to Stieglitz. Unlike Weber and Hartley, who never became wholeheartedly "American," Marin reveled in his native country. He involved himself deeply in its landscape, which he approached largely through instinct and intuition, and he was always anxious to experiment with new ways of seeing. In any given year, there were recapitulations of earlier trials, exceptional breakthroughs, and

experiments that do not follow any set pattern. His constant, energetic search for novel modes of expression and unique pictorial solutions make this period of Marin's creative life one of the most exciting in the history of American art.

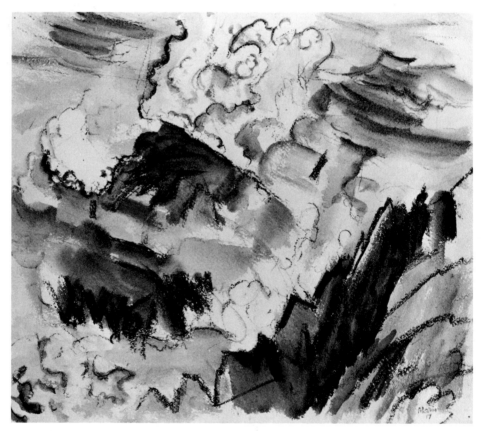

97. John Marin. *Study of the Sea.* 1917. Watercolor. The Columbus Gallery of Fine Arts, Columbus, O.: Ferdinand Howald Collection.

Dove: Life and Work, 1913-1917

Arthur Dove continued to live in Westport between 1913 and 1918. During these years he worked diligently at his farming, turning to painting only when he could spare the time for it. He was close enough to visit 291 and for his artist friends to call on him, and he became acquainted with the writers Van Wyck Brooks and Sherwood Anderson, Stieglitz admirers who also lived in Westport. Although the artist had no further one-man shows at 291 or elsewhere between 1913 and 1917, he did participate in exhibitions such as the Exhibition of Contemporary Art at The National Arts Club (1914), The Forum Exhibition of Modern American Painters (1916), and the Society of Independent Artists (1917). Because he remained faithful to the promise of abstraction, his work was always difficult to comprehend, and it attracted few buyers during this period. Still he courageously pursued it in the face of public indifference.

Until the Armory Show, Dove's knowledge of European modernism had been limited, for 291 offered only a fragmentary glimpse of the great aesthetic revolution taking place abroad. He had been struggling to create an art that was as experimental and searching as the innovative efforts of the European avant-garde, yet without fresh stimulation his painting undoubtedly would have drifted from the mainstream of modernism. The Armory Show came at exactly the right moment, giving Dove new inspiration and serving as a catalyst for his art for the rest of the decade.

Between 1913 and 1917, Dove continued to paint in an abstract idiom. Jerome Mellquist, drawing his data from Stieglitz and Dove in their later years, said that the painter "had been respectively impressed by Matisse, Kandinsky (in his 'kaleidoscopic' phase) and Picabia." [5] This reference gives us the key to the direction of Dove's post–Armory Show abstract painting. While his interest in Matisse dominated his work before 1913, Dove was undoubtedly impressed by Kandinsky's *Improvisation No. 27* (1912, Figure 82), displayed in the Armory Show. This major canvas remained in New York, accessible to Dove, for Stieglitz purchased it to educate his 291 confreres. Dove also obtained a copy of Kandinsky's seminally important treatise *On the Spiritual in Art* (third printing, 1912) and on November 19, 1913,[6] acquired *Der Blaue Reiter*, the celebrated almanac issued in 1912 by Kandinsky and Marc. Picabia's influence on Dove, on the other hand, was more immediate than Kandinsky's, stemming not only from the French painter's works hanging in the Armory Show but also from his actual presence within the Stieglitz circle.

Kandinsky and Picabia were the leading propagandists for the cause of abstraction early in the decade. Dove must have responded not only to their works but also to their theories, though we cannot positively corroborate the latter point, for between 1913 and 1917 he said very little about his aims in painting. Kandinsky and Picabia, of course, were not the only artists who interested Dove at this time; his works of the years 1913–1917 reveal influences from Cubism and Futurism as well. Still, as always, he remained true to his own unique vision and used ideas from other artists only as a springboard.

At the beginning of the 1913–1917 period, Dove was pursuing two distinct modes of abstraction, sometimes using a lyrical, organic style and at other times a more mechanical, geometric idiom inspired mainly by the dynamic Cubism of Picabia and the Futurists.[7] It is hard to say which of these two styles came first, for both resulted from his experience with the Armory Show. Because of the dominant influence of Cubism in The Ten Commandments, however, we may assume that he continued in this direction immediately after the Armory Show in works such as *Pagan Philosophy* (1913?, Metropolitan Museum of Art, New York)[8] and *Music* (1913?, Figure 98).[9] In the latter work, Dove took the established conventions of Analytical Cubism — a subdued palette, hard, geometric forms, and a shallow pictorial field — and used them to create a totally nonobjective image. Pure abstraction of this kind was exceptional anywhere in the world in 1913; at this time even Picasso and Braque had not departed completely from the natural image. Marcel Duchamp, whose *Nude Descending a Staircase* (1912) and *The King and Queen Surrounded by Swift Nudes* (1912, Figure 99) (both in the Armory Show) undoubtedly influenced the dynamic abstract movement of *Music*, likewise had not yet cut his ties with recognizable form. But Duchamp's friend Picabia had, early in 1913, produced totally abstract watercolors, which drew heavily upon the Cubist vocabulary, and it was undoubtedly the *idea* of these paintings, several of which had been based on Negro music, that stimulated Dove. He could have seen them at 291 early in 1913, together with published remarks by Picabia justifying abstraction because of its parallels to music.

Typically, Dove did not imitate Picabia's style but used his ideas as a point of departure for a language of dynamic abstraction that owes as much to the spirit of Italian Futurism as it does to Picabia or orthodox Cubism. In *Music*, Dove enlivened the pictorial field through a series of spiral rhythms, accented by a graduated crescendo of geometric elements. In its spirited movement, swirling outward from the lower center of the canvas, it re-

98. Arthur Dove. *Music.*
1913? Oil on canvas. Collection of William C.
Dove.

99. Marcel Duchamp. *The King and Queen Surrounded by Swift Nudes.*
1912. Oil on canvas. Philadelphia Museum of Art:
The Louise and Walter Arensberg Collection.

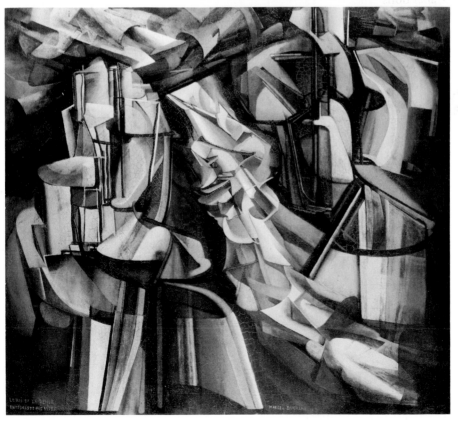

sembles a 1911 work of the same title by the Futurist Luigi Russolo (Collection of Eric Estorick, London).[10] But in translating the musical experience into purely nonobjective terms, Dove parted company with the Futurists.

Equally nonobjective is Dove's *Abstraction* (1914, Figure 100), though it is a much more lyrical work, closer in spirit to Kandinsky's abstractions than to Cubism or Futurism. The American artist followed Kandinsky in treating the canvas as an arena for the interplay of nonobjective pictorial elements and in combining patches of intense color, having little or no modulation, with strong, dark outlines that weave through or enclose these chromatic areas. Both compositions are dynamic and moving, with no fixed focal point or compositional axis.

At the same time, Dove made a fresh, original statement in his *Abstraction*. The painting is totally nonobjective, without the lingering suggestions of organic subject matter found in Kandinsky's abstract canvases of 1912–1914. It abandons Kandinsky's rich psychic space in favor of the two-dimensional reality of the picture surface, a cardinal principle of the Cubist aesthetic, but it is far more advanced than any Cubist painting of its time. True, Dove's use of unmodulated areas of vivid color, defined by enclosing contours, recalls Synthetic Cubism, a style that he may have known. But his painting deals with the rhythm and relationship of these elements in an abstract "musical" sense, well in advance of the Synthetic Cubist aesthetic of 1914. Finally, Dove's composition is surprisingly ahead of its time, having a random, expansive, noncentered quality, forecasting the achievement of the Abstract-Expressionists of the 1940s and fifties.

Music and *Abstraction* established the range of possibilities for Dove's art until the closing of 291. If there is any general tendency in his paintings of this period, it is away from the rectilinear structuring and hard contours of Cubism. Dove's lyrical side, revealed in works influenced by Kandinsky, seems to have tempered his interest in pure geometry, and during the teens these two facets are often combined in a single work, such as *Abstraction* (1915, Figure 101) and *Sentimental Music* (1917, Metropolitan Museum of Art, New York).[11] The little-known *Abstraction* is most revealing to students of twentieth-century art, for like the 1914 *Abstraction*, it also forecasts the idiom of Abstract-Expressionism. Applying muted tones of tan, gray, and brown with loose strokes, Dove combined rectilinear and curved forms that relate to each other in a spontaneous yet well-organized composition of flat surfaces. In his mixture of firm pictorial structure and free, informal execution, in fully abstract terms, Dove looks forward to the canvases of Robert Motherwell of the early 1950s and (if reduced in chromatic and

100. Arthur Dove. *Abstraction*. 1914. Oil on canvas. Collection of Mr. and Mrs. George Perutz. Courtesy: Estate of Arthur G. Dove, Terry Dintenfass, Inc.

101. Arthur Dove. *Abstraction.* 1915. Oil on board. Courtesy: Estate of Arthur G. Dove, Terry Dintenfass, Inc.

gestural intensity) the freely brushed nonfigurative paintings of Willem de Kooning of the late 1950s.

Dove sustained his efforts in pictorial abstraction throughout the decade. His 291 colleagues Marsden Hartley and Georgia O'Keeffe started in the direction of abstraction later than he; and the American Synchromists Macdonald-Wright and Morgan Russell attained a coherent nonobjective style only during the summer of 1913, well after Dove's breakthrough of 1911–1912 and did so not in America but in Paris under the direct inspiration of Delaunay's Orphist canvases. Dove is thus the leading American pioneer in the abstract idiom through the close of 291.

Walkowitz: Life and Work, 1913-1917

Walkowitz had been introduced to Stieglitz by Hartley in 1911 or 1912, and a close friendship between the newcomer and the photographer soon developed. Between 1911 or 1912 and 1917, Walkowitz spent much of his time at 291 talking with the artists and critics there and absorbing ideas from advanced European and American painting that he could incorporate into his own work. In this period he seems to have shared the attitude toward New York expressed in the work of Stieglitz, Marin, and Weber. Like them, he saw the city bursting with the energy of growth, expressed through its towering skyscrapers and swarms of people in the streets below. Though less gifted, he created his own visual hymns to the vigor and dynamism of the metropolis.

Walkowitz had occasionally painted views of the city before his first trip to Europe in 1906, but they were executed in a realistic style that paralleled, and possibly owed a debt to, the art of the Ash-Can group. After his return to the United States, New York life became his major source of inspiration, and he produced many abstract paintings and drawings based on this theme, which he called "Improvisations of New York." Although some of these city views are rather conventional in composition, Walkowitz soon infused greater energy into the buildings by tilting their axes, much as Marin had done in cityscapes of 1912. Undoubtedly following Marin's lead, Walkowitz created rapidly flowing lines in the foreground of *Cityscape* (Figure 102) and juxtaposed against this visual tumult a mass of interlocking skyscrapers whose height he exaggerated by inclining their tops away from the viewer.

Walkowitz essayed various means of transforming the city into a visually

102. Abraham Walkowitz. *Cityscape*. Watercolor. Zabriskie Gallery, New York.

dynamic image, working not from nature but rather letting his imagination run free. At times he placed Cubist grids over the facades of tall office buildings, or he multiplied the number of skyscrapers — beyond anything Marin would do — thereby exaggerating the discord and confusion presented by the spectacle of New York City. Sometimes he carried his improvisations to extremes, using city buildings as a point of departure for Cubist fantasies that have few ties with the world of reality. In *Improvisation of New York* (Figure 103) the skyscrapers have been reduced to a topsy-turvy assortment of triangles, wedges, and acute angles, tilting and leaning in every direction. In this work, Walkowitz has tried to convey the dynamic tumult and the powerful upward thrust of the buildings of the city by using devices borrowed from Marin, including a painted outer border that vignettes the

216

103. Abraham Walkowitz. *Improvisation of New York*. Oil on canvas. Zabriskie Gallery, New York.

scene. But in his eagerness to transmit his feelings with maximum impact, he has driven his points home too aggressively. Everything is in motion; there is no repose, no stabilizing elements to provide relief to the turbulent movement.

Around 1913 or 1914 Walkowitz began to execute nonobjective paintings and drawings, rather personal works in which he applied lessons he must have learned from the Armory Show, particularly from the art of Kandinsky.[12] Although there are variations within Walkowitz's abstract style, he followed

a fairly consistent approach of drawing curvilinear arabesques over the surface of the page and suggesting very little depth.[13] Sometimes he relied almost entirely on a linear network, inserting a few patches or smudges of delicate color between the lines. However, he was most successful when he orchestrated this style with a full range of hues, as in his *Color Symphony* (1914, Figure 104), undoubtedly inspired by Kandinsky and possibly also by Dove but not imitating these artists.[14] Walkowitz suggested organic, leaf-like images by meandering blue-gray lines and interlocking curves whose rhythms were echoed by wider lines, each in its own color, which flowed between them. The variegated hues of this work, comparable in richness to some of Kandinsky's 1911–1912 abstractions, testify to Walkowitz's innate gifts as a colorist of great sensitivity.

Despite the visual similarities between Walkowitz's and Kandinsky's abstract paintings, the American artist did not follow Kandinsky's system of consciously generating predictable emotions by given colors and forms. Like Kandinsky, Walkowitz thought that abstract visual elements could communicate the artist's feelings, but these forms, he felt, should be determined intuitively, on a highly personal basis. As he said: "Art is only through feeling, so alive and sensitive that the picture is as the breath out of the mouth, but coming from the heart." [15] In this sense, Walkowitz was truly a follower of Kandinsky's idea of "inner necessity" — perhaps even more than Kandinsky was himself.

Walkowitz sometimes varied his organic abstractions by imposing over their forms a geometric linear grid, inspired by Cubism. He was usually more successful when he did not try to mix spontaneous flowing lines and rigid rectilinear contours in the same work. But he did achieve an effective fusion of curves and straight lines in a series of abstractions, probably of the mid or late teens, inspired by French Cubism or its American variations. In *Symphony in Lines* (Figure 105) Walkowitz created a firm geometric armature of arcs, straight lines, and acute angles, frequently connected to each other, that reach into every corner of the sheet. To further enrich the work, he placed accents of color with soft contours within this linear network.

There is in this and related pictures an unusual two-dimensional quality to the design that has few parallels or antecedents. Max Weber's leaf and flower paintings of 1911–1912 and several of Dove's 1911–1912 nature abstractions may be cited as possible precedents, but Walkowitz affirmed, more than these two artists, the idea that painting should be a flat surface covered with an overall nondirectional linear network. In this he anticipated De Kooning's Abstract-Expressionist canvases of the late 1940s.

104. Abraham Walkowitz. *Color Symphony*. 1914. Watercolor. Zabriskie Gallery, New York.

105. Abraham Walkowitz. *Symphony in Lines*. Charcoal and pastel. Zabriskie Gallery, New York.

Stieglitz must have been well disposed toward Walkowitz's work, for he gave him four exhibitions between 1912 and 1917. (Walkowitz was also included in the Armory Show and the Forum Exhibition of 1916, but Stieglitz's exact role in placing him in these shows is unknown.) The photographer thought highly enough of him to devote part of the October 1913 issue of *Camera Work* to his work, reproducing seven examples, and he obtained money for the artist's second trip to Europe in 1914 to study art in Greece, Italy, and North Africa. But one senses that Stieglitz did not have the enthusiasm for the art of Walkowitz that he showed for Marin, Hartley, Dove, and O'Keeffe.

Walkowitz was the most important minor artist of the Stieglitz circle. Dependent mainly on the innovations of other avant-garde painters, he produced a large body of works that reflect the aesthetic climate of 291. He was a gifted colorist, but his paintings are often flawed by his monotonous compositional devices and his failure to achieve real sensitivity in drawing. Walkowitz flourished to the best of his ability within the electric atmosphere of 291; when that enterprise collapsed and he was cut off from Stieglitz, his work declined in vigor and importance, and he never regained the position he had held in the world of American painting from 1908 to 1917. He continued to produce, however, in a modernist vein, and in his later years he aggressively defended his position as one of the innovators in early twentieth-century American art.[16]

Hartley: Life and Work, 1913-1917

BERLIN, MAY 1913–DECEMBER 1915

On May 17, 1913, Hartley arrived in Berlin, where he lived, except for one brief trip to the United States, until the end of 1915. He soon immersed himself in the cultural life of the capital, attending the theater, concerts, and art galleries. Berlin was paradise; surrounded by sympathetic friends — Demuth visited him for several weeks — and delighted by the warmth of the German people, Hartley felt that he had at last found his true spiritual home. The boy in him was enchanted by the festive pageants presented by the Kaiser and his family and by the elaborate army parades. The tension, energy, and power

of these colorful spectacles, so much in contrast to the gray monochrome of Paris, inspired many of his paintings in the years 1913–1915.

Maintaining his ties with Kandinsky, Marc, and the Blaue Reiter group, Hartley believed that he belonged to the most advanced community in Europe, one in which, unlike any in the United States at that time, he had a chance of winning critical and financial support. By 1913 he had succeeded in placing his pictures in galleries in London, Berlin, and Munich, and in the fall of that year five of his paintings were shown in Herwarth Walden's Herbst Salon, the last great international show held in Germany before World War I. Stieglitz, who was supporting Hartley, hoped that he could somehow help himself by selling his work to collectors in Germany, but unfortunately very few purchases materialized, and Hartley was always short of money.[17]

In his first German period (May–November 1913), Hartley devised a pictorial vocabulary that was individual and personal, not obviously imitating the work of any other artist; yet in his choice of forms and colors he was clearly indebted to the general vocabulary of French and German modernism, particularly to Kandinsky and Marc. Hartley earnestly tried to draw his visual language from within himself, usually in response to some external stimulus, but he unconsciously reflected many of the pictorial discoveries of the two leading artists of the Blaue Reiter group, the Orphists, and Picasso and Braque, who were moving into collage and Synthetic Cubism. In his desire to make an artistic statement that was uniquely his own, he turned to subject matter that had not been emphasized by his German colleagues — abstractions based on the pageantry of the Kaiser and his entourage, military parades, and subjective "portraits" of Berlin — along with purely nonrepresentational compositions.

Gertrude Stein observed that Hartley's special forte at this time was making pictures that depended almost exclusively on color, allowing that element to triumph over line. She asserted, moreover, that he had succeeded in attaining results in his painting that in Kandinsky's were "only a direction."[18] Conscious of his debt to Kandinsky, Hartley purposely stressed the distinctions between himself and the Munich artist. About his German work of 1913, Hartley wrote that he wanted "to express a fresh consciousness of what I see & feel around me — taken directly out of life & from no theories & formulas as prevails so much today. . . ."[19] Although Kandinsky's name is not mentioned, the phrase "theories and formulas" obviously refers to the systematic principles of color and expression that he had proposed in *On the Spiritual in Art*. Hartley did admit, however, that his search was reinforced

106. Marsden Hartley. *Painting No. 48*. 1913. Oil on canvas. The Brooklyn Museum: Dick S. Ramsay Fund.

by Gertrude Stein's writings, the implication being that he followed her example in allowing his unconscious mind to dictate much of his pictorial imagery. From his liberated, fertile imagination he called up a multitude of arcane symbols, often private in meaning, that reinforce the prevailing mystical tone of his 1913 paintings.

This personal symbology appears in *Painting No. 48* (1913, Figure 106), a complex, dynamic abstraction dominated by a large centralized numeral eight, punctuated also by the number six foreshortened on the top of an unidentified drum-shaped element and by a Christian cross encircled by a flaming disc. In August, Hartley wrote Stieglitz that he was exploring the mystical significance of the number eight, which he saw everywhere in Berlin, yet he was at a loss to explain its precise occult meaning.[20] Stylistically,

107. Marsden Hartley. *Military*. 1913. Oil on canvas. Courtesy Wadsworth Atheneum, Hartford, Conn.

Painting No. 48 typifies Hartley's quest for an exciting, vibrant vocabulary that would have few, if any, links with other artists' styles. Yet the heavy outlining, the coarse brushwork, and the dynamic conflict between the shapes link the composition with the expressionist idiom of the Blaue Reiter painters. Moreover, there are clear echoes of Delaunay's Orphism in the repeated discs, stacked one above the other, at the right and left of the central images.

Something of the spirit of Kandinsky's abstract paintings of 1911–1912 permeated *Military* (also known as *Pre-War Pageant;* 1913, Figure 107), a canvas in which Hartley was carried away by his private numerology. Like Kandinsky, he worked with abstract imagery, numbers in Hartley's case being the only elements referring to the real world. (They do not signify one specific reality, as they do in Picasso's and Braque's Analytical Cubist

108. Wassily Kandinsky. *Improvisation No. 18*. 1911. Oil on canvas. Städtische Galerie im Lenbachhaus, Munich.

work, but carry esoteric symbolic meanings in addition to their military associations.) As in Kandinsky's *Improvisation No. 18* (1911, Figure 108), the abstract forms are almost entirely curvilinear and swirl about dynamically within the shallow picture-space. Characteristically, and unlike the Cubists, Hartley filled the entire canvas with equal emphasis, and in spite of the urgent visual thrusts within the painting, the effect is rather decorative. His juxtaposition of uniform tones of color and his sense of pattern may have been stimulated by the art of collage and early Synthetic Cubism, and it is also likely that his decorative sense was strengthened by his study of various kinds of primitive art, including American Indian art, in Berlin.

109. Marsden Hartley. *Movements*. 1913. Oil on canvas. Courtesy of The Art Institute of Chicago: Alfred Stieglitz Collection.

In the years 1913–1915, Hartley thoroughly explored the possibilities of abstraction. *Movements* (1913; the date is often given as 1915, Figure 109), one of the few canvases in his German oeuvre that do not refer in any way to the external world, illustrates the forceful dynamism of his fully abstract style. Aggressive, spirited movement is conveyed by a series of inverted V's, and the visual turbulence is carried further by agitated zig-zag lines and sweeping curves. The organic vitality of these inventive forms recalls the 1912–1913 abstractions of Kandinsky, but the driving sense of force suggests close analogies to Italian Futurism.

To alleviate Hartley's financial distress, Stieglitz planned a third show for

him at 291 in January and February 1914. The photographer, now hard pressed for money himself, reasoned that Hartley should try to finance his future expenses in Germany by exhibiting and selling his work at 291. Reluctantly Hartley left Berlin in November 1913 with a collection of his recent abstract paintings, the first "Germanic" series, to show in New York. The stamp of approval was given to the exhibition by essays for the catalogue by Gertrude Stein and her friend Mabel Dodge, which accompanied Hartley's own foreword.[21] He stated that the forms and colors in his paintings were created from his own experiences and feelings about the inner substance of things. It was essential, he thought, for the artist's pictorial language to emanate directly from his personal emotions, not from existing styles and theories of art. "The idea of modernity," he wrote, "is but a new attachment to things universal . . . a new fire of affection for the living essence present everywhere." [22]

Considering the American prejudice against abstraction, Hartley's show was reasonably successful. Some critics praised his achievements, and the sale of several paintings yielded enough money for him to live for another year in Germany. He was only too glad to depart for Europe in the spring — he despised New York — and he made his way back to Berlin, via London and Paris. During his brief stay in Paris, Hartley renewed his ties with Gertrude Stein and, in her company, visited Picasso in his studio in April. He also saw the Salon des Indépendants, which, except for Delaunay's entries, he considered very dull.[23] He arrived in the German capital at the end of April.

Hartley's second period in Germany, which he prolonged until December 1915, must have been a disappointment. The threat of war swept away the city's spirit of festive gaiety; although the parades continued, he now despaired at seeing the youth of Germany marching to their death. The prospect of war, moreover, seriously damaged the market for modern art, thus shattering his hopes for financial security.[24] During this period, the artist was frequently destitute, and he repeatedly begged Stieglitz for help, but Stieglitz had little money and the mails carrying his checks to Hartley were frequently delayed. Hartley's financial worries were sometimes so severe that he could not paint, and on several occasions, he did not even have enough money to buy pigments and canvas. Although he resumed painting in May, it was not until September that he fully regained his equilibrium; from then to the end of 1915, he continued to produce abstract paintings based on his experiences in Berlin.

The ebullient vitality that Hartley expressed in his first Germanic series subsided during his second period in Berlin. Sensing the growing military

tensions between the Great Powers, he painted several canvases that reflect his private escape from the inevitable, terrifying prospect of war. For a time, he turned to American Indian themes and motifs, which he viewed as a serene, pacific antidote to the prospect of armed conflict. For Hartley to identify with the American Indian, as he said he did, was to affirm the idea of human dignity, a principle that he knew would soon be threatened by the outbreak of war.[25] The forms Hartley chose for his Indian subjects are simple, pure, and hieratic; it is as if he tried to create images of compelling ritualistic power to ward off the evil specter of bloodshed.[26]

War, however, came to Germany early in August. Living in Berlin, Hartley was alternately fascinated and repelled by the conflict. The intensified military activity gave him exciting new subject matter, also favored by the Futurists, but his paintings of wartime subjects address the viewer in a serious, sometimes threatening, tone. In his military canvases, such as *Painting No. 5* (1914-1915, Figure 110), he continued the practice of using symbols, though specific references are made to actual inscriptions and military regalia. His composition, moreover, became more subdued in its movement and his coloration more somber, with increased emphasis on black. Like the work of his first Germanic series, the design was relatively flat, but now he emphasized combinations of textures and patterns, in the manner of the Cubist collage. Possibly these many attributes, shapes, and colors were meant to refer to a particular German military figure; yet there are insufficient clues to his identity, and we must satisfy ourselves with this as a generalized evocation of the military spirit.

However, in the masterpiece of his second Berlin period, *Portrait of a German Officer* (1914-1915, Figure 111), Hartley employed an abstract and symbolic vocabulary to create a memorial portrait of his beloved friend Karl von Freyburg, a lieutenant in the German army, who was killed on October 7, 1914. Borrowing from the methods of Cubist collage, but working entirely in oil, he assembled a number of fragments that relate to the subject: the initials K.v.F., the Iron Cross, regimental insignia (E signifying the Bavarian Eisenbahn regiment), tassels and braid, and various flags and military banners. Together these forms and symbols signify, but do not describe, a particular officer. Stylistically, *Portrait of a German Officer* may be aligned with Picasso's Synthetic Cubism, with its brightly colored, overlapping, and interlocking planes of uniform color. But the visual excitement conveyed by the wavy lines, sharp points, and ragged contours places it in the expressionist camp. Unlike Picasso's and Braque's Cubist collages of 1913–1914, Hartley employed signs and attributes literally to define a specific person. In this, his

227

110. Marsden Hartley. *Painting No. 5.* 1914–1915. Oil on canvas. Collection Whitney Museum of American Art, New York: Anonymous Gift.

111. Marsden Hartley. *Portrait of a German Officer*. 1914–1915. Oil on canvas. The Metropolitan Museum of Art: The Alfred Stieglitz Collection, 1949.

use of the collage technique parallels, and may have been affected by, the Italian Futurists, who frequently used topical fragments, including descriptive phrases and numbers, to refer to an actual object or event.

Explaining his wartime paintings of 1914–1915, Hartley stated that there was no hidden symbolism. Their motifs, he said, were "only those which I have observed casually from day to day," affirming at the same time that the painting reflected his "notion of the purely pictural [*sic*]." [27] The forms of *Painting No. 5* and *Portrait of a German Officer* obviously were derived from more than observation. To be sure, the themes and military iconography were drawn from the visual world, but they were transformed and then reassembled in a new order on canvas. Through their evocative power, the resulting colors, lines, and shapes re-create for the viewer the artist's feelings about the essential nature of his subject. Hartley's creative principles thus fused the Symbolist-Synthetist approach of Gauguin, carried to the extreme of abstraction by Kandinsky, with the specificity of Cubist and Futurist collage techniques which refer, openly or obliquely, to a concrete subject in nature.

During his second Berlin period, Hartley preferred not to attach himself to Herwarth Walden's Der Sturm, the dynamic center of expressionist activity in the city. He was drawn, however, to a lesser-known promoter of modernism, Otto Haas-Haye, a painter and designer of women's clothing who operated a gallery for contemporary art, sponsored a publishing house, and issued a periodical, *Zeit-Echo*, devoted mainly to German artists and writers who were depicting contemporary life. Hartley was pleased to report to Stieglitz that in Haas-Haye's gallery he had at last found the European equivalent of 291.[28] Much to Hartley's delight, Haas-Haye offered him a show at his gallery in the house of Max Liebermann in October 1915. None of the work was sold, but Hartley received considerable publicity in the Berlin newspapers.

Although Hartley was able to work productively in Berlin, he gave serious thought, on several occasions in 1915, to the idea of returning to the United States. Continually hampered by having so little money and depressed by the suffering caused by the war, he finally capitulated and sailed for home on December 11 of that year.

HARTLEY IN THE UNITED STATES, 1915–1917

Returning to New York in December 1915, Hartley renewed his friendship with Mabel Dodge. Although he preferred to associate with her lively,

cosmopolitan group, he did not sever his ties with Stieglitz and his circle. The photographer offered him a fourth exhibition in April 1916, consisting of the paintings he had produced during his second period in Germany, together with earlier examples. Because Hartley sold few works from this show or from the Daniel Gallery, where his work was also on view, he was forced to rely on Stieglitz for financial support.

It was Stieglitz who made it possible for Hartley to live and paint in Provincetown during the summer of 1916. There Hartley mingled with the Mabel Dodge circle, along with other progressive artists, writers, and social reformers — William and Marguerite Zorach, Eugene O'Neill, Leo Stein, Hutchins and Neith Hapgood, John Reed, and Hippolyte Havel. Charles Demuth, whom he had met in Europe, was also a member of this congenial group, and Hartley established a close friendship with him at this time. After most of the others left at the end of the summer, the two artists rented a house and remained there to paint for several weeks.

In the Provincetown paintings, Hartley abandoned mysticism and symbolic content, fabricating his designs almost always out of nonrepresentational geometric elements. (Sometimes the dominant triangular shapes were suggested by sails and sailboats.) A typical work is *Abstraction, Provincetown* (1916, Figure 112), a canvas based entirely on nonobjective forms, flatly colored, set in shallow space, and crisply demarcated by straight lines and curves. The vocabulary is closely derived from Synthetic Cubism, especially that of Albert Gleizes, but Hartley departed from the French painter's style by placing greater emphasis on arcs and circles and by using a vocabulary of pale, muted shades of color.

Seeking a place where he could pursue his painting yet live cheaply, Hartley spent the winter of 1916–1917 in Bermuda, which was nearly deserted because of the war. Demuth joined him, and the two lived and worked together at Hamilton and Saint George. The local landscape held little appeal for Hartley; he thought it too quaint and pretty, suitable only for Childe Hassam and "lady painters." [29] Therefore he concentrated on still-life painting, probably partly because Demuth was returning gradually to a representational mode, in works like *A Bermuda Window in a Semi-Tropic Character* (1916-1917, Figure 113). Utilizing an open-window setting, this still life follows one of Derain's favorite compositional devices as well as reflecting Demuth's interest in lush, sensuous flowers. It is hard to say whether Hartley influenced Demuth while the two were together during the winter of 1916-1917. The latter drew heavily, for the first time, upon the example of Cézanne and Analytical Cubism in his crisply drawn, delicate watercolor

112. Marsden Hartley. *Abstraction, Province-
town.* 1916. Oil on board. Courtesy of The
Art Institute of Chicago: Alfred Stieglitz
Collection.

113. Marsden Hartley. *A Bermuda Window in a
Semi-Tropic Character.* 1916–1917. Oil on
board. Present location unknown.

vignettes of the island's architecture, but his style has little in common with Hartley's in Bermuda.

Hartley did not reveal any strong new directions; he sometimes worked in a quasiprimitive Synthetic Cubist manner, and at other times he followed Demuth in using vigorous, organic curves in his flower compositions. There are, however, several still-life paintings in which he forecast the new outburst of energy that would mark his expressionist work at the beginning of the new decade, and, in a letter to Stieglitz, he spoke of painting landscapes in Bermuda that were full of anguish, terror, and spiritual content.[30] Yet there were two sides to Hartley's artistic personality in Bermuda. About his paintings he also wrote: "I know they will look fairly well for they are all subdued, and of the same quietude and intensity, which is gratifying to me, for I want my work in both writing and painting to have that special coolness, for I weary of emotional excitement in art, weary of episode, of legend and of special histories, which most painters occupy themselves with." [31]

At the time of the closing of 291, Hartley's art lacked the definite direction it had shown in Germany in 1913–1915. In retrospect, these seem to be the most important years of his career. He had succeeded in keeping pace with the most advanced developments in European painting and aesthetics, yet he also listened to the inner voice of his own creative impulse and was not ashamed of his American roots. In the German abstractions, he combined his native expressionism with his innate sense of two-dimensional design, and the results were strong paintings, tied to particular moving experiences. When Hartley was forced to abandon the congenial creative ambience of Berlin, however, his style faltered, and upon his return to America he began to experiment with form for form's sake. Perhaps a need for relief from the emotional intensity of his experiences in Berlin induced this change, but, whatever the reason, Hartley's most important period was over.

Georgia O'Keeffe:
Life and Work, to 1917

Georgia O'Keeffe (Figure 114) was born on November 15, 1887, near Sun Prairie, a farming community not far from Madison, Wisconsin.[32] She spent her early years on the family's six-hundred-acre farm, attending a country school and then continuing her studies at the Sacred Heart Academy in Madison. By the age of ten she had decided to become an artist. When she

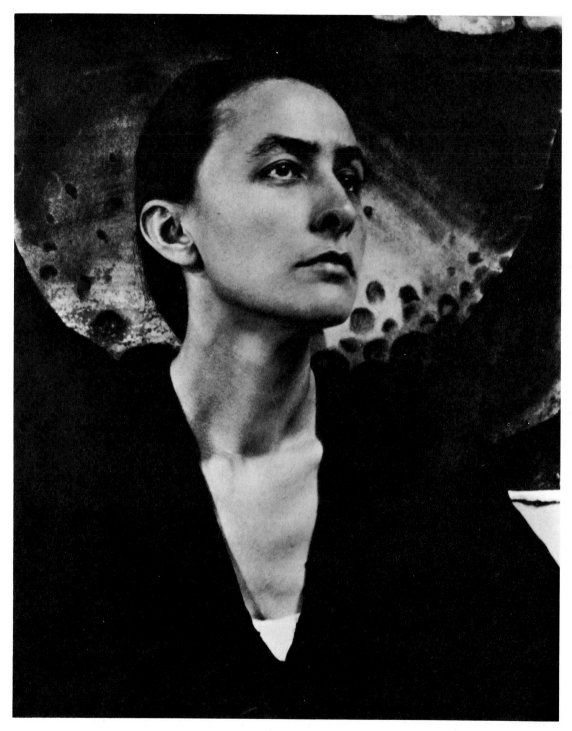

114. Alfred Stieglitz. *Georgia O'Keeffe.* 1918. Photograph. Collection of Pearl Korn.

was fifteen, the family moved to Williamsburg, Virginia, and she completed her schooling at the Chatham Episcopal Institute between 1902 and 1904.

O'Keeffe received her first professional training at the Art Institute of Chicago, where, in 1905 and 1906, she studied with John Vanderpoel, a well-known expert in human anatomy. In 1907 she went to the Art Students League in New York to spend a year under the tutelage of William Merritt Chase, F. Luis Mora, Frank Vincent DuMond, and Kenyon Cox. She was successful in following Chase's methods and, for a time, she "loved using the rich pigment he admired so much." [33] Her skill as a still-life painter was rewarded by a Chase Still Life Scholarship, which enabled her to spend part of the summer studying painting in the League Outdoor School at Lake George, New York.

An independent, self-critical spirit, O'Keeffe soon realized that it was useless to continue in the paths that others had already trodden. As she said, apropos of Chase's style: "I began to realize that a lot of people had done this same kind of painting before I came along. It had been done and I didn't think I could do it any better." [34] She abandoned painting between 1908 and 1912, though she did work for two years, 1909–1911, in Chicago as an advertising artist, drawing lace and embroidery.

After her family had moved from Williamsburg to Charlottesville, one of her sisters suggested that she attend a summer 1912 art class at the University of Virginia taught by Alon Bement. A professor of art at Columbia University, Bement played a vital role in O'Keeffe's early development, for despite his timidity and conservative mind, he communicated to her the ideas of Arthur Wesley Dow, one of the most important art educators of his time.[35] Bement constantly encouraged her and urged her to go to Columbia and study under Dow directly.

Dow had revolutionized the teaching of art by eschewing realism in favor of a system of design based on a few fundamental elements of line, value, and color. Students were expected to learn how these could be used in creating beautiful compositions, designs that were not only harmonious but also expressive of a variety of human emotions. Dow had derived many of his principles from the Synthetist painters around Gauguin at Pont-Aven and from Oriental art, which he had studied under Ernest Fenollosa in Boston. Understandably, Dow's emphasis was on flat, decorative composition in a quasi-Oriental mode, not on clever brushwork and descriptive realism.

At the end of the summer, O'Keeffe took a position as art supervisor in the public schools of Amarillo, Texas, where she remained for two years. Then in the fall of 1914, she finally went to New York, where she enrolled in

Dow's classes at Teachers College, Columbia University. She purchased his book *Theory and Practice of Teaching Art* (1908), but she could never afford to buy his influential volume *Composition* (1899, revised and enlarged edition, 1913). She did not feel that the latter work was absolutely essential to her, since she was obtaining the master's advice directly.[36] She also studied the illustrations in Arthur Jerome Eddy's *Cubists and Post-Impressionism* (1914), a book Bement had recommended to her for the plates, not the text.[37] It was here that she discovered the work of Arthur Dove, for which she professed great admiration. (Eddy had reproduced Dove's *Based on Leaf Forms and Spaces* [1911–1912] in color.) After this, O'Keeffe recalled, she "trekked the streets looking for others." [38] She also studied with much interest the 1915 Matisse exhibition at the Montross Gallery and the Forum Exhibition of Modern American Painters, 1916, where she again admired Dove's work.[39]

Her other early contacts with modern art came mainly at 291, which she first visited to see the 1908 show of Rodin drawings. Her companions engaged Stieglitz in conversation, and she listened but did not participate. Subsequently, she attended other exhibitions at 291 — Picasso-Braque, Picabia (1915), Marion Beckett and Katharine Rhoades, and Marsden Hartley (1916) — and she expressed her admiration for Marin's watercolors. Although she admired Stieglitz and what he was doing at 291, she kept her distance from him when she visited the gallery. He was "terrifying," she recalled, and asked too many personal questions.[40]

In the summer of 1915, while O'Keeffe was teaching at the University of Virginia, her friend and fellow Columbia student Anita Pollitzer began to send her information about Stieglitz and 291. In August, for example, Miss Pollitzer asked him to send O'Keeffe the June issue of *291*,[41] and subsequently the artist wrote for a subscription to that periodical.

The autumn of 1915 found O'Keeffe teaching for a semester at Columbia College, Columbia, South Carolina, a position she took reluctantly, only because she had to earn a living. Although she found the college conservative and her environment culturally barren, she was able to do a great deal of drawing and painting in her free time. She now realized that she had the facility to work in any way her teachers had told her, but she decided deliberately to seek an original, inventive style to express her personal ideas. "I realized that I had a lot of things in my head that others didn't have," she said. "I made up my mind to put down what was in my head!" [42] It would almost seem that she was following the advice of Robert Henri in making this decision. She admired his teachings, which she had received secondhand in letters from a friend who had been studying with him, and

she may also have heard echoes of Henri's ideas from George Bellows, with whom she studied briefly. Stieglitz's ideas, too, came to her via letters and clippings from Anita Pollitzer, who continued to talk with him at 291.

From this period of self-scrutiny in 1915 and early 1916 came a series of remarkable charcoal drawings, mostly abstract, that testify to the fertility of her creative imagination. *Drawing No. 13* (1915, Metropolitan Museum of Art), an outstanding example from this group, has no title to suggest a connection with the real world. Its abstract vocabulary consists of three contrasting forms — a flat plane with sawtooth edges; several bulbous, egg-shaped forms, progressively diminishing in size; and a pair of wavy lines, approximately parallel to each other, moving from the bottom to the top of the page.[43] Pressing close upon each other, these stylized, simplified shapes only hint at the organic forms of the landscape, but the ties with nature are tenuous. Of course, this and the other drawings probably would not have materialized as they did without Dow's and Bement's stimulus, but they are different from anything her teachers produced. That O'Keeffe knew Cubism and the early abstract art of Picasso, Braque, Picabia, and Dove is obvious. But she created *Drawing No. 13* distinctly in her own imaginative terms.

Late in 1915 she sent a group of these drawings — called "Lines and Spaces in Charcoal" — to Anita Pollitzer in New York. Against O'Keeffe's instructions, she showed them to Stieglitz, who was profoundly impressed by her sensitivity and talent. It was on this occasion that he exclaimed, "Finally a woman on paper."[44] He was so moved by these "really personal abstractions"[45] that he included them, together with pictures by Charles Duncan and René Lafferty, in an exhibition held at 291 in May, June, and July 1916. In the meantime, O'Keeffe, who had not been told of these plans, had returned to New York to study under Dow during the spring semester, 1916. When she heard of the exhibition, she went to Stieglitz and demanded that it be taken down. But Stieglitz, always persuasive, convinced her that the drawings should be left on the walls. Despite her initial reservations, this must have been a dream come true, for she had said that his high regard for her work would mean more to her than anything else and that 291 was the only place where she would care to exhibit in New York.

We do not know exactly what happened in the meeting between Stieglitz and O'Keeffe, but she undoubtedly fascinated him because she embodied so many of the traits, both personal and artistic, that he admired. After she left New York, he wrote her at the University of Virginia, where she was teaching in the 1916 summer session, and then at Canyon, Texas, where, in the fall, she had started to teach at West Texas Normal School. Stieglitz's letters

115. Georgia O'Keeffe. *Blue No. II.* 1916. Watercolor. The
Brooklyn Museum: Bequest of Miss Mary T. Cockcroft.

encouraged, challenged, and stimulated O'Keeffe. In addition, he helped to
expand her horizons by sending issues of *Camera Work*, the avant-garde
journal *The Seven Arts* (he obtained a subscription for her), and one of his
favorite books, Goethe's *Faust*. In the winter of 1916–1917, she read Willard
Huntington Wright's *Modern Painting* (1915) and *The Creative Will*
(1916), Arthur Jerome Eddy's *Cubists and Post-Impressionism* (1914), and
writings on modern art by De Zayas and Clive Bell. For a time Nietzsche
fascinated her.

In Texas, O'Keeffe continued to paint and draw in an exceptionally origi-
nal idiom. In a numbered series of watercolors entitled simply *Blue* she ex-
plored contrasts and harmonies of shape in completely nonobjective terms.
Working with extremely fluid variations of blue in *Blue No. II* (1916,
Figure 115) she set a pair of bold semicircular forms against four heavily

brushed diagonal strokes to create a powerful abstraction in the simplest, most economical manner. The relationship of these elementary shapes is the substance of the painting; there is no other pretext for it.

Her extraordinary talent for abstract composition gave her more representational works of 1916–1917 a strength of visual impact hardly matched by any other American artist of that time. Moved by the lonely openness and primitive power of the Texas landscape, she devised a simple, yet sophisticated, pictorial shorthand that captured the essence of her experiences without resorting to literal detail. In *Light Coming on the Plains No. II* (1917, Figure 116) she reduced the image of the early morning sun penetrating the darkness to a pair of deep blue shapes, one large and the other much smaller, each defined by a gentle curve. An untouched patch of pure white paper on the horizon signifies the brightness of the sun, and its subtle radiant light attacks the darkness in gradually diminishing steps and then is absorbed by it. The watercolor is small and unimposing; yet her breadth of vision and economy of means produced an effect that is monumental.

More boldly colored is O'Keeffe's *Evening Star No. V* (1917, Figure 117), again, one of a series. The watercolor consists of nothing more than several slightly modulated planes of intense color — yellow, orange, and red — expanding outward in concentric rings from the star to the fluctuating deep blue of the sky. The effect is so fresh, so free of "influence" that one is tempted to compare it to American color-abstractions of the 1960s by artists like Noland and Olitski. O'Keeffe, however, was not committed, as they were, to nonobjective color for its own sake. She drew her inspiration from the natural world, searching, as Matisse had done, for an abstract language that would convey the essence of her experience, yet whose visual harmonies would have a strong and lasting impact upon the viewer.

O'Keeffe sent examples of her Texas work to Stieglitz early in 1917, and in April and May he gave her an exhibition at 291, her first one-woman show (Figure 118). This was the last exhibition before the gallery permanently shut its doors at the end of the season. O'Keeffe came east in June to see Stieglitz and to view her show, but when she arrived her pictures had already been taken down. Stieglitz, however, rehung the exhibition for her to see.

O'Keeffe returned to Texas to teach during the summer and fall of 1917. After a bout of illness during the spring of 1918, she came to New York at Stieglitz's invitation. Fascinated by her fresh, unconventional talent and her engaging personality, he offered her financial support for a year so she could paint without having to earn a living by teaching. As it turned out, they fell

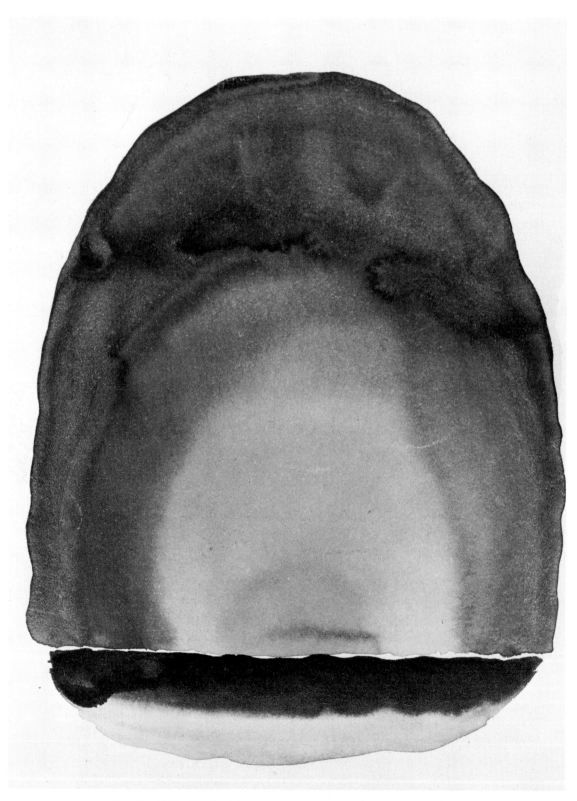

116. Georgia O'Keeffe. *Light Coming on the Plains No. II.* 1917. Watercolor. Amon Carter Museum, Fort Worth, Tex.

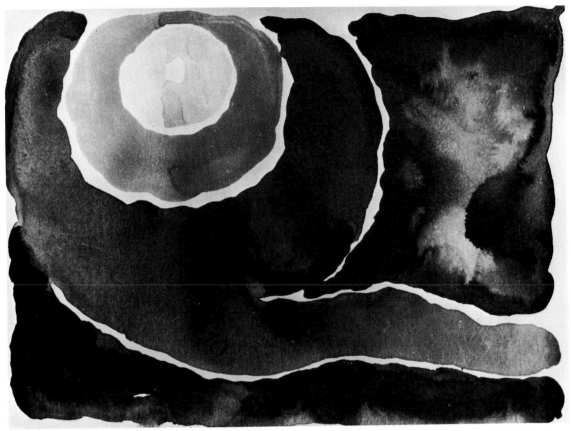

117. Georgia O'Keeffe. *Evening Star No. V.* 1917. Watercolor. Collection of Mrs. Everett H. Jones, San Antonio, Texas.

118. Alfred Stieglitz. *O'Keeffe Exhibition at 291, 1917*. Photograph. Zabriskie Gallery, New York.

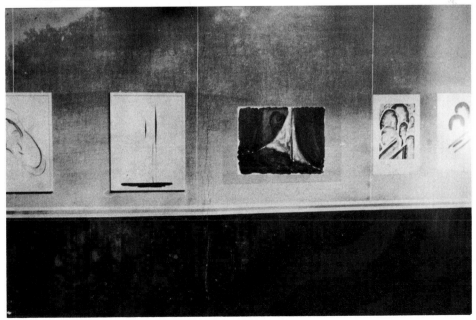

in love and, in 1918, they began to share their personal and professional lives in a union that ended only with Stieglitz's death in 1946.

O'Keeffe's works of 1915–1917 were but a prelude to her later achievements as one of America's leading abstract painters. These early experimental efforts were very much in keeping with the spirit of 291, though not self-consciously so. Unlike most of the artists who were attracted to 291, O'Keeffe kept her distance, preferring to study the exhibitions and to draw what she could from them without becoming part of the devoted circle around Stieglitz. By deliberately remaining independent of artistic cliques and fashions, she was able to preserve her original vision. In this light, her artistic achievement of the years 1915–1917 is all the more significant, for much of what she did came from her own imagination, guided but not directed by a knowledge of European and American modernism. Like Dove, she grasped the full potential of abstraction, and she also drew much of her inspiration from nature in its unspoiled state. Her lyrical and poetic sense, however, was stronger than Dove's, and she was unquestionably the most subtle and sensitive painter who was attracted to 291.

Paul Strand:
Life and Work, to 1917

In the final years of 291, Stieglitz became so discouraged by the lack of artistic vision among photographers that he almost gave up hope for any progress in the medium. He had long since stopped showing photographs at the gallery and had cut his ties with White, Coburn, Käsebier, and most of the other major pictorialists except Steichen. The Photo-Secession had virtually disintegrated.

But when young Paul Strand (Figure 119) appeared on the scene, seeming to understand what 291 really meant, Stieglitz's photographic interests blossomed once again. Strand promised a photographic renaissance, but like all rebirths in the arts, the pattern of the past was not repeated exactly. He represented a modernized version of what the older Photo-Secession photographers like White and Käsebier had achieved; Strand was a master of his craft, and he applied principles of pictorial composition from the fine arts to his photographic images. But his visual sources were far more up-to-date, far more advanced for his time than the earlier Photo-Secessionists' artistic sources had been in theirs.

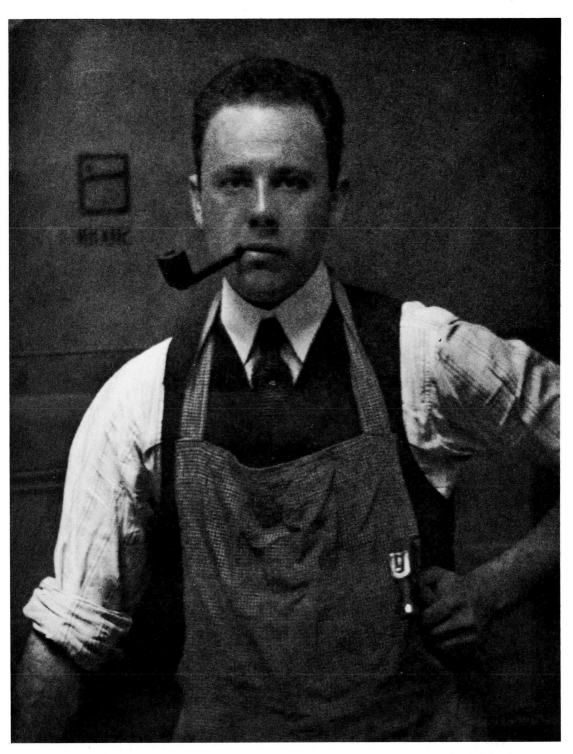

119. Alfred Stieglitz. *Paul Strand*. 1917. Photograph. Copyright 1971 by Paul Strand.

This marriage of art and photography, in modern terms, is exactly what Stieglitz had been seeking since the early days of the Photo-Secession. At the beginning, he had favored Steichen as the one who had best combined the aesthetics of art and photography, but Stieglitz had always harbored doubts about the fuzziness and romanticism of Steichen's imagery. Strand, however, did not have these shortcomings. From 1915 on, he made precise, sharp-focus prints, compatible with the "straight" approach that Stieglitz advocated. And he also understood far better than Steichen the lessons of European Cubism and abstraction. Learning much from the exhibitions at 291 and the Armory Show, Strand became the first photographer whose style was heavily influenced by modernist painting and sculpture.

Paul Strand was born in New York City on October 16, 1890, the only child of Jacob and Matilda Stransky (the family changed the name to Strand shortly before his birth). Strand grew up in the city, attending public schools until 1907, when he entered the Ethical Culture High School. It was there that he took a class in drawing, but, he recalled, he had "very little interest and little talent for it." [46] More important for his creative development was a class in art appreciation taught by Charles H. Caffin, one of the most sensitive critics writing in America at that time. Caffin not only praised the abstractness of Whistler's paintings and Japanese art, he was also a perceptive critic of photography and in 1901 had published *Photography as a Fine Art*, a pioneering book on the subject. We do not know exactly what Strand derived from the class, but he remembers being impressed by the critic's teaching and his wide knowledge. Caffin's predilection for pictorial abstraction must in some way have conditioned his thinking.

Another teacher, Lewis Hine, introduced Strand to the craft of photography. Later renowned for his stirring documentary photographs of immigrants, laborers, and slum dwellers, Hine was a biology instructor and served as a semiofficial photographer for the school. In 1901 he had obtained permission to start a class called "Nature Study and Photography," [47] and it was here that Strand learned to take, develop, and print photographs. Hine's greatest contribution, Strand recalled, was to take the class to 291, where the students saw some of the finest available examples of pictorial photography, works by the English photographers Hill and Adamson, Julia Margaret Cameron, and Craig Annan; the Austrians Hugo Henneberg, Hans Watzek, and Heinrich Kuehn; the French photographers Demachy and Puyo, and the Americans Steichen, Coburn, Käsebier, White, Eugene, and, of course, Stieglitz. Greatly inspired by his visits to 291, Strand soon decided he would become a photographer and try to do the kind of work he had seen

there. His father approved of his choice of this career, although, unlike Stieglitz's father, he could not support his son while he learned his craft. Upon graduation from high school in 1909, Strand had to go to work as a clerk and salesman in his father's importing business, and he pursued photography in his free time on the weekends. During this period, he systematically studied techniques and materials, conscientiously building a solid foundation for his future work.

In 1911 Strand took his savings and went to Europe for the summer. He saw no examples of modern art there that might have influenced him; the work he admired in the museums was that of the Pre-Raphaelites and the Barbizon school, which he later came to believe was "very poor painting." After his return, Strand set himself up as a commercial photographer, specializing in portraits and views of colleges and fraternity houses. At the same time, he was practicing photography as an art, following the currently fashionable fuzzy, soft-focus styles of the Photo-Secession, reminiscent of Clarence White.

Strand continued to visit 291 from time to time, studying the exhibitions there and bringing his work to Stieglitz for criticism. The proprietor was genuinely interested in the photographs, and his comments, Strand recalled, were enormously helpful, for Stieglitz "would look very attentively and kindly tell me where they succeeded and where they failed." Stieglitz offered general advice, too, and persuaded Strand to give up soft-focus effects:

This lens, as you're using it, makes everything look as though it is made of the same stuff: grass looks like water, water looks as if it has the same quality as the bark of the tree. You've lost all the elements that distinguish one form of nature — whether stone or whatever it may be — from another. This is a very questionable advantage; in fact, you have achieved a kind of simplification that looks good for the moment but is full of things which will be detrimental to the final expression of whatever you are trying to do.

Strand admitted that this "made a great deal of sense, and the problem could be easily solved by stopping the lens down." White and Käsebier also offered suggestions, but Strand said that Stieglitz gave him "the best criticism I ever had from anybody because it was the kind of criticism that you could say, 'yes, that's so,' and you could do something about it."

In addition to the photography he saw on his visits to 291, Strand found himself "tremendously interested" in the Cézanne watercolors, and he was drawn, as well, to the works of Matisse and Picasso. He saw these exhibitions before the Armory Show, which, in turn, he felt was a "tremendous event."

At that show he was particularly attracted to Cézanne – he saw his oils there for the first time – and also Picasso and Brancusi. After that, Strand continued to visit 291, and he was undoubtedly stimulated by the Picasso-Braque show and the Brancusi exhibition, both of 1914.

Although Strand had practiced the art of photography with some success before 1915, in that year he was suddenly recognized as a major new talent, producing a remarkable group of abstract photographs that were unparalleled at that time. Strand made his first experiments in this direction at Twin Lakes, Connecticut, during the summer of 1914, or more likely, 1915, and it was here that he produced two of his most important images, *Abstraction, Bowls* (Figure 120) and *Abstraction, Porch Shadows* (Figure 121). At this time, Strand set out to "find out what this abstract idea was all about and to discover the principles behind it. I did those photographs as part of that inquiry, the inquiry of a person into the meaning of this new development in painting. I did not have any idea of imitating painting or competing with it but was trying to find out what its value might be to someone who wanted to photograph the real world." He also said:

I think I understood the underlying principles behind Picasso and the others in their organization of the picture space, of the unity of what that organization contained, and the problem of making a two-dimensional area have a three-dimensional character, so that the viewer's eye remained in that space and went into the picture and didn't go off to the side. Everything in the picture related to everything else.

In *Abstraction, Bowls* Strand carefully arranged four ordinary kitchen bowls at different angles and recorded their interlocking shapes, independent of their utilitarian function. By thoughtfully planning his camera angle and by careful framing, Strand created a photograph rigorously organized according to abstract principles. The nearest parallels in French painting are found in Picasso's and Braque's early Cubist still lifes of 1908–1909, though the closest example, compositionally, is not a still life but a landscape, Braque's *Houses at L'Estaque* (1908, Herman Rupf Collection, Bern).[48] Strand, however, was not interested in imitating painting literally. Instead, he adroitly brought the constructive methods of Cubism to bear on the task of making a picture that was true to the optical properties of the photographic medium.

A similar application of modernist aesthetics to photography may be found in his powerful *Abstraction, Porch Shadows*. To create the desired arrange-

120. Paul Strand. *Abstraction, Bowls.* 1914 or 1915. Photogravure. Courtesy, The Witkin Gallery, Inc., New York.

121. Paul Strand. *Abstraction, Porch Shadows.* 1914 or 1915. Photogravure. Courtesy, The Witkin Gallery, Inc., New York.

ment, he tilted a porch table on its side so that its curved edge made a forceful contrast to the parallel diagonals of the shadow of the railing. Once again he tried to obliterate his subject's function, fragmenting the elements and placing heavy emphasis on their formal relationships. He skillfully accentuated the formal message of the photograph by tilting the finished image ninety degrees from the angle at which it was taken, thus moving the viewer still another step away from the world of physical reality.

The abstractness of this photograph makes it one of the most advanced pictures in America created in any medium at that time. Only Dove and Hartley, among American artists, had previously produced paintings that reveal this degree of abstraction; and Strand surely would have seen their works at 291. In later years, he professed great admiration for Hartley, and he admitted that when he executed *Abstraction, Porch Shadows*, he was visually close to the painter in using bold, simple geometric shapes and patterns, such as those found in his German canvases. In the work of both artists, abstract elements are treated largely in two-dimensional terms, arranged with little concern for pictorial depth. Both Hartley and Strand were exceptional, for they practiced an extremely advanced style for their time, the language of both men echoing the Synthetic Cubism of Picasso and Braque of 1912–1913.

Strand's early essays helped him study the relationships between inanimate objects that he could manipulate and control. Having succeeded in this, he was ready to apply the lessons he had learned to the world of human activity and to abandon formal experimentation for its own sake, never again returning to pure abstraction. His new approach is found in *Wall Street* (1915, Figure 122), a scene in which pedestrians, casting long shadows, pass before the Morgan Building, whose imposing mass dwarfs them. Strand recalls that, at this time, he had become "interested in using photography to see if he could capture the physical movement of the city and, at the same time, using the movement of people and automobiles or whatever it might be, in an abstract way, always retaining the abstract principle. . . ." His innate gift of selectivity brought him success in this venture, for the pattern of the figures in movement in *Wall Street* could not have been more effective if Strand had arranged them himself.

More obviously related to the aesthetics of Cubism is Strand's celebrated *The White Fence* (Figure 123). In this photograph, taken at Port Kent, New York, in the summer of 1916, he claimed he was applying the lessons he had learned in his 1914–1915 abstractions to a subject taken from the real world. Strand remarked that the shapes of the fence, rather than the back-

122. Paul Strand. *Wall Street*. 1915. Photogravure. Lunn Gallery/Graphics International Ltd., Washington, D.C.

123. Paul Strand. *The White Fence*. 1916. Photograph. Private Collection.

ground, fascinated him, for each broken picket was different from every other one. He believed he was visualizing the subject in a Cubist manner, treating the fence as a flat, geometric element close to, and paralleling, the picture plane; by this means he placed a limit on spatial recession. The simple, planar sides of the buildings behind the fence similarly prohibit any pronounced flow into pictorial depth. The photograph succeeds as an abstract design because Strand reduced the subject to a few clearly defined geometric elements and balanced them against each other with consummate skill. In doing so, his aesthetic was not far from that of the Cubist painters, but Strand here celebrated the particulars of the American experience.

In 1916 Strand turned quite emphatically from two-dimensional pattern and abstract form to the real world, selecting anonymous street people as his subjects. He has said that his formal experiments culminated in these photographs, images that include *Blind Woman* (1916, Figure 124) and *Portrait* (1916, Figure 125). To record these common people going about their daily activities, Strand devised a false lens for his Ensign reflex camera pointing ninety degrees away from the real lens, so that he could focus on his subjects without making them camera shy. Unlike his contemporary Baron de Meyer, who photographed picturesque gypsies and peasants posed in the studio, Strand "wanted to solve the problem of photographing these people within an environment in which they lived." He recalled having some thoughts on social reform when he was photographing these people of the streets, but he was not using his camera in the manner of Jacob Riis to expose the mistreatment of the working classes. He confessed: "I photographed these people because I felt that they were all people whom life had battered into some sort of extraordinary interest and, in a way, nobility." The subject of *Blind Woman*, his masterpiece of this group, appealed to him simply because she had "an absolutely unforgettable and noble face." In his statements about his city portraits, Strand sounds very much like one of the Ash-Can painters — perhaps Henri or Sloan. This group of artists, like Strand, portrayed the daily activity of common people in the city, not to point out social injustices, but because their lives reflected the human drama in its most natural and telling form. In this connection, Stieglitz's photograph of the lower classes in *The Steerage* (1907, Figure 34) could also be seen as a source of inspiration for Strand's individual portraits, and we should accept the possibility that this realistic image influenced the young photographer.

On a visit to 291 in 1915, Strand brought in a group of his latest abstract works, and they so impressed Stieglitz that he offered to publish them in *Camera Work* of October 1916 and to give Strand a show at the gallery.

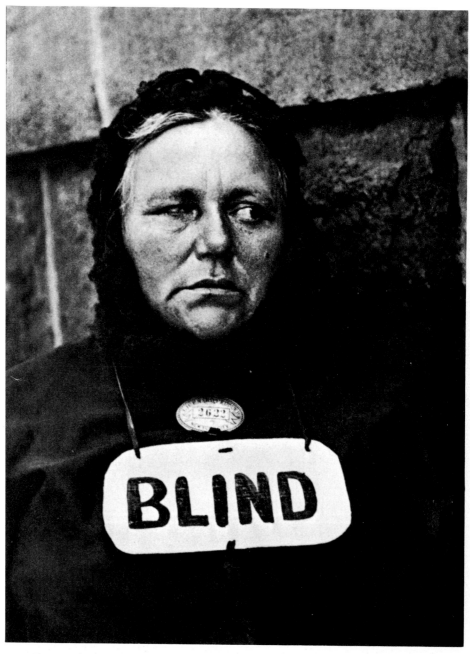

124. Paul Strand. *Blind Woman*. 1916. Photogravure. Lunn Gallery/Graphics International Ltd., Washington, D.C.

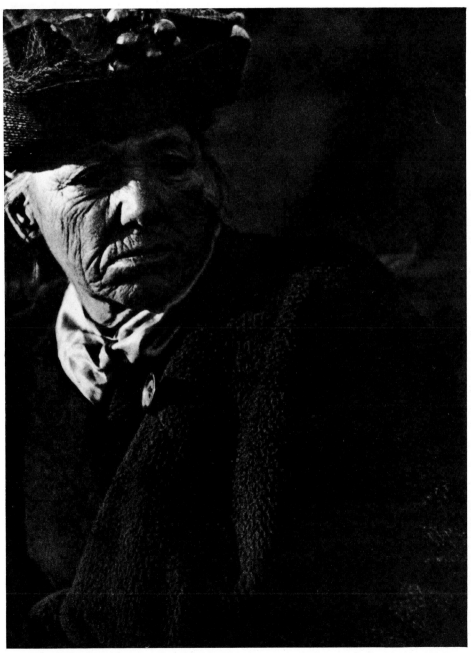

125. Paul Strand. *Portrait*. 1916. Photogravure. International Museum of Photography at George Eastman House, Rochester, N.Y.

Having thus won Stieglitz's approval, Strand was welcomed as a co-worker at the gallery. Stieglitz told him: "This is your place, too; come whenever you want, meet with the other people." Although Strand became a member of the inner circle of 291 late in the lifespan of that institution, he drew a great deal from the embers of creative vigor that continued to glow there. He recalled:

It was a place where one felt very alive and very much at home, and you got something every time you went there. There was a real battle going on, a real struggle for recognition of what these people were doing, both photographers and painters. . . . Stieglitz would come in and would explain the right of people to experiment and carry on serious investigations of their medium and its relationship to the life of their time. That kind of conversation was very stimulating because at that time you felt that you were a part of something happening in the world that was going to be very important to many people.

Stieglitz's discovery of Strand's fresh talent seems to have rejuvenated him and helped to restore some of the original vitality of 291, and during the last few years of the gallery's existence he devoted himself to the celebration of Strand's genius. He wrote of Strand in *Camera Work:*

His work is rooted in the best traditions of photography. His vision is potential. His work is pure. It is direct. It does not rely upon tricks of process. In whatever he does there is applied intelligence. In the history of photography there are but few photographers who, from the point of view of expression, have really done work of any importance. And by importance we mean work that has some relatively lasting quality, that element which gives all art its real significance.[49]

Strand's one-man show took place in March and April 1916, and the last two issues of *Camera Work* were devoted mainly to reproductions of Strand's recent photographs. Just as Steichen's photographs and ideas permeated the early volumes of *Camera Work*, so Strand's dominated the final issues of that periodical. Stieglitz had thus come full circle. A tireless searcher for new talent, it is fitting that his most important years of patronage came to an end with the recognition of an artist working in the medium which was his own first love — photography.

The Achievement of the Artists
of the Stieglitz Circle

The most gifted painters of the Stieglitz group — Marin, Dove, Hartley, and O'Keeffe — rank among the leading American avant-garde artists of their time. There were several others who rivaled them in talent and dedication to advanced concepts in painting — Man Ray, Max Weber, Joseph Stella, Stanton Macdonald-Wright, Morgan Russell, Charles Sheeler, Morton Schamberg, and William and Marguerite Zorach. But none of these artists belonged to a group that was as unified, personally and aesthetically, as Stieglitz's 291. Yet the 291 artists did not constitute a "school" in the strict sense of the word, for each one had a distinctive style. Stieglitz attracted artists who valued their own uniqueness of vision, and when they became part of his circle, he continued to encourage their individuality. Still, their varied personal expressions in painting fall within a broadly definable aesthetic category.

The idea of pictorial abstraction, as mentioned earlier, was central to Stieglitz's thinking. But equally important was his belief that the artist's sincere expression of his deepest feelings, whether for their own sake or for the communication of an actual experience, was essential to good art. These views helped to set the parameters for the artists of his circle, each of whom had developed, in the 1913–1917 period, a style that could be labeled "abstract expressionism," in the sense that Alfred Barr used the term for Kandinsky's early improvisations.[50] As in Kandinsky's aesthetic, there was much in the art of the 291 circle derived from the Symbolist-Synthetist theory of painting, but that theory was now carried to its logical extreme — the expression of feelings and ideas through purely abstract forms. The Stieglitz group, however, modified the Kandinskian aesthetic by borrowing freely from different "Post-Impressionist" styles, such as those of Cézanne and Cubism, that affirmed the structure of the work of art. The Americans also absorbed, in varying degrees, ideas from Italian Futurist painting, the most appropriate source to help them express the dynamic spirit of their country.

There were other models outside the European avant-garde that helped to educate the "abstract expressionists" of 291 — children's drawings and paintings, African Negro sculpture, and pre-Columbian art. These art forms had engaged the interest of the early twentieth-century European modernists, and, primarily through the efforts of Stieglitz and De Zayas, examples of this kind of work were made available through shows at 291 and The Modern Gallery. The Americans in the years 1913–1917 seem to have used these

sources in much the same way that European artists had — to accentuate and strengthen an already well defined modernist aesthetic.

The artistic tenets of the Stieglitz group were fairly homogeneous, although there was much room for individual experimentation and original discovery. Members learned not only from European modernism and its sources but also from each other, both through collective discussion and one-to-one contacts; Marin's influence on Walkowitz, Dove's on O'Keeffe, and Hartley's on Paul Strand were a result of the latter type of interchange. Still, despite these cases of "influence," the artists maintained their individuality, and thus the style of each one could not be mistaken for that of any of the others.

In the last analysis, the Stieglitz circle must be seen as the leading *group* of avant-garde American artists prior to the end of 291 in 1917. Stieglitz's instinct for artistic quality had enabled him to identify painters of marked ability, and all those who were close to him, with the exception of Walkowitz, became leaders of advanced painting in America in the second quarter of the century. They would not have attained this position, however, if Stieglitz had not nurtured their talents and offered them financial help during their formative years.

·CHAPTER EIGHT·

Alfred Stieglitz·His Contributions and Limitations

Stieglitz has been accused of borrowing heavily from the ideas of others and having few original thoughts of his own. To stress this negative view is to overlook his real strengths. He had the ability to absorb quickly the latest artistic ideas and to restate them with passionate conviction. Much of his importance, too, rests upon his willingness to support new, experimental art, whether or not he fully understood it; even in the last years of 291, for example, when Stieglitz was in his early fifties, he kept up with the latest developments in abstraction and unconscious imagery. He attracted sympathetic artists and thinkers, and at 291 they found a climate that welcomed experimentation and innovation. He stirred this audience by his personal example, vehemently arguing for what he liked and disliked, rather than coldly enunciating a fixed aesthetic doctrine. The intensity of his verbal barrages and the force of his personality drove his listeners into action.

Stieglitz aroused fanatical loyalty in his admirers, and many of them have credited him with almost superhuman powers. Admittedly, his contribution was monumental, but it would be a mistake to ignore his flaws. From 1908 to 1917, he missed many opportunities to accomplish his goals, and toward the end of these years he lost much of the dynamic vitality that had made his earlier efforts so successful.

If the driving force of his ego was Stieglitz's chief asset in the crusade for modern art in America, it was also a distinct liability. In the early years of 291, he was torn between a desire to attract a wide audience for the artists he presented and the need to control the public's experience of their work according to his own special needs and standards. Ultimately the latter goal

triumphed, and as a result he was unable fully to capitalize on the gains he had made.

What were his major contributions and shortcomings? His most important achievement was the series of pioneering shows of modern European art held at 291 before the Armory Show of 1913. They exposed artists, critics, and connoisseurs to the revolutionary currents in art emerging in Europe; previously, only a few Americans had known anything of these crucially important developments. Stieglitz articulated and explained, with the help of his associates, what was happening in European avant-garde painting and sculpture, using all of his energies to make people take these new forms of art seriously. At the beginning, he approached his task with optimism, and he managed to attract a few devoted collectors such as the Meyers, but stubborn resistance by conservative critics and the public ultimately wore him down. He felt increasingly that his efforts had been ignored and misunderstood, and he began to indulge in self-pity that alienated much of his audience and drove away friends and allies.

During the years when 291 was devoted to modern art as well as to photography, *Camera Work* played a vitally important role in disseminating information about advanced art and aesthetics. The journal complemented the shows at the gallery, presenting critical evaluations of the works of art on view there. At the height of his enthusiasm for modern art in the years 1910–1913, Stieglitz secured for *Camera Work* the best available articles and reviews by writers close to avant-garde developments abroad, and for several years it ranked with the leading modern foreign periodicals. *Camera Work* helped to unravel the mysteries of modern art for an elite American audience, but after 1913, the periodical, like the gallery, lost much of its momentum. There were often delays between issues, their size gradually diminished, and the content became far less innovative.

Stieglitz performed a heroic task in sponsoring progressive American painters when other dealers in New York ignored them. Although he relied, in part, on the opinion of his friends, he had a gift for sensing creative vitality and the promise of growth in young artists like Marin, Hartley, Dove, and O'Keeffe, often on the basis of their immature, experimental work. It is safe to say that the artists of his circle would not have flourished as they did without his encouragement and financial support. In his role as benevolent patron, Stieglitz was at his best; but even here his monumental ego caused trouble: he was willing to encourage artists in whom he believed only as long as they shared his goals and ideas. If, however, they challenged his authority, they risked being expelled from his circle.

Indeed, Stieglitz's life before 1917 was punctuated by a series of broken friendships. In the early years of the Photo-Secession, photographers Gertrude Käsebier, Clarence White, and Alvin Langdon Coburn severed their relationships with him over various disagreements, and among the artists Weber was the first (in 1911) to cross swords with him. The organizers of the Armory Show kept Stieglitz at a safe distance, though they solicited his advice. Steichen, his closest friend, had begun to pull away from his authority as early as 1914. By 1915 several of Stieglitz's younger associates — De Zayas, Haviland, and Agnes Meyer — embarked upon a tactful withdrawal, setting up The Modern Gallery as a commercial branch of 291 in that year and publishing *291* in 1915–1916. These breaks substantially weakened Stieglitz's leadership of the progressive elements in the New York art world. Had he been more tolerant of others' views, he could have enlisted a powerful group of allies to promote his cause, but he was chary of too much success.

His stubborn individualism undoubtedly limited the financial rewards of the 291 artists. He was so firmly opposed to publicity and commercialism that he made few efforts to promote their work. His views on the sacredness of art and the rarity of true creative genius made him treat the work of art as a priceless object — an admirable position, to be sure — but he often made it so difficult for buyers to purchase these examples (the prospective owner had to be worthy of them) that the artist suffered economically. Fortunately, Stieglitz did not restrain De Zayas and his friends from founding The Modern Gallery as an extension of 291.

From 1913 to 1917, Stieglitz paid more and more attention to American art, gradually losing interest in the Europeans. He continued to sponsor shows of the artists closest to him — Marin, Hartley, and Walkowitz — and he deserves a great deal of credit for discovering and exhibiting the work of Paul Strand. Moreover, his willingness to give untried painters a chance bore fruit with O'Keeffe.

Stieglitz's proud individualism kept him from mingling with other groups in the vanguard of American art that emerged after 1913. He knew the Mabel Dodge and Arensberg circles, as well as the bohemian intelligentsia of Greenwich Village, but he did not actively participate in the affairs of these groups. After 1913 he would not struggle to retain his position as the leading sage and prophet of modernism. Realizing that the Armory Show had accomplished many of his goals, he was content to let people come to him and the exhibitions at 291 if they wished to, but he did not pursue them.

·CHAPTER NINE·

Epilogue · Stieglitz and His Friends after 1917

The Interim, 1917-1925

After Stieglitz gave up his lease on 291 in June 1917, he rented a room on a lower floor, where he remained for a year, occasionally visited by loyal friends. Yet it must have been a grim winter, for Stieglitz recalled: "I walked up and down in my overcoat, my cape over the coat, hat on, and still I would be freezing. . . . I had nowhere else to go — no working-place, no club, no money. I felt somehow as Napoleon must have felt on his retreat from Moscow." [1] The winter of 1917–1918 represented a crucial turning point in Stieglitz's career, because for the first time in years he did not have to care for a gallery or worry about defending modern art in the pages of *Camera Work*. His attention now began to center on Georgia O'Keeffe, who bade fair to embody in her painting the highest ideals he had been seeking for that medium. In 1918 he moved out of his home at 1111 Madison Avenue, leaving his wife and daughter in order to live with O'Keeffe in a small Manhattan studio. In that year the two began to spend their summers together at Lake George.

Stieglitz's devotion to O'Keeffe is the key to this phase of his life. Their love and the presence of her unique talent seem to have reawakened the best of his creative abilities. With O'Keeffe as both source of inspiration and model, Stieglitz produced a series of penetrating photographic portraits and figure studies of her. From now into the 1930s he also used his camera to explore the stark geometry of skyscrapers in New York, and at Lake George he recorded, ever more abstractly, the informal aspects of the natural environment. The prints of these years, particularly his cloud studies, are landmarks in the history of photography. O'Keeffe, in turn, worked intently at

her painting during this period, rapidly becoming one of America's leading abstract artists. O'Keeffe and Stieglitz were married in 1924, shortly after his divorce from Emmeline.

Although Stieglitz had no showplace of his own from 1918 to 1925, he continued to offer moral and financial support to the painters of his immediate circle and occasionally arranged exhibitions of their work for other New York galleries, such as Montross and Anderson. He devoted himself almost exclusively to American art, believing that his deserving countrymen had been swamped by the tide of European modernism that had now swept over New York. Moreover, he was adopted as a kind of American culture hero by an emerging generation of writers and critics, including Sherwood Anderson, William Carlos Williams, Paul Rosenfeld, and Waldo Frank. Stieglitz's passionate devotion to freedom and vitality of expression in contemporary art, to distinctly American values, and to fine craftsmanship inspired these younger men. Stieglitz had not actively sought this kind of recognition, but when it came he accepted it with uncharacteristic modesty.

In the 1920s a whole new group of allies, including Carl Zigrosser, Herbert Seligmann, Louis Kalonyme, D. H. Lawrence, Hart Crane, and Jerome Mellquist, gathered around him, supplanting the scattered company of 291. Without a gallery of his own, Stieglitz could no longer hold court, but he nevertheless managed to maintain close intellectual and spiritual ties with his circle of friends. In 1922 and 1923 Stieglitz, Rosenfeld, and Seligmann worked together briefly for a common cause, the production of the magazine *MSS*, devoted to experimental prose, poetry, criticism, and music. Unfortunately, it did not last beyond six issues.

The Intimate Gallery and An American Place

In 1925, after eight years of work behind the scenes in the New York art world, Stieglitz organized at the Anderson Galleries in New York a major exhibition called "Seven Americans." Devoted to 159 works by Marin, Dove, Hartley, O'Keeffe, Strand, Demuth, and himself, the show was a visual testimony to the artists he believed in. Its success encouraged him to establish The Intimate Gallery in Room 303 of the Anderson Galleries building, 489 Park Avenue, starting with a comprehensive Marin show in December 1925. Stieglitz hoped that The Intimate Gallery would perpetuate the spirit of 291, but the scope of the new establishment was clearly more limited. The

261

aura of the experimental laboratory had faded, and he focused almost entirely on selling the work of a select group of American artists. A 1927 announcement of the gallery proclaimed:

The Intimate Gallery is dedicated primarily to an Idea and is an American Room. It is used more particularly for the intimate study of Seven Americans: John Marin, George O'Keeffe, Arthur G. Dove, Marsden Hartley, Paul Strand, Alfred Stieglitz and Number Seven (six + X) [X was "the Unknown, whoever that might be"]. . . .

The Intimate Gallery is a Direct Point of Contact between Public and Artist. It is the Artist's Room. It is a Room with but One Standard. Alfred Stieglitz has volunteered his services and is its directing Spirit.

The Intimate Gallery is not a Business nor is it a "Social" Function. The Intimate Gallery competes with no one nor with anything.[2]

Stieglitz was present in the galleries from ten in the morning until six in the evening, and if a visitor showed genuine interest in the works on view, the proprietor might engage him in a conversation that could be probing, often revealing, and sometimes insulting. He continued to insist on a noncommercial approach to paintings; because he believed they were products of the artist's unique gift of creativity, it was impossible to place a dollar value on them. One dared not haggle over the price of a work of art. Stieglitz liked to challenge his customers to offer what they were willing to sacrifice for a picture. He had no time for those who saw art in financial terms or who bought for investment. Despite these unconventional sales methods, the gallery was financially successful. Stieglitz's momentum, however, was checked by a heart attack in 1928, from which he never fully recovered, and the sale of the Anderson Galleries building forced him to withdraw from business in the fall of 1929.

Stieglitz had no desire to start a new gallery, but his wife and his friends the Strands and Dorothy Norman wanted him to have a place where he could show the work of artists he believed in. Reluctantly, he agreed to let them raise money for another gallery, and in this way An American Place was born. (Ansel Adams's photograph of Stieglitz at An American Place is reproduced as Figure 126.) Established in December 1929 in Room 1710, 509 Madison Avenue, the gallery was renowned for its clean, sparsely covered gray and white walls. Here, once again, Stieglitz concentrated on the artists he had sponsored at The Intimate Gallery, though Hartley gradu-

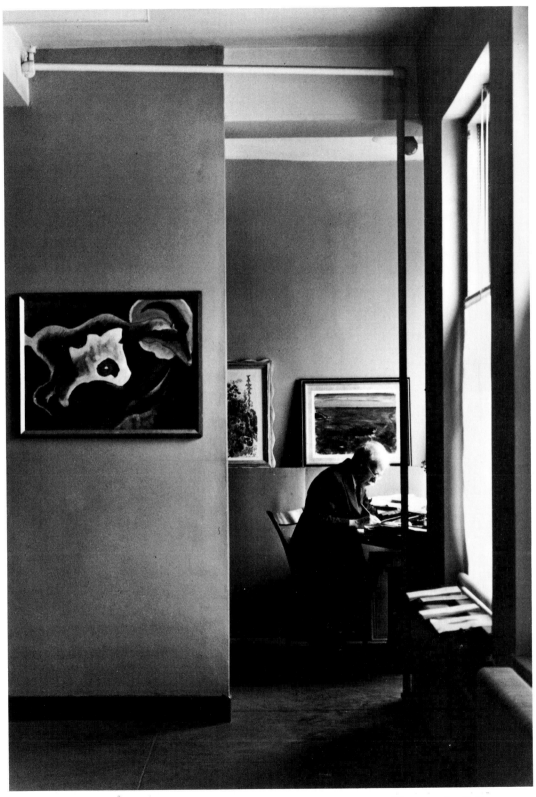

126. Ansel Adams. *Alfred Stieglitz at An American Place*. 1933. Photograph. Collection of Ansel Adams.

127. Josephine Marks. *Alfred Stieglitz*. c. 1944. Photograph. Private Collection.

ally strayed from the fold and the works of several other American and European painters and photographers were brought into the gallery. New exhibitors included George Grosz, Ansel Adams, Eliot Porter, Robert C. Walker, and William Einstein. An American Place perpetuated the non-commercial spirit of Stieglitz's previous galleries, and in his later years it became the entire focus of his life. His heart attack and successive seizures made him a semi-invalid, and, as he grew older, he spent his days on a cot in the back room of the gallery. His declining physical strength compelled Stieglitz to abandon photography in 1937, but not before he had made a group of striking portraits of his devoted friend and associate Dorothy Norman. She had become his business manager in 1933 and did much to keep the gallery going.

Stieglitz continued to receive friends at An American Place and talked interminably to the dwindling number of visitors who came in, but he no longer held a position of commanding importance in the world of avant-garde painting and sculpture. As time went on, until his death in 1946, his

failing health and growing remoteness from the mainstream of the arts in New York made him seem like a relic from another era. (Josephine Marks's photograph of him, taken about 1944, is reproduced as Figure 127.)

Stieglitz and the Artists
of His Circle after 1917

After the decline and collapse of 291, many of the artists closest to Stieglitz continued to see him, but the peripheral figures were scattered, never again to assemble under his sponsorship. Some of the regulars, like Walkowitz and Steichen, were permanently alienated from his circle — the former because O'Keeffe, in effect, replaced him and the latter because Stieglitz could not tolerate the commercialism of his photography. There were new recruits, like Strand and Demuth, who allied themselves to Stieglitz, but the unified community of artists had disintegrated with the closing of 291.

After 1917 O'Keeffe continued to mature as a painter, thanks in large part to Stieglitz's encouragement and support. Of the Stieglitz group, she was the first to win popular success; her work has sold well since 1924, the year of her first flower paintings, to the present day. Her artistic integrity and skill in abstract design have brought her acclaim as one of the leading painters of our time.

John Marin, Stieglitz's closest artist friend, similarly had a long, productive career after 1917. He established a way of life that remained essentially unchanged until his death in 1953 — painting in Maine almost every summer and spending the winter at his home in Cliffside, New Jersey. His work, like O'Keeffe's, eventually began to attract buyers, and although he was never rich, he was able to live comfortably from the sale of his paintings. His style was certainly advanced for its time in America, though when compared to vanguard movements in Europe in the 1920s and 1930s, it appears *retardataire*. Nevertheless, he kept up a degree of inventiveness and creative vitality that many of his American contemporaries lacked in the period between the wars.

Hartley's later career was more uneven. After 1917 he continued to obtain support from Stieglitz and was greatly encouraged by substantial sales from a large auction of his paintings, which his mentor arranged at the Anderson Galleries in 1921. But Hartley never allowed himself to depend exclusively on Stieglitz and sought patronage from other sources. In the late 1930s he

drifted away from Stieglitz and after 1937 no longer exhibited at An American Place. Like most of the painters who returned to America after discovering modern art in Europe, he established an expressionist style which he repeated without much change. Still, he always felt his subjects deeply and frequently produced canvases that are personally expressive and function as abstract designs. When he succeeded, there were few American painters between the wars who surpassed him.

Of the leading members of the Stieglitz circle, Dove suffered the greatest neglect, for his continuing commitment to abstraction made his art difficult for the public to understand and accept. He sold few paintings, except to Duncan Phillips, an enlightened patron who came to his rescue in 1925. Through Phillips's support, Dove was able to survive, but he was never offered a major museum exhibition during his lifetime. It is hard to account for the indifference to Dove's work, because he is a painter of the first rank. However, he surfaced in another unexpected way: he is now acknowledged as an influence on the rising generation of Abstract-Expressionists in the 1940s, the first group of American painters to win international recognition. Thus, of all the members of the Stieglitz group, Dove appears to have exerted the greatest influence on the generation that followed him.

The poet William Carlos Williams, one of Stieglitz's later admirers, perceived that in the United States "two cultural elements were left battling for supremacy, one looking toward Europe, necessitous but retrograde in its tendency — though not wholly so by any means — the other forward-looking but under a shadow from the first. They constituted two great bands of effort, which it would take a Titan to bring together and weld into one again." [3] In Williams's view, Stieglitz was such a Titan. Each of the major painters of his circle learned something from advanced currents in European art, yet still remained essentially American. The creative stance of the Stieglitz group after the war is visually summarized by Marin's superb watercolor *Lower Manhattan* (1920, Figure 128). It shows that the artist had learned from Cubism valuable lessons about the reduction of form to simple geometric shapes and made full use of the expressive qualities of color. But there is something here that transcends the mere echoing of Cubism and Fauvism: these European styles have been fused, as it were, in the course of Marin's enthusiastic response to the subject, so that the result is a highly personal as well as a distinctly American statement. In addition, the American quality resides in the dynamism and energy, the sense of new worlds to conquer in this view of the then-new Woolworth Building soaring above the Elevated tracks. The vigorous, slashing execution, although reminiscent

128. John Marin. *Lower Manhattan*. 1920. Watercolor. Collection, The Museum of
Modern Art, New York: The Philip L. Goodwin Collection.

of European expressionist brushwork, now speaks of an optimistic American response to experience.

After 1917 none of the Stieglitz group participated in the latest avant-garde developments in Europe, and they did not make any innovative contributions to the internationally prominent movements in the arts between the Wars. But with Stieglitz's encouragement, they developed into artists of the first magnitude and were among the best America had to offer prior to the advent of Abstract Expressionism in the late 1940s.

In spite of all that Stieglitz accomplished, he remained a pessimist who complained about the unfortunate state of the arts in America. Still, at the end of his life, he must have taken pride in his own accomplishments and the achievements of his talented protégés. He had every right to.

·NOTES·

All letters are from the Alfred Stieglitz Archive, Collection of American Literature, Beinecke Rare Book and Manuscript Library, Yale University, unless otherwise noted.

Abbreviations

AAA	Archives of American Art, Washington, D.C.
AS	Alfred Stieglitz
CN	*Camera Notes*
CW	*Camera Work*
ES	Eduard Steichen
LC	Library of Congress, Washington, D.C.
MH	Marsden Hartley
MOMA	Museum of Modern Art, New York
MW	Max Weber
YCAL	Alfred Stieglitz Archive, Collection of American Literature, Beinecke Rare Book and Manuscript Library, Yale University

Chapter 1. Alfred Stieglitz:
The Formative Years
(Notes 1–5, for Nancy Newhall's text,
are by WIH.)

1 Stieglitz's twin brothers earned distinguished reputations in their chosen fields. Leopold received his M.D. at Heidelberg and became a noted New York physician. Julius earned a Ph.D. in chemistry at the University of Berlin and became chairman of the chemistry department at the University of Chicago.

Notes

2 Hedwig Stieglitz, an avid reader, shared her husband's fondness for these artistic gatherings and undoubtedly helped to nurture Alfred's literary interests.

3 Alfred Stieglitz's parents had filled their house with paintings, sculptures, and reproductions by academic artists; and the work of his father, which he could not help seeing, was thoroughly conventional. In addition, there lived for a time in the Stieglitz household one Fedor Encke (1851–1926), a portrait and genre painter from Germany, who produced likenesses of Theodore Roosevelt and J. P. Morgan. The American sculptor Moses Ezekiel (1844–1917) was one of Edward Stieglitz's favorite artists. Julius Gerson, a family friend, made a watercolor for Stieglitz's thirteenth birthday, January 1, 1877. Young Stieglitz was thus exposed early to art and artists, yet in his autobiographical remarks he said very little about these experiences.

4 Before Alfred went to Germany in 1881, he was drawn principally to readings that stressed hero figures he could identify with. He admired the tales of Horatio Alger and read over and over again *The Boys of Seventy-six*, which glorified the heroic escapades of General Nathanael Greene in the Revolutionary War. The American general appealed to Stieglitz because of his unorthodox military tactics; he often retreated, yet appeared to win, and he lost few men in the process. In quite another vein, he was attracted to Goethe's *Faust*, who would, at first glance, seem to have little in common with General Greene. Paul Rosenfeld, however, characterized the general's appeal for Stieglitz: "Like Goethe's *Faust*, the image of democratic victory gained over a long period, and the willingness to let the enemy purchase Pyrrhic triumphs dearly, proves endlessly gratifying" (Waldo Frank et al., eds., *America and Alfred Stieglitz: A Collective Portrait* [Garden City, N.Y., 1934], p. 63). Through his youthful readings, Stieglitz became a passionate believer in the "fairy tale of America" and displayed an optimistic faith that his native country could develop toward a state of perfection (Alfred Stieglitz, "Four Happenings," *Twice a Year*, nos. 8–9 [Spring - Summer, Fall - Winter, 1942], p. 106).

5 He was a member of the class of 1884 but never graduated. In the *Merit Roll of the College of the City of New York*, he ranked tenth in his class in 1879–1880 and sixth in 1880–1881.

6 Dorothy Norman, *Alfred Stieglitz: An American Seer* (New York, 1973), p. 32. My account of Stieglitz's early tastes is taken from his own recollections, published in Norman, and from unpublished documents which she allowed me to study.

7 New York *Herald*, 8 Mar. 1908.

8 Dorothy Norman, "Alfred Stieglitz, Introduction to an American Seer," *Aperture* 8 (1960): 6.

9 I found clues to the identity of artists Stieglitz admired in a previously unknown group of his photographs owned by Wade Mack that came to my attention in 1973. The Mack collection includes ten Stieglitz photographs of works of art, including examples by the painters named in the text (except Hasemann), and of several examples that cannot be identified. Two of the unidentified paintings are entitled *Psyche* and *Eros Disarmed* and represent the academic-sentimental idiom popular in the official salons. Peter Bunnell discussed these copies, the copies of Hasemann's work, and their influence on Stieglitz's style of photography in a paper, "The Early European Photographs of Alfred Stieglitz," International Museum of Photography, Rochester, N.Y., Feb. 21, 1975.

10 This roommate, it seems, taught Stieglitz an important lesson which he later recounted: "When I was a boy of 19 I openly declared that Rembrandt was rot. At this time I was living in Berlin with a sculptor who was a very wise person. Instead of arguing with me he sent me every day to look at the statues and the Old Madonnas, and gradually things began to happen to me. That's the best you can do for a person — keep putting things in front of him. . . ." (Agnes Ernst, "New School of the Camera," New York *Morning Sun*, 26 Apr. 1908). The reference to Stieglitz's travels is from Paul Rosenfeld, *America and Alfred Stieglitz*, p. 65.

11 "Distinguished Photographers of Today — Alfred Stieglitz," *The Photographic Times* 23 (1 Dec. 1893): 689.

12 I am indebted to Peter Bunnell for suggesting the analogy to Menzel in "The Early European Photographs of Alfred Stieglitz."

13 "Alfred Stieglitz and His Latest Work," *The Photographic Times* 28 (Apr. 1896): 164

14 Dorothy Norman, "From the Writings and Conversations of Alfred Stieglitz," *Twice a Year*, no. 1 (Fall–Winter 1938), p. 95.

15 Charles H. Caffin, "Photography as a Fine Art," *Everybody's Magazine* 4 (Apr. 1901): 367.

16 Norman, "Alfred Stieglitz," p. 9.

17 Norman, "From the Writings and Conversations," p. 98.

18 Quoted in "Alfred Stieglitz and His Latest Work," p. 161.

19 Neil Leonard, "Alfred Stieglitz and Realism," *The Art Quarterly* 29 (1966): 283.

20 Caffin, "Photography as a Fine Art," p. 369. In 1896 an interviewer reported, "He delights in producing street scenes representing every day life, and has made a special study of trying to reproduce in black and white the ever varying effects of sunlight. This he considers the most difficult problem in pictorial photography" ("Alfred Stieglitz and His Latest Work," p. 163).

21 Caffin, "Photography as a Fine Art," p. 369.

22 Reproduced in Norman, *Alfred Stieglitz: An American Seer*, pl. V.

23 Reproduced in Doris Bry, *Alfred*

Stieglitz: Photographer (Boston, 1965), pl. 6.

24 Reproduced in Charles H. Caffin, *Photography as a Fine Art*, (New York, 1901), p. 35.

25 Keiley, quoted in Caffin, *Photography as a Fine Art*, p. 99.

26 Alfred Stieglitz, "Six Happenings," *Twice a Year*, nos. 14–15 (Fall–Winter 1946–1947), pp. 188–189.

27 Caffin, *Photography as a Fine Art*, p. 199.

28 Alfred Stieglitz, "Modern Pictorial Photography," *The Century Magazine* 64 (Oct. 1902): 824–825.

29 Caffin, "The Development of Photography in the United States," in *Art in Photography*, ed. Charles Holme (London, 1905), p. US 3.

30 "Valedictory," *CN* 6 (July 1902): 3.

31 *Philadelphia Photographic Salon* (Philadelphia: Pennsylvania Academy of the Fine Arts, 24 Oct.–12 Nov. 1898), no pagination. There was a so-called international photographic salon, held in a public art gallery, that preceded the Philadelphia show: the First Annual International Salon and Exhibition, sponsored by the Pittsburgh Amateur Photographers' Society, Carnegie Art Galleries, January 1898. Although it was billed as an international salon, there were only three entrants from Europe. Virtually none of the progressives in the Stieglitz group participated.

32 *CN* 5 (July 1901): 33.

33 Alvin Langdon Coburn, *Alvin Langdon Coburn, Photographer: An Autobiography* (London, 1966), p. 20.

34 *CW*, no. 9 (Jan. 1905), p. 56.

35 Alfred Stieglitz, "Four Happenings," *Twice a Year*, nos. 8–9 (Spring–Summer, Fall–Winter 1942), p. 117.

36 Alfred Stieglitz, "The Photo-Secession," in *American Annual of Photography and Photographic Times Almanac* (New York, 1904), p. 42.

37 Ibid.

38 Stieglitz, "Four Happenings," p. 117.

Chapter 2. Stieglitz, Steichen, and the Photo-Secession

1 I am using the original spelling of Steichen's first name, Eduard, which the photographer dropped about 1918 in favor of Edward.

2 Charles H. Caffin, "Progress in Photography," *The Century Magazine* 75 (Feb. 1908): 484.

3 Edward Steichen, *A Life in Photography* (Garden City, N.Y., 1963), no pagination.

4 Ibid.

5 Caffin, "Progress in Photography," p. 486.

6 Ibid., p. 491.

7 ES to AS, undated [1901].

8 Steichen submitted his photograph of Rodin to the Salon at the sculptor's suggestion (Charles H. Caffin, "The New Photography," *Munsey's Magazine* 27 [Aug. 1902]: 736).

9 "Tells about His Work," undated clipping, no source indicated [1902], Steichen scrapbook, MOMA.

10 *CW*, no. 3 (July 1903), p. 5. This

statement was later revised and published in *CW*, no. 9 (Jan. 1905), p. 56: "To hold together those Americans devoted to pictorial photography, to uphold and strengthen the position of pictorial photography; to exhibit the best that has been accomplished by its members or other photographers, and, above all, to dignify that profession until recently looked upon as a trade."

11 Three more issues of *CN* were published after Stieglitz resigned as editor; then the Camera Club of New York discontinued that journal, ending with the December 1903 issue.

12 *CW*, no. 1 (Jan. 1903), p. 15.

13 Alfred Stieglitz, "Four Happenings," *Twice a Year*, nos. 8–9 (Spring–Summer, Fall–Winter 1942), p. 118.

14 Ibid., p. 119.

15 *CW*, no. 12 (Oct. 1905), p. 59.

16 Stieglitz, "Four Happenings," p. 120.

17 Exhibition announcement, *CW*, no. 13 (Jan. 1906), no pagination.

18 Steichen, *A Life in Photography*, no pagination.

19 Stieglitz, "Four Happenings," p. 121.

20 Roland Rood, "The 'Little Galleries' of the Photo-Secession," *American Amateur Photographer* 16 (Dec. 1905): 567.

21 Ibid.

22 *CW*, no. 14 (Apr. 1906), p. 48.

23 For this exhibition Stieglitz established a pattern he would follow, with few exceptions, in his dealings with painters and sculptors who showed at 291. He took no commissions for the sale of the artists' works and he charged them nothing for the printing of catalogues and postage.

24 Steichen, *A Life in Photography*, no pagination.

25 Stieglitz, "Four Happenings," p. 122.

26 *CW*, no. 18 (Apr. 1907), p. 37.

27 The rediscovery of the art of Pamela Colman Smith is largely the work of Melinda Boyd Parsons, who wrote her master's thesis (University of Delaware, 1975) on the artist. Subsequently Ms. Parsons organized an exhibition of her work for the Delaware Art Museum (Sept. 11–Oct. 19, 1975) and The Art Museum, Princeton University (Nov. 4–Dec. 7, 1975), for which she wrote a biography and study of her style, *To All Believers — The Art of Pamela Colman Smith* (Wilmington, Del., 1975). Miss Smith has been well known to tarot enthusiasts, for she was the designer, in 1909, of the Rider deck, one of the most popular decks in use today.

28 J. B. Yeats, *Letters to His Son W. B. Yeats, 1869–1922*, ed. Joseph Hone (London, 1944), p. 61.

29 Dorothy Norman, "From the Writings and Conversations of Alfred Stieglitz," *Twice a Year*, no. 1 (Fall–Winter 1938), p. 82.

30 Stieglitz issued a limited-edition portfolio (eight copies) of work by Pamela Colman Smith (New York, 1907), which consisted of photographs he made from her paintings and drawings.

31 Stieglitz, "Four Happenings," p. 119.

Chapter 3. 291 and the Arts before the Armory Show

1 Waldo Frank et al., eds., *America and Alfred Stieglitz: A Collective Portrait* (Garden City, N.Y., 1934), p. 326.
2 Ibid.
3 William Zorach, *CW*, no. 47 (July 1914), p. 38.
4 Interview with Marie Rapp Boursault, Stieglitz's former secretary, 13 Jan. 1973.
5 Ibid.
6 Jerome Mellquist, *The Emergence of an American Art* (New York, 1942), p. 192.
7 Nicole Maritch Haviland to William Innes Homer, 18 Mar. 1973.
8 This is significant in the light of his later promotion of pre-Columbian art through The Modern Gallery.
9 Benjamin de Casseres, *CW*, no. 26 (Apr. 1909), p. 17.
10 Ibid.
11 William Arnett Camfield, "Francis Picabia (1879–1953): A Study of His Career from 1895 to 1918" (Ph.D. diss., Yale University, 1964), p. 137.
12 Marius de Zayas to AS, 25 Jan. 1911. It may have been this very volume that Marsden Hartley studied in 1911.
13 De Zayas to AS, 10 July 1911.
14 Agnes E. Meyer, *Out of These Roots* (Boston, 1953), p. 68.
15 Ibid., p. 81.
16 Ibid., pp. 81–82.
17 Agnes Ernst to AS, 5 Jan. 1909.
18 Ibid.
19 Ibid.
20 *CW*, no. 25 (Jan. 1909), p. 22.
21 The one oil painting in the show, the small *Nude in a Wood* (c. 1906, The Brooklyn Museum), was lent by George F. Of, a painter, framemaker, and visitor at 291. Purchased for Of, at his request, by Sarah Stein in Paris, it was the first Matisse to enter an American collection.
22 *CW*, no. 23 (July 1908), p. 10.
23 *CW*, no. 25 (Jan. 1909), p. 17.
24 *CW*, no. 29 (Jan. 1910), pp. 53–54.
25 *CW*, nos. 34–35 (Apr.–July 1911), p. 66.
26 AS to E. A. Jewell, 19 Dec. 1939.
27 AS to Selma Schubart, 4 Oct. 1909.
28 Steichen quoted in Joseph Shiffman, "The Alienation of the Artist: Alfred Stieglitz," *American Quarterly* 3 (1951): 250.
29 Hartmann, quoted in "Alienation of the Artist," p. 251.
30 *CW*, no. 3 (July 1903), p. 17.
31 *CW*, no. 12 (Oct. 1905), pp. 25–26.
32 *CW*, no. 13 (Jan. 1906), pp. 43–44.
33 Stuck's *Sin* (1893, Bayerische Staatsgemäldesammlungen, Munich) is reproduced in Heinrich Voss, *Franz von Stuck* (Munich, 1973), p. 116. Lenbach's portrait of Duse is reproduced in Jeanne Bordeaux, *Eleanora Duse: The Story of Her Life* (London, 1924), no pagination. The first painting Stieglitz purchased was a watercolor, *The Square, Venice* (1881, YCAL), a realistic portrayal

of the subject by Robert Blum. He acquired it because Steichen urged him to buy American works of art (previously Stieglitz had purchased only American photographs).

34 Information from Edward Steichen, *A Life in Photography* (Garden City, N.Y., 1963), no pagination.

35 Dorothy Norman, "From the Writings and Conversations of Alfred Stieglitz," *Twice a Year*, no. 1 (Fall–Winter 1938), pp. 80–81.

36 Alfred Stieglitz, "Four Happenings," *Twice a Year*, nos. 8–9 (Spring–Summer, Fall–Winter 1942), p. 128.

37 Georgia O'Keeffe, "Stieglitz: His Pictures Collected Him," *New York Times Magazine*, 11 Dec. 1949, p. 26.

38 Steichen, quoted in Alfred H. Barr, Jr., *Matisse, His Art and His Public* (New York, 1951), p. 113.

39 Alfred Stieglitz, "Leo Stein," unpublished typescript, p. 2, YCAL.

40 Alfred Stieglitz, "The Story of Weber," unpublished typescript, Feb. 22, 1923, p. 10, YCAL.

41 Lloyd Goodrich, interview with Weber, 9 Nov. 1948 (AAA microfilm NY59–8).

42 Max Weber, "The Fourth Dimension from a Plastic Point of View," *CW*, no. 31 (July 1910), p. 25.

43 Norman, "From the Writings," p. 84.

44 "Art Photographs and Cubist Painting," *New York Sun*, 3 Mar. 1913. In a letter to Arthur Jerome Eddy, 10 Nov. 1913, he compared the

aesthetic perfection of the drawing to that of a Bach fugue.

45 ES to AS, undated [Feb. 1911].

46 AS to Sadakichi Hartmann, 22 Dec. 1911.

47 AS to the editor of the *New York Evening Sun*, 14 Dec. 1911.

48 AS to Heinrich Kuehn, 14 Oct. 1912.

49 AS to Fritz Goetz, 26 Dec. 1913.

50 AS to W. Orison Underwood, 22 Dec. 1911.

51 AS, "291," unpublished typescript, p. 1, YCAL.

52 AS to Waldo Frank, 6 July 1936.

53 AS to Fritz Goetz, 23 Dec. 1914.

54 AS to Alfred Lohr, 12 Dec. 1916.

55 AS to ES, undated [1909].

56 AS to Kuehn, 22 May 1912.

57 Interview with Marie Rapp Boursault, 13 Jan. 1973.

58 *CW*, no. 47 (July 1914), p. 40.

59 Ibid., p. 14.

60 Ibid., p. 62.

61 Ibid., p. 31.

62 AS to John G. Bullock, 26 Mar. 1917.

63 Interview with Marie Rapp Boursault, 13 Jan. 1973.

64 Ibid.

Chapter 4. The Rise of the American Avant-Garde: Artists of the Stieglitz Circle before 1913, I (Marin, Dove)

1 Robert Henri, *The Art Spirit* (Philadelphia and London, 1923), p. 146.

2 Max Weber, "The Matisse Class," unpublished manuscript read before

the Matisse symposium, Museum of Modern Art, 19 Nov. 1951, AAA microfilm NY 59–6.

3 *CW*, no. 30 (Apr. 1910), p. 54.

4 Israel White, quoted in *CW*, no. 31 (July 1910), p. 46. D. Putnam Brinley (1879–1963) did not maintain close ties with Stieglitz and the 291 circle. Although he was involved with the preparations for the Armory Show, he remained fairly conservative in painting, following an Impressionist style. He later concentrated on mural painting and crafts, working under the inspiration of medieval art. Laurence Fellows (1885–1964) had no further contacts with 291. After a period of residence in England and France, he returned to America and became well known for his humorous drawings for *Judge* and the old *Life* magazine and his advertising illustrations for *Vanity Fair* and *Esquire*.

5 "Alfred Stieglitz: Four Marin Stories," *Twice a Year*, nos. 8–9 (Spring–Summer, Fall–Winter 1942), p. 157.

6 Much of our information about Marin's early life comes from autobiographical summaries published in *The Selected Writings of John Marin*, ed. Dorothy Norman (New York, 1949), pp. viii–xi.

7 Ibid., p. ix.

8 Minutes of the board of trustees, Stevens Institute of Technology (1886), courtesy of Joseph B. Devlin.

9 *The Selected Writings of John Marin*, p. ix.

10 In an autobiographical sketch Marin used the term "blank" for the years when he was not employed or enrolled in an art school (*MSS*, no. 2 [Mar. 1922], p. 5).

11 During this period he managed to make his first sale, a group of sketches, the proceeds from which enabled him to buy Maxime Lalanne's *A Treatise on Etching* (Boston, 1880), a technical manual that introduced him to Charles Blanc's monumental study *L'Oeuvre complet de Rembrandt*, 2 vols. (Paris, 1859–1861), in which many of the Dutch master's finest etchings were reproduced.

12 Various conflicting dates are given for Marin's stay in Paris and the trip he made, toward the end of that period, to the United States. There is no question about his arrival in Paris in 1905. Dorothy Norman gives December 1909 as the date of departure for his brief visit to New York (*The Selected Writings of John Marin*, p. x), a plausible proposal, since he is known to have returned to the United States to arrange his first one-man show at 291. He was on his way back to France on May 18, 1910, for in a letter of that date written from shipboard he mentioned that he has sighted England and expected to be in Paris on the following day. He was painting in the Tyrol during the summer of 1910, and a letter from De Zayas to Stieglitz, October 28, 1910, places him in Paris as of that date. He is known to have

been back in New York in time to see the Cézanne exhibition at 291, Mar. 1–25, 1911, and it is likely that he was there to arrange his second one-man show, Feb. 2–22, of the same year.

13 Marin, quoted in Mackinley Helm, *John Marin* (Boston, 1948), p. 22.

14 *The Selected Writings of John Marin*, p. x.

15 Marin later expressed his "profound respect" for Boudin, chiefly because that French painter understood boats and the sea (Marin to AS, 10 Sept. 1936, reproduced in *John Marin by John Marin*, ed. Cleve Gray [New York, 1970], p. 135). After his youthful exposure to academic art at home (via reproductions) and at the Metropolitan Museum, he said "the then moderns began to creep in so that Manet got to be tops to me" (ibid., p. 136). He had little interest in the old masters except for Tintoretto, whose work he genuinely admired (interview with Dorothy Norman, 30 Jan. 1973). Marin claimed that he had not seen the work of Cézanne before it was exhibited at 291 in 1911. But Sheldon Reich has argued convincingly that Marin must have viewed Cézanne's paintings at the 1907 Salon d'Automne (where Marin showed his own work), that he could not have avoided Matisse's art on display at that Salon in 1908 (where Marin again exhibited), and that he would have known the work of Signac, Marquet, Rousseau, Delaunay, and Weber shown at the 1907 Salon des Indépendants, in which he also participated (Reich, *John Martin*, 2 vols. [Tucson, 1970], 1:16). Jo Davidson, Marin's friend and billiard-playing companion, recalled that they went to the Salon des Indépendants together (*Between Sittings* [New York, 1951], p. 47).

16 Reproduced in Reich, *Marin*, 2:334 (cat. no. 09.7).

17 Reproduced in ibid., 2:339 (09.35).

18 Two critics who reviewed Marin's exhibitions in 1909 and 1910 — Caffin and Elizabeth Luther Cary — linked his work with that of Signac and Matisse, among other artists. See Caffin, *CW*, no. 27 (July 1909), p. 42, and Cary, *CW*, no. 30 (Apr. 1910), pp. 45–46.

19 Marin, quoted by B. P. Stephenson, *CW*, no. 30 (Apr. 1910), p. 45.

20 Arthur Carles to John E. D. Trask, undated [early 1910], Archives, Pennsylvania Academy of the Fine Arts.

21 Caffin, quoted in *CW*, no. 48 (Oct. 1916), p. 37. An interesting eye-witness account of the Stieglitz group in 1910, using fictionalized (but usually recognizable) names, was presented by Temple Scott, an habitué of the Holland House ("Fifth Avenue and the Boulevard Saint–Michel," *The Forum* 44 [Dec. 1910]: 665–685). In this article Marin, alias Seaman, was mentioned as one of the regulars at the Holland House. According to Scott's account, he benefited from advice about his painting given by Max Weber (Michael Weaver).

22 *CW*, nos. 42–43 (Apr.–July 1913), p. 42.

23 E. A. Taylor, "The American Colony of Artists in Paris (second article)," *The International Studio* 44 (July 1911): 112.

24 It is possible to account for almost all of Marin's pre-1911 works without invoking the idea of direct influence from Cézanne. However, there is one watercolor, dated 1908, which is distinctly Cézannesque in color, drawing, and brushwork: *The Four Mills at Meaux*, reproduced in Reich, *Marin*, 2:331 (08.19). (It was exhibited at 291 from Mar. 30 to Apr. 17, 1909.) Sheldon Reich has pointed out that *The Seine after the Storm* (1908), reproduced in *Marin*, 2:332 (08.23), also resembles Cézanne (Reich, *Marin*, 1:30).

25 Reproduced in Alfred H. Barr, Jr., *Matisse, His Art and His Public* (New York, 1951), p. 309.

26 "The Water Colors of John Marin," *CW*, no. 39 (July 1912), p. 38.

27 This title is used by Reich in *Marin*, 2:359, but the Philadelphia Museum of Art gives *Rolling Land – Delaware River Country*.

28 This painting was reproduced in the catalogue of the first group exhibition of Der Blaue Reiter (1911) and in the almanac *Der Blaue Reiter* (Munich, 1912). It might have been known to Marin through these channels.

29 Reproduced in Reich, *Marin*, 2:371 (12.59). Although the painting is signed and dated "Marin 11," Reich believes, rightly I think, that it was dated incorrectly and should be 1912 (ibid., 2:371).

30 Reproduced in ibid., 2:370 (12.52).

31 Now in the National Gallery of Art, Washington, and reproduced in Reich, *Marin*, 2:372–373 (12.66, 12.67, 12.68, 12.69), four watercolors of the series were exhibited in the Armory Show of 1913.

32 *Exhibition of Water-colors – New York, Berkshire and Adirondack Series – and Oils by John Marin, of New York* (New York: Photo-Secession Gallery, 20 Jan.–15 Feb. 1913), reprinted in *CW*, nos. 42–43 (Apr.–July 1913), p. 18.

33 Reich, *Marin*, 1:57.

34 Translation from Joshua C. Taylor, *Futurism* (New York, 1961), p. 124.

35 Ibid., p. 128.

36 Reich, *Marin*, 1:57–58.

37 In *American Art Journal* 1 (Spring 1969): 45, Reich compares this work to Marin's *Movement, Fifth Avenue* (1912).

38 Mackinley Helm has pointed out that Marin knew Whitman's writings and that the artist often expressed himself in a Whitmanesque style (*John Marin*, pp. 39, 54). Compare, for example, the following excerpts from "Mannahatta":

Rich, hemm'd thick all around with sailships and steamships – an island sixteen miles long, solid-founded,
Numberless crowded streets – high growths of iron, slender,

*strong, light, splendidly uprising
toward clear skies; . . .*

*A million people — manners free
and superb — open voices — hos-
pitality — the most courageous
and friendly young men;*
*The free city! no slaves; no owners
of slaves!*
*The beautiful city, the city of
hurried and sparkling waters! the
city of spires and masts!*
The city nested in bays! my city!

(Walt Whitman, *Leaves of Grass*
[Philadelphia, 1900], p. 320 [first
published in 1860]).

39 Frederick S. Wight, *Arthur G.
Dove* (Berkeley, 1958), p. 25.

40 Information from Dove's Cornell
University transcripts. The area in
which he took his degree was
"Arts," without mention of any
more specific major subject.

41 New York *Globe*, 28 Feb. 1912.

42 Dove told Samuel Kootz that he had
spent eighteen months in France
(Kootz, *Modern American Painters*
[New York, 1930], p. 36). But
entries in John Sloan's diaries of
1908–1909 (published as *John
Sloan's New York Scene* [New
York, 1965]) indicate that the
length of Dove's stay was closer to
fourteen months: that is, from May
or June 1908 to the end of July
1909.

43 Mellquist states that "Dove saw the
work of Matisse" in Paris (*The
Emergence of an American Art*
[New York, 1942], p. 363). Since

Mellquist was close to the Stieglitz
circle in the late 1930s and un-
doubtedly obtained his information
directly from Dove, his informa-
tion can be considered reliable.

44 Duncan Phillips, "Arthur Dove,
1880–1946," *Magazine of Art* 40
(May 1947): 194.

45 In his own unpublished catalogue
of his works Dove stated that he
thought they might be from that
year; but we have no accounts of
the paintings being displayed near
the time of their creation, so we
cannot date them from exhibition
records or reviews. If the 1910 date
is correct, then they would be
among the earliest abstractions
created anywhere in the world and,
therefore, of paramount historical
importance.

46 The term "Ten Commandments"
was not used in the press reviews of
the 291 show in 1912 or the sub-
sequent exhibition, also in 1912, at
the Thurber Galleries, Chicago. Ap-
parently this title was devised at a
later date, perhaps by Stieglitz.
There is no doubt, however, that
The Ten Commandments were con-
ceived as a group, "each with its
own different motive," as Dove
pointed out in a letter to Samuel
Kootz, published in Kootz, *Modern
American Painters*, p. 37; although
Dove said Stieglitz "made room for
them" in 1910, other evidence indi-
cates that the date for their first
public exhibition should be 1912. In
his own card file, which is not com-
pletely accurate, Dove dated them

variously from 1910 through 1914, with many falling in 1911 or 1912. Not all of the works from the series have been found, nor can we be entirely sure about which pastels belong to it. But there is a core of works that we can identify by citations in contemporary writings.

47 Transcription of taped interview, Jan.–Mar. 1958, Oral History Collection, Columbia University, pp. 271–272. He gave Mar. 28 as the exact date of the visit.

48 Reproduced in *Max Weber* (New York: Bernard Danenberg Galleries, Inc., 12–30 May 1970), p. 33.

49 Reproduced in Henry R. Hope, *Georges Braque* (New York, 1949), p. 41.

50 Reproduced in Joshua C. Taylor, *Futurism* (Garden City, N.Y., 1961), p. 37.

51 Arthur Jerome Eddy, *Cubists and Post-Impressionism* (Chicago, 1914), p. 49.

52 Kootz, *Modern American Painters*, p. 37.

53 Dove had displayed examples of his "Impressionist" work at Thurber's for several years prior to the 1912 show. At the 1912 exhibition there were a few examples of his earlier style which were apparently included as a foil for the abstract pastels.

54 Eddy, *Cubists and Post-Impressionism*, p. 48.

55 Published in *La Grande Revue* (Paris), 25 Dec. 1908; for an English translation, see Barr, *Matisse*, pp. 119–123.

56 H. Effa Webster, Chicago *Examiner*, 15 Mar. 1912.

57 Chicago *Sunday Tribune*, 17 Mar. 1912.

58 Ibid. Monroe's citation of the manifesto, in turn, exactly duplicates the first part of the excerpt published in the *Literary Digest*, 12 Mar. 1912, mentioned in the text. The entire *Literary Digest* selection was reprinted as part of an article, "Mr. Dove's Italian Cousins," in the Chicago *Evening Post* (undated clipping [Mar. 1912], Dove scrapbook, AAA N70-51). Stieglitz's artist friend Oscar Bluemner wrote him at length about the Futurist exhibition at the Sackville Gallery, letter of 7 May 1912.

59 Chicago *Sunday Tribune*, 17 Mar. 1912.

60 Chicago *Examiner*, 15 Mar. 1912.

61 Kootz, *Modern American Painters*, p. 37.

62 Unidentified newspaper clipping, 16 Mar. 1912, Dove scrapbook.

Chapter 5. The Rise of the American Avant-Garde: Artists of the Stieglitz Circle before 1913, II (Weber, Walkowitz, Hartley)

1 Lloyd Goodrich, "Notes on Conversation with Max Weber," unpublished manuscript, 16 June 1948, AAA NY 59-8, p. 1.

2 Ibid., p. 3.

3 MW to Jake Heyman, 25 May 1903, AAA N/69-82.

4 Ibid.

5 Goodrich, "Notes on Conversation with Max Weber," p. 11.

6 MW to Mr. Defenbacher, 19 Sept. 1946, published in *Magazine of Art*, Walker Art Center edition, 39 (Nov. 1946): ii.

7 MW to Marius de Zayas, 22 Apr. 1951, AAA N/69–83.

8 Weber, "The Matisse Class," unpublished manuscript read before Matisse symposium, Museum of Modern Art, 19 Nov. 1951, p. 13, AAA NY 59–6.

9 Gertrude Stein left no written record of meeting Max Weber, but in a letter to her of 30 Apr. 1913, Alvin Langdon Coburn referred to "Mr. Max Weber of New York whose work you no doubt know . . ." (*The Flowers of Friendship*, ed. Donald Gallup [New York, 1953], p. 42). We know that Weber was acquainted with Leo Stein, for there are several caricatures of Leo by Weber on a sheet of drawings in the Yale University Art Gallery. Information courtesy of Phylis North.

10 Holger Cahill, *Max Weber* (New York, 1930), p. 11.

11 Weber, "The Matisse Class," p. 9.

12 "Matisse Speaks to His Students," notes by Sarah Stein, 1908, published in Alfred H. Barr, Jr., *Matisse, His Art and His Public* (New York, 1951), p. 551.

13 Weber reported that Matisse occasionally took the members of the class to his studio and showed them his own early paintings and drawings, drawings by Maillol, "black and whites" by Rouault, ink drawings by Van Gogh, a Cézanne painting of bathers (undoubtedly the *Three Bathers*, Musée de Ville de Paris), and his collection of African Negro sculpture (Weber, "The Matisse Class," p. 14).

14 Goodrich, "Notes on Conversation with Max Weber," p. 5.

15 Lloyd Goodrich, *Max Weber* (New York, 1949), p. 14.

16 According to Alfred H. Barr, Jr., whose text was presumably approved by Weber, the artist spent hours "before the archaic sculpture of Egypt, Assyria and Greece, in the Trocadéro before the sculpture of mediaeval France, and in the Musée Guimet before the painting and stone figures of China and Japan" (*Max Weber Retrospective Exhibition, 1907–1930* [New York: MOMA, 13 Mar.–2 Apr. 1930], p. 8).

17 According to Barr, "Visits to Spain disclosed to him El Greco, Velásquez and Goya" (ibid.). In Italy he studied the work of Giotto, Masaccio, Mantegna, Castagno, Piero della Francesca, Donatello, Della Robbia, Michelangelo, Giorgione, Titian, and Tintoretto (Cahill, *Max Weber*, p. 10).

18 Alfred Stieglitz, "The Story of Weber," unpublished typescript, p. 3.

19 Ibid.

20 Lloyd Goodrich, interview with Max Weber, 9 Nov. 1948, AAA NY 59–8. The Cézanne reproductions were exhibited at 291 at the

time of the 1910 Rousseau show.

21 Weber, "Chinese Dolls and Modern Colorists," *CW*, no. 31 (July 1910), p. 51. Weber's dissatisfaction with Matisse was also recorded by Temple Scott, "Fifth Avenue and the Boulevard Saint-Michel," *Forum* 44 (July–Dec. 1910): 668.

22 Holger Cahill, *American Sources of Modern Art* (New York: MOMA, 10 May–30 June 1933), p. 7.

23 Reproduced in *Max Weber* (Santa Barbara: The Art Galleries, University of California at Santa Barbara, 6 Feb.–3 Mar. 1968), p. 33.

24 Reproduced in Christian Zervos, *Pablo Picasso* (Paris, 1942), vol. 2, no. 113.

25 Ibid., no. 108.

26 This method seems to have been adapted from works such as Picasso's *Nu à la draperie*, 1907, Hermitage Museum, Leningrad (Zervos, vol. 2, no. 47), and *Trois nus féminins*, 1907–1908, Douglas Cooper Collection, London (Zervos, vol. 2, no. 53).

27 One of Weber's essays on photography included a diatribe against Steichen's work, and Stieglitz therefore refused to publish it. However, he did print Weber's "The Fourth Dimension from a Plastic Point of View," *CW*, no. 31 (July 1910), p. 25; "Chinese Dolls and Modern Colorists," ibid., p. 51; and a poem, "To Xochipilli, Lord of Flowers," *CW*, no. 33 (Jan. 1911), p. 34.

28 Stieglitz had absorbed ideas from Steichen and other members of the 291 group, but Dorothy Norman pointed out to the author that he acknowedged that only two individuals had strongly influenced his thinking about art — Sadakichi Hartmann and Max Weber (interview with Dorothy Norman, 21 Nov. 1972). Stieglitz admitted in later years that Weber, "being very intelligent, became helpful in a way in clarifying my own ideas" ("The Story of Weber," p. 10).

29 The titles of the works are listed in the catalogue of the Armory Show, reprinted with annotations, in Milton W. Brown, *The Story of the Armory Show* (Greenwich, Conn., 1963). The examples are reproduced in Sandra E. Leonard, *Henri Rousseau and Max Weber* (New York, 1970).

30 AS to Mrs. [Edith] Halpert, 20 Dec. 1930, AAA N 692.

31 Mrs. Meyer had agreed to give $500 for the picture, enough to support Weber for a year (AS, "The Story of Weber," p. 17).

32 Some of Weber's lectures on art, written in 1914, were published as *Essays on Art* (New York, 1916).

33 Davies apparently helped Weber whenever he could. He bought several of his paintings and induced Lizzie Bliss to do the same. Hamilton Easter Field also purchased a few of his early oils and exhibited his work at his gallery in Brooklyn.

34 Reproduced in Alfred Werner,

Max Weber (New York, 1975), pl. 55.

35 Ibid., pl. 50.

36 Ibid., pl. 53.

37 Ibid., pl. 2.

38 Ibid., pl. 69.

39 Abram Lerner and Bartlett Cowdrey, "A Tape Recorded Interview with Abraham Walkowitz," *Journal of the Archives of American Art* 9 (Jan. 1969): 12. Walkowitz's memory for dates was not always accurate. He stated that he studied at the National Academy of Design in the years 1898–1900 and with Shirlaw in 1899. The National Academy of Design has no school records before 1902, but its files indicate that Walkowitz attended classes in Life Painting and Etching in October 1902 and a class in Life Painting, February–May 1904 (Sylvia Lochan, National Academy of Design, to WIH, 8 Feb. 1973). Marsden Hartley recalled that Walkowitz had studied at the National Academy when he was there in the 1900–1901 season.

40 In his unpublished autobiographical notes (AAA D303), Walkowitz referred to working with an "art club group of a few" in 1898 and sketching, in 1898–1899, with a life class in a room near the Educational Alliance.

41 Henry McBride, who later became a noted critic, served for a time as director of the school of fine arts at the Educational Alliance. In one account, Walkowitz recalled that he had taught with McBride, but elsewhere he reported that he had been a student of McBride at the Alliance. (*Art Students League News* [Jan. 1963], p. 1). Both statements may be true.

42 Norma Ketay, "What It Meant to Be an Ultra-Modern Jewish Artist in America 60 Years Ago," *The Day — Jewish Journal*, 11 May 1958, p. 7.

43 Walkowitz, quoted in *The Jewish News*, 1 Mar. 1963, p. 12.

44 We know that Walkowitz had also seen the work of Courbet, Manet, Renoir, Pissarro, Van Gogh, and Gauguin (MW to Walkowitz, 15 Nov. 1907).

45 Lerner and Cowdrey, "A Tape Recorded Interview," p. 15.

46 Ibid., p. 13.

47 "New York Jews in Art," *The Federation Review* 3 (June 1909): 127.

48 It is extremely difficult, if not impossible, to arrive at an accurate chronology of Walkowitz's work. The issue is confused because he dated some of his pictures incorrectly, long after they were painted; many, however, remain undated. Furthermore, he often employed two or more dissimilar styles concurrently, a practice that makes it hard to date his work accurately. As far as I can determine, he kept no systematic record of his own oeuvre.

49 This and several other paintings of the group bear a close resemblance to the 1908–1909 canvases of the German expressionist Emil Nolde. The similarity is, in all likelihood, coincidental.

50 Matisse had incorporated elements from children's art as early as 1906–1907 in such paintings as *Marguerite* (1906 or 1907, reproduced in Barr, *Matisse*, p. 332). Paul Klee, in Germany, had become convinced that contemporary painters could learn much from children's art and had been influenced by it himself as early as 1908.

51 Lerner and Cowdrey, "A Tape Recorded Interview," p. 13.

52 Ibid. In his unpublished notes, Walkowitz stated, "first modern exhibition at Julius Haas gallery 1908 second exhibition 1909" (AAA D303). The 1909 show was held from April 3 to 17.

53 Hartley, unpublished manuscript autobiography, AAA D267.

54 Ibid.

55 Hartley to Richard Tweedy, 15 Dec. 1900, AAA D261. Hartley recalled that Abraham Walkowitz was also studying at the Academy at the time, but we do not know whether they met; it is likely that they did, for Hartley later introduced Walkowitz to Stieglitz. Hartley also attended, in 1900–1901, a design class at the Artists'-Artisans' School on East Thirty-third Street, managed by Douglas John Connah.

56 MH to Tweedy, 27 May 1900, AAA D271.

57 Ibid.

58 MH to Tweedy, 25 Oct. 1900, AAA D271.

59 Ibid.

60 MH to Tweedy, 17 June 1900, AAA D271.

61 MH to Tweedy, 23 Nov. 1900, AAA D271.

62 MH to Tweedy, 10 July 1901, AAA D271.

63 MH to Marguerite Reuwée, 21 July 1904, AAA D267.

64 In a letter to Norma Berger, his niece, 3 Nov. 1910, he referred to Pater as one of his favorite authors and praised the writings of Thackeray, Henry James, George Meredith, and Maeterlinck. During this decade, he is known to have read the progressive German periodical *Jugend*.

65 MH to Tweedy, 25 Oct. 1900, AAA D271.

66 Samuel M. Kootz, *Modern American Painters* (New York, 1930), p. 40.

67 Jerome Mellquist, "Marsden Hartley, Visionary Painter," *The Commonweal* 39 (31 Dec. 1943): 277. Hartley, quoted in Kootz, *Modern American Painters*, p. 40, indicated that he saw a reproduction of a Segantini in *Jugend*.

68 Kootz, *Modern American Painters*, p. 40.

69 Hartley, unpublished manuscript autobiography, AAA D267.

70 Ibid.

71 Arthur B. Davies was one of the first influential figures in the New York art world to appreciate Hartley's work. The admiration was mutual; when the younger man was a student at the National Academy of Design, he had been impressed by an exhibition of Davies's work at the Macbeth Galleries

(Hartley, unpublished essay on Arthur B. Davies, YCAL).

72 This information about Hartley's relation to "The Eight" comes from John Sloan's diary, published as *John Sloan's New York Scene* (New York, 1965), pp. 301–303. In spite of this rejection, Hartley professed his admiration for Robert Henri (Hartley, unpublished essay on Davies).

73 O'Sheel met Hartley about 1904–1905. At the time of their meeting Hartley was much interested in Irish literature, hence his attraction to O'Sheel, a poet and Celtophile active in the Philo-Celtic Society of New York.

74 Charles H. Caffin, "Unphotographic Paint: The Texture of Impressionism," *CW*, no. 28 (Oct. 1909), p. 20.

75 Ibid.

76 During Hartley's tenure at 291, he would have encountered, among others, Dove, Weber, Marin, Walkowitz, De Zayas, Haviland, Kerfoot, and Keiley. He spoke with admiration of Marin's work (Mackinley Helm, *John Marin* [Boston, 1948], p. 25). Apparently Hartley and his work were not universally admired by the 291 group; in letters to the artist, Stieglitz occasionally mentioned defending Hartley against accusations made by his colleagues. Weber went so far as to ask Stieglitz to expel the Maine painter as an imposter (AS to Hartley, 27 Oct. 1923).

77 In a letter to Stieglitz of March [no day indicated] 1912, from Lewiston, Maine, Hartley expressed his desire to return to see the Matisses, a reference, no doubt, to the exhibition of his drawings and reproductions held at 291 from 23 Feb. to 8 Mar. 1911.

78 AS to MH, 26 Oct. 1923.

79 Ibid.

80 Hartley stated in a letter to Gertrude Stein, written in October 1913, that he saw his first Cézannes at Mrs. Havemeyer's home (*The Flowers of Friendship*, ed. Donald Gallup [New York, 1953], p. 85). In a letter to Stieglitz, July [no day indicated] 1911, Hartley implied that he had not yet seen original examples by Cézanne.

81 The book Hartley consulted was probably Julius Meier-Graefe's *Paul Cézanne* (Munich, 1910).

82 Reproduced in Robert Rosenblum, *Cubism and Twentieth Century Art* (New York, 1961), pl. V.

83 Reproduced in Zervos, *Picasso*, vol. 2, no. 79.

84 Hartley's canvas shows close affinities to Picasso's *Joueur de guitare* (1910), Zervos, *Picasso*, vol. 2, no. 223. It is possible that Stieglitz brought back from France, at the end of the summer of 1911, photographs of Cubist works for the edification of the artists of 291. He had met Picasso on this trip.

85 MH to AS, July [no day indicated] 1911.

86 MH to Norma Berger, 2 Apr. 1911.

87 *CW*, no. 38 (Apr. 1912), p. 36.

88 Writing to Stieglitz, 20 June 1912, Hartley offered to send him Vol-

lard's edition of the letters of Van Gogh and Gauguin's *Noa-Noa*.

89 Hartley, unpublished manuscript autobiography. In letters to Stieglitz and in an unpublished essay on Gertrude Stein (YCAL) Hartley stated that he saw the work of Cézanne (particularly the watercolors), Matisse, and Picasso at the Stein apartment. The presence of three portfolios of Picasso's work enabled him to study the artist's draftsmanship.

90 Hartley and Stein kept up an active correspondence between 1912 and 1934. She included Hartley as one of the characters in a play she wrote in 1913, published in her *Geography and Plays* (Boston 1922).

91 Reproduced in Elizabeth McCausland, *Marsden Hartley* (Minneapolis, 1952), p. 19.

92 Charles Demuth (1883–1935) formed a close friendship with Hartley and Rönnebeck, and together they frequented the Stein salon and art galleries in Paris. Hartley found Demuth intelligent and witty and was devoted to him. Demuth returned to the United States early in 1914 and, at Hartley's suggestion, included 291 in his tours of the New York galleries. He must have become well acquainted with Stieglitz in that year, because he invited Demuth to write a tribute to 291 for *Camera Work* (July 1914, published Jan. 1915). He stated that his first conversation with Stieglitz

affected his 1914 watercolor *Early Landscape* (1914, Metropolitan Museum of Art); his acknowledgment of Stieglitz's influence was recorded in his inscription on the back of the painting, which Demuth gave him as a tangible record of that talk. Demuth repeatedly expressed his admiration for Marin, whose watercolors helped to shape his style around 1915. Charles Daniel, the New York dealer, gave Demuth his first show in October and November 1914; years later, Daniel recalled that Stieglitz did not wish to show anyone at that time who would compete with Marin.

In the public mind, Charles Demuth is linked to the 291 group. But before 1917 he was not a member of the inner circle. Although he knew Stieglitz and benefited from the 291 exhibitions, he had close ties only with Marsden Hartley. When Demuth attained artistic maturity, he became a regular exhibitor at Stieglitz's Intimate Gallery and An American Place and was one of the small group — Marin, O'Keeffe, and Dove — who remained loyal to the proprietor.

93 In a postcard to Stieglitz, September [no day indicated] 1912, Hartley said he thought it was necessary for Stieglitz, as well as himself, to have the *Blaue Reiter* almanac.

94 Hartley offered to have Katharine Rhoades take *On the Spiritual in Art* back to Stieglitz. The photographer, however, must have

learned of the book from another source before Hartley wrote him about it, because excerpts from it were published in the July 1912 issue of *Camera Work*. On 12 June 1914, Hartley wrote Stieglitz that Kandinsky's book had appeared in English.

95 MH to Rockwell Kent, 22 September 1912, AAA.

96 Ibid.

97 MH to AS, 9 Oct. 1912.

98 After seeing the Marc exhibition, Hartley corresponded with the German artist, and from this exchange came an invitation for Hartley to exhibit with the Blaue Reiter group. Apparently Marc invited him to show his work without ever having seen it; he was convinced by Hartley's letters that he had something worthwhile to say. Through Frank Eugene, a pictorial photographer and friend of Stieglitz living in Munich, Hartley arranged to place some of his work in the Goltz Gallery, Munich.

99 MH to Rockwell Kent, undated [Feb. 1913], AAA.

100 Hartley is known to have admired the work of Klee, along with Kandinsky and Marc, and at this time the Swiss artist was experimenting with unconscious imagery, following the instinctive procedures of children's art. Significantly, the picture postcard that Hartley sent Stieglitz from the Erster Deutscher Herbst Salon, Berlin, postmarked 22 Sept. 1913, reproduced a work by Klee embodying highly inventive linear pictographs closely allied to children's drawings and also paralleling Hartley's own efforts.

101 MH to AS, undated [July 1912]. After his first visit to Germany, he wrote Stieglitz that he could never become French or German, that he would always be American (MH to AS, undated [Feb. 1913]). Later in the year, on 28 Sept., he wrote Stieglitz that he thought America was stifling and that he could be American anywhere; yet at the same time he denied that he felt American and thought he belonged to no particular place.

102 MH to AS, undated [received 20 Dec. 1912].

103 Hartley's prolonged stay in Berlin was made possible by financial aid from Paul Haviland.

104 MH to AS, undated [May 1913].

105 Ibid.

Chapter 6. Stieglitz and Modern
Art in America

1 Milton W. Brown, *The Story of the Armory Show* (Greenwich, Conn., 1963), p. 30.

2 Besides Davies, others in attendance, or represented by proxy, were Henry Fitch Taylor, Karl Anderson, D. Putnam Brinley, Gutzon Borglum, John Mowbray-Clarke, Leon Dabo, James E. Frazer, William Glackens, Walt Kuhn, Ernest Lawson, Jonas Lie, Elmer MacRae, Jerome Myers, Allen Tucker, and J. Alden Weir.

3 Brown, *The Story of the Armory Show*, p. 31.

4 Ibid., p. 307.

5 Walt Kuhn, *The Story of the Armory Show* (New York, 1938), p. 8.

6 Ibid.

7 Ibid., p. 11.

8 Although Kuhn had studied in Paris and Munich in the years 1901–1903 and had visited these cities in 1904, these journeys preceded the outbreak of violent artistic revolution in Europe.

9 Edward Steichen, *A Life in Photography* (Garden City, N.Y., 1963), no pagination.

10 See Davies to AS, 3 Apr. 1911; AS to Davies, 16 Jan. 1913.

11 Kuhn, *The Story of the Armory Show*, p. 10.

12 MH to AS, undated [early Nov. 1912].

13 Included were Marion Beckett, Oscar Bluemner, Arthur Carles, Marsden Hartley, John Marin, Alfred Maurer, and Katharine Rhoades.

14 Brown, *The Story of the Armory Show*, p. 90.

15 AS to Ward Muir, 30 January 1913.

16 AS to Davies, 18 February 1913.

17 For a discussion of the gallery situation after the Armory Show see Judith K. Zilczer, "'The World's New Art Center': Modern Art Exhibitions in New York City, 1913–1918," *Archives of American Art Journal* 14 (1974): 2–7, and her checklist "Modern Art and Its Sources: Exhibitions in New York, 1910–1925" in *Avant-Garde Painting and Sculpture in America, 1910–25*, ed. William Innes Homer (Wilmington: Delaware Art Museum, 4 Apr.–18 May 1975), pp. 166–170.

18 The Forum Exhibition of Modern American Painters was designed to present the best examples of contemporary American art to the public, without a commercial intermediary. Organized by the critic Willard Huntington Wright, with the aid of a five-man selection committee (Dr. Christian Brinton, Robert Henri, W. H. deB. Nelson, Alfred Stieglitz, and Dr. John Weichsel), the show displayed 193 works by seventeen prominent American modernists. Each of the major circles of avant-garde activity was represented. Exhibitors with ties to 291 were Dove, Hartley, Marin, Maurer, and Walkowitz; Ben Benn, a peripheral member of the circle, was included at Walkowitz's suggestion (Martica Sawin, "Abraham Walkowitz, the Years at 291: 1912–1917" [master's thesis, Columbia University, 1967], p. 61). Weber was conspicuously absent.

Stieglitz thought highly of Wright and of the spirit and execution of the Forum Exhibition (AS to Paul B. Haviland, 19 Apr. 1916). Wright, in turn, acknowledged Stieglitz's idealism as a source of inspiration to him (Wright to AS, 26 Mar. 1916).

19 AS to John G. Bullock, 26 Mar. 1917.

20 Also deserving of mention, among avant-garde activists in New York, is Robert J. Coady (1876–1921), virtually forgotten until 1975. Al-

though he was never the focal point for a circle of artists, he was a vigorous spokesman for modern European and American art. Starting as a painter, he studied in Paris and there became a friend of Max Weber and of Gertrude and Leo Stein. With the American sculptor Michael Brenner (1885–1969), who was also acquainted with the Steins, he established the Washington Square Gallery in New York, which was devoted mainly to vanguard European art. Started in 1914, the gallery subsequently moved uptown to Fifth Avenue and was renamed The Coady Gallery. Working with his partner Brenner, who served as his European agent, he enlisted the cooperation of Kahnweiler, Picasso's dealer in Paris. Before withdrawing from business in 1919, Coady had exhibited the work of Picasso, Matisse, Gris, Braque, and Derain, among others. In addition, he showed African Negro carvings (first presented in the spring of 1914), sculpture from the South Sea Islands, and the art of American Negro children. Like Stieglitz, Coady edited and published a periodical – *The Soil* (1916–1917) – which reflected the aesthetic tenets of the gallery and its proprietor. In that journal he promoted not only avant-garde European art and primitive art but also the American popular culture of the machine age, often in a satirical vein. Although there were many similarities between Coady's activities and Stieglitz's, the two men seem to have had few contacts with each other. Coady's contribution was brought to light by Judith K. Zilczer in a paper presented at a symposium at the University of Delaware, 18 Apr. 1975, and published as "Robert J. Coady, Forgotten Spokesman for Avant-Garde Culture in America," *American Art Review* 2 (Sept.–Oct. 1975): 77–89.

21 *The Flowers of Friendship*, ed. Donald Gallup (New York, 1953), p. 71.

22 Mabel Dodge Luhan, *European Experiences*, vol. 2 of *Intimate Memories* (New York, 1935), p. 333.

23 Mabel Dodge Luhan, *Movers and Shakers*, vol. 3 of *Intimate Memories* (New York, 1936), p. 38.

24 Luhan, *Movers and Shakers*, p. 83.

25 Jo Davidson, *Between Sittings* (New York, 1951), p. 81.

26 Pierre Cabanne, *Dialogues with Marcel Duchamp* (New York, 1971), p. 49.

27 Charles Sheeler (1883–1965), a Philadelphia modernist, had close ties with the Arensberg circle and De Zayas. Stieglitz admired him and corresponded with him as early as 1911. In a letter to a Mr. Reiner, 11 June 1915, he referred to Sheeler as a painter friend from Philadelphia.

28 Recollections of Edith Clifford Williams, a member of the Stieglitz and Arensberg circles, tape recording by Malitte Pope Matta, 1 Jan. 1976.

29 Willy Verkauf, *Dada* (Teufen, Switzerland, n.d. [1957]), p. 8.

30 Ibid., p. 10.

31 The Society of Independent Artists followed the example of the French Société des Artistes-Indépendants, which initiated the first no-jury, no-prize salon in 1884. This idea was brought to the United States by several expatriates who joined the Arensberg circle. The SIA was organized in the fall of 1916 at several meetings at the Arensbergs' apartment. The French group, including Duchamp, Roché, and Crotti, worked with several sympathetic Americans – Arensberg, Pach, Covert, Man Ray, Katherine Dreier, William Glackens, and George Bellows. As with the Forum Exhibition of 1916, the Independents represented an alliance of different groups that believed in the modernist cause, but the Arensberg circle dominated the society. Walter Arensberg was the managing director, his cousin Covert was secretary, and Duchamp was chairman of the hanging committee. On 23 Mar. 1917, Stieglitz sent Covert a check for SIA membership for O'Keeffe, Hartley, and himself.

32 The Arensbergs' close friend Beatrice Wood indicated a reason for their move: "Walter had gone through a fortune, his, and possibly some of Lou's, was drinking heavily, loaning money to anyone who asked for it, so finally Lou read a riot act. Either he stopped the philandering, and go West with her, or she would leave him" (Beatrice Wood to WIH, 8 Jan. 1976).

33 Duchamp quoted in Cabanne, *Dialogues*, p. 54.

34 AS to Arthur Carles, 11 April 1913.

35 William Arnett Camfield, "Francis Picabia (1879–1953): A Study of His Career from 1895 to 1918" (Ph.D. diss., Yale University, 1964), p. 99.

36 Reproduced in Robert Rosenblum, *Cubism and Twentieth Century Art* (New York, 1961), p. 162.

37 Camfield, "Picabia," pp. 115–116.

38 *CW*, nos. 42–43 (Apr.–July 1913), p. 20.

39 *CW*, special number (June 1913), p. 12.

40 Aesthetic notions of a more frivolous kind, usually attributed to Picabia but of uncertain origin, found their way into *Camera Work* (special number, June 1913) when Stieglitz reprinted "Vers l'amorphisme," an unsigned essay by Victor Méric originally published in the French periodical *Les Hommes du jour*, 3 May 1913. Probably meant to be a tongue-in-cheek statement, this manifesto declared war on artistic form. Its tone is iconoclastic and, as some scholars have observed, proto-Dada because the writer denied the validity and sacredness of visible form, whether abstract or figurative. It is hard to discover the origins of these ideas; whatever the writer's sources were, it is an unusual statement, and it does not find a place in the mainstream of American or European art theory.

41 Reproduced in William A. Cam-

field, *Francis Picabia* (New York: The Solomon R. Guggenheim Museum, 1970), p. 77.

42 Ibid., p. 78.

43 William A. Camfield, "The Machinist Style of Francis Picabia," *Art Bulletin* 48 (Sept.–Dec. 1966): 314.

44 I am indebted to Paul Schweizer for identifying these previously unexplained elements.

45 "Alfred Stieglitz: Four Happenings," *Twice a Year*, nos. 8–9 (Spring–Summer, Fall–Winter 1942), p. 131.

46 Marius de Zayas to Agnes Meyer, 15 July 1915, Agnes Meyer Papers, LC.

47 Marius de Zayas to AS, 27 Aug. 1915, De Zayas Papers, collection of Rodrigo de Zayas.

48 Agnes Meyer to AS, 16 August 1915.

49 Announcement inserted in *291*, no pagination.

50 *CW*, no. 48 (Oct. 1916), pp. 63–64.

51 Jerome Mellquist, *The Emergence of an American Art* (New York, 1942), p. 209.

52 Stieglitz paid relatively little attention to American sculpture. As a photographer, he probably had a natural preference for two-dimensional media. But he may have neglected sculpture, too, because very few American modernists were making significant advances in that medium between 1908 and 1917. He did exhibit one sculpture by Georgia O'Keeffe, along with her paintings and drawings, in 1917; the artist claimed that it was no longer

extant (interview, 22 Sept. 1972). For a discussion of the situation in sculpture, see Roberta K. Tarbell, "Advanced Tendencies in American Sculpture, 1910–25" in *Avant-Garde Painting and Sculpture in America*, ed. Homer, pp. 26–27.

53 Arthur Jerome Eddy, *Cubists and Post-Impressionism*, 2nd ed. (New York, 1919), p. 220. De Zayas had proposed such a show to Stieglitz as early as 1911 (De Zayas to AS, 21 Apr. 1911).

54 The Severini exhibition has been discussed in detail by Joan M. Lukach, "Severini's 1917 Exhibition at Stieglitz's '291,'" *Burlington Magazine* 113 (Apr. 1971): 196–207.

55 Hamilton Easter Field reported in 1920: "A little farther down the avenue the old building which was, so to speak, the cradle of ultramodern art, Number '291', is gone, and already a skyscraper filling the entire frontage of the block is taking its place. The Holland House, where Stieglitz and the radicals used to lunch, is an office-building. So pass away the glories of this earth!" (*The Arts*, 1 [4 Dec. 1920]: 25).

Chapter 7. Life and Work of the Artists of the Stieglitz Circle, 1913–1917

1 For a discussion of other avant-garde artists and groups that paralleled the efforts of the Stieglitz circle, see *Avant-Garde Painting*

and *Sculpture in America, 1910–25,* ed. William Innes Homer (Wilmington: Delaware Art Museum, 4 Apr.–18 May 1975), pp. 18–27, 30–158.

2 Charles Daniel (1878–1971) had been inspired by the example of Stieglitz and 291 and at first equaled, then surpassed, his mentor as a successful promoter of modern American art. Besides handling the work of Marin and Hartley, by arrangement with Stieglitz, he gave shows to Man Ray, William and Marguerite Zorach, and Thomas Hart Benton, among others, at his gallery at 2 West Forty-seventh Street. (It closed in 1932.) The collector Ferdinand Howald bought many of his early American moderns, including his first group of Marins, from Daniel. Howald subsequently gave his magnificent collection to the Columbus (Ohio) Gallery of Fine Arts.

3 Dorothy Norman, ed., *The Selected Writings of John Marin* (New York, 1949), p. 27.

4 The year 1916 may have been the date of his Weehawken Sequence, 100 small oil sketches on canvas board, executed out-of-doors in Weehawken, New Jersey. The dating of these paintings is open to debate, Marin having insisted that they were painted in 1903–1904 and later inscribing many of them with that date. Their execution, however, seems too advanced, too sophisticated and assured for 1903–1904. On the basis of style, Sheldon Reich has placed most of the Weehawken

pictures about 1916 (*John Marin,* 2 vols. [Tucson, 1970], 1:85–98), but because of the irreconcilable controversy over their dating they will not be discussed here.

5 Jerome Mellquist, *The Emergence of an American Art* (New York, 1942), p. 365.

6 This date, with the handwritten note "from Mr. Stieglitz" appears on the flyleaf of Dove's copy of *Der Blaue Reiter,* collection of William Dove.

7 Dove produced very few paintings and pastels from 1913 to the closing of 291, and these works are difficult to date precisely. The artist's card file, in the possession of William Dove, gives specific years for most of the works of this period, but the style of these examples often suggests that his dates are off the mark by at least a year or two. We will indicate our uncertainty about questionable dating by using a question mark after the dates for certain works cited in the text.

8 Reproduced in Henry Geldzahler, *American Painting in the Twentieth Century* (New York, 1965), p. 52.

9 This painting is dated on the stretcher 1912 or 1913 (the last digit appears to have been changed from 2 to 3). The artist's card file indicates a date of 1913.

10 Reproduced in Joshua C. Taylor, *Futurism* (New York, 1961), p. 28.

11 Reproduced in Geldzahler, *American Painting,* p. 52.

12 Among Walkowitz's effects was found a copy of *On the Spiritual in Art* (1912) with annotations in

German (the hand has not been identified). Through attending the Armory Show and through his association with Stieglitz, Walkowitz would have had access to Kandinsky's *Improvisation No. 27* (Metropolitan Museum of Art, Figure 82).

13 Two abstractions of this type, *From Life to Life, No. I* and *No. II*, were reproduced in *CW*, no. 44 (Oct. 1913), pp. 49, 51.

14 The character of the forms, but not the color, is comparable to Dove's *Based on Leaf Forms and Spaces* (1911–1912, Figure 55) and *Calf* (1911) (Collection of Melville Cane, New York).

15 *CW*, no. 44 (Oct. 1913), p. 25.

16 In later years he often placed impossibly early dates on some of his 1906–1913 works, thereby trying to establish his priority.

17 Goltz reneged on his promise to give Hartley a show in June at his Munich gallery, and the American artist therefore arranged to have the Dietzel gallery in Berlin handle his work.

18 Stein to AS, undated [Apr. 1913?], published in Donald Gallup, "The Weaving of a Pattern: Marsden Hartley and Gertrude Stein," *Magazine of Art* 41 (Nov. 1948): 259.

19 MH to Stein, undated [18 Oct. 1913], reproduced in Gallup, "The Weaving of a Pattern," p. 259.

20 MH to AS, undated [received September 1913].

21 During Hartley's brief stay in New York, he found a sophisticated cultural oasis in Mrs. Dodge and her entourage at 23 Fifth Avenue. Miss

Stein's contribution to the Hartley catalogue was an excerpt from a 1913 play, which featured Hartley as one of the characters.

22 *An Exhibition of Paintings by Marsden Hartley, of Berlin and New York* (New York: Photo-Secession Gallery, 12 Jan.–5 Feb. 1914), reprinted in *CW*, no. 46 (Jan. 1914), p. 17.

23 MH to AS, undated [received 14 May 1914].

24 Hartley wrote Stieglitz that he hoped the work of Kandinsky, Marc, or Klee could be shown at 291 but expressed reservations because the dimensions of their pictures would be too large for the gallery (MH to AS, 30 June 1914).

25 For Hartley's identification with the American Indian, see MH to AS, 12 Nov. 1913 [*sic*, read 1914].

26 At Berlin's Ethnographical Museum Hartley could have seen, in Room VII, examples of the art of North American Prairie Indians. These works were collected by a Museum expedition that went to America in the years 1881–1883.

27 *Exhibition of Paintings by Marsden Hartley* (New York: Photo-Secession Gallery, 4–22 Apr. 1916).

28 MH to AS, 5 Aug. 1915.

29 MH to AS, undated [22 Mar. 1917].

30 MH to AS, 18 Jan. 1917.

31 MH to Carl Sprinchorn, undated [Bermuda, 1917], published in *Lyonel Feininger — Marsden Hartley* (New York: Museum of Modern Art, 1944), p. 62.

32 Her father, Francis O'Keeffe, was of Irish descent; her mother, Ida

Totto, was of Hungarian and Dutch origin.

33 O'Keeffe, quoted in Katherine Kuh, *The Artist's Voice* (New York and Evanston, n.d. [c. 1962]), p. 189.

34 Ibid.

35 Ibid., p. 190, and interview, 22 Sept. 1972.

36 Interview, 22 Sept. 1972.

37 Ibid.

38 O'Keeffe, quoted in Suzanne M. Mullett, "Arthur G. Dove" (master's thesis, The American University, 1944), p. 27.

39 Interview, 22 Sept. 1972.

40 Interview, 22 Sept. 1972.

41 AS to Anita Pollitzer, 9 Aug. 1915. This issue of *291* reproduced works by Marin and Picabia.

42 *Georgia O'Keeffe Drawings*, introduction by Lloyd Goodrich (New York, 1968), no pagination.

43 Reproduced in Lloyd Goodrich and Doris Bry, *Georgia O'Keeffe* (New York: Whitney Museum of American Art, 8 Oct.–29 Nov. 1970), p. 41.

44 This story has been told by several people. For the most detailed account see Anita Pollitzer, "That's Georgia," *Saturday Review of Lit-erature* 33 (4 Nov. 1950): 42.

45 AS to Paul Haviland, 19 Apr. 1916.

46 All quotations are from interviews with Paul Strand conducted on 28 Dec. 1971, 25 June 1974, and 7 Feb. 1975, unless otherwise indicated. Strand died on March 31, 1976.

47 Information from the archives of the Ethical Culture Schools, New York.

48 Reproduced in John Golding, *Cubism: A History and an Analysis* (London, 1959), p. 25.

49 *CW*, no. 48 (Oct. 1916), pp. 11–12.

50 Barr used "abstract expressionism" as early as 1929. For a history of the term, see Irving Sandler, *The Triumph of American Painting* (New York and Washington, 1970), p. 2.

Chapter 9. Epilogue: Stieglitz and His Friends after 1917

1 Stieglitz, quoted in Dorothy Norman, *Alfred Stieglitz: An American Seer* (New York, 1973), p. 134.

2 Gallery announcement reproduced in ibid., p. 169.

3 *Selected Essays of William Carlos Williams* (New York, 1954), p. 135.

·APPENDIX I·

Exhibitions at 291

1905–1906

November 24–January 4	Photographs by members of the Photo-Secession
January 10–January 24	Work by French photographers (Demachy, Puyo, etc.)
January 26–February 2	Photographs by Herbert G. French
February 5–February 19	Photographs by Gertrude Käsebier and Clarence White
February 21–March 7	British exhibition: photographs by J. Craig Annan, Frederick Evans, D. O. Hill
March 9–March 24	Photographs by Eduard Steichen
April 7–April 28	German and Austrian photographers: Heinrich Kuehn, Hugo Henneberg, Hans Watzek, Theodore and Oscar Hofmeister

1906–1907

November 10–December 30	Exhibition of photographs by members of the Photo-Secession
January 5–January 24	72 drawings (including watercolors) by Pamela Colman Smith
January 25–February 12	Photographs by Baron A. De Meyer and George H. Seeley
February 19–March 5	Photographs by Alice Boughton, William B. Dyer, C. Yarnall Abbott
March 11–April 10	Photographs by Alvin Langdon Coburn

1907–1908

November 18–December 30	Exhibition of members' work
January 2–January 21	58 drawings by Auguste Rodin
February 7–February 25	Photographs by George H. Seeley
February 26–March 11	Etchings and bookplates by Willi Geiger; etchings by Donald Shaw MacLaughlan; drawings by Pamela Colman Smith
March 12–April 2	Photographs by Eduard Steichen
April 6–April 25	Drawings, lithographs, watercolors, etchings, and 1 oil by Henri Matisse

1908–1909

December 8–December 30	Exhibition of members' work
January 4–January 16	25 caricatures by Marius de Zayas; autochromes by J. Nilsen Laurvik
January 18–February 1	Photographs by Alvin Langdon Coburn
February 4–February 22	Photographs in color and monochrome by Baron A. De Meyer
February 26–March 10	Etchings, drypoints, and bookplates by Allen Lewis
March 17–March 27	Drawings by Pamela Colman Smith
March 30–April 17	15 oil sketches by Alfred Maurer; 24 watercolors by John Marin
April 21–May 7	Photographs of Rodin's *Balzac*, by Eduard Steichen
May 8–May 18	Paintings by Marsden Hartley
May 18–June 2	21 Japanese prints from the F. W. Hunter Collection, New York

1909–1910

November 24–December 17	Monotypes and drawings by Eugene Higgins
December 20–January 14	30 lithographs by Henri de Toulouse-Lautrec
January 21–February 5	Color photographs by Eduard Steichen
February 7–February 19	43 watercolors, 20 pastels, and 8 etchings by John Marin
February 23–March 8	Drawings and reproductions of paintings by Henri Matisse
March 9–March 21	Younger American Painters (D. Putnam Brinley, Arthur B. Carles, Arthur Dove, Lawrence Fellows, Hartley, Marin, Maurer, Steichen, Max Weber)
March 21–April 18	41 drawings and watercolors by Rodin
April 26–Indefinitely	25 caricatures by Marius de Zayas

1910–1911

November 18–December 8	Lithographs by Manet, Cézanne, Renoir, and Toulouse-Lautrec; drawings by Rodin; paintings and drawings by Henri Rousseau
December 14–January 12	46 drawings and etchings by Gordon Craig
January 11–January 31	Drawings and paintings by Max Weber
February 2–February 22	Watercolors by John Marin
March 1–March 25	20 watercolors by Cézanne
March 28–April 25	83 drawings and watercolors by Pablo Picasso

1911–1912

November 7–December 8	Watercolors by Gelett Burgess
December 18–January 15	Photographs by Baron A. De Meyer
January 18–February 3	Paintings by Arthur B. Carles
February 7–February 26	Paintings and drawings by Marsden Hartley
February 27–March 12	Pastels by Arthur Dove
March 14–April 6	12 sculptures and 12 drawings by Henri Matisse
April 11–May 10	Work by untaught children, aged two to eleven

1912–1913

November 20–December 12	Caricatures by Alfred J. Frueh
December 15–January 14	Drawings and paintings by Abraham Walkowitz
January 20–February 15	Watercolors by John Marin
February 24–March 15	Photographs by Alfred Stieglitz
March 17–April 5	16 New York studies by Francis Picabia
April 8–May 20	18 caricatures by Marius de Zayas

1913–1914

November 19–January 3	Drawings, pastels, and watercolors by Abraham Walkowitz
January 12–February 14	Paintings by Marsden Hartley
February 18–March 11	Second exhibition of children's work
March 12–April 4	8 sculptures by Constantin Brancusi
April 6–May 6	25 paintings and 11 drawings by Frank Burty (Haviland)

1914–1915

November 3–December 8	18 African sculptures

December 9–January 11	Drawings and paintings by Picasso and Braque; Archaic Mexican pottery and carvings; "Kalograms" by Torres Palomar
January 12–January 26	3 paintings by Francis Picabia
January 27–February 22	Paintings by Marion H. Beckett and Katharine N. Rhoades
February 23–March 26	Oils, watercolors by John Marin
March 27–April 17	Third exhibition of children's work

1915–1916

November 10–December 7	Drawings and paintings by Oscar Bluemner
December 8–January 19	14 sculptures and 10 drawings by Elie Nadelman
January 18–February 12	Watercolors by John Marin
February 14–March 12	Drawings and watercolors by Abraham Walkowitz
March 13–April 3	Photographs by Paul Strand
April 4–May 22	Paintings by Marsden Hartley
May 23–July 5	Drawings by Georgia O'Keeffe; 2 watercolors and 1 drawing by Charles Duncan; 3 oils by René Lafferty

1916–1917

November 22–December 20	Watercolors and drawings by Georgia S. Engelhard, of New York, a child ten years old
December 17–January 17	Watercolors by Abraham Walkowitz
January 22–February 7	Recent work by Marsden Hartley
February 14–March 3	Watercolors by John Marin
March 6–March 17	25 paintings, drawings, pastels by Gino Severini
March 20–March 31	18 paintings and sculpture by Stanton Macdonald-Wright
April 3–May 14	Recent work by Georgia O'Keeffe

·APPENDIX II·

Chronology · The Stieglitz Circle and Early Modernism in America (1902-1917)

1902 Stieglitz establishes the Photo-Secession; resigns as editor of *Camera Notes*.

Exhibition, American Pictorial Photography, arranged by the Photo-Secession.

Steichen in N.Y.C. (Jan.–Feb.), in Rome (Mar.); returns to U.S., (mid-summer); takes studio at 291 Fifth Ave. (fall).

Marin studies at Art Students League, N.Y.C. (1902–1903).

1903 Stieglitz founds, edits, and publishes *Camera Work;* first of fifty numbers published.

Steichen in Boston and N.Y.C.

Dove graduates from Cornell University.

Demuth attends Drexel Institute (may have begun in 1901–1902) until 1905.

1904 Stieglitz in Europe (May–Oct.), visits Berlin, Dresden, Munich, London.

Steichen in N.Y.C. and Mamaroneck, N.Y.

Demuth's first trip to Paris, remains for only a few weeks.

1905 Formation of The Little Galleries of the Photo-Secession, 291 Fifth Ave., under Stieglitz's direction.

Weber goes to Paris (Sept.), remains in Europe until the end of 1908.

Marin goes to Paris (Sept.).

Demuth studies at Pennsylvania Academy (1905–1907).

Carles visits Europe for first time, summer.

O'Keeffe studies at Art Institute of Chicago (1905–1906).

1906 Steichen settles in France (Paris and later Voulangis), makes frequent trips to U.S. until 1914.
 Walkowitz to Paris, meets Weber; Weber and Walkowitz in Italy together (spring and summer).

1907 Stieglitz in Europe (May–Sept.), visits Paris, Innsbruck, Baden-Baden.
 Walkowitz returns to N.Y.C. (late summer).
 Demuth in Paris, London, and Berlin (1907–1908, five months).
 Carles to Paris (June), remains until 1910.
 O'Keeffe a student at Art Students League (1906–1907).
 Walter Pach to Paris.
 De Zayas moves from Mexico to N.Y.C.; meets Stieglitz.

1908 Weber studies in Matisse class, beginning in Jan., remains less than a year.
 Steichen visits U.S. early in the year.
 Formation, in Steichen's studio, of New Society of American Artists in Paris.
 Dove sails for France (middle of 1908).
 Marin meets Steichen (date usually given as 1909).
 Demuth returns to U.S., enrolls at Pennsylvania Academy.
 Paul Haviland joins the Stieglitz circle.
 Agnes Ernst Meyer meets Stieglitz.
 Exhibition of "The Eight," Macbeth Galleries.

1909 Stieglitz in Europe (June–Sept.), visits Paris, Dresden, Munich.
 Weber arrives in N.Y.C. (Jan.), meets Stieglitz, lives with Walkowitz; show at Haas Gallery.
 Marin meets Stieglitz; in Dec. 1909, returns to U.S. for several months (date uncertain).
 Walkowitz show at Haas Gallery.
 Dove returns to N.Y.C. (around the end of July); in 1909 or 1910 meets Stieglitz.
 Strand graduates from Ethical Culture School, N.Y.C., joins Camera Club of New York.

1910 Steichen visits U.S. in Mar.; summer in London; rest of year in France. Has exhibition (Jan.), Montross Gallery.
 Dove moves to Westport, Conn.
 Hartley settles in N.Y.C.
 Marin paints in N.Y.C., then returns to Europe.
 Carles returns to Philadelphia.

Albright Art Gallery, Buffalo, N.Y., international exhibition of pictorial photography, arranged by Stieglitz and the Photo-Secession.

Exhibition of Independent Artists, N.Y.C.

1911 Stieglitz's last trip to Europe (May–Nov.), visits Munich, Stuttgart, Paris, Lucerne.

Weber breaks with Stieglitz (Jan.).

Marin returns to U.S.

Demuth living and painting in Lancaster, Pa. (1911–1912).

Strand spends six weeks in Europe, his first trip.

Independent Exhibition, gallery of the Society of Beaux-Arts Architects, N.Y.C., organized by Rockwell Kent.

1912 Hartley goes to Europe (Apr.), lives in Paris.

Marin at Adirondacks, summer.

Carles visits France.

Walkowitz introduced to Stieglitz by Hartley in 1911 or 1912.

Steichen visits U.S. (Mar.).

Bluemner to Europe (spring).

Demuth studies in Paris (1912–1914), meets Hartley.

Strand establishes himself as a commercial photographer.

O'Keeffe is art supervisor, Amarillo, Tex. (1912–1914).

Association of American Painters and Sculptors makes preparations for the Armory Show.

Mabel Dodge settles in N.Y.C.

1913 International Exhibition of Modern Art (Armory Show).

Picabia visits N.Y.C.

Hartley visits Berlin (Jan.), then visits Munich, sees Kandinsky. In Apr., sees Marc in Sinselsdorf (Bavaria); settles in Berlin (May). To N.Y.C. for a brief visit late in the year.

Demuth visits Berlin.

First Synchromist show, Munich; Synchromist show in Paris.

Walter Arensberg visits Armory Show.

Opening of Daniel Gallery.

1914 Steichen visits U.S. (Jan.–Apr.); returns to France but leaves for U.S. in Sept., result of outbreak of World War I.

Marin's first summer in Maine.

Hartley returns to Paris early in year, moves to Berlin in Apr.

Maurer leaves Paris to live in U.S.

Weber teaches art history and appreciation at the White School of Photography, N.Y.C. (1914–1918).

Walkowitz visits Europe (five months).

O'Keeffe studies under Dow at Teachers College, Columbia (to 1915).

Demuth returns to U.S. (spring), to Provincetown in summer; in 1914–1916 divides time between Lancaster and N.Y.C.

Arensbergs move to N.Y.C.

Exhibition of Contemporary Art, National Arts Club.

Opening of Bourgeois Galleries.

Opening of Carroll Galleries; Synchromist exhibition.

Opening of Washington Square Gallery.

Exhibition of Paintings and Drawings by Contemporary Americans, Montross Gallery.

1915 Duchamp arrives in N.Y.C.

Hartley in Berlin, returns to U.S. in December.

Picabia visits N.Y.C.

Opening of The Modern Gallery.

Publication of *291* magazine (Mar. 1915–Feb. 1916).

O'Keeffe teaching (fall) at Columbia College, S.C.

First Demuth exhibition, Daniel Gallery, N.Y.C.; summer in Provincetown.

Strand shows Stieglitz his abstract photographs, becomes a member of 291 circle.

Matisse exhibition, Montross Gallery.

1916 Hartley at Provincetown (summer), also visits Bermuda (winter), 1916–1917, with Demuth in both places.

Macdonald-Wright returns to U.S., lives in N.Y.C. (until 1919).

Forum Exhibition of Modern American Painters.

Founding of the Society of Independent Artists.

Bluemner moves from N.Y.C. to N.J.

O'Keeffe studies under Dow at Columbia (spring), meets Stieglitz. In fall becomes head of art department, West Texas Normal School, Canyon (1916–1918).

1917 291 closes (June).

Last issue of *Camera Work* published.

First exhibition of the Society of Independent Artists, Grand Central Palace, N.Y.C.

Carles joins faculty of Pennsylvania Academy of the Fine Arts.

Steichen to France (July), with U.S. Army.
Demuth divides time between Lancaster, Pa., and N.Y.C., 1917–1918.
Mabel Dodge leaves N.Y.C. for Taos, N.M.

·APPENDIX III·

Exhibitors at 291 Not Included in Text*

Marion H. Beckett (dates unknown) was a close friend of Agnes Meyer and Katharine Rhoades. Together, they often visited 291, where, because of their dignity and statuesque beauty, they were known as "The Three Graces." Little is known of Beckett's early career. Like Rhoades, she exhibited in the Armory Show and remained in the Stieglitz circle afterward. She was particularly close to Steichen.

Although she had not studied abroad, she looked at avant-garde French paintings during her trips to Europe, and their influence was evident in the portraits she exhibited at 291 in 1915. Her work, however, was relatively conservative by 291 standards (Figure 129). Nothing is known of her later life.

Oscar Bluemner (1867–1938), a native of Hannover, Germany, immigrated to Chicago in 1892, and then, in 1901, settled in New York. Starting as an architect, he turned to painting sometime before the Armory Show, in which he exhibited five landscapes. Soon afterward, at Stieglitz's invitation, he wrote an important article for *Camera Work* explaining modern art ("Audiator et Altera Pars: Some Plain Sense on the Modern Art Movement," *Camera Work*, special number [June 1913], pp. 25–38). He frequented 291, and in 1915 Stieglitz gave him his first American one-man show (he had had one at the Gurlitt Galleries, Berlin, in 1912). The advanced character of Bluemner's style, dependent upon both Cubism and Fauvism, undoubtedly made him appealing to Stieglitz (Figure 130).

* For the biographies of Craig, Frueh, Geiger, and Lewis I have drawn, in part, on the unpublished research reports of my graduate students Mary Duffey and Betsy Fahlman.

129. Marion H. Beckett. *Portrait of Agnes Meyer*. Oil on canvas. Present location unknown.

130. Oscar Bluemner. *Old Canal Port*. 1914. Oil on canvas. Collection of Whitney Museum of American Art.

Gelett Burgess (1866–1951) is best known as a humorous writer, not as a painter. Educated at M.I.T., he worked for several years in California as a draftsman and instructor of topographical drawing; he then turned to writing and became one of the most prolific and popular humorists of his era. His books, including *Goops and How to Be Them* (1900), *The Burgess Nonsense Book* (1901), and *Are You a Bromide?* (1907), delighted a generation of children and adults. Although he often illustrated his own writings, Burgess apparently had no serious interest in the fine arts until he traveled to Europe in 1908. In Paris, he interviewed the young leaders of the modern movement — Matisse, Picasso, Braque, Derain, Friesz, Metzinger, and others — and in May 1910 published an article, "The Wild Men of Paris," in the *Architectural Record*. Stimulated by this experience, he produced a series of Symbolist watercolors, which were shown at 291 in 1911. In the brochure for the exhibition, "Essays in Subjective Symbolism," he stated that his watercolors were "but personal and intimate attempts, in whimsical spirit, to render in graphic form some interpretation of the pose of the mind under stress of certain emotions" (exhibition catalogue, no pagination). Paul Haviland wrote that his work was presented because "it represented a new expression of an individual point of view in pictorial literature" (*Camera Work*, no. 37 [January 1912], p. 46). Having had his show at 291, Burgess disappeared from Stieglitz's precincts, and nothing more was heard of his painterly ambitions.

Arthur B. Carles (1882–1952), a Philadelphian, became a member of the New Society of American Artists in Paris, and, like many of his progressive young American colleagues, fell under the influence of Matisse (Figure 131). (Whether he actually studied with Matisse is open to question.) Steichen brought Carles's work to Stieglitz's attention and arranged for him to be included in the Younger American Painters show. Late in 1910, the artist returned to his native city, which was to be his home for the rest of his life. At Steichen's instigation, Carles was given a show at 291 in 1912. The artist came to the gallery during his visits from Philadelphia, but because he did not remain in the avant-garde he, like Maurer, did not enjoy Stieglitz's unqualified patronage. Carles's art continued to develop in a Fauvist vein during the teens, but he did not confront the formal issues of Cubism and abstraction until later in his career.

Gordon Craig (1872–1966), the illegitimate son of Ellen Terry, pioneered a new conception of theater design, combining movement, light, and sound and relying on the relationship of abstract, nondescriptive forms. His rebellion against conventional ideas made him attractive to Steichen, who brought a group of drawings and etchings based on stage designs to show at 291 in 1910–1911. About these, Craig wrote, "We must translate movement through the medium of inanimate forms and thereby produce once more an impersonal art which shall take its place by the side of two sister arts — music and architecture" (exhibition

131. Arthur B. Carles. *Interior with Woman at Piano*. 1912–1913. Oil on canvas. The
Baltimore Museum of Art, Baltimore, Md.

catalogue, no pagination). This exhibition was probably more an expression of
Steichen's interests than Stieglitz's, and thus Craig and his art did not figure in the
future of 291.

Charles Duncan (1892– ?) was a New York artist and poet who was obliged
to earn his living as a sign painter. He often visited 291 in the company of Morton
Schamberg. An abstract painter, he showed two watercolors and a drawing, with
works by O'Keeffe and René Lafferty, in 1916. (In a letter to Arthur Jerome
Eddy, 30 March 1916, Stieglitz said he had been watching these three artists for
some time and thought they fit together.) Duncan also published his poetry in
The Blind Man (May 1917) and *MSS* (March 1922).

Alfred J. Frueh (1880–1968), like Burgess and De Zayas, appealed to Stieglitz
because he was a master of satire. A cartoonist for the New York *World* who had

studied under Matisse, Frueh did theatrical caricatures in his spare time to please himself. Learning of his work from one of the artist's friends, Stieglitz expressed admiration for Frueh's noncommercial approach, and when he went abroad in 1912, the impresario mounted a show of caricatures that had been left in his care. It consisted mainly of drawings of theatrical personalities such as John Drew and Lillian Russell, created in the satirical tradition of Max Beerbohm. Frueh seems to have had no close ties with the 291 circle and went on to become a well-known caricaturist for *The New Yorker*.

Willi Geiger (1878–1970) was a Bavarian artist who had studied at the Munich academy under Franz von Stuck and in the early 1900s turned to etching as his favorite medium. His etchings were in the "decadent" fin-de-siècle tradition of irrational fantasy and satire, with distorted human and animal forms reminiscent of Félicien Rops. There is no record of how Stieglitz learned about Geiger's work, but in all likelihood he heard of him from Frank Eugene, a Secessionist photographer who knew and had photographed Geiger and whom Stieglitz visited in Germany in 1907. Stieglitz had admired the mysterious, symbolic art of Stuck, and it is not surprising that he was interested in one of his most talented students. Geiger's etchings, moreover, complemented the visionary works of Pamela Colman Smith, with which they were shown in 1908.

Frank Burty Haviland (1886–1971), who used only his first two names as a painter, was Paul Haviland's younger brother. Raised in an artistic French family, he met the Steins when he was in his early twenties and became a close friend of Picasso. Establishing himself in Céret, in the Pyrenees, in 1909, Burty played host to such pioneers of modernism as Braque and Gris, as well as Picasso, who often visited him there. A painter in his own right, Burty practiced a refined form of Cubism, much under the influence of Picasso and Braque, though without their originality (Figure 132). His 1914 show at 291, held after he had painted for only four years, was his first anywhere. In later life, he was curator of the museum at Céret.

Eugene Higgins (1874–1958), an American artist of Irish extraction, shared Geiger's use of exaggerated romantic imagery, but his themes were drawn mainly from the world of the urban poor. Poverty-stricken in his early career, Higgins studied at the Académie Julian in Paris and then returned to New York, where he portrayed with great compassion the tragic plight of the peasants and workers. Haviland introduced him to 291. It is surprising that his Millet-like style, with strong sentimental overtones, appealed to Stieglitz; but apparently it did, for Higgins was given a show in 1909. The alliance was short-lived, however; there were no further contacts between the artist and 291.

René Lafferty (dates unknown) of Philadelphia exhibited three oils in 1916.

132. Frank Burty (Haviland).
Still Life. Oil on canvas.
Collection of Katharine
Graham, Washington,
D.C.

He had been a student in Robert Henri's night class where, Stuart Davis recalled, he had painted red, white, and blue nudes (interview, 23 June 1964). He had been confined to a mental hospital for two years prior to showing his work at 291. Davis said that he died young.

Allen Lewis (1873–1957) was a friend of the Brooklyn art patron Hamilton Easter Field, a cousin of Paul Haviland who proposed the 1909 show. Stieglitz was undoubtedly sympathetic because he admired excellence in typographical design and careful workmanship in the tradition of Dürer, traits Lewis's work displayed in large measure. Haviland praised Lewis because "it is singularly refreshing to come across the work of a man who seems to have kept himself untouched by the modern spirit of indifference to the philosophy of life; and who combined a remarkable feeling for composition with a seriousness of purpose and a simple faith reminiscent of the spirit of the old German masters" (*Camera Work*, no. 27 [July 1909], p. 27). Although Lewis never became a member of the inner circle at 291, he advertised his bookplates in *Camera Work*, and in 1913

309

133. Allen Lewis. *Bookplate for Alfred Stieglitz.* 1913. The Brewer Bookplate Collection, University of Delaware Library.

executed one for Stieglitz, a complex work regarded as a masterpiece of its kind (Figure 133).

Stanton Macdonald-Wright (1890–1973), cofounder in 1913 of the Synchromist movement, was not a member of the inner circle at 291, having his own coterie of friends and followers in New York. Stieglitz, however, admired his color-abstractions and in 1917 gave him his first one-man show in America.

Donald Shaw MacLaughlan (1876–1938) was a Canadian-born etcher who, after studying in Paris with Gérôme, settled in New York and specialized in architectural and landscape subjects. In Paris, Stieglitz had been impressed by the quality of the proofs he had pulled from plates by Rembrandt and offered him a show of his own work in 1908. Apparently this was MacLaughlan's only contact with 291.

Alfred Maurer (1868–1932) was not an early member of the 291 circle because he lived and worked in Paris from 1897 to 1914. There he first painted in an academic manner and then, in 1907, became one of the first American followers of Matisse. For a few years — 1907–1912 — Maurer was at the forefront of the avant-garde (Figure 134). His brilliantly colored Fauve landscapes attracted the attention of Steichen, who in 1908 drew the painter into the New Society of

134. Alfred Maurer. *Landscape*. 1907. Oil on panel. Nebraska Art Association: Thomas C. Woods Fund.

135. Katharine N. Rhoades. *Untitled drawing*. c. 1915. Reproduced in *291*, no. 2, April 1915. Ex Libris, New York.

American Artists in Paris. Believing in the promise of Maurer's work, Steichen organized the two-man show of his oil sketches and Marin's watercolors for 291 in March and April 1909.

Maurer's work was next shown at 291 in 1910 in the Younger American Painters exhibition. But from then on he did not exhibit there, though a show was projected for 1917–1918. It is hard to explain why Stieglitz did not immediately continue his patronage; Maurer's absence from New York might be one reason why he was neglected, and Stieglitz may have objected to his inability to progress beyond his Fauvist style. Still, the two remained on friendly terms, and Maurer was a welcome visitor at 291.

Elie Nadelman (1882–1946), a native of Poland, lived and worked in Paris for ten years (1904–1914) where he was close to Gertrude and Leo Stein. Inspired by classical Greek sculpture, Michelangelo, Rodin, and Seurat, Nadelman created idealized sculptural forms in a modernized abstract mode. His 1909 show at the Galérie Druet impressed Stieglitz, who, in the summer of 1910, imported a group of drawings to display at his gallery. The drawings, however, were recalled for a London exhibition before they could be hung — although they were shown informally — and it was not until 1915–1916 that an exhibition materialized at 291. Aspiring to higher social echelons, Nadelman did not remain with the Stieglitz circle.

Torres Palomar (dates unknown) exhibited only once at 291. A Mexican artist about whom little is known, he specialized in "kalograms," or "kalogramas," small,

usually decorative geometric designs in which one's name or initials are fitted. The kalogram was a fad of the mid-teens; *Vanity Fair* reported: "Nowadays, not to have a Kalogram is to be socially ostracized. It's like not having a motor-car, or a Pom, or a wrist-watch. Everybody's doing it!" (*Vanity Fair*, 4 [June 1915]: 46). Palomar, according to *Camera Work*, "stands in a field by himself, both in invention and as an artist" (*Camera Work*, no. 48 [October 1916], p. 7).

Katharine N. Rhoades (1885–1965) was a painter, poet, and close friend of Agnes Meyer and Marion Beckett. She studied painting in New York under Mrs. Charles Sprague-Smith (a pupil of Robert Henri), and sometime between 1908 and 1910 traveled to Europe with Beckett and the sculptor Malvina Hoffman. Here she was exposed to the art of the avant-garde, though we do not know exactly how it affected her work because most of it, except the portraits, has been destroyed. A frequent visitor at 291, she, along with her friends Meyer and Beckett, became a member of Stieglitz's inner circle. She exhibited in the Armory Show and published her poetry in *Camera Work* and *291;* and she helped to produce the latter journal, to which she contributed a remarkably advanced drawing (Figure 135). Stieglitz showed her paintings with Beckett's in 1915.

In that year, she was introduced to Charles Freer, the collector of Oriental art. Working for him as secretary and research associate, she was involved in the opening of the Freer Gallery of Art, Washington. Like her friend Agnes Meyer, she was devoted to Freer and his gallery for a time; but she subsequently moved to New York, where she turned from art to religious interests.

·BIBLIOGRAPHY·

Stieglitz and the 291 Circle

"Alfred Stieglitz and His Latest Work." *The Photographic Times* 28 (Apr. 1896): 161–169.
"Alfred Stieglitz, Artist, and His Search for the Human Soul." New York *Herald*, 8 Mar. 1908.
Anderson, Sherwood. "Alfred Stieglitz." *New Republic* 32 (25 Oct. 1922): 215–217.
Barnes, Djuna. "Giving Advice on Life and Pictures." New York *Morning Telegraph*, 25 Feb. 1917.
Beginnings and Landmarks: "291," 1905–17. New York: An American Place, 27 Oct.–27 Dec. 1937.
Benson, E. M. "Alfred Stieglitz: The Man and the Book." *American Magazine of Art* 28 (Jan. 1935): 36–42.
Brown, Milton Wolf. "Alfred Stieglitz—Artist and Influence." *Photo Notes* (Aug.–Sept. 1947): 1, 7–8.
Bruno, Guido. "The Passing of '291.'" *Pearson's Magazine* 38 (Mar. 1918): 402–403.
Bry, Doris. *Alfred Stieglitz: Photographer.* Boston: Museum of Fine Arts, 1965.
———. "The Stieglitz Archive at Yale University." *Yale University Gazette* 25 (Apr. 1951): 123–130.
Bunnell, Peter C. "Alfred Stieglitz and Camera Work." *Camera* 48 (Dec. 1969): 8.
Caffin, Charles H. "Photography as a Fine Art: Alfred Stieglitz and His Work." *Everybody's Magazine* 4 (Apr. 1901): 359–371.
Canaday, John. "New Talent Fifty Years Ago." *Art in America* 47 (Spring 1959): 19–33.
Carter, Huntley. "Two Ninety-One." *Egoist* 3 (1 Mar. 1916): 43.
Craven, Thomas. "Stieglitz—Old Master of the Camera." *Saturday Evening Post* 216 (8 Jan. 1944): 14–15, 36, 38.
"Distinguished Photographers of To-day—Alfred Stieglitz." *The Photographic Times* 23 (1 Dec. 1893): 689–690.
Dreiser, Theodore. "A Master of Photography." *Success*, 10 June 1899, p. 471.
Engelhard, Georgia. "The Grand Old Man." *American Photography* 44 (May 1950): 18–19, 50.
———. "Alfred Stieglitz, Master Photographer." *American Photography* 39 (Apr. 1945): 8–12.
Ernst, Agnes. "New School of the Camera." New York *Morning Sun*, 26 Apr. 1908.
Exhibition of Photographs by Alfred Stieglitz. Text by Doris Bry. Washington, D.C.: National Gallery of Art, 15 Mar.–27 Apr. 1958.
Evans, Jean. "Stieglitz." *PM*, 23 Dec. 1945.
Flint, Ralph. "What Is '291'?" *Christian Science Monitor*, 17 Nov. 1937, p. 5.

Frank, Waldo, et al., eds. *America and Alfred Stieglitz: A Collective Portrait*. Garden City, N.Y.: 1934.

Freed, Clarence I. "Alfred Stieglitz – Genius of the Camera." *American Hebrew* 114 (18 Jan. 1924): 305, 318, 324.

Garfield, George, and Frances O'Brien. "Stieglitz: Apostle of American Culture." *The Reflex* 3 (Sept. 1928): 24–29.

Haines, Robert E. "Alfred Stieglitz and the New Order of Consciousness in American Literature." *Pacific Coast Philology* 6 (Apr. 1971): 26–34.

Hamilton, George Heard. "The Alfred Stieglitz Collection." *Metropolitan Museum Journal* 3 (1970): 371–392.

History of an American: "291" and After; Selections from the Stieglitz Collection. Philadelphia: Philadelphia Museum of Art, 1944.

Homer, William Innes. "Picabia's 'Jeune fille américaine dans l'état de nudité' and Her Friends." *Art Bulletin* 58 (Mar. 1975): 110–115.

———. "Alfred Stieglitz." *Dictionary of American Biography*, Supplement 4 (1974): 778–781.

———. "Alfred Stieglitz and an American Aesthetic." *Arts* 49 (Sept. 1974): 25–28.

———. "Stieglitz and 291." *Art in America* 61 (July–Aug. 1973): 50–57.

Humphries, Marmaduke [Rupert Hughes]. "Triumphs in Amateur Photography: Alfred M. Stieglitz." *Godey's Magazine*, Jan. 1898, pp. 581–592.

Jewell, Edward Alden. "The Legend That Is Stieglitz." New York *Times*, 18 Aug. 1946, x, p. 8.

Kreymborg, Alfred. "Stieglitz and 291." New York *Morning Telegraph*, 14 June 1914.

Larkin, Oliver. "Stieglitz and '291.'" *Magazine of Art* 40 (May 1947): 179–183.

Laurvik, John Nilsen. "Alfred Stieglitz, Pictorial Photographer." *International Studio* 44 (Aug. 1911): xxi–xxvii.

Leonard, Neil. "Alfred Stieglitz and Realism." *Art Quarterly* 29 (1966): 277–286.

Longwell, Dennis. "Alfred Stieglitz vs. The Camera Club of New York." *Image* 14 (Dec. 1971): 21–23.

Louchheim, Aline B. "'An American Place' to Close Doors," New York *Times*, 26 Nov. 1950, xi, p. 9.

Lukach, Joan M. "Severini's 1917 Exhibition at Stieglitz's '291.'" *Burlington Magazine* 113 (Apr. 1971): 196–207.

Macdonald-Wright, Stanton. "Art." *Rob Wagner's Script* 30 (23 Sept. 1944): 12–13.

Marks, Robert. "Man with a Cause." *Coronet* 4 (Sept. 1938): 161–170.

Mellquist, Jerome. *The Emergence of an American Art*. New York, 1942.

Meyer, Agnes Elizabeth Ernst. *Out of These Roots: The Autobiography of an American Woman*. Boston, 1953.

Minuit, Peter [Paul Rosenfeld]. "291 Fifth Avenue." *Seven Arts* (Nov. 1916): 61–65.

Moore, Clarence B. "Leading Amateurs in Photography." *Cosmopolitan* 12 (Feb. 1892): 421–433.

Muir, Ward. "Stieglitz and Others in New York." *The Amateur Photographer and Photography* 46 (14 Aug. 1918): 187–188.

———. "Alfred Stieglitz: An Impression." *The Amateur Photographer and Photographic News* 57 (24 Mar. 1913): 285–286.

Mumford, Lewis. "A Camera and Alfred Stieglitz." *The New Yorker* 10 (22 Dec. 1934): 30.

Munson, Gorham. "291: A Creative Source of the Twenties." *Forum* 3 (Fall–Winter 1960): 4–9.

Newhall, Nancy. "Alfred Stieglitz." *Photo Notes* (Photo League Bulletin) (Aug. 1946): 3–5.

Norman, Dorothy. *Alfred Stieglitz: An American Seer*. New York, 1973.

———. *Alfred Stieglitz: Introduction to an American Seer*. New York, 1960.

———. "Photography's Patron Saint." New York *Post*, 9 Feb. 1944.

———. "From the Writings and Conversations of Alfred Stieglitz." *Twice a Year*, no. 1 (Fall–Winter 1938), pp. 77–110.

———. "Alfred Stieglitz." *Wings* (Dec. 1934): 7–9, 26.

Norman, Dorothy, ed. *Stieglitz Memorial Portfolio, 1864–1946*. New York, 1947.

O'Keeffe, Georgia. "Stieglitz: His Pictures Collected Him." *New York Times Magazine*, 11 Dec. 1949, pp. 24, 26, 28–30.

Pusey, Merlo J. *Eugene Meyer*. New York, 1974.

Ringel, Fred J. "Master of Photography." *Wings* (Dec. 1934): 13–15, 26.

Rood, Roland. "A Retrospect." *Burr McIntosh Monthly* 18 (Dec. 1908): no pagination.

Rosenfeld, Paul. "Stieglitz." *Dial* 70 (Apr. 1921): 397–409.

Scott, Temple. "Fifth Avenue and the Boulevard Saint-Michel." *Forum* 44 (Dec. 1910): 665–685.

Search-Light [Waldo Frank]. *Time Exposures.* New York, 1926.

Seligmann, Herbert J. "Burning Focus." *Infinity* 16 (Dec. 1967): 15–17, 26–29; 17 (Jan. 1968): 29–34.

———. *Alfred Stieglitz Talking.* New Haven, 1966.

———. "Alfred Stieglitz and His Work at 291." *American Mercury* 2 (May 1924): 83–84.

Shiffman, Joseph. "The Alienation of the Artist: Alfred Stieglitz." *American Quarterly* 3 (Fall 1951): 244–258.

Soby, James Thrall. "Alfred Stieglitz." *Saturday Review of Literature* 39 (28 Sept. 1946): 22–23.

Stieglitz, Alfred. "Six Happenings (and a Conversation Recorded by Dorothy Norman)." *Twice a Year*, nos. 14–15 (Fall–Winter 1946–1947), pp. 188–202.

———. "Thoroughly Unprepared" and other stories. *Twice a Year*, nos. 10–11 (Fall–Winter 1943), pp. 245–264.

———. "Four Happenings." *Twice a Year*, nos. 8–9 (Spring–Summer, Fall–Winter 1942), pp. 105–136.

———. "Three Parables and a Happening." *Twice a Year*, nos. 8–9 (Spring–Summer, Fall–Winter 1942), pp. 163–171.

———. "Ten Stories." *Twice a Year*, nos. 5–6 (Fall–Winter, Spring–Summer 1941), pp. 135–161.

"Stieglitz, at 70, Recalls Birth of Modern Art," New York *Herald Tribune*, 1 Jan. 1934.

The Stieglitz Circle. Claremont, Calif.: Pomona College Gallery, 11 Oct.–15 Nov. 1958.

The Stieglitz Circle. Poughkeepsie, N.Y.: Vassar College Art Gallery, 2–20 December 1972.

Strand, Paul. "Alfred Stieglitz: 1864–1946." *New Masses* 60 (6 Aug. 1946): 6–7.

T. [Horace Traubel]. "Stieglitz." *The Conservator*, 27th year, no. 10 (Dec. 1916), p. 137.

Webb, Edgar A. "A Unique Specimen of the American Artist; He Is Looking for a Real Human Soul." Fresno *Daily Republican*, 11 Aug. 1908.

Weegee [Arthur Fellig]. *Naked City.* New York, 1945.

Young, Mahonri Sharp. *Early American Moderns.* New York, 1974.

Zigrosser, Carl. *A World of Art and Museums.* Philadelphia, 1975.

———. "Alfred Stieglitz." *Twice a Year*, nos. 8–9 (Spring–Summer, Fall–Winter 1942), pp. 137–145.

Pictorial Photography and the Photo-Secession

Anderson, A. J. *The Artistic Side of Photography.* Toronto, n.d. [c. 1910].

Black, Alexander. "The Artist and the Camera: A Debate." *Century Magazine* 64 (Oct. 1902): 813–822.

Caffin, Charles H. "The New Photography." *Munsey's Magazine* 27 (Aug. 1902): 729–737.

———. *Photography as a Fine Art.* New York, 1901.

Coburn, Alvin Langdon. *Alvin Langdon Coburn, Photographer.* Edited by Helmut and Alison Gernsheim. London, 1966.

Doty, Robert. *Photo-Secession: Photography as a Fine Art.* Rochester, N.Y., 1960.

Dreiser, Theodore. "The Camera Club of New York." *Ainslee's Magazine* (Sept. 1899): 324–355.

Green, Jonathan, ed. *Camera Work, a Critical Anthology.* Millerton, N.Y., 1973.

Hartmann, Sadakichi. *Landscape and Figure Composition.* New York, 1910.

———. "The Photo-Secession, a New Pictorial Movement." *The Craftsman* 6 (Apr. 1904): 30–37.

Holme, Charles, ed. *Art in Photography.* London and New York, 1905.

Oliver, Maude I. G. "The Photo-Secession in America." *International Studio* 32 (Sept. 1907): 199–215.

The Painterly Photograph. Text by Weston Naef. New York: The Metropolitan Museum of Art, 8 Jan.–15 Mar. 1973.

"The Photo-Secession: Its Aims and Work." *International Studio* 28 (June 1906): xcix–cx.

Rood, Roland. "The 'Little Galleries of the Photo Secession.'" *American Amateur Photographer* 16 (Dec. 1905): 566–569.

Steichen, Eduard J. "The American School." *Photogram* 8 (Jan. 1901): 4–9.

Steichen, Edward. "The Fighting Photo-Secession." *Vogue* 97 (15 June 1941): 22, 74.

Stieglitz, Alfred. "The Photo-Secession." *The American Annual of Photography and Photographic Times Almanac*. New York, 1904, pp. 41–44.

———. "The Photo-Secession – Its Objects." *Camera Craft* 7 (Aug. 1903): 81–83.

———. "Modern Pictorial Photography." *Century Magazine* 64 (Oct. 1902): 822–826.

———. "Pictorial Photography." *Scribner's Magazine* 26 (Nov. 1899): 528–537.

———. "The Progress of Pictorial Photography in the United States." *The American Annual of Photography and Photographic Times Almanac*. New York, 1899, pp. 158–159.

Stieglitz's Contemporaries and the Period

Agee, William. "New York Dada, 1910–30." *Art News Annual* 34 (1968): 104–113.

Armory Show, 50th Anniversary Exhibition, 1913–1963. Utica, N.Y.: Munson-Williams-Proctor Institute, 17 Feb.–31 Mar. 1963.

Avant-Garde Painting and Sculpture in America, 1910–25. Edited by William Innes Homer. Wilmington, Del.: Delaware Art Museum, 4 Apr.–18 May 1975.

Baur, John I. H. *Revolution and Tradition in Modern American Art*. Cambridge, Mass., 1958.

———. "The Machine and the Subconscious: Dada in America." *Magazine of Art* 44 (Oct. 1951): 233–237.

Benton, Thomas Hart. *An American in Art: A Professional and Technical Autobiography*. Lawrence, Kansas, 1969.

———. *An Artist in America*. New York, 1939.

Birnbaum, Martin. *The Last Romantic*. New York, 1960.

———. *Introductions*. New York, 1919.

Blumenschein, Ernest L. "The Painting of Tomorrow." *Century Magazine* 41 (Apr. 1904): 845–850.

Brinton, Christian. "Current Art, Native and Foreign." *International Studio* 49 (May 1913): lvi–lvii.

———. "Evolution Not Revolution in Art." *International Studio* 49 (Apr. 1913): xxvii–xxxv.

———. "Fashions in Art." *International Studio* 49 (Mar. 1913): viii–x.

Brown, Milton W. *The Story of the Armory Show*. Greenwich, Conn., 1963.

———. *American Painting from the Armory Show to the Depression*. Princeton, 1955.

———. "Cubist-Realism: An American Style." *Marsyas* 3 (1943–1945 [1946]): 139–160.

Buffet-Picabia, Gabrielle. "Some Memories of Pre-Dada: Picabia and Duchamp." In *The Dada Painters and Poets*. Edited by Robert Motherwell. New York, 1951.

Burgess, Gelett. "The Wild Men of Paris." *Architectural Record* 27 (May 1910): 400–414.

Camfield, William A. *Francis Picabia*. New York: The Solomon R. Guggenheim Museum, 1970.

Carter, Huntley. *The New Spirit in Drama and Art*. New York and London, 1913.

Churchill, Allen. *The Improper Bohemians*. New York, 1959.

Cortissoz, Royal. *Art and Common Sense*. New York, 1913.

Andrew Dasburg. Text by Jerry Bywaters. Dallas: Dallas Museum of Fine Arts, 3 Mar.–21 Apr. 1957.

Dasburg, Andrew. "Cubism – Its Rise and Influence." *Arts* 4 (Nov. 1923): 278–283.

Davidson, Abraham. "Cubism and the Early American Modernist." *Art Journal* 26 (Winter 1966–1967): 122–129.

Davidson, Jo. *Between Sittings*. New York, 1951.

The Decade of the Armory Show. New York: Whitney Museum of American Art, 27 Feb.–14 Apr. 1963.

De Zayas, Marius. "Cubism." *Arts and Decoration* 6 (1916): 284–286, 308.

———. "Modern Art; Theories and Representations." *Forum* 54 (Aug. 1915): 221–230.

———. "The New Art in Paris." *Forum* 45 (Feb. 1911): 180–188.
De Zayas, Marius, and Paul B. Haviland. *A Study of the Modern Evolution of Plastic Expression.* New York, 1913.
Dijkstra, Bram. *The Hieroglyphics of a New Speech.* Princeton, 1969.
Du Bois, Guy Pène. *Artists Say the Silliest Things.* New York, 1940.
Eddy, Arthur Jerome. *Cubists and Post-Impressionism.* Chicago, 1914.
Eldredge, Charles. "The Arrival of European Modernism." *Art in America* 61 (July–Aug. 1973): 35–41.
"The European Art-Invasion." *Literary Digest* 51 (27 Nov. 1915): 1224–1226.
Farnham, Emily. *Charles Demuth: Behind a Laughing Mask.* Norman, Okla., 1971.
The Forum Exhibition of Modern American Painting. New York: Anderson Galleries, 13–25 Mar. 1916.
Gallup, Donald, ed. *The Flowers of Friendship: Letters Written to Gertrude Stein.* New York, 1953.
G., F. J. [Frederick James Gregg?]. "The World's New Art Centre." *Vanity Fair* 3 (Jan. 1915): 31.
Hamilton, George Heard. "John Covert, Early American Modern." *College Art Journal* 12 (Fall 1952): 37–42.
Hapgood, Hutchins. *A Victorian in the Modern World.* New York, 1939.
Homer, William Innes. *Robert Henri and His Circle.* Ithaca, N.Y., 1969.
Kellner, Bruce. *Carl Van Vechten and the Irreverent Decades.* Norman, Okla., 1968.
Kimball, Fiske. "Cubism and the Arensbergs." *Art News Annual* 24 (1955): 117–122.
Kootz, Samuel M. *Modern American Painters.* New York, c. 1930.
Kreymborg, Alfred. *Troubador: An Autobiography.* New York, 1925.
Kuhn, Walt. *The Story of the Armory Show.* New York, 1938.
Lancaster, Clay. "Synthesis: The Artistic Theory of Fenollosa and Dow." *Art Journal* 27 (Spring 1969): 286–287.
Laurvik, John Nilsen. *Is It Art? Post-Impressionism, Futurism, Cubism.* New York, 1913.
Lebel, Robert. *Marcel Duchamp.* New York, 1959.
Les Soirées de Paris. Paris: Galérie Knoedler, 16 May–30 June 1958.
Liasson, Mara. "The Eight and 291: Radical Art in the First Two Decades of the 20th Century." *American Art Review* 2 (July–Aug. 1975): 91–106.
The Life and Times of Sadakichi Hartmann, 1867–1944. Riverside, Calif.: University Library, University of California, Riverside, 1–31 May 1970.
Lincoln, Louise Hassett. "Walter Arensberg and His Circle, New York: 1913–20." Master's thesis, University of Delaware, 1972.
Loeb, Harold. *The Way It Was.* Toronto and New York, 1959.
Luhan, Mabel Dodge. *Movers and Shakers.* Vol. 3 of *Intimate Memories.* New York, 1936.
MacColl, W. D. "The International Exhibition of Modern Art: An Impression." *Forum* 50 (July 1913): 24–36.
Mackworth, Cecily. *Guillaume Apollinaire and the Cubist Life.* London, 1961.
May, Henry F. *The End of American Innocence, 1912–1917.* New York, 1959.
Mayerson, Charlotte Leon. *Shadow and Light: The Life, Friends and Opinions of Maurice Sterne.* New York, 1965.
McBride, Henry. "Modern Art." *Dial* 70 (Apr. 1921): 480–482.
McCausland, Elizabeth. "The Daniel Gallery and Modern American Art." *Magazine of Art* 44 (Nov. 1951): 280–285.
Mellquist, Jerome, and Lucie Wiese. *Paul Rosenfeld: Voyager in the Arts.* New York, 1948.
Myers, Jerome. *Artist in Manhattan.* New York, 1940.
The 1913 Armory Show in Retrospect. Introduction by Frank Anderson Trapp. Amherst, Mass.: Department of Fine Arts and American Studies, 17 Feb.–17 Mar. 1958.
Pach, Walter. *Queer Thing, Painting.* London and New York, 1938.
———. "The Point of View of the 'Moderns.'" *Century Magazine* 41 (Apr. 1914): 851–852, 861–864.
Pemberton, Murdock. "A Memoir of Three Decades." *Arts* 30 (Oct. 1955): 27–32.
Pioneers of Modern Art in America. Text by Lloyd Goodrich. New York: Whitney Museum of American Art, 1946.

Poore, Henry Rankin. *The Conception of Art*. New York, 1913.
————. *The New Tendency in Art*. Garden City, N.Y., 1913.
"Post Impressionism." *Art and Progress* 3 (Oct. 1912): 752.
The Quest of Charles Sheeler. Text by Lillian Dochterman. Iowa City: University of Iowa, 17 Mar.–14 Apr. 1963.
Ray, Man. *Self Portrait*. Boston and Toronto, 1963.
Reid, Benjamin Lawrence. *The Man from New York: John Quinn and His Friends*. New York, 1968.
Rosenfeld, Paul. *Port of New York*. New York, 1924.
————. "American Painting." *Dial* 71 (Dec. 1921): 649–670.
Rourke, Constance. *Charles Sheeler, Artist in the American Tradition*. New York, 1938.
Sanouillet, Michel. *Dada à Paris*. Paris, 1965.
————. *Picabia*. Paris, 1964.
————. *391*. Paris, 1960.
Seligmann, Herbert J. "Why 'Modern' Art?" *Vogue* 62 (15 Oct. 1923): 76–77, 110, 112.
Stein, Gertrude. *The Autobiography of Alice B. Toklas*. New York, 1933.
Stein, Leo. *Journey into the Self*. New York, 1950.
————. *Appreciation: Painting, Poetry, and Prose*. New York, 1947.
Stieglitz, Alfred. "The First Great Clinic to Revitalize Art." New York *American*, 26 Jan. 1913.
Tashjian, Dickran. *Skyscraper Primitives: Dada and the American Avant-Garde: 1910–25*. Middletown, Conn., 1975.
Toklas, Alice B. *What Is Remembered*. New York, 1963.
Tomkins, Calvin. *Living Well Is the Best Revenge*. New York, n.d.
Varèse, Louise. *Varèse: A Looking-Glass Diary*. New York, 1972.
Wasserstrom, William. *The Time of* The Dial. Syracuse, 1963.
Weber, Brom. *Hart Crane*. New York, 1948.
Weston, Edward. *The Daybooks of Edward Weston*. 2 vols. Rochester, N.Y., 1961.
Williams, William Carlos. *The Autobiography of William Carlos Williams*. New York, 1951.
Wolf, Ben. *Morton Livingston Schamberg*. Philadelphia, 1963.
Wright, Willard Huntington. "Modern Art." *International Studio* 41 (Apr. 1917): lxii–lxiv.
————. "Forum Exhibition at the Anderson Galleries." *Forum* 55 (Apr. 1916): 457–471.
————. "An Abundance of Modern Art." *Forum* 105 (Mar. 1916): 318–334.
————. "Aesthetic Struggle in America." *Forum* 55 (Feb. 1916): 201–220.
————. *Modern Painting: Its Tendency and Meaning*. New York, 1915.
————. "Impressionism to Synchromism." *Forum* 50 (Dec. 1913): 757–770.
Zigrosser, Carl. *The Artist in America*. New York, 1942.
Zilczer, Judith Katy. "The Aesthetic Struggle in America, 1913–1918: Abstract Art and Theory in the Stieglitz Circle." Ph.D. dissertation, University of Delaware, 1975.
————. "Robert J. Coady, Forgotten Spokesman for Avant-Garde Culture in America." *American Art Review* 2 (1975): 77–89.
————. "'The World's New Art Center': Modern Art Exhibitions in New York City, 1913–1918." *Archives of American Art Journal* 14 (1974): 2–7.

Artists of 291

BLUEMNER, OSCAR
Oscar Bluemner. New York: New York Cultural Center, 16 Dec. 1969–8 Mar. 1970.
Oscar Bluemner: American Colorist. Cambridge, Mass.: Fogg Art Museum, 11 Oct.–15 Nov. 1967.

CARLES, ARTHUR B.
Gardiner, Henry G. *Arthur B. Carles*. Philadelphia, 1970.
Marin, John. "On My Friend Carles." *Art News* 42 (Apr. 1953): 20, 67.

DE ZAYAS, MARIUS
"Marius de Zayas: A Master of Ironical Caricature." *Current Literature* 44 (Mar. 1908): 281–283.
Rünk, Eva Epp. "Marius de Zayas: The New York Years." Master's thesis, University of Delaware, 1973.

DOVE, ARTHUR
Arthur Dove: The Years of Collage. College Park, Md.: University of Maryland Art Gallery, 13 Mar.–19 Apr. 1967.
Goldwater, Robert. "Arthur Dove: A Pioneer of Abstract Expressionism in American Art." *Perspectives U.S.A.*, no. 2 (Winter 1953), pp. 78–80.
Haskell, Barbara. *Arthur Dove*. San Francisco: San Francisco Museum of Art, 21 Nov. 1974–5 Jan. 1975.
McCausland, Elizabeth. "Dove, Man and Painter." *Parnassus* 9 (Dec. 1937): 3–6.
Phillips, Duncan. "Arthur G. Dove, 1880–1946." *Magazine of Art* 40 (May 1947): 193–197.
Solomon, Alan. *Arthur G. Dove*. Ithaca, N.Y.: Andrew Dickson White Museum of Art, Cornell University, 1954.
Wight, Frederick S. *Arthur G. Dove*. Berkeley and Los Angeles, 1958.

HARTLEY, MARSDEN
Gallup, Donald. "The Weaving of a Pattern: Marsden Hartley and Gertrude Stein." *Magazine of Art* 41 (Nov. 1948): 256–261.
Hartley, Marsden. "Art and the Personal Life." *Creative Art* 2 (June 1928): xxxi–xxxiv.
———. *Adventures in the Arts*. New York, 1921.
McCausland, Elizabeth. *Marsden Hartley*. Amsterdam: Stedelijk Museum, 1961.
———. *Marsden Hartley*. Minneapolis, 1952.
———. "The Return of the Native." *Art in America* 40 (Spring 1952): 55–79.
Mellquist, Jerome. "Marsden Hartley, Visionary Painter." *The Commonweal*, 31 Dec. 1943, pp. 276–278.

MARIN, JOHN
Barker, Virgil. "The Water Colors of John Marin." *The Arts* 5 (Feb. 1924): 64–83.
Benson, E. M. *John Marin: The Man and His Work*. Washington, D.C., 1935.
Helm, Mackinley. *John Marin*. Boston, 1948.
John Marin by John Marin. Edited by Cleve Gray. New York, 1970.
John Marin, 1870–1953. Los Angeles: Los Angeles County Museum of Art, 7 July–30 Aug. 1970.
Josephson, Matthew. "Leprechaun on the Palisades." *The New Yorker*, 14 Mar. 1942, pp. 26–30, 32.
Mellquist, Jerome. "John Marin, Painter of Specimen Days." *American Artist* 13 (Sept. 1949): 57–59, 67–69.
Reich, Sheldon. *John Marin: A Stylistic Analysis and Catalogue Raisonné*. 2 vols. Tucson, Ariz., 1970.
Saunier, Charles. "John Marin — peintre-graveur." *L'Art Décoratif* 18 (Jan. 1908): 17–24.
The Selected Writings of John Marin. Edited by Dorothy Norman. New York, 1949.
Stieglitz, Alfred. "Four Marin Stories." *Twice a Year*, nos. 8–9 (Spring–Summer, Fall–Winter 1942), pp. 156–162.
Zigrosser, Carl. *The Complete Etchings of John Marin*. Philadelphia, 1969.

MAURER, ALFRED
Alfred H. Maurer, 1868–1932. Text by Sheldon Reich. Washington, D.C.: National Collection of Fine Arts, 1973.
McCausland, Elizabeth. *A. H. Maurer*. New York, 1951.

O'KEEFFE, GEORGIA
Georgia O'Keeffe. Edited by Mitchell A. Wilder. Fort Worth: Amon Carter Museum of Western Art, 17 Mar.–8 May 1966.
Georgia O'Keeffe Drawings. Introduction by Lloyd Goodrich. New York, 1968.

Bibliography

Goodrich, Lloyd, and Doris Bry. *Georgia O'Keeffe*. New York: Whitney Museum of American Art, 8 Oct.–29 Nov. 1970.

Goossen, E. C. "O'Keeffe." *Vogue* 33 (Mar. 1967): 221–224.

Pollitzer, Anita. "That's Georgia." *Saturday Review of Literature*, 4 Nov. 1950, pp. 41–43.

Some Memories of Drawings: Georgia O'Keeffe. New York, 1974.

Tomkins, Calvin. "The Rose in the Eye Looked Pretty Fine." [Profile of Georgia O'Keeffe.] *The New Yorker*, 4 Mar. 1974, p. 40.

Willard, Charlotte. "Georgia O'Keeffe." *Art in America* 51 (Oct. 1963): 92–96.

The Work of Georgia O'Keeffe: A Portfolio of Twelve Paintings. Introduction by James W. Lane. Appreciation by Leo Katz. New York, 1937.

RHOADES, KATHARINE N.

Clark, H. Nichols B. "Katharine Nash Rhoades." In *Avant-Garde Painting and Sculpture in America, 1910–25*, edited by William Innes Homer. Wilmington, Del.: Delaware Art Museum, 4 Apr.–18 May 1975, p. 118.

SMITH, PAMELA COLMAN

Caldwell, Martha B. "Pamela Colman Smith: A Search." *Southeastern College Art Conference Review* 7 (Fall 1974): 33–38.

Macdonald, M. Irwin. "The Fairy Faith and Pictured Music of Pamela Colman Smith." *The Craftsman* 23 (1912): 20–34.

Parsons, Melinda Boyd. "The Rediscovery of Pamela Colman Smith." Master's thesis, University of Delaware, 1975.

————. *To All Believers — The Art of Pamela Colman Smith*. Wilmington, Del.: Delaware Art Museum, 11 Sept.–19 Oct. 1975.

STEICHEN, EDUARD

Caffin, Charles H. "Progress in Photography, with Special Reference to the Work of Eduard J. Steichen." *Century Magazine* 75 (Feb. 1908): 483–498.

Gallatin, A. E. "The Paintings of Eduard J. Steichen." *International Studio* 40 (Apr. 1910): xl–xliii.

Geldzahler, Henry. "Edward Steichen: The Influence of a Camera." *Art News* 60 (May 1961): 27–28, 52–53.

Homer, William Innes. "Eduard Steichen as Painter and Photographer, 1897–1908." *American Art Journal* 6 (Nov. 1974): 45–55.

Josephson, Matthew. "Commander with a Camera." [Profile of Eduard Steichen.] *The New Yorker*, 10 June 1944, pp. 29–41.

"Mr. Steichen's Pictures." *Photographic Art Journal* 2 (15 Apr. 1902): 25–29.

Sandburg, Carl. *Steichen the Photographer*. New York, 1929.

Steichen, Edward. *A Life in Photography*. Garden City, N.Y., 1963.

Steichen the Photographer. Texts by Carl Sandburg, et al. New York, 1961.

STRAND, PAUL

Coke, Van Deren. "The Cubist Photographs of Paul Strand and Morton Schamberg." In *One Hundred Years of Photographic History: Essays in Honor of Beaumont Newhall*, edited by Van Deren Coke. Albuquerque, N.M., 1975, pp. 35–42.

Deschin, Jacob. "Paul Strand: An Eye for Truth." *Popular Photography*, Apr. 1972, p. 68.

Hill, Paul, and Tom Cooper. "Interview, Paul Strand." *Camera* 54 (Jan. 1975): 47–50.

Homer, William Innes. "Stieglitz, 291, and Paul Strand's Early Photography." *Image* 19 (June 1976): 10–19.

Newhall, Nancy. *Paul Strand: Photographs, 1915–1945*. New York: Museum of Modern Art, 1945.

Paul Strand: A Retrospective Monograph. 2 vols. Millerton, N.Y., 1971.

Tomkins, Calvin. "Look to the Things Around You." [Profile of Paul Strand.] *The New Yorker*, 14 Sept. 1974, p. 44.

WALKOWITZ, ABRAHAM

Lerner, Abram, and Bartlett Cowdrey. "A Tape Recorded Interview with Abraham Walkowitz." *Journal of the Archives of American Art* 9 (Jan. 1969): 10–16.

Lichtenstein, Isaac. *Ghetto Motifs: Abraham Walkowitz*. New York, 1946.

Reich, Sheldon. "Abraham Walkowitz: Pioneer of American Modernism." *American Art Journal* 3 (Spring 1971): 72–83.

Sawin, Martica R. *Abraham Walkowitz, 1878–1965*. Salt Lake City: Utah Museum of Fine Arts, University of Utah, 27 Oct.–1 Dec. 1974.

————. "Abraham Walkowitz, the Years at 291: 1912–1917." Master's thesis, Columbia University, 1967.

————. "Abraham Walkowitz, Artist." *Arts* 38 (Mar. 1964): 42–45.

Siegel, Priscilla Wishnick. "Abraham Walkowitz: The Early Years of an Immigrant Artist." Master's thesis, University of Delaware, 1976.

WEBER, MAX

Cahill, Holger. *Max Weber*. New York, 1930.

Goodrich, Lloyd. *Max Weber*. New York, 1949.

Leonard, Sandra E. *Henri Rousseau and Max Weber*. New York, 1970.

Max Weber. Text by Ala Story. Santa Barbara, Calif.: The Art Galleries, University of California at Santa Barbara, 6 Feb.–3 Mar. 1968.

Max Weber Retrospective Exhibition. Text by William Gerdts. Newark, N.J.: The Newark Museum, 1 Oct.–15 Nov. 1959.

Max Weber Retrospective Exhibition, 1907–1930. Text by Alfred H. Barr, Jr. New York: Museum of Modern Art, 13 Mar.–2 Apr. 1930.

North, Phylis Burkley. "Max Weber: The Early Paintings (1905–1920)." Ph.D. dissertation, University of Delaware, 1975.

Weber, Max. *Essays on Art*. New York, 1916.

Werner, Alfred. *Max Weber*. New York, 1975.

Archival Material

Madrid, Spain. Collection of Rodrigo de Zayas. Marius de Zayas papers.

New Haven, Conn. Beinecke Rare Book and Manuscript Library, Collection of American Literature. Alfred Stieglitz Archive; Gertrude Stein papers; Marsden Hartley to Norma Berger.

New York. Columbia University Library. Oral History Collection (Max Weber tapes).

New York. Museum of Modern Art. Edward Steichen Archive: Marsden Hartley, "The Spangle of Existence, Casual Dissertations." Unpublished manuscript.

Washington, D.C. Archives of American Art, Smithsonian Institution. Abraham Walkowitz papers (microfilm); Armory Show papers; Arthur Dove papers (microfilm); Downtown Gallery papers (microfilm); Elizabeth McCausland papers; Marsden Hartley files (microfilm); Hartley to Rockwell Kent; Max Weber papers (microfilm).

·INDEX·

Index